We Are at Home

We Are at Home

PICTURES OF THE OJIBWE PEOPLE

Bruce White

FOREWORD BY

Gerald Vizenor

MINNESOTA HISTORICAL SOCIETY PRESS

www.mhspress.org

The Minnesota Historical Society Press is a member
of the Association of American University Presses.

Manufactured in the United States of America

10 9 8 7 6 5 4 3 2 1

♾ The paper used in this publication meets the minimum requirements of the American National Standard for Information Sciences—Permanence for Printed Library materials, ANSI Z39.48-1984.

International Standard Book Number 13: 978-087351-579-5 (cloth)
International Standard Book Number 10: 0-87351-579-X (cloth)

Library of Congress Cataloging-in-Publication Data

White, Bruce.
Pictures of the Ojibwe people / Bruce White.
p. cm.
Includes bibliographical references and index.
ISBN-13: 978-0-87351-579-5 (cloth : alk. paper)
ISBN-10: 0-87351-579-X (cloth : alk. paper)
1. Photography, Artistic.
2. Ojibwa Indians—History—Pictorial works.
I. Title.
TR654.W363 2007
779′.208997333—c22
2007000522

*Publication of this book was supported in part
by a generous gift from the late Laura Jane Musser.*

We Are at Home

Foreword

THE ANISHINAABE CREATED BY NATURAL REASON a sense of imagic presence and mythic survivance in the painted and incised pictures of animals, birds, and miniature characters on birch bark, wood, and stone. These images, or *pictomyths,* were venerated and carried into every native season, experience, and sacred histories.

These pictomyths on wood, bark, hide, and stone were created by visions and sustained by stories. Some photographs of ancestors are stories, the cues of remembrance, visual connections, intimations, and representations of time, place, and families, a new native totemic association alongside traditional images and pictomyths.

"Drawings were also made in the soft, dry ashes of a fire or on the dry earth," wrote Frances Densmore in *Chippewa Customs.* "The drawings in the ashes or in dry earth were usually a map, an illustration or a narrative, or a delineation used in the working of a charm."

Densmore observed that the "figures included crude illustrations of men, animals, birds, and other material objects, and in the Midewiwin symbols representing the sky, earth, lakes, and hills, as well as sounds and 'spirit power.' A simpler symbolism was used in messages and casual records, including signs to represent days, direction, and duplication of numbers."

In the *Midewiwin,* or Grand Medicine Society, "picture writing could be used to represent the name of a person" and the image of a dream might be represented "by a symbol painted" on a "blanket, or on the hide" of a wigwam.

The figures painted on stone, on the face of granite, are more fantastic than any representations of natural motion or naturalism. There is no trace of face or hands in some visions and dream images, but explicit lines that show sound, voice, and heart. The "artist was groping toward the expression of the magical aspect of his life, rather than taking pleasure in the world of form around him," noted Selwyn Dewdney and Kenneth E. Kidd in *Indian Rock Paintings of the Great Lakes.* Essentially, "the origin and purpose of these deceptively simple paintings remain a mystery."

These Anishinaabe pictomyths—transformations by vision and memory—and symbolic images are totemic pictures and not directly related to emulsion photographs; yet, there is a sense of survivance, cultural memory, and strong emotive associations that bears these two sources of imagic presence in some native families.

The Anishinaabe convene familiar cultural pictures: images and photographs of family, friends, and honorable political and historical figures. Native families rarely decorate the walls of their houses on reservations with pictures of strangers or posters of classical or modern art; however, copies of expressionist paintings by George Morrison, David Bradley, Frank Big Bear, Patrick DesJarlait, and many other native artists are appreciated in native homes. Color photographs of President John F. Kennedy and copies of portrait photographs of Geronimo, Chief Joseph, Sitting Bull, Bear's Belly, American Horse, Qahatika Girl, and many other distinguished natives photographed by the inimitable Edward Curtis are not uncommon in many reservation homes.

Everlasting Sky, John Kakageesick, was not photographed by Edward Curtis, but he was a notable native at home in Warroad, Minnesota. Kakageesick is forever pictured in a simulated bright orange headdress on color postcards sold at the Warroad Historical Society. Everlasting Sky was probably 124 years old when he died in December 1968. I was a journalist for the *Minneapolis Tribune* at the time and reported the funeral ceremonies. By native tra-

dition he would have been buried in his finest buck-skin clothing with his knees bent toward his chest, leaving the world in the same position as his birth, but the local mortician dressed the body of Kakageesick in a blue suit and white shirt and placed him in a fluffy satin metal coffin. He was buried, after a traditional honoring ceremony, in the Highland Park Cemetery.

The Warroad Village Council declared May 14, 1844, the estimated date of birth to celebrate the presence of Kakageesick in the town. Everlasting Sky lived on a land allotment on Muskeg Bay, Lake of the Woods, and his experiences reached beyond the establishment of the state and reservations. He was an adult at the time of the Civil War and probably heard stories about President Abraham Lincoln.

Bruce White presents two views of Everlasting Sky in this memorable study of photographs of the Anishinaabe in Minnesota. Kakageesick wears an elaborate headdress with a beaded headband in the postcard picture; in the second photograph he wears a striped flannel shirt and holds a ceremonial pipe. Everlasting Sky "continued to live on his land south of the city until his death," writes White. "He was a familiar figure in Warroad throughout his life. Postcards with his face on them came to symbolize the city's history and heritage."

The Kodak Brownie, first introduced as an inexpensive cardboard box camera in 1900, provided a new and original source of native stories—the ready, arrested images of friends and family. The spare meniscus lens captured natives in ordinary scenes and in common, untouched poses at home and at work, gathering wild rice and berries, curing hides, and preparing maple sugar. The Brownie scenes of friends and family were almost always casual; at times they were fortuitous in contrast to the studio photographs a generation earlier. The studio poses were formal, often ceremonious natives and families—in sharper focus, retouched poses in front of ethereal backdrops. The box camera, however, inspired a new perception and consciousness of the real, of humans and nature, a new expressive, won-drous world of black, white, and gray eyes and hands in distinctive, arrested motion.

The eyes and hands are metaphors of presence in photographs, a sense of presence and right of natural stories in arrested expressions and gestures. The eyes are emotive, and some eyes seem to insinuate a moment of truth: rage, shame—a verity, even in the black and white shadows. Many native bodies are cultural objects, dressed at times for the studio and with the simulations of traditional vestments.

That sense of presence is evident in many verbal references to people and scenes in photographs. The present tense, more often than not, is used descriptively, creating a sense of presence. In one photograph, for instance, Mary Wind *wears* high-heeled shoes, rather than the past tense, she *wore* high heels. The present tense continues the sense of motion, presence, and survivance.

The Brownie Camera overturned the disposition of studio poses and masters of portraiture. The inexpensive box camera could easily be carried anywhere, and for that reason the photographs were of more common, customary scenes, and sometimes the images inspired more personal stories. Studio and box camera pictures are equally and rightly treasured nonetheless, and both create a sense of presence in native memories and stories.

The Brownie Camera was a prelude to individuality and modernity, and yet the pleasure and practice of taking photographs scarcely superseded the direct traditional connection to stories about native images on bark, wood, and stone.

"Photography evades us," declared Roland Barthes in *Camera Lucida*. "Whatever it grants to vision and whatever its manner, a photograph is always invisible: it is not it that we see." The photograph "represents that very subtle moment when, to tell the truth, I am neither subject nor object but a subject who feels he is becoming an object."

The Anishinaabe, by their visionary practices, were always original and individualistic. They embraced with ironic confidence most industrial technologies of modernity—inexpensive telephones, au-

tomobiles, electrical power, refrigeration—and yet continue their stories that create a unique sense of cultural presence and survivance.

Bruce White presents in this marvelous selection of studio and box camera photographs a common, emotive, concerted narrative portrait of several generations of natives named the Ojibwe and Anishinaabe. "In the 1850s, photographers in St. Paul took pictures of visiting Ojibwe leaders," observes White. "In the artificial surroundings of the studio or gallery, these photographs show the leaders in direct frontal poses reminiscent of European portraits, sometimes wearing clothing not their own and holding objects that fit the white man's stereotypical views of the things Indians should have."

White selected hundreds of photographs for this collection and provides narrative histories and cultural comments in seven descriptive chapters. "The process of understanding Ojibwe photographs departs from simplistic, surface interpretations enforced through stereotypical presentations and opens the photograph to new possibilities," writes White. "The goal of studying these photographs is not closure but an opening toward a richer view of the process of photography and of the Anishinaabe lives and histories represented."

One photograph shows two native women standing on a wood plank sidewalk in front of a store, Confections and Tobacco's. One woman has her back turned to the camera to show her child and a decorative cradleboard. A man watches the photographer from inside the store. He wears a white shirt and tie and seems to be amused. The two women wear dark clothes. The man in the window is a distraction, not the subject of the photograph taken in about 1910 in northern Minnesota.

Roland Barthes described in *Camera Lucida* his "general, enthusiastic commitment" to photographs as *studium,* an appreciation and participation in the figures, faces, gestures, and actions. Likewise, a general appreciation of the Anishinaabe in photographs is studium, a familiarity of the images of natives. "To recognize the *studium* is inevitably to encounter the photographer's intentions, to enter into harmony with them, to approve or disapprove of them, but always to understand them, to argue them within myself," observed Barthes. Culture, the very source of studium, "is a contract arrived at between creators and consumers."

The picture of the two native women in front of Confections and Tobacco's, one with her back turned to show a cradleboard to the photographer, is appreciated by this theory of studium, a common cultural curiosity that animates the scene and photographic practice. The concentration of this distinctive picture, and the apparent intention of the photograph to focus on a decorative cradleboard, is broken by the face of a man inside the store. The man is not part of the native scene and, in fact, seems to be amused by the entire situation and presence of the photographer.

Barthes used the word *punctum* to designate a break in the concentration and intention of the photographer. The punctum is a "wound"; the photograph is "punctuated" by accident or chance. The face of the man inside the store, in this sense, is punctum, a "bruise" or "wound" in the concentration of the scene. The focus of the picture is punctuated by chance, a surprise that may arouse another interest in the picture. Barthes declared that punctum has the "power of expansion"—the power of one image or scene to change or expand the association of another.

Harry Ayer photographed an Anishinaabe couple, Tom and Mary Wind, and their baby in front of Miller's Tea Room, Wigwam Bay, at Lake Mille Lacs in about 1925. Mary wears a print dress, silk stockings, and high-heeled shoes with leather straps, and she carries a baby wrapped in a quilt on her back. Tom Wind wears a wool driving cap, a long-sleeved shirt, and rubber hip boots. There is no trace of native traditions. Mary's slip and Tom's waders are the only apparent punctum in this photograph.

Edward Bromley, a newspaper photographer, visited the White Earth Reservation more than a century ago and photographed George Lufkins, his wife, and

three children standing on the porch of a frame house with glass windows. George wears a black fedora, four-button coat, and leather boots. His wife wears a stylish blouse and a long, checkered dress, pleated at the hem. She holds a child in a striped shirt. The two other children wear school uniforms: double-breasted black coats, caps, and high-top leather shoes. The eldest boy wears an oversized coat—the sleeves hang almost to his knees, the punctum in this picture. The greatcoat punctuates the experiences of a child at federal school and the expansion of fugitive stories in the picture.

Bug-ah-na-ge-shig, or *bagone giizhig,* Hole-in-the-Day, an eminent native warrior, was photographed by James S. Drysdale, Walker, Minnesota, shortly after the war at Sugar Point, near Bear Island in Leech Lake. The Third Infantry had invaded the reservation in search of Bug-ah-na-ge-shig on October 5, 1898. The Pillagers, only nineteen warriors, defeated more than seventy immigrant soldiers and won the war in one day. Hole-in-the-Day is pictured in a structure of a maple sugar lodge. He wears a fedora and an ammunition belt and cradles a Winchester rifle on his arm. The most memorable punctum in this photograph is the heavy necklace, a collection of spent rifle shells fired by the army at Sugar Point. The necklace is an ironic remembrance of native survivance.

Among the images collected here are active, communal scenes seldom seen in studio photographs. The inexpensive box camera made it possible to photograph natives fully occupied in almost any activity. "From the earliest photographs of Ojibwe people taken by whites, it is hard to find adequate and balanced representations of people's lives," declares Bruce White. "Studio portraits of people standing against a painted backdrop give few clues to these people's relationships, lifestyles, spiritual beliefs, or values."

White overturns the simulations of stoical, isolated natives in studio portrait photographs as he presents a diverse natural domain of natives in active, communal situations. There are pictures of spiritual leaders, unique characters, families, ceremonial associations, singers, drummers, and dancers as well as the "individual stories and experiences" of the people photographed. When examined in this context, White notes, "Their photographs are part of a rich record of struggle, survival, and triumph though many generations." These are pictures and stories of survivance.

Bruce White has created a marvelous, appreciative, and respectful journey of photographs, images, stories, and cultural narratives among the Anishinaabe of Minnesota. His picture, heart, and generous spirit are surely seen in this book.

GERALD VIZENOR

We Are at Home

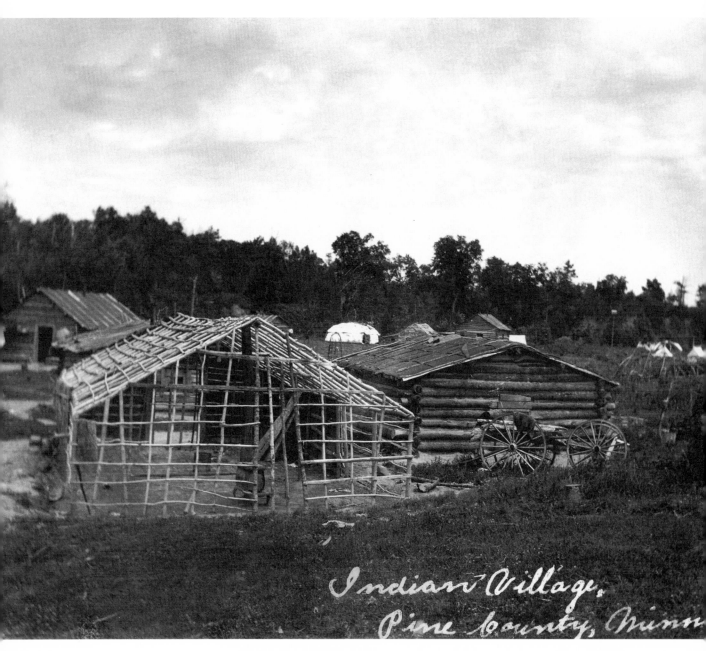

Indian Village,
Pine County, Minn

A view of Aazhoomog village in eastern Pine County by Ross Daniels around 1915 shows a variety of bark and wood structures.

Introduction

The Starting Point of Stories

Photographs are not stories, but they can be the starting points of stories. Nothing is self-evident in a photograph, despite all appearances. One day in May 1987 I drove from St. Paul to Hinckley, a trip of about seventy miles. I was late as usual. On the seat next to me was a copy of a 1928 photograph, taken by a white photographer and sportsman named John W. G. Dunn. It showed an Ojibwe woman standing in a doorway to a house, holding a little girl in her arms. I was going to see that same woman, Doris Boswell, who now lived east of Hinckley, ten miles from where the picture was taken in eastern Pine County. Her daughter Esther Towle, the little girl in the picture, lived just down the road.

In the picture there was something on Doris Boswell's hands. I thought it might be warts or a skin condition of some kind. How was I going to ask her about it? All I could think about was what an intrusion my visit was going to be. I was not used to dropping in on people like this, but I had been doing research on the historical photographs of Ojibwe people in Minnesota for several years and had finally realized that I had a lot to learn from Ojibwe people themselves.

In Hinckley I used a pay phone to call Doris (though on the phone and in person I called her Mrs. Boswell) and say I was going to be late. She seemed surprised that I was coming that day. I became more and more nervous as I drove. The trip from Hinckley seemed to take forever. I passed through Cloverdale and drove another ten miles before I crossed Crooked Creek and came to Doris Boswell's house.

When I turned into her driveway, Doris was burning trash in a barrel along one side. I got out of my car, introduced myself, and told her again why I was there. When I showed her the picture of her and her daughter, she took it and suggested that we go into the little frame house near the road—the old house that she had lived in for many years and where her niece and her niece's husband were now staying.

The house had wood floors and a barrel stove in its main living space. Mrs. Boswell and I sat down on a worn couch. She got up and turned on a light so she could see the picture better. She looked closely at the picture for a few minutes. Then she said, "I was baking bread that day."

The Ojibwe in Minnesota

The Ojibwe, or Anishinaabeg, as they call themselves, have had a long association with the region of Minnesota and the Great Lakes of Canada and the United States. Over the last 350 years, the Ojibwe encountered French, British, and American traders, government representatives, missionaries, lumbermen, and settlers, surviving and sometimes prospering in these encounters.

In Minnesota, the first white settlers came in the mid-1800s; most came to the state just before and after the Civil War. As it happened, this period was also the time when a variety of photographic processes were first developed and popularized. The Ojibwe people and scenes of Ojibwe life were among the first subjects for photographers in Minnesota.

In the 1850s, photographers in St. Paul took pictures of visiting Ojibwe leaders. In the artificial surroundings of the studio or gallery, these photographs show the leaders in direct frontal poses reminiscent of European portraits, sometimes wearing clothing not their own and holding objects that fit the white man's stereotypical views of the things Indians should have. Occasionally the photographers ventured out of their studios to make pictures at events such as annuity payments, when native people received money for land that had been sold under treaties.

Photographers took the pictures not for the Ojibwe but for white customers, who saw native people as exotic. Sometimes the photographs became the basis for engravings in national magazines, so that people all across the country could view the picturesque native people of the new state of Minnesota. The pictures were presented with captions that emphasized stereotypical ideas about native people. Women were referred to as "squaws" and men as "chiefs" or "warriors." Children were "papooses." In general, native people were considered little more than local scenery, parts of the natural world that newly arrived European Americans saw themselves transforming.

As technology improved and cameras became more portable, photographers left their studios to visit Ojibwe communities along the Mississippi and St. Croix rivers and Lake Superior. Setting up shop in Duluth and smaller northern Minnesota towns, they traveled throughout the Ojibwe villages and reservations that were being established just before and after the Civil War. Powwows, such as the annual June 14 celebration at the White Earth Reservation, provided an opportunity for many photographers to record Ojibwe people in a tribal setting. The introduction of the dry-plate photographic process and later the Kodak camera meant that journalists, artists, government employees, and tourists could all take their own pictures of Ojibwe people.

But even though they took the photographs in authentic Ojibwe communities, these early photographers shared many of the white prejudices about the Ojibwe and focused on certain themes that fit in with

stereotypes about how Indians should look and act. They were fascinated by babies in cradleboards, by bark canoes and houses, by wild ricing and maple sugaring, but they took few pictures of Ojibwe people working as lumberjacks or driving wagons or automobiles—aspects of Ojibwe lives that did not match the way white people imagined them. Sometimes they even staged pictures, photographing Ojibwe wearing Plains Indian headdresses and fringed buckskin, for example, to make the people seem more "authentic."

Eventually, the popularization of photography allowed Ojibwe people to have pictures of themselves taken for their own purposes. Families commissioned their own studio portraits. They also bought their own cameras, like the popular Kodak Brownie, and recorded their daily lives and important events in treasured snapshots. Like many other peoples, the Ojibwe have made the technology of photography their own, in the process creating a richer, more complex record of their own lives.

Doris Boswell and Esther Towle

After showing Doris Boswell the picture of herself and her daughter, I showed her some other pictures I had brought. There was one of her father, also taken by John W. G. Dunn in 1928, and Doris talked about the fact that her father was wearing overalls in the photograph. When she saw a group of studio photographs by Pine City photographer Ross Daniels, which I had also brought from the collections of the Minnesota Historical Society, she started to name the people in them: Jennie Peterson, Rachel Clark, John Razer, Maggie Churchill Dunkley. I made notes as quickly as I could, because the people in the pictures had not been identified until then.

All my questions seemed lame and awkward. But when I asked her a silly question, such as "Is that what they always wore?" she would respond with a gentle, "In a way."

I told her that I had other pictures that I had not brought, and I asked if I could come back another time, when she wasn't busy. She said she was never very busy. As we walked out of the old house, she asked me if I would like to come into her new house and see some of her own pictures. Her niece's husband said, "Yeah, she's got a lot of pictures."

In her living room, as we sat on the couch beneath an impressive photographic display of her grandchildren, she brought out a Victorian-style album with plush covers. Inside were a number of Daniels pictures. She told me more names—Jack Churchill, John Clark, Juliette Cook, who was her sister, and Harry Cook, her brother-in-law. I could not bring myself to ask her to let me borrow the photographs to make copies, but I spoke about coming back again. Before I left, I showed her a photocopy of a picture of John Clark from one of Dunn's diaries. The copy included a small piece of the diary's next page, which showed a

portion of another picture—only the tip of a man's nose to the top of his cap. Seeing this small segment of photograph, Doris immediately said, "That's Pete Nickaboine."

After saying goodbye, I drove a little way down the road to the east to see Doris's daughter, Esther Towle. Esther had a column in the Hinckley newspaper that reported on the comings and goings of her family and her neighbors. Esther's residence in the woods on the south side of the highway was a long, one-story house with wooden stairs on one end. There were two pieces of tree trunk by the front door that had been chewed by beavers. Her husband had brought these over from Lake Lena as a touch of humor for her son's high-school graduation party the following Sunday.

All over the living room—on the floor, on the chairs, on the couch— were bits of cloth, and I asked Esther if she made quilts. "Not in the summer," she said. But she added, "I belong to two drums, so I have to keep up my quilting"—a remark I did not fully understand until later.

She invited me to sit down. I pulled out the picture of her with her mother. She said she thought she had seen it before, in a smaller version, probably a postcard. She told me that her mother had been baking bread the day the picture was taken and the photographer would not let her wash her hands because he wanted to take a picture of her as she was.

There were several framed pictures of Jesus on the wall. Esther took out a picture of herself in her twenties. It showed her with her hair in a Joan Crawford style, seated on a round stool in a café. She told me that this picture was taken when she was the head waitress in a restaurant in St. Paul.

I showed her more pictures, and she told me many stories. Later on, back in St. Paul, I wrote down what I could remember.

Photography and Indian People

The topic of photography and the way it was used to record American Indian people in the nineteenth and twentieth centuries has long been an area of interest for me. At the time they were taken and for a long time afterward, photographs of Indian people were in demand by whites who saw the Indians as exotic. But more recently Indian people themselves, as well as anthropologists, historians, and others, have raised questions about the nature of such photographs and the intentions of those who made them.

Much recent work has focused on the degree of distortion in the work of photographers such as Edward Curtis—who recorded many Indian people throughout North America but never the Minnesota Ojibwe—and the stereotypical way in which they posed and shaped their subjects to create a romanticized "traditional" view of Indian peo-

ple. Others have pointed out the colonialist and dehumanizing nature of such photography, inspired in part by Susan Sontag's provocative theoretical work on photography. Sontag argued that the pervasive cultural model of photography is an aggressive one: "like a car, a camera is sold as a predatory weapon—one that's as automated as possible, ready to spring." Furthermore, she suggested, "the act of taking pictures is a semblance of appropriation, a semblance of rape."

In the case of nonwestern peoples such as American Indians, photography was an instrument of control and domination. Photography symbolized and aided the subjugation of such peoples. Gerald Vizenor wrote that during the process of domination of native communities throughout the world, "the new technologies of photography capture the fugitive other in the structural representation of savagism and civilization" and cameras were the "instruments of institutive discoveries and predatory surveillance." He wrote: "The decorative feathers, beads, leathers, woven costumes, silver turquoise, bone, native vesture, and *indian* simulations have turned humans into mere objects that bear material culture in photographs." For Vizenor, even the word *Indian*, in its capitalized form, is a colonial image, a simplistic misrepresentation of the rich complexity of authentic people.

Yet Ojibwe people do value the pictures taken of their ancestors, even ones that seem compromised by stereotypes. The variety of circumstances under which photographs were taken suggests possibilities hidden behind or on the edge of those stereotypical feathers and beads. These possibilities arise from the fact that photographs, as Ira Jacknis wrote, "by their nature must always be a record of a unique action—snapping the shutter on a particular space at a particular time." Despite all their best intentions, photographers cannot completely control the way their subjects act in the presence of the camera. Photographs are inevitably the result of an interaction between photographer and subject—what might be called a photographic encounter—in which each attempts to impose meanings on the situation. As Marshall McLuhan wrote, "Nobody can commit photography alone."

Even Vizenor acknowledges that Indian people in photographs might undermine the distorting nature of the photography process, saying, "the *Indian* in photographs should be seen in the eyes and hands, an honorable invitation to underived narratives, rather than public representations and closure." He adds: "The eyes and hands of wounded fugitives in photographs are the sources of stories, the traces of native survivance; all the rest is ascribed evidence, surveillance, and the inter-image simulations of dominance. The eyes and hands have never been procured in colonial poses, never contrived as cultural evidence to serve the fever of institutional power."

Meeting the Dunkleys

Later in the summer of 1987, someone told me about John and Marian Dunkley, who lived along the same highway in Pine County as Doris Boswell. I called their daughter, Geri Germann, a teacher in the Pine County schools, and told her about my project, that I wanted to learn from Ojibwe people about their photographs. She told me her parents would probably be glad to see me, though her mother was ailing. I arranged to meet her at her parents' house one day in September 1987.

The Dunkleys lived ten miles east of Hinckley near Cloverdale, along the south side of the road. Their small square house was probably built in the 1930s. Behind the house was a metal drum with a pulley attachment, an improved method for parching wild rice.

John, Marian (I addressed them as Mr. and Mrs. Dunkley), Geri, and I sat at the kitchen table. They served me coffee; I think Geri had brought some long johns from a bakery. As we sat there I showed them the same pictures I had shown to Doris Boswell. They too told me the names of the people in the photographs: Josie St. John, John Dunkley's grandmother; Tom Hill, his uncle; Annie Staples, his aunt. One of Ross Daniels's photographs, showing three young women, had special importance for Marian. One of the women was her sister Maggie, another was her cousin Nancy Songetay, and the third was another cousin, Charlotte Reynolds. The three women were about the same age and had played together as children.

A small boy walked into the room. It was Paul Maurice. The Dunkleys babysat for him when his parents—Marcie, Geri's sister, and Dave Maurice—who lived across the driveway, were busy. It was clear he had the run of the place. Later on I often saw Paul and talked with him and his father when I came to visit.

Marian had had a stroke and had difficulty talking, but it was clear that she remembered many things and was distressed that she could not express them. When I showed them the photographs from the Minnesota Historical Society, she wondered why nobody had put labels on the pictures. They should always do that, she said. Later I learned that she had done this herself with her own family pictures.

I saw John and Marian Dunkley again in July 1988. They were staying in a nursing home in Sandstone, where they'd gone because Marian's health had deteriorated and John was not able to take care of her by himself. We sat together in an empty dining room, and this time I asked to tape the interview.

We talked about the studio portraits taken by Daniels in Pine City. In some of the pictures, the people were wearing suits with the pants legs rolled up. John pointed out that these suits were not regular day-to-day clothing. Some of the people must have gotten the suits from the photographer. At that time, many photographers lent nice clothes to

their subjects, white and Indian alike, and even the articles of Ojibwe clothing in the pictures—such as moccasins or bandolier bags—were not everyday items. More often Ojibwe people wore some of the same simple cloth clothing that their white neighbors did.

I learned more about John and Marian's families. Marian's maiden name was Churchill, and she came from a village located at the mouth of the Tamarack River on the Minnesota side of the St. Croix River near Danbury, Wisconsin. Her mother was a Songetay, with ties to the St. Croix Band of Ojibwe in Wisconsin. John's family, the Dunkleys, and his mother's parents, the St. Johns, had lived along the St. Croix River in the area of Yellow Banks, where St. Croix State Park is today. Like many Ojibwe, the Dunkleys and St. Johns had moved to the White Earth Reservation in western Minnesota after 1910, at the urging of the federal government. But also like many families, they moved back to Pine County in 1924, when John was eight years old.

The Dunkleys told me many family stories, including how John and his mother and siblings had gone to White Earth in the late 1920s and then walked all the way back to Pine County. They talked about the various villages in eastern Pine County where Ojibwe people lived or had lived in the past. There was *Aazhoomog*, or crossroads, the village near Lake Lena; *Gibaakwa'iganing*, "the dam," at the site of a logging dam on the Tamarack River; and *Agamiing*, the village at the mouth of the same river, where the Songetays and Churchills lived.

John also mentioned that a relative of one of the people in one of the photographs, Alvina, the daughter of Scott Matrious, wanted a copy of the picture. Her married name was Aubele, and she lived at Aazhoomog.

Contexts of Photography

The anthropologist Paul Byers points out that photographs are the result of an interaction—often a negotiation—between the subject and the photographer in which each attempts to impose meanings on the resulting product. Though the phrase "taking pictures" originally described the work of artists in capturing a subject, it has also been used to describe the role of the active subject in the process of photography. People who are not happy with photographs of themselves often say that they "don't take a good picture." In this sense, both photographers and subjects can be said to "take pictures."

The full photographic experience can be seen as a spectrum of possibilities, based on the relationship between photographer and subject. At one end of the spectrum is a certain type of fashion photographer who has ultimate control over the process of photography; police photographers making mug shots of criminals may have similar control. Such photographers treat their subjects as poseable figures to be moved and twisted at will. Photographers at this end of the spectrum may ex-

emplify the predatory photographer, "shooting" their subjects secretly or quickly without their permission, believing that in the process they are "capturing" the subject's "true self." Similarly, subjects may believe that they must allow themselves to be photographed without appearing to react to the camera. "The good manners of a camera culture," Sontag says, "dictate that one is supposed to pretend not to notice when one is being photographed by a stranger in a public place as long as the photographer stays at a discreet distance—that is, one is supposed neither to forbid the picture-taking nor to start posing."

On the other hand, there are photographers who choose not to act in a predatory manner. These photographers make photographs of what people look like when they pose themselves, in the belief that this too reveals something important about the subjects that may not be evident when they are photographed secretly. And there are subjects who seek to impose more explicit meanings on the photographs made of them.

Even more extreme are the examples of subjects who object strongly when they see a photographer attempting to photograph them. Other subjects seek to have ultimate control over the process of photography. A person who takes his or her own photograph in a coin-operated photo booth or with a camera operated by a long cable exerts a great deal of control over his or her own photograph. A person of power and influence who hires a photographer to take his or her picture may have similar control.

In between these extremes are the bulk of photographs, which result from negotiation of various kinds between subject and photographer. Many fashion photographers want their models to be not passive objects but active participants in producing the photograph.

A full, detailed description of what goes on when a photograph is taken would not simply record that a photographer had "captured" a passive subject on film. It would describe the physical setting in which the picture was made and inventory the material objects recorded on film. It would answer questions about what kind of photograph the photographer was trying to take and what steps he or she took to accomplish it. What artistic and cultural traditions influenced the photographer? How did the photographer frame the picture? What did he or she say to the subject?

At the same time, such a description of the making of a picture would record what the subject was hoping for from the picture. How did the subject stand or sit? In what ways did the subject present himself or herself for the camera? What meanings did the pose, the clothing, and the objects surrounding the subject have in his or her culture or personal history? And finally, the role of bystanders must be considered. Who else stood behind the camera with the photographer, shaping the process of picture making and picture use?

These questions describe photographic interaction as though it al-

ways takes place on a conscious level. In fact, a variety of factors, both conscious and unconscious, impinge on the process of photography. Age, gender, and social standing and the rules of etiquette, though never mentioned by either party, may well influence what happens, even if those involved believe that they are part of a dispassionate, "scientific" study. The physical setting may be one of those factors that works at a less-than-conscious level in influencing the creation of photographs. For example, many people may find it difficult to be completely at ease in the photographer's studio, and the setting may very well encourage people to assume a false identity, through clothing or gesture. On the other hand, when photographing people inside their homes, photographers may not be able to shape the composition of the photographs and pose the subjects the same way that they are able to do in studios.

Going to Lake Lena

On a Saturday morning in June 1989, my wife, Ann, and I drove from St. Paul to Lake Lena to visit Alvina Aubele. Alvina was living in her brother Dave's house. Following her directions, we found the blue house across from an orange house, just past a Y in the road. A black dog sat on the steps, and as we walked toward the door, Alvina came out to warn us about him, though he did not seem dangerous.

"I thought I missed you," she said, "I went to the community center awhile ago." Her hands were covered with flour. "I can't shake hands with you," she said. "I'm making fry bread."

We could not help but think back to that day in 1928 when Dunn photographed Doris Boswell. We sat down at the kitchen table, and Alvina gave us coffee and fry bread. I described my project and explained that John Dunkley had told me about her. She said, "I was surprised when you called me because I didn't know anyone named Bruce White."

After awhile, Alvina's brother Dave came in the front door, holding a good-sized bass by its lower jaw with his thumb and forefinger. He had been fishing in the lake across the road. As Alvina got up from the table and started to filet the fish, I explained my project to Dave. He was very familiar with the work of Edward Curtis and the way Curtis posed and manipulated the people he photographed.

I took out the photograph that John Dunkley told me Alvina had wanted. It showed her grandfather, George Matrious, and his nephew, Bill, sitting in Ross Daniels's photography studio in Pine City. Alvina and Dave told me about their grandfather, who had come originally from Wisconsin, about their father, and about other relatives. Another of the Daniels photographs showed four children posed with another in a cradleboard. These children were their mother's family, and the baby in the picture was probably their mother. At this point, Alvina brought out a square color snapshot taken in the 1950s or early 1960s

of four people arranged in a group, two sitting in lawn chairs, in front of a house and a car. These were four of the same people, including their mother, who had posed in that photo studio so many years before.

I showed them Dunn's photograph of Doris Boswell. It turned out that in 1928 Doris Boswell's house had stood on the same spot as Dave's did in 1987. Looking at the photograph, Alvina also thought that the bread dough on Doris Boswell's hands looked like warts.

As we talked, it seemed to me that in cases where Alvina and Dave did not know the people in the photographs, they focused on the possible use of props, the fact that the suits, neckties, and hats were not things people in the area would have worn. But when they talked about pictures of people they knew, this was less a concern. Instead they overlooked the manipulations and distortions, viewing these photographs as family pictures.

After looking at many of the pictures I had brought, Dave suggested that it would be nice to have all the pictures framed so they could be put on display in the tribal center. I said that that was something I'd been thinking about and I wondered who would be the right person to talk to about doing it.

"Me," he said, laughing. It was then that I learned Dave was the local representative on the Mille Lacs tribal council. Dave and his sister had grown up nearby. The house in which he had lived did not have electricity or television until he was a teenager, but later he became a cameraman for public television. For awhile he worked on "Wall Street Week" in Baltimore, until he decided to return to Lake Lena.

It was now early afternoon, and both Dave and Alvina were ready to go to the tribal center, where the ceremonial part of a dance was going to begin. There were two drum groups in the area, and each held a dance in the spring and the fall. We were invited to come to the public part of the dance in the evening.

The Goal of This Book

The purpose of this book is to search for those traces of what Vizenor termed native survivance, to look at photographs of Ojibwe people in a different way. It is to deconstruct these Ojibwe photographs taken during the first hundred years of photography, stripping away the layers of stereotypical props and understandings, and to learn something of the experiences of the people pictured, the Ojibwe people, the Anishinaabeg of Minnesota. This kind of archaeology requires looking at images very carefully to learn about what details they contain and what these details represent.

It may seem an impossible task. Photographs of Ojibwe people may appear to be so compromised by the photographic process that nothing can be done to alter their meaning. To do so would mean changing the

assumptions and inferences that all viewers make in viewing photographs; since many stereotypes about Indian people are firmly ingrained in American culture, how can one hope to shape the way Indian photographs are viewed?

Of course, the same things might be said of any effort to change the common view of a historical event or period. The practice of history always involves presenting new information in ways that will convince the reader or viewer to understand the past in a new way. And the stereotypical understanding of Indian photographs can arise as much from the way photographs are presented as they can from anything inherent in the image.

There are a variety of ways to approach Ojibwe photographs in order to suggest the meanings hidden beneath and around the stereotypes. One important step, and one I tried to follow in working on this book, is to present these photographs, whenever possible, with details about the process through which they came to be made. Unfortunately, this deep description is not always an option, since photographers of the past saw picture taking as a casual, fleeting event not worth mentioning or describing. But sometimes the ways in which photographers presented their images to the public, in the form of mounted photographs or in newspapers or magazines, give us clues as to how they made their pictures.

It is equally important to learn about the people pictured—their names, their lives, their families, their communities, their histories, their words. Respect or politeness, if not historical accuracy, seems to call, at least, for mentioning their names, though often people who use photographs of Indian people make no such effort to gather any information at all. Details about people in photographs provide clues about the role those photographs played in the lives of those pictured. They test the stereotypical assumptions about the subjects by revealing the degree to which those assumptions match the reality of individual lives.

Another way to reveal the purpose of photographs is to compare a variety of photographs that show the same people or the same scenes. By comparing similar photographs, we can learn whether certain features reflect a particular photographer's practice, or if the photographer imposed his or her own views on the subject rather than showing the subject's genuine aspects. Viewing all the existing photographs of a person is often revealing. One photograph shows a simplistic view of a person's life; many views of the same person, taken by many different photographers, show that person's life from many dimensions, undermining the simplistic view.

The most challenging photographs are those about which nothing is recorded or known. In such cases, any interpretation may be a guess, though that guess may be an educated one, based on cultural understandings, knowledge of Ojibwe history, and the body of all other pho-

tographs taken of Ojibwe people. Viewers must approach these photographs with care and respect, avoiding reading meanings into facial expressions and poses and keeping their minds open to unanticipated possibilities. Every photograph arises from complex circumstances and is complex by its nature, even if that complexity is not fully understood.

The process of understanding Ojibwe photographs departs from simplistic, surface interpretations enforced through stereotypical presentations and opens the photograph to new possibilities. The overall goal in studying these photographs is not to answer all the questions and, in doing so, provide closure, but to provide an opening through which to learn more about the Anishinaabe lives represented in the pictures.

Pleasant Memories

The tribal center in Lake Lena was a long, low building with a parking lot on two sides. As my wife and I got out of our car, we heard someone giving a speech in Ojibwe. Going to a tribal dance was a new experience for both of us, and we felt very self-conscious as we stood in the doorway. Someone motioned us to sit down on the padded bench along the wall by the door.

The speaker was facing the drum in the center, around which the drummers, including Dave Matrious, were sitting. After a moment, I realized that I knew him. His name was Jim Clark. Months before, in the winter, I had heard him take part in a storytelling session at Mille Lacs along with his aunt, Maude Kegg. Although he was from Aazhoomog, actually Gibaakwa'iganing, the village at the dam, his family also had ties at Mille Lacs. And his daughter was in an Ojibwe class I had been taking all year at the University of Minnesota. Just the week before, I had gone to see him about the photographs. He had looked carefully at them, sometimes with a magnifying glass. He knew many of the people; some were his relatives, and he told me stories about them. He taught Ojibwe at Anderson School in Minneapolis, and he was often in demand as a speaker. I had not expected to see him there at the dance. I also noticed Doris Boswell and her granddaughter sitting across the room.

The drummers played a song and then put the drum away. Tables were set up in the center of the room and covered with many small bowls of food that people had brought from home. First the elders were invited to eat. Tea was served out of a large camp kettle. We took our cue from Dave and Alvina about when it was time for us to get our food. By coincidence or plan, we sat next to the bowl that held the bass Dave had caught and Alvina had cooked earlier in the day. When Jim Clark walked by, I stood up to shake his hand. He greeted me warmly, saying,

"See, this is what I was telling you about. This is what I do. This is where I come from."

Many people were interested in the photographs. Later on, during a pause in the dance, Larry Smallwood, also a teacher in Minneapolis, came up to ask me about a photograph of Pete Nickaboine, the man who had raised him as a child. We walked out to the car, where I had the pictures. As we were talking, other people came out. They started passing around the pictures and looking at them. Soon Jim came out and began to tell stories about some of the people in the pictures, pointing out details that no one else would have noticed. There was so much talk going on at the same time that I could not catch it all. I was talking to one woman and heard only the end of one of Jim's stories about being a kid and trying to hide something from the adults. "Have you ever tried to pour smoke out of a bottle?" he asked.

The drumming started again inside. It was for the women's dance, which involved the exchange of quilts. When Esther Towle said she had to keep up her quilting because she belonged to two drums, she meant that she had to make enough quilts to give away at two different drum dances. During the dance, people also gave money and tobacco.

After the women's dance, a bowl of food was placed on the floor. A man came forward and stood over it as he spoke about loved ones who had passed away. Then people went to the center of the room and ate some of the food. Later, the bowl was passed around with a spoon in it, so that everyone could share.

Around 10 PM, Ann and I decided that we should head home, but Dave asked us if we could wait for a few minutes. He walked across the room and spoke with Alvina and Jim Clark and came back and sat next to me. Jim then walked to the center of the room, a quilt under his arm, and spoke in Ojibwe. I later learned that he talked about the photographs and how they brought back many pleasant memories. He came over and gave the quilt to Dave, who gave it to me. I felt honored, pleased, and embarrassed all at the same time.

The music and dancing began again, and Ann and I drove back to St. Paul under a full moon. When we got home, we put the quilt on the bed and slept soundly.

In the months after this event, I pondered the meaning of the quilt. It was clear I had done little to deserve it. Instead, the people gave it to me because of what I might do in the future. I had been given a responsibility, but it remained to be seen whether I could carry it out.

Later on that summer I went back to see John Dunkley; Marian had died in the spring. Although we had met only twice before, seeing John again was like meeting a kind old friend. For the next few years, I went to see him as often as I could to talk about photographs, about his life, and about the people of Pine County. He passed away in 1993.

In the fall of 1989, after my son, Ned, was born, Ann and I returned to Lake Lena for another dance. My son sat on Doris Boswell's lap and watched the dancers. People seemed more interested in talking with me when I was holding my son, and I realized that babies could be a link between people of different cultures.

In June 1990, with Dave Matrious's help, I put up a display of photographs from the Minnesota Historical Society and from the Dunkleys' family collection in the tribal center, along three sides of the room where the dances were held. Over the years the tobacco smoke from the dances covered the frames and glass with a fine patina. The photographs stayed there until a new community center was built.

How This Book Came to Be

When I was thirteen, I heard my grandfather, Edward McCann, tell the story of his meeting with Ojibwe leaders Migizi and Wadena. But when I began to do research on Ojibwe photographs in the late 1970s, as an employee of the Minnesota Historical Society, I was not really thinking about my grandfather's experiences. As an editor, researcher, and avid amateur photographer, I was sometimes asked to do research in the wonderful photograph collections of the historical society, and I began to notice and admire, sometimes for the wrong reasons, the many photographs of Ojibwe people.

In the fall of 1985, the historical society gave me a grant to write a book on those photographs. During the intervening months I looked at hundreds of photographs, did research on them, and drafted four or five chapters. But as I did so, I became more and more aware of my own ignorance of Ojibwe people, history, and culture. Though I was supposed to finish the manuscript in the spring of 1986, the awareness of my lack of understanding kept me from doing so.

From the beginning of this project, there has hardly been a time when I did not ask myself what right I had to be doing it. What right did I, as a white person, have to write a book about Ojibwe people? What contribution did I have to make? Over the years I have given many answers but none that really satisfied me. In 1986, I enrolled in the graduate school of anthropology at the University of Minnesota. Going back to school did not turn out to be a magic key to finishing this book, nor did it answer my doubts. However, spurred on by what I was learning, particularly in classes taught by my advisor and friend, ethnohistorian Janet Spector, and in courses on anthropological methods taught by Timothy Dunnigan, I began to visit Ojibwe people to learn about their own experiences of being photographed and of taking pictures and about their lives and communities.

Later on my friend, anthropologist Sharon Doherty, explained to me

that anthropology was about visiting, about going to see people and sitting with them around the kitchen table and talking with them about things that were important or even not so important. This was why I went to see Doris Boswell, Esther Towle, John and Marian Dunkley, Dave Matrious, Alvina Aubele, and later many other Ojibwe people. Without their help and interest, I would have known very little.

In 1987, I met and interviewed photographer Monroe Killy, who shared much valuable information about the photographs he took in Ojibwe communities in the 1930s and 1940s. Killy told me many of the Ojibwe people in his photographs were patient with him, his camera, and his questions. The example of Killy's growth and understanding of Ojibwe people over the years and his perspectives on the practice of picture making gave me yet another view of the process of photography.

During the eight years I was in graduate school, I tried to learn more about Ojibwe history and culture. In 1994, I completed a dissertation on the topic of Ojibwe photographs entitled "Familiar Faces: The Photographic Record of the Minnesota Anishinaabeg." The title referred to particular Ojibwe people who appeared in the work of many different photographers as well as to the facile knowledge gained through stereotypes that made many non-Indians think they knew these Ojibwe people well.

In 1993 and 1994, I was privileged to testify for the Mille Lacs Band of Ojibwe in its lawsuit against the State of Minnesota regarding their rights under the Treaty of 1837. This case was decided by the U.S. Supreme Court in 1999 in favor of the Mille Lacs Band and other Ojibwe bands in Minnesota and Wisconsin. This experience and subsequent work with other Indian communities in court cases have helped me understand the meaning of history for Ojibwe people. History matters to them, in part, because the issues of the past return again and again. The struggles of Ojibwe people today to affirm their identity and their rights are a continuation of the struggles of their ancestors to survive and flourish in an invaded country.

Even after my many opportunities to learn about Ojibwe history firsthand from Ojibwe people, this book project stretched on and on, because there was always much more to learn and more photographs to see. The only thing that has allowed me to finish this book now is the understanding that it is not nor can it ever be the final word. This book is one exploration of Ojibwe photographs, part of a discussion that began without me and can continue on after I'm gone.

I cannot write about these photographs the way an Ojibwe person could, and I know this book can never duplicate the rich family and community history in which Ojibwe people view these photographs. But I have tried to give as much information—and as much new information—about these photographs as I can, not as evidence of the stereo-

types with which whites have viewed Indian people but as records of people with a rich history and culture. What I have tried to show in this book is that photographs are the beginning of stories, of history, in Gerald Vizenor's words, "an honorable invitation to underived narratives, rather than public representations and closure." Having finished my narrative, I hope that many others will tell their own stories and that those narratives will be received with respect.

What Is in This Book, and What Is Not

One of the most challenging aspects of doing this book has been deciding which pictures to include. This book contains hundreds of photographs selected from thousands in many repositories documenting the Ojibwe people of Minnesota. It is no surprise that one of the richest collections of Ojibwe photographs—one that provides the largest number of photographs in this book—is in the Minnesota Historical Society in St. Paul. Other photographs in this book are from the collections of local historical societies and regional archives from throughout the state. Many beautiful and interesting photographs have been left out simply because there was not enough room.

Photographs of drums and Midewiwin enclosures during ceremonies have not been used because many Ojibwe people believe that these should not have been photographed. Only one photograph of a cemetery is included because individuals might be tempted to seek out these places and engage in amateur archaeology. Only one photograph of a government-run Indian school has been included in the book; these schools are a complex subject and deserve separate discussion of the kind given in Brenda Child's 1998 work, *Boarding School Seasons,* inspired by the experiences of her own family at Red Lake.

This book roughly covers Minnesota Ojibwe photographs from the earliest existing pictures to around 1950—a date picked simply to limit the size of the book, though it includes at least one photograph from the 1960s. But the Ojibwe people survive and flourish today, and many wonderful photographs of Minnesota Ojibwe were produced after the 1950s, by a range of photographers including many who worked for various newspapers. One Minneapolis newspaper photographer was Charles Brill, who after a visit to Red Lake in the 1960s left the newspaper world to live and photograph at Red Lake, creating the rich body of work represented in his 1974 book, *Indian and Free: A Contemporary Portrait of Life on a Chippewa Reservation,* later revised as *Red Lake Nation.* Brill's work and that of many other photographers, professional and amateur, deserve other books, as do the photographs the Ojibwe people themselves have produced in the last half century.

To show the rich, individual history of Ojibwe communities, more

photographic studies of individual Minnesota reservations should be done. Several books show examples of how Ojibwe communities themselves can provide valuable insight into historical and contemporary photographs: Red Lake High School's 1989 book, *To Walk the Red: Memories of the Red Lake People,* Thomas L. Peacock's 1998 book, *A Forever Story: The People and Community of the Fond du Lac Reservation,* and the 2004 work of Elizabeth M. Tornes, Leon Valliere, Jr., and photographer Greg Gent, *Memories of Lac du Flambeau Elders.*

The chapters in this book deal with themes and subjects that provide a means for understanding the process of photographing Ojibwe in Minnesota and the way in which these photographs reflect the history and culture of the people. Chapter 1 begins with babies in *dikinaaganan,* or cradleboards—a good introduction to the Ojibwe culture, the people, and the various ways they have been photographed in the past.

Chapter 2 covers the major topic of the earliest Ojibwe photographs: *ogimaag,* the people known as chiefs, so often seen as symbols of their people. Chapter 3 shows how photographers began to venture out of their studios to photograph Ojibwe people in their own communities. This and subsequent chapters offer accounts of particular photographers whose work relates to the theme of the chapter.

Chapter 4 includes photographs documenting the various seasonal subsistence activities—maple sugaring, fishing, gardening, berry picking, ricing, hunting, and others—that are important aspects of Ojibwe traditions and rich subjects for many photographers. Chapter 5 shows the various ways in which photographers portrayed Ojibwe lives and the important relationships between people. It contrasts white photographers' portrayals of Ojibwe individuals with the family pictures of the people themselves.

Chapter 6 explores a series of beautiful but enigmatic photographs and asks what conclusions can be drawn about such pictures without detailed information. In chapter 7, I discuss the need to respect the Ojibwe people in the photographs.

This is not the first book of Ojibwe photographs, nor should it be the last. Instead, it is an effort to further a continuing conversation, not only about these particular photographs but also about the meaning of any photographs that document people and their lives, cultures, and communities.

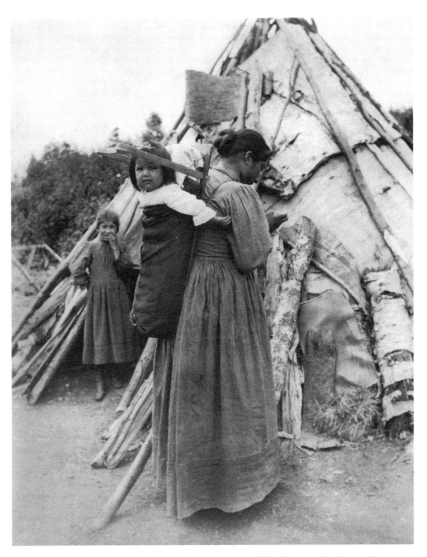

A penciled note on the back of this photograph reads, "Chief Caribou's wife and baby in a Dick a nah gan." If that note is accurate, it is likely this photo from around 1900 was taken in Grand Portage. There was a leader named Caribou at Grand Portage at that time, and birch bark–covered tipis, seen in the background, were sometimes used in that area. Called *bajiishka'ogaan,* such dwellings were common in northern Minnesota's deep pine forests, where the smaller, smooth-barked trees used for *wiigiwam* frameworks were not available. The conical structure may also have been warmer than the domed wiigiwam, known as a *waaginogaan.*

For the first year of its life, the Ojibway baby is taken most excellent care of in its well known cradle. It is wrapped in a great many thicknesses of flannel and soft material, which effectually exclude all cold, and it is perfectly warm and comfortable in any weather. Its head is protected from injury by the wooden piece surrounding it. It likes the firm feeling of being bound and swathed in this frame, and will cry to be put in it.
J. A. GILFILLAN, 1897

1

Dikinaaganan / Cradleboards

Photographs of Ojibwe babies in cradleboards, or *dikinaagan* (plural *dikinaaganan*), are a good introduction to the ways in which Ojibwe people have been photographed over the years. It is not surprising that photographers have taken so many pictures of dikinaaganan. The inventiveness of these cradleboards, combined with the cute babies and proud expressions of the women holding them, made dikinaaganan a perfect photographic subject.

The cradleboard is an ingenious solution to a universal problem: how to amuse, protect, and transport babies. The mother wraps a blanket or other covering—sometimes one with ornate beadwork, called a *dikineyaab*—around both the flat board and the child to keep the baby securely in place. Looped across the top of the board, parallel to it, is a stiff wooden bow; its characteristic double bend gives the bow a loose M shape. The bow works much like a crash bar, keeping the child's head from hitting the ground if the cradleboard falls over or rolls sideways.

Cradleboards allowed Ojibwe women to take care of their children while doing their daily tasks. The women could lean the boards against trees or carry them on their backs while they were gardening, cutting wood, paddling canoes, parching wild rice, or boiling maple sap over a hot fire. Perched in the cradleboards, children were protected from hazards but could still watch, listen, smell, and hear everything that happened around them. Many white visitors to Ojibwe villages described small toys hanging from the bow in the same way mobiles are hung over cribs to amuse and stimulate the baby. But few photographs show those toys, perhaps because the trinkets hid the babies' faces from the photographer's lens.

While much has been written about the dikinaagan and Ojibwe child-rearing practices, we often have no details about the people in the pictures, such as the women's names and how old their babies were. Early Minnesota photographers recorded little specific information about the Indian people they photographed, so we cannot even be sure that the women in the pictures are actually the mothers of the children they carried. And it is impossible to know if the babies actually were happy in the dikinaaganan, as the missionary J. A. Gilfillan claimed.

The photographs of dikinaaganan shown on these pages represent a full range of ways of making pictures, from studio photographs taken with elaborate professional cameras to outdoor scenes and intimate views inside Ojibwe houses taken with simple equipment. They show

varying intentions on the part of the photographers, whether they were purely commercial photographs or family pictures meant only for the people captured in the moment. These many types of photographs, the photographers who took them, and their interaction with the Ojibwe people will be explored in more detail in the rest of this book.

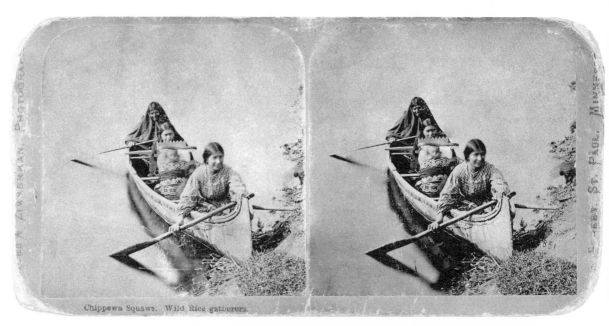

Charles A. Zimmerman titled this stereoscopic photograph "Wild Rice Gatherers," but it is not known if the unnamed women and a baby held safely in a dikinaagan were actually gathering wild rice. The canoe was a bit crowded for ricing, although the people may have been on a lake where this activity was taking place. The title could also refer to the Ojibwe people of the St. Croix River, who were known among their people as the "rice makers" because of the plentiful wild rice found in their region.

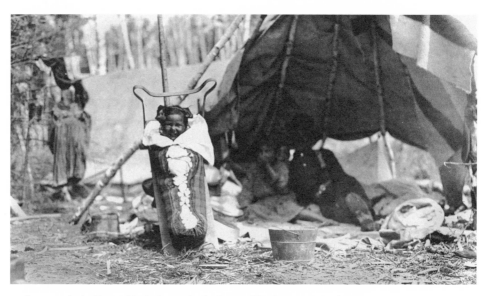

Conservationist Ernest Oberholtzer—who had many friends among the Ojibwe people—took this photograph of a smiling child in a cradleboard at Rainy Lake in the 1920s.

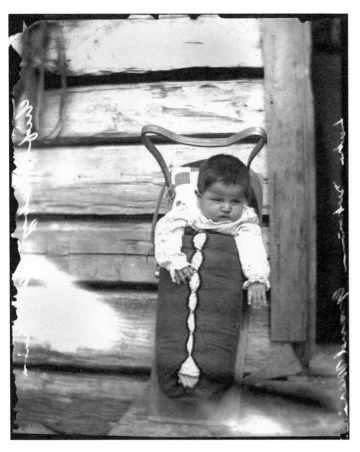

A quilted pillow cushions this child's head as his cradleboard leans against the side of a hand-hewn log cabin. Beginning in the nineteenth century, some Ojibwe families on reservations lived in log cabins that they or the federal government had built. This photograph was taken by a *Minneapolis Journal* photographer around 1910 at Grand Marais, as indicated by the scrawled label on the right side of the image's negative.

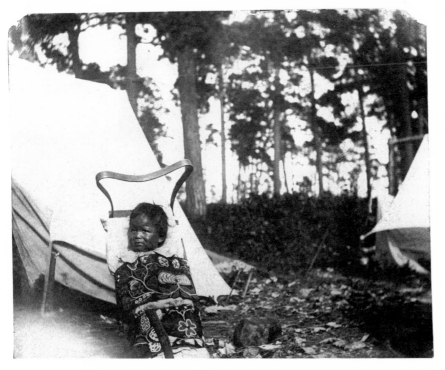

This cradleboard photograph was probably taken or collected by the St. Paul newspaper reporter William H. Brill around 1898. Its label describes the subject as a "Bear Island baby," indicating that the picture was taken at Bear Island on Leech Lake. The cloth tent is the kind sometimes used by the Ojibwe when berry picking, but these tents could also have been ones erected by the U.S. Army. Bear Island was the location of a famous battle between a group of Ojibwe and U.S. soldiers in 1898. The photographer covered the event for the *St. Paul Pioneer Press.*

Although the woman holding the dikinaagan is shown in front of a Plains Indian–style tipi, she or the cradleboard may have been Ojibwe. Edward Bromley photographed this scene at a 1902 celebration at White Earth, which included a number of Sisseton Dakota visitors. The *Minneapolis Times* published the picture with the caption "Ojibway Mother and Child," and the accompanying article referred to the "Chippewa Papoose and Cradle." The word *papoose* was not Ojibwe but a label whites used to refer to babies in their dikinaaganan. Today, however, Ojibwe people sometimes use the word in a joking way.

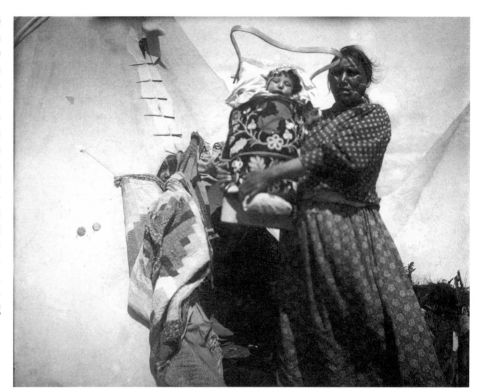

Snuggly wrapped, this child would have been protected from the nearby cooking fire, even if the dikinaagan were on the ground or leaning against a tree. A *Minneapolis Journal* photographer captured this White Earth scene around 1910.

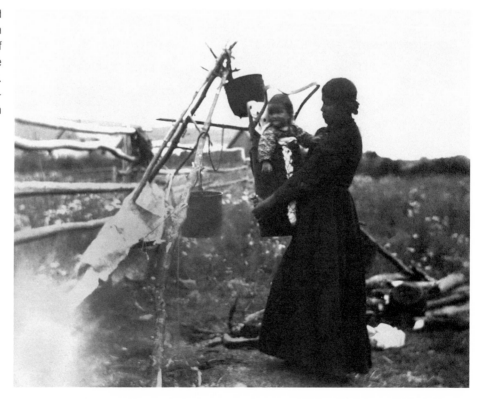

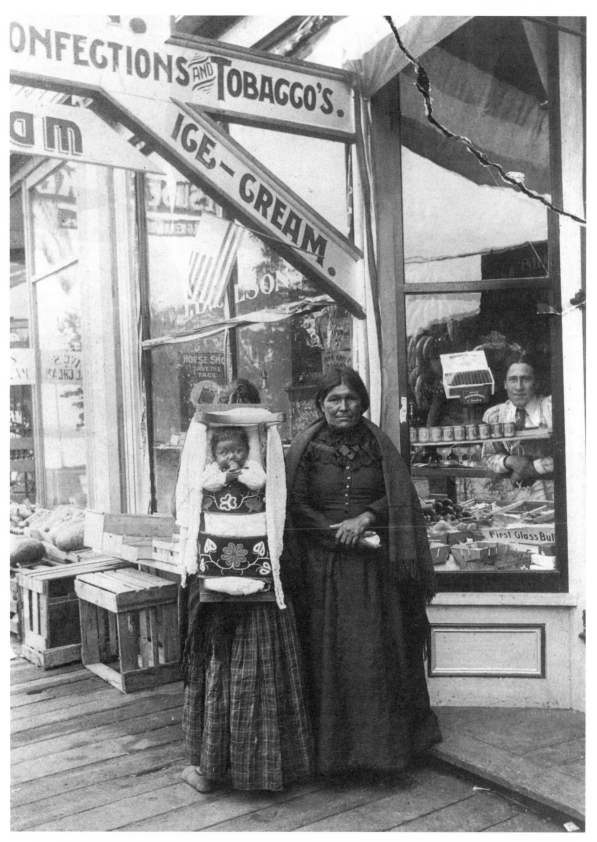

Taken in front of the Ole B. Olson grocery store in Kelliher, just east of Red Lake, around 1910—with a storekeeper peering out from behind the glass—this view is one example of how photographers chose to show the baby rather than the woman carrying the cradleboard.

Photographers often chose to focus on cradleboards and the babies in them instead of on the women holding them. That was the likely intention of James Methven, who took this picture at Mille Lacs in 1902. The intentions of the woman in the picture are less obvious. Given that she is hiding her face in an enigmatic gesture, she may not have wanted her identity known.

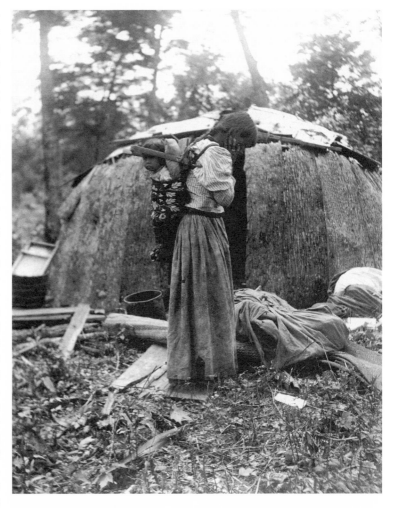

This 1940 photograph taken at Red Lake by Monroe Killy, a photographer interested in Ojibwe culture, shows a cradleboard innovatively made into a hammock. Anthropologist M. Inez Hilger wrote that in the 1930s she saw baby hammocks, made from quilts or blankets, used on all the Ojibwe reservations she visited. Called a *wewebizoniigin*, from *wewebizo*, "to swing," the hammock was sometimes "fastened cornerwise in a home where a mother was doing her kitchen work; or fastened cornerwise over a bed on which a grandmother was sewing while tending the baby."

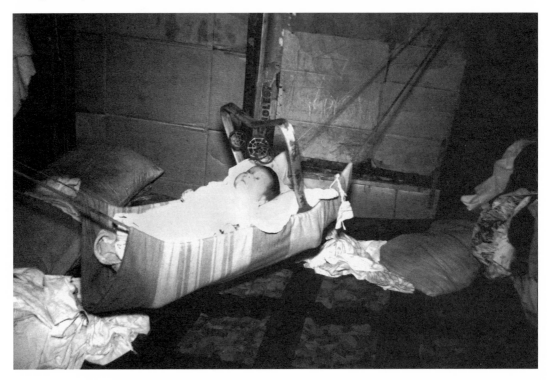

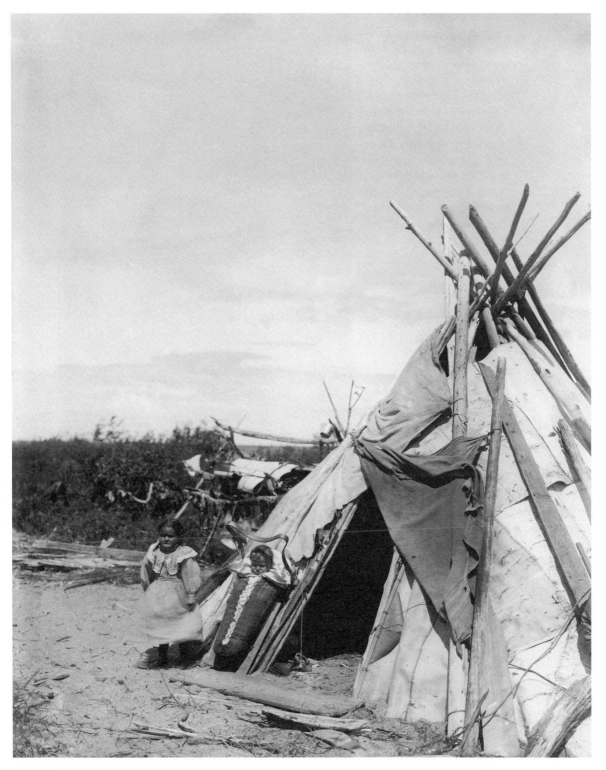

Photographer Henry F. Nachtrieb took this 1901 picture of a fishing village on the south shore of Lake of the Woods. (Note the rack of drying fish in the background.) Nachtrieb was a member of the Minnesota Zoological Survey that was studying the lake's fish resources. He used a large-format camera, probably on a tripod, and a lens well designed to record sharp details, such as the child in the dikinaagan and the birch-bark and wood framework of the Ojibwe version of a tipi, known as a *bajiishka'ogaan.* But the shutter speed was too slow to capture the movement of the little girl's dress. A note written on the negative suggests the children belonged to the local Angus family.

After 1900, postcards became the most popular means for distributing images of the Minnesota Ojibwe. Edward McCann, a Methodist minister at Onamia in 1910, was an avid photographer and collector of photographs, particularly postcards. His collection included postcards showing the Ojibwe people of Mille Lacs. He might have been the one to take this picture at the general store in Onamia, where local Ojibwe often visited and where he sometimes helped out.

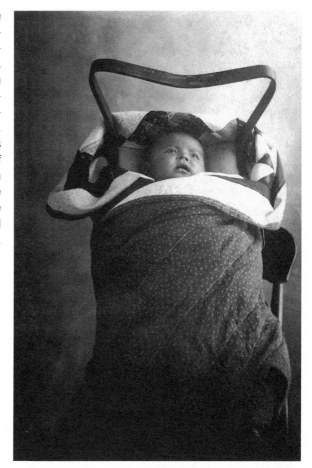

Around 1910, Ross Daniels set up a photography studio in Pine City; over the next few years, he photographed the Ojibwe people of Pine County, taking a series of handsome, sharply detailed portraits of family groups in front of a scenic backdrop. Many of the photographs were taken for the sitters themselves, who appear to have had a major role in deciding how they would be photographed. These pictures survive in the family albums of the region's Ojibwe. In this photograph are Annie Wind and her baby daughter Jennie (later Sutton) around 1914.

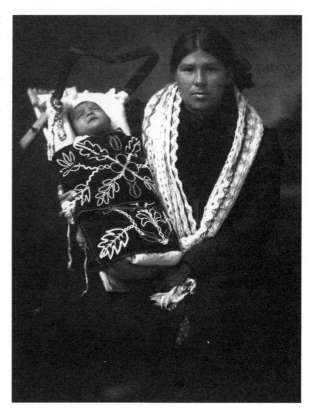

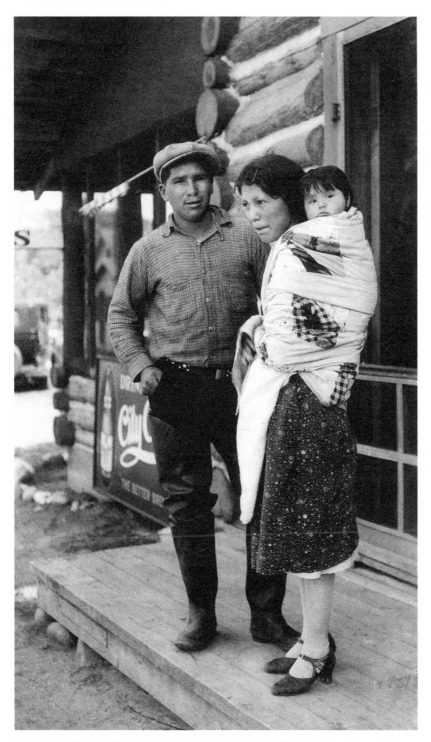

Beginning before 1920, photographer Harry Ayer and his wife, Jeanette, made a business of interpreting Ojibwe culture for tourists visiting Mille Lacs. The Ayers hired Ojibwe to work at their trading post, to put on dances and demonstrations, and to pose for photographs that could be made into postcards. In this Ayer photograph, taken in front of Miller's Tea Room at Wigwam Bay, Mary Wind shows how to carry a child in a quilt—a method known as *bimoomaawaso* (literally, "to carry a baby along on one's back"). The man beside her is her husband, Tom.

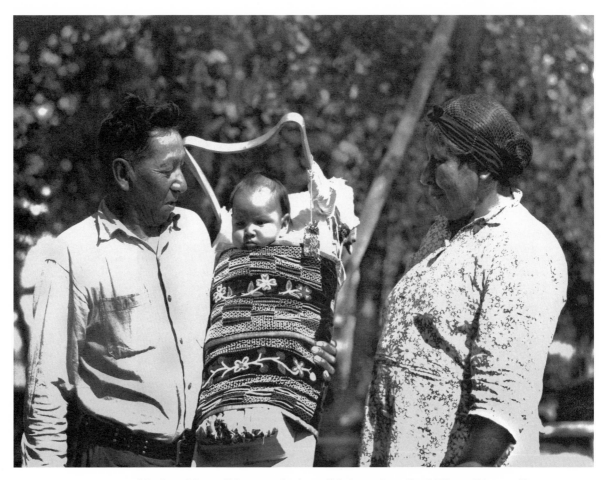

John B. and Susan Chicag proudly show off their grandson, Gerald Wayne Chicag, at Nett Lake in September 1946. This photograph is one of many Monroe Killy took not only to record Ojibwe culture but to chronicle the friendly and helpful people he met.

Ojibwe Women's Clothing

The women pictured in this book wear cloth dresses, blouses, shawls, and other such garments—not the buckskin or fur they might have worn hundreds of years before. Beginning in the seventeenth century, Ojibwe women obtained cloth and blankets from traders and quickly learned how to sew clothing for themselves and their families. Writing around 1804, the fur trader Peter Grant described Ojibwe women as wearing ankle-length dresses of blue cloth; the dresses had long sleeves made of red or blue melton with an opening along the inside of the arm. The women wrapped themselves in blankets for warmth. In summer they wore not only colorful calico and chintz dresses but also beaded leggings and other decorated garments. By the late nineteenth century, most Ojibwe clothing, except for a few winter garments and moccasins, was made of cloth. Dress fashions for Ojibwe women in the early 1900s resembled those of whites, except for beaded and decorated garments worn for special occasions, such as dances or powwows.

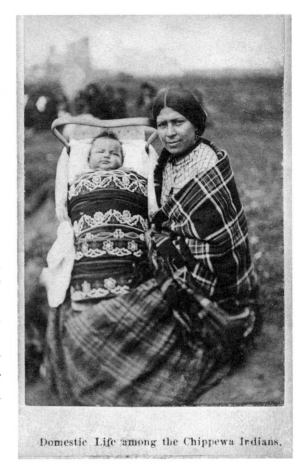

Domestic Life among the Chippewa Indians.

St. Paul photographer Charles Zimmerman did not record the names of this Ojibwe woman and her child, titling this cradleboard photograph just "Domestic Life among the Chippewa Indians." The woman's clothing is the kind typically worn by Ojibwe women in the nineteenth century.

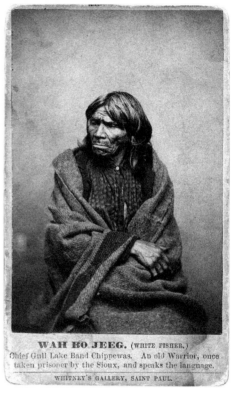

WAH BO JEEG. (WHITE FISHER.)
Chief Gull Lake Band Chippewas. An old Warrior, once
taken prisoner by the Sioux, and speaks the language.
WHITNEY'S GALLERY, SAINT PAUL.

Queweya, known as Kecheosunya (Elder Brother), shown in a carte de visite view from around 1860.

Wah-bo-jeeg, a longtime leader of the Gull Lake Ojibwe, is pictured in this carte de visite by Joel Whitney.

2

Ogimaag / Leaders

The Ojibwe word *ogimaag* (singular, *ogimaa*) has usually been translated with the English word *chiefs*, an overused and not always accurate expression. The word *ogimaag* refers to those in the community, usually men, who led their supporters in important activities, such as war, hunting, and harvesting, and who represented their communities in meetings with government officials. Leadership among the Ojibwe was not a matter of coercive authority but of influence gained through eloquence, generosity, war skills, and spiritual abilities. Not every Ojibwe leader had all of these characteristics; the leaders' roles depended on their individual natures and on the needs of the communities in which they lived. In some cases, those whom whites described as chiefs may not have been ogimaag in Ojibwe terms. For non-Indians, these leaders represented the Ojibwe not only politically but also symbolically, which is why many historic photographs were taken of them.

During the 1850s and 1860s, Ojibwe leaders passed through St. Paul on their way to negotiate and sign treaties in Washington, DC. Also, in 1862, at the beginning of the Dakota Conflict, a number of Ojibwe leaders came to St. Paul to offer to fight against the Dakota. This particular offer was refused, though many Ojibwe fought in the Civil War. Such events gave St. Paul photographers an opportunity to take portraits of Ojibwe leaders.

Although mechanically produced, the earliest photographs of Ojibwe leaders resembled paintings, following styles of portraiture perfected over the centuries by European artists. The earliest portraits did not always show the ogimaag as they might have looked when they walked into the studio. The men had blankets carefully draped around them and sometimes held symbolic objects, such as pipes or weapons. These props suggest that photographers portrayed the ogimaag in ways that white customers expected these leaders to appear, which means these photographs may not be a truthful record of Ojibwe people at the time.

The first photographs were daguerreotypes. These were followed by *cartes de visite*, literally, visiting cards. Cartes de visite with printed labels were much like baseball cards, showing pictures and giving a few details about those Ojibwe leaders who were well known in Minnesota's white communities. Photographs of these leaders may be seen as valuable historical records of Ojibwe leadership and Ojibwe clothing. They also reflect the intentions of photographers, who sometimes posed their subjects with props, making it difficult to know for sure

what really is represented. Research on particular Ojibwe leaders and their lives reveals that sometimes people photographed in the most rigid of settings can impose important meanings on photographs that go well beyond the photographers' intentions.

As photographic technologies changed, the carte de visite went out of fashion. But photographers did not lose their fascination with Ojibwe ogimaag. A number of them—including St. Paul photographer Joel Whitney, anthropologist Frances Densmore, government official Darwin Hall, and Methodist minister and amateur photographer Edward McCann—recorded contrasting portraits of Ojibwe leaders.

Joel Whitney's Portraits

St. Paul photographer Joel Whitney had a studio located at the corner of Third and Cedar streets, where he took as many as thirty early portraits of Minnesota Ojibwe leaders. These portraits do not appear to have been done for the leaders themselves but were taken to be sold to white customers.

Several props appear in eleven of the portraits. The same pipestone pipe with an ornately carved wooden stem appears in five of the images. In two pictures, the subjects are wearing the same bandolier bag. Three others show subjects wearing a band with a zigzag pattern. Other props, each appearing in several pictures, include mittens, a hood, a blanket coat, and a bear-claw necklace. The recurrence of these props may mean that Whitney gave them to the subjects to hold because they were objects whites expected to see in portrayals of Indians. But they might also have other significance. The pipe, for example, might appear in three portraits because each of the men holding it was a member of the same delegation that came to St. Paul. Or perhaps they were on their way to Washington, DC, to present that particular pipe to a government official, to obtain and commemorate an agreement. Pipes were also used as persuasive tools for other purposes, including going to war. Peezhikee (Buffalo), an early nineteenth-century leader at La Pointe, Wisconsin, described clearly the importance of tobacco at an 1826 meeting with U.S. treaty commissioners. He compared his own authority to that of the government agents: "You are strong [enough] to make your young men obey you. But we have no way, Fathers, to make our young men listen, but by the pipe."

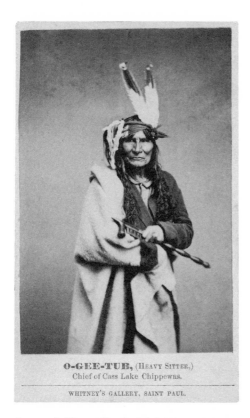
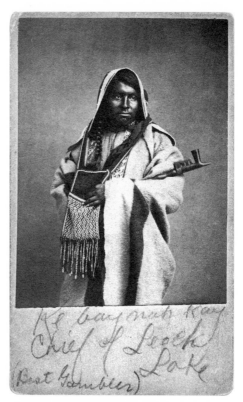

O-gee-tub (Heavy Sitter) of Gull Lake and Ke-bay-nah-kay (Best Gambler) of Leech Lake both hold the same pipestone pipe in these Whitney images from the early 1860s. The second image is attributed to Charles A. Zimmerman, Whitney's later partner and successor. It was not mounted as a carte de visite, but it was likely taken for that purpose.

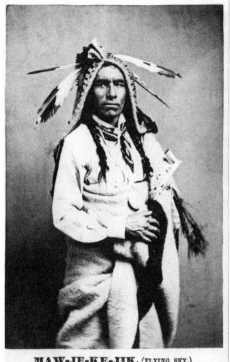

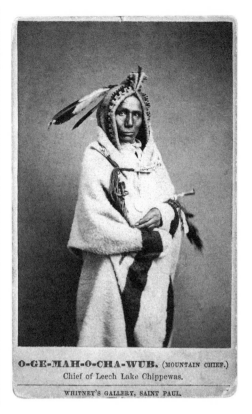

MAW-JE-KE-JIK. (FLYING SKY.)
First Chief of Cass Lake Chippewas.

WHITNEY'S GALLERY, SAINT PAUL.

O-GE-MAH-O-CHA-WUB. (MOUNTAIN CHIEF.)
Chief of Leech Lake Chippewas.

WHITNEY'S GALLERY, SAINT PAUL.

In two cartes de visite from the 1860s, Maw-je-ke-jik of Cass Lake and O-ge-mah-o-cha-wub (Mountain Chief), a leader at Leech Lake, are shown wearing what may be the same hood and possibly holding the same pipe. The hood may have been made from a blanket or a capot, an Ojibwe man's coat. According to Peter Grant, an early fur trader, capots came to the knees and were fastened with a gun screw, a worm, or a peg of wood. The coats were held in place at the waist with a "worsted belt" or sash in which Ojibwe men sometimes carried their tomahawks and knives. Some of the earliest capots were ready-made cloth garments supplied by fur traders. The Ojibwe eventually made their own capots out of old blankets or woolen cloth. Capots also had hoods, which Grant described as "a cloth cape resembling a turban."

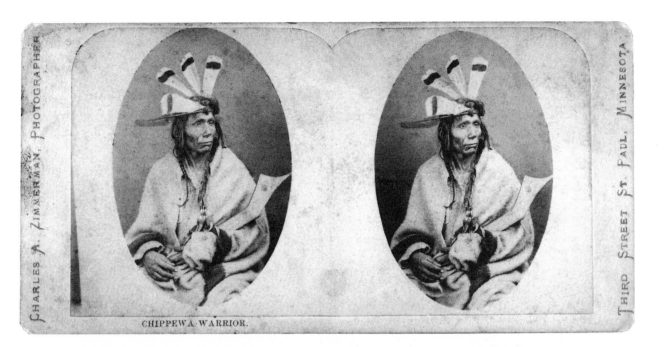

CHIPPEWA WARRIOR.

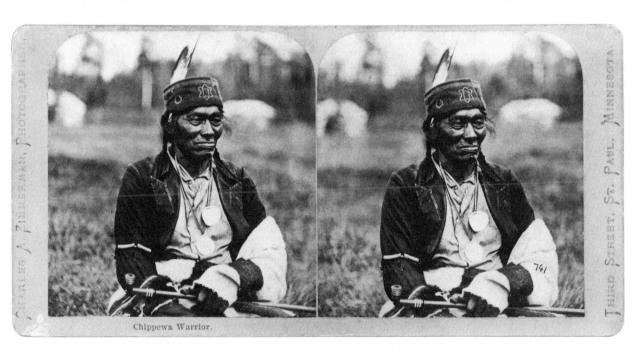

Chippewa Warrior.

These two pictures demonstrate a change in photographic portraiture: the move from the indoor studio to an outdoor setting in the 1860s. While outdoor picture taking gave photographers the opportunity to show Ojibwe leaders against the backdrop of an Ojibwe community, the subjects' poses still had a stiff formality reminiscent of European paintings. Both images are by Charles A. Zimmerman and show O-ge-mah-o-cha-wub (Mountain Chief), of Leech Lake.

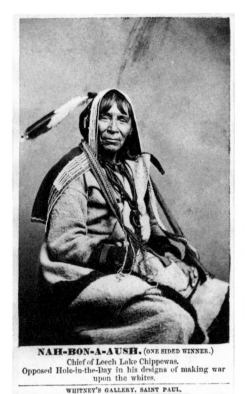

NAH-BON-A-AUSH. (ONE SIDED WINNER.)
Chief of Leech Lake Chippewas.
Opposed Hole-in-the-Day in his designs of making war
upon the whites.

WHITNEY'S GALLERY, SAINT PAUL.

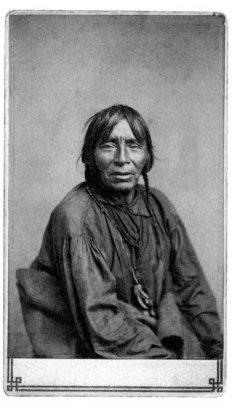

Nah-bon-a-aush (One-sided Winner), a leader at Leech Lake, is shown in two contrasting cartes de visite produced by Whitney around 1860. In one image, Nah-bon-a-aush wears mittens, a blanket coat, a blanket, feathers, and several beaded bands hung clumsily around his shoulders; in the other he wears only a simple cotton shirt and a single eagle claw on a string. The first image was mounted with a printed label that referred to his opposition to Hole-in-the-Day (Po-go-nay-ke-shick), a Gull Lake Ojibwe leader who, it was rumored, intended to join the Dakota in fighting against the whites during the 1862 U.S.–Dakota War. The second image has no label, suggesting that it may not have been meant for resale. Whitney perhaps preferred the first image because Nah-bon-a-aush was dressed more as Whitney's white customers thought an Indian ought to look.

Po-go-nay-ke-shick or Hole-in-the-Day

The most frequently photographed Ojibwe leader of the 1850s and 1860s was Kwiwisens (Boy), known more widely by the name of his father, the leader Po-go-nay-ke-shick (Hole-in-the-Day or Hole-in-the-Sky). At least ten photographic images of the man survive, five of which were probably taken by Whitney.

Po-go-nay-ke-shick's celebrity among whites was based on his reputation as a warrior fighting against the Dakota and as an orator and diplomat in his dealings with the U.S. government. He made a powerful impression on many white people and cultivated his reputation among them. He seemed to want whites to believe that he was the premier chief among the Ojibwe, a leader with more power than any other. Whereas Whitney identified other leaders as representing specific com-

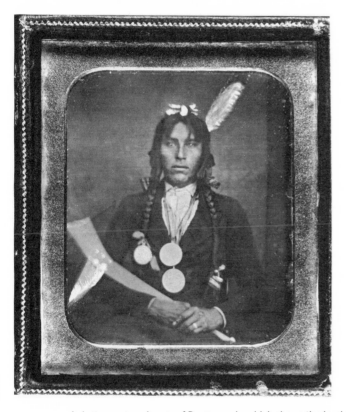

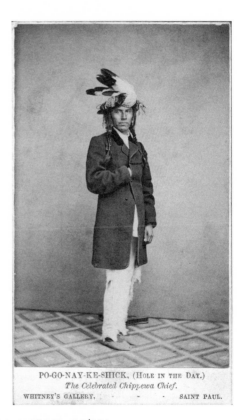

PO-GO-NAY-KE-SHICK, (HOLE IN THE DAY.)
The Celebrated Chippewa Chief.
WHITNEY'S GALLERY, - - - SAINT PAUL.

A daguerreotype image of Po-go-nay-ke-shick shows the leader as a young man, wearing a stylish coat and displaying peace medals received from the U.S. government. The image was hand colored to show the blue of the coat and the tone of Po-go-nay-ke-shick's skin. It also seems to have been retouched in a clumsy fashion to show a blade protruding from the end of the gun-stock war club. A carte de visite image from around 1860 shows a full-length portrait of the leader, wearing a frock coat.

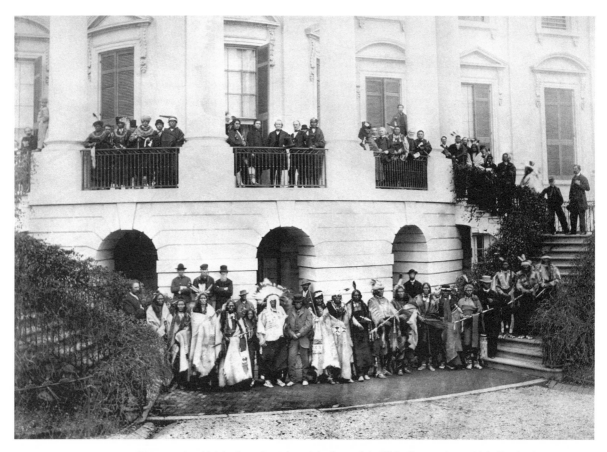

Po-go-nay-ke-shick is shown in a view of the front of the White House along with Indian leaders from all over the United States. He is standing on the balcony, next to the second column from the left and just to the left of President Andrew Johnson, who is at the center of the balcony. This picture was probably taken at the signing of the Treaty of 1867, which established the White Earth Reservation. Po-go-nay-ke-shick was assassinated before his people moved to White Earth the following year.

munities, he labeled Po-go-nay-ke-shick "the Celebrated Chippewa Chief."

Po-go-nay-ke-shick's influence actually may have gone well beyond the Gull Lake and Mississippi Ojibwe community where he lived, but he was not universally accepted as a leader among other groups of Ojibwe. The very idea that there could be a single overriding leader of all the Ojibwe was more in keeping with European aristocratic ideas than with Ojibwe democratic traditions. It may be that Po-go-nay-ke-shick gave white people the kind of overarching Ojibwe leader that they expected.

In many ways Po-go-nay-ke-shick was an exceptional individual. He was a warrior and a skilled speaker and negotiator within the Ojibwe tradition. However, he also created a new pattern of leadership and action among the Ojibwe, using the traditional role of an Ojibwe war

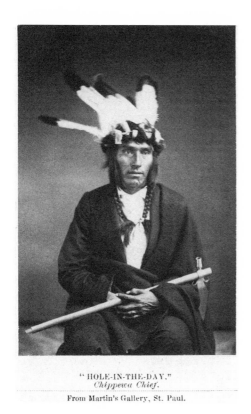

"HOLE-IN-THE-DAY,"
Chippewa Chief.

From Martin's Gallery, St. Paul.

James Martin took this portrait of Po-go-nay-ke-shick in the early 1860s.

leader and diplomat for his own benefit, not just that of his people. He often demanded and received special treatment from U.S. government officials. He used the money he received from the U.S. government not only for his fellow Ojibwe but also to construct his own two-story frame house in Crow Wing and to operate several successive farms. He amassed wealth in a way that few leaders within the sharing traditions of the Ojibwe had ever done.

He also seemed to enjoy having his photograph taken. An 1860 newspaper reported that he had seven "large portraits" of himself in his house. Some of the portraits may have been daguerreotypes, though one record indicates that he had a least one painting done of himself.

The image Po-go-nay-ke-shick projected in his photographs was in keeping with his reputation and entrepreneurial behavior. His frock coat and blanket, combined with a feathered turban, represented the roles of both warrior and diplomat. Yet this combination also symbolized that he was neither a "blanket" Indian nor one who had completely assumed the new characteristics that whites sought to impose on native people.

Naganab or Foremost Sitter

Born as early as the 1790s, Naganab, or Foremost Sitter, became an Ojibwe leader, by his own memory, at the time of the Black Hawk War in 1832. Like many Ojibwe leaders, he rose to prominence during the era of the fur trade due to his ability to win both the loyalty of his followers and the confidence of the traders. Naganab's name, spelled in a variety of ways, meant "foremost sitter" or "he sits first in the row."

Naganab was known for his diplomatic eloquence at Ojibwe councils and in dealings with white traders and government officials. He represented his people at a number of government treaty signings and was part of several delegations to Washington, DC. In order to properly represent his people, Naganab dressed as many Ojibwe leaders did, wearing the same kind of clothing worn by U.S. military or civilian government officials.

Richard F. Morse, who met Naganab at an annuity payment meeting on Madeline Island in 1855, reported that the leader came wearing the older style of clothing, including a blanket and leggings. But, Morse said, "[h]e soon drew from the Agent a suit of rich blue broadcloth, fine vest, and neat blue cap." Morse thought Naganab's white standards of dress were admirable, later writing: "He aspired more than any other chief at La Pointe to become civilized, and to be like the white men in manners and dress; although he inclined to show off the dandy, he wore no ear jewels, and remarked when a trader offered to sell him silver eardrops . . . that he had 'been too long, too much Indian,' he was going to be more white man."

Naganab's fondness for white styles of clothing reflected his initial optimistic attitude toward the American government. As time went on, however, his views—and his clothing—changed. When Naganab first became a leader of his people, the Ojibwe were in a position to grant concessions to whites in return for many benefits. Owners of all of northern Minnesota and Wisconsin, they could afford to give up a little land in exchange for yearly payments of money and other useful things.

By the 1880s, however, the Ojibwe were living on reservations—a fraction of the lands they had owned in the 1830s—and whites were demanding even this property. This state of affairs, in part, was the reason for the government commission, headed by Henry Rice, that visited the Ojibwe reservations, including Fond du Lac, in 1889.

Naganab was still a leader of the Fond du Lac Ojibwe at the time. He continued to wear his presidential medal, but his attitude toward the U.S. government had changed. Critical of the way past treaties were handled, Naganab no longer was convinced of the government's benevolence. In speaking to the commission, Naganab began with a complaint about the boundaries that had been set in the 1850s for the Fond du Lac

Reservation. He explained what land he thought had been left out of past government surveys, that pine and minerals had been taken from Indian lands without compensation. He also spoke of the benefits he had hoped his people would receive that had not been given them, noting that promised improvements had not been made on the reservation.

His skepticism was combined with a changed attitude about white dress. "We think the time is past when we should take a hat and put it on our heads just to mimic the white man, to adopt his custom without being allowed any of the privileges that belong to him," he said. "We wish to stand on a level with the white man in all things. The time is past when my children should stand in fear of the white man."

Naganab concluded with his summary of the role of an Ojibwe ogi-maag: "I thank the Master of Life for allowing me to say these words, and that my children should witness my anxiety for their welfare. Also, that all the people here will not lose sight of the fact that all my life I have worked for their interest, after I am called away from this world."

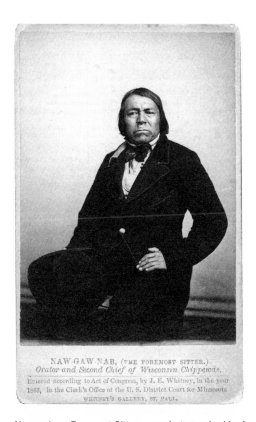

NAW-GAW-NAB, (THE FOREMOST SITTER.)
Orator and Second Chief of Wisconsin Chippewas.
Entered according to Act of Congress, by J. E. Whitney, in the year 1863, in the Clerk's Office of the U. S. District Court for Minnesota.
WHITNEY'S GALLERY, ST. PAUL.

Naganab, or Foremost Sitter, was photographed by Joel Whitney in January 1863, when the longtime Fond du Lac Ojibwe leader was on his way again to Washington, DC. Whitney photographed him wearing a frock coat and holding a broad-brimmed hat. The only clue to his Ojibwe heritage was the medal he wore on his chest—a medal that also symbolized his relationship with the U.S. government. Whitney copyrighted his images of Naganab and marketed them with printed labels, both as stereo views and as carte de visite portraits.

The Clothing of Ojibwe Men and Ogimaag

Clothing worn by Ojibwe people in the nine-teenth century, and recorded in early photo-graphs, consisted mostly of garments made from imported cloth, linen, and woolen fabrics; only a few items were made of leather. For the Ojibwe, woolen blankets were an all-purpose garment as well as an item of bedding. In many ways the use of blankets was a logical outgrowth of earlier fur robes. Both men and women wore blankets in cool weather as a kind of overcoat. Ojibwe men wore them hung over one shoulder and wrapped under the opposite arm, drawing them around the waist—a characteristic style that was recorded in many artworks and photographs.

Throughout the nineteenth century, blankets were seen by many as a symbol of Indians who clung to traditions. Though obtained from whites, blankets were used by Indians in an Indian way. Even Ojibwe who had begun wearing white peo-ple's clothing still wore blankets and other more traditional garb on occasions that celebrated their people's ways of life. Traditional Ojibwe some-times referred to the blankets they wore as a sym-bol of their attitude toward Christianity. At a meet-ing with a U.S. government delegation in 1889, a sixty-nine-year-old Ojibwe man named Pus-se-nas of Red Lake said, "I have not taken up religion yet, as it is shown by my blanket."

Ojibwe men wore breechcloths in all seasons. The breechcloths were secured with a string, to which they also tied leggings made of woolen cloth and decorated with ribbons and beads. Garters were fastened around the leggings just be-low the knees. The leggings and breechcloths were either made by Ojibwe women or purchased ready-made from traders. Ojibwe women also made coats, or capots, out of blankets or woolen cloth, and traders supplied the Ojibwe with the same kinds of loose-fitting shirts and coats worn by whites.

Clothing worn for ceremonies or celebrations was more likely to be decorated than everyday clothes. On leather clothing the Ojibwe used a va-riety of local materials, including porcupine quills and beads made of copper, pipestone, shells, and wood. At the same time cloth garments began to replace leather, the Ojibwe obtained European-manufactured beads in a variety of sizes and col-ors. They applied the beads to cloth, wove them into a fabric, and used them in necklaces. Traders also brought a variety of silver ornaments, manu-factured in Montreal and elsewhere, in patterns influenced by Indian designs.

Many Ojibwe leaders were photographed hold-ing pipes, which were an important means by which the Ojibwe carried out the rituals of politics and diplomacy. The use of pipes in making peace probably led to the significance of one special item of Ojibwe clothing, the bandolier bag. The origins of the beaded pouches with wide bandolier-style straps has been a puzzle. It has been suggested that the Ojibwe started making them in imitation of ammunition pouches carried by British and Amer-ican soldiers in the eighteenth and nineteenth cen-turies. Another possibility is revealed by the name used by many Ojibwe for bandolier bags. They called these bags *gashkibidaaganag*, which can mean "tobacco pouch." This name suggests that bandolier bags evolved from smaller Ojibwe to-bacco pouches made of skin and decorated with porcupine quills and other natural ornaments. As such, the bags were the logical accompaniments to the ceremonial pipes that the Ojibwe used in their mediations with spirits, other Indians, or white people. In 1889, an Ojibwe leader at Leech Lake presented a pipe to a visiting U.S. government offi-cial, saying, "I have heard that since coming you have been presented with a magnificent beaded sack, and a beaded sack never goes without a pipe."

By the late nineteenth century, these "bandolier bags" were the quintessential article of ceremonial clothing, worn on all important occasions. In 1898, missionary J. A. Gilfillan wrote that "one of the beadwork pouches is the great ornament of an Ojibwe and any person wearing it is considered to be in full dress." Such bags also came to be symbols of wealth or power. Persons of high standing in the community might wear two bags to indicate their status.

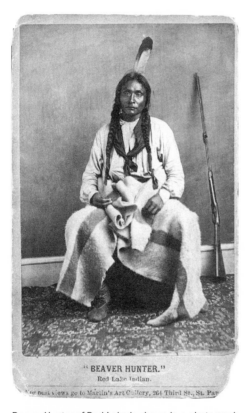

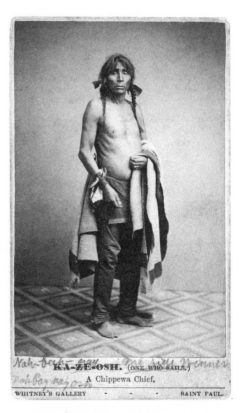

Beaver Hunter of Red Lake is shown in a photograph produced by James Martin's gallery in St. Paul around 1860. The Ojibwe leader wears a European-style shirt, a scarf, and a blanket—a common form of dress for Ojibwe men.

This Whitney photograph, believed to be of Nah-bon-a-aush, the Ojibwe leader from Rabbit Lake, shows him wearing a breechcloth, leggings, and a blanket. It is one of the few existing photographs that document this style of dress, which was common for Ojibwe men before they started wearing trousers in the late nineteenth century.

Wah-bon-ah-quod, or White Cloud, became the major civil leader of the Gull Lake–Mississippi Ojibwe in 1868, after the death of Hole-in-the-Day and the community's move to White Earth. This photograph of Wah-bon-ah-quod was taken by James Martin in St. Paul in the 1860s. The picture is rare among early photographs of Ojibwe leaders because it shows Wah-bon-ah-quod's face painting: a series of dots lines his cheeks and rises from the bridge of his nose. Face painting is not evident in many early photographs, perhaps because the primarily blue-sensitive emulsions of the period had difficulty separating colors as tones of gray. Both Ojibwe men and women painted their faces in various colors and designs.

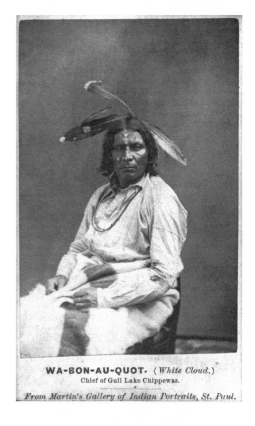

WA-BON-AU-QUOT. (*White Cloud.*)
Chief of Gull Lake Chippewas.

From Martin's Gallery of Indian Portraits, St. Paul.

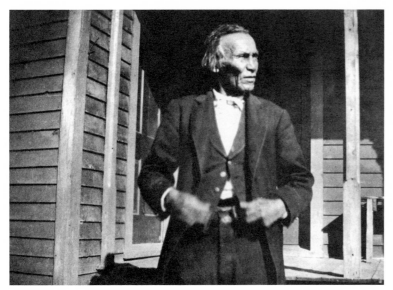

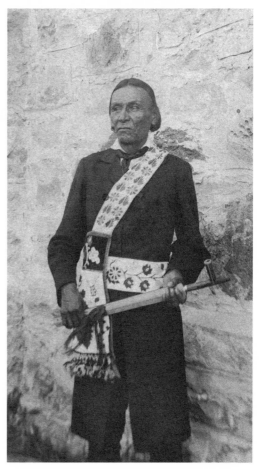

These pictures of Wah-bon-ah-quod were taken at White Earth. In the image at the right, he is shown next to St. Columba's Episcopal Church, where he was a member. A convert to Christianity, Wah-bon-ah-quod was known for his oratory. A missionary wrote in 1874 that he was "the most eloquent man in the nation . . . He never pauses for a word, but like [a] whirlwind is borne along by the torrent of his eloquence."

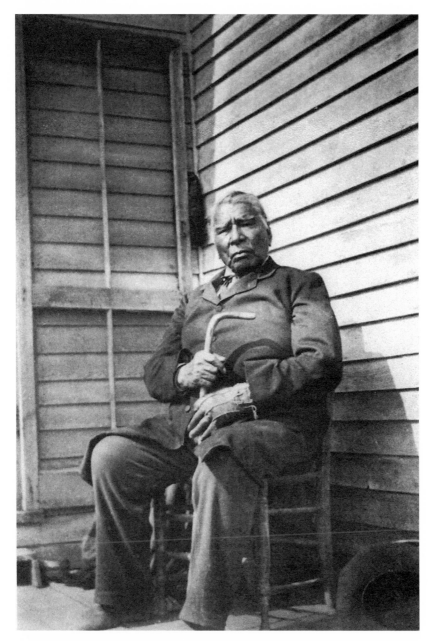

Ojibwe leader Enmegabowh, or John Johnson, was from Ontario of Odawa and Ojibwe ancestry. He became an Episcopal minister in the area of Gull Lake, where he married a cousin of Po-go-nay-ke-shick's. At White Earth he came to have great influence on the community.

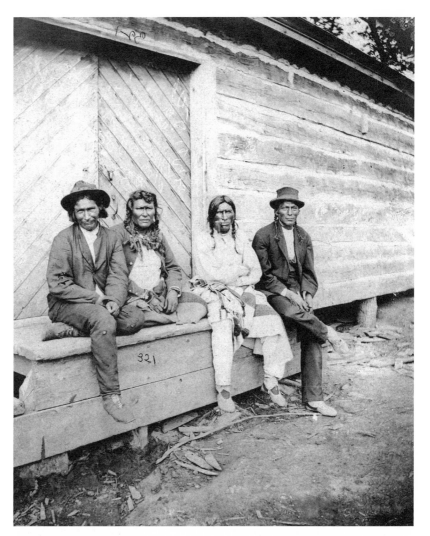

This 1873 photograph was said by one owner of the image to show White Earth leaders Ogih-vag, She-ia-quash, Wa-bezhish, and Me-shek-ig-zhick (or more accurately, May-zhuck-ke-ge-shig) in front of the White Earth Indian Agency warehouse. The photograph was taken by Charles Tenney of the Winona firm Hoard and Tenney.

May-zhuck-ke-ge-shig, or Lowering Sky, in a photograph that may have been taken at White Earth by Robert G. Beaulieu, was a longtime leader at White Earth in the late nineteenth century. He had been a war leader and a compatriot of Hole-in-the-Day before the Mississippi Ojibwe moved to White Earth. In 1904, Theodore H. Beaulieu wrote that May-zhuck-ke-ge-shig was "considered the wisest oracle of the tribe" and that there was "no chief, to-day among all the Chippewas who possesses, in so distinguished a degree, the traditional hereditary title and merits of chief" as he did. May-zhuck-ke-ge-shig often represented the White Earth Band in Washington, DC. As late as 1911, when he was in his eighties, a newspaper reported: "He is going tomorrow with other men of his tribe . . . to plead with the powers that be in Washington for a more intelligent and conscientious administration of the Indian affairs as they pertain to the Chippewas."

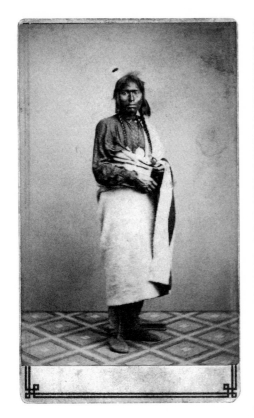

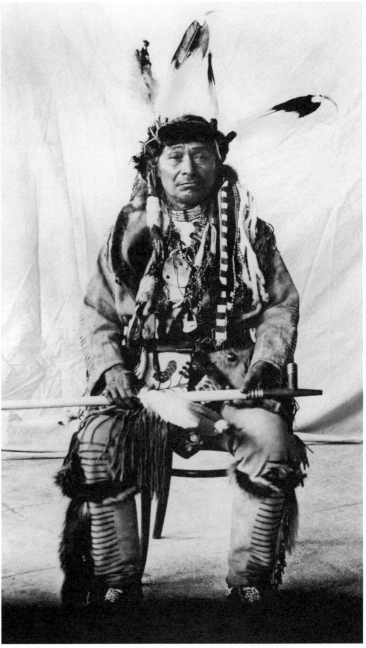

Niganibines, or Leading Bird of Prey, of Leech Lake was the son of a famous chief, Eshkebugecoshe, or Flat Mouth, and he became known by his father's English name. Until his death in 1907, he was a civil leader and, as a high-ranking member of the Midewiwin religious order, had a reputation as someone especially knowledgeable about Ojibwe religious beliefs. At right he is pictured as a young man in a Whitney carte de visite from around 1860. The other photograph, probably taken by a photographer in Washington, DC, shows him in his later years, in the 1890s.

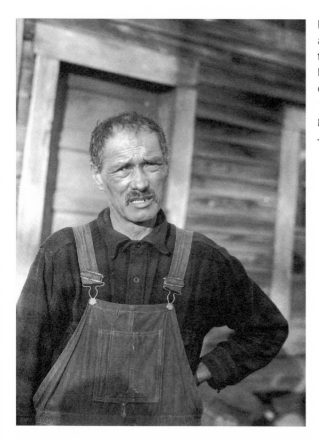

Nebageshig (Dark Sky), also known as Jim Stevens, was the leader of the group of Ojibwe living near Lake Lena along the St. Croix River in eastern Pine County in the early 1900s. John W. G. Dunn photographed him in front of his house in January 1928.

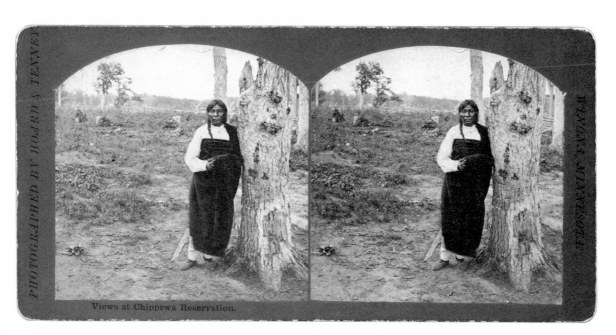

Improved photographic technology and the removal of Mississippi Ojibwe communities to White Earth in the late 1860s provided new settings for many photographs of Ojibwe leaders. The new scene was recorded in the 1870s by Charles Tenney. Shown above is the Ojibwe leader Na-tah-mesch-kung, photographed at White Earth around 1873. He stands in front of land that had been cleared and fenced for cultivation.

Although formal portraits usually show Indian leaders dressed in their culture's ceremonial attire, shirts, trousers, and boots were what many Ojibwe men commonly wore in their daily lives during the early twentieth century, as seen in this image from Doris Boswell's family collection. The photograph was taken by G. Willard Shear in Grantsburg, Wisconsin.

Kakaygeesick or Everlasting Sky

Kakaygeesick (Everlasting Sky), also known as John Kakaygeesick, had a long history in Warroad and Lake of the Woods. A spiritual leader of the Ojibwe community in that region, Kakaygeesick was said to have been 124 years old when he died in 1968. His brother Nahmaypoke was also a local leader. They and the other members of their community were not part of an Ojibwe reservation but held land around the mouth of the Roseau River—land granted to them by the federal government in 1905.

Both Kakaygeesick and Nahmaypoke were revered not only by their people but also by settlers. Before his death in 1916, Nahmaypoke gave some of his land to the town of Warroad for a new school. Kakaygeesick continued to live on his land south of Warroad until his death. He was a familiar figure in the town throughout his life, and postcards with his face on them came to symbolize the city's history and heritage.

The Ojibwe writer Gerald Vizenor, who covered Kakaygeesick's funeral for the *Minneapolis Tribune*, wrote: "John Ka Ka Geesick was known to tourists because he had posed for a photograph from which postcards were printed and sold. He was invented and colonized in the photograph, pictured in a blanket and a turkey feather headdress. On the streets of the town he wore common clothes. The feathered visage encouraged the romantic expectations of tourists. He was a town treasure, in a sense, an image from the tribal past, but when he died the mortician dressed him in a blue suit, with a white shirt and necktie."

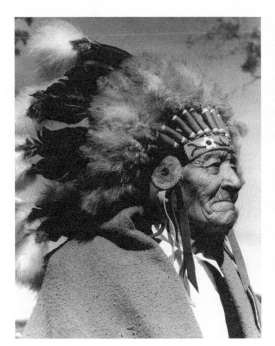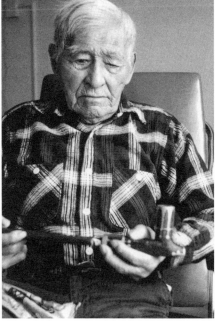

These contrasting images show Kakaygeesick first as he was depicted on postcards and then as his family knew him.

Darwin Hall and Wa-we-yay-cum-ig

Like many white people who spent some time among the Ojibwe, Darwin Hall was a collector of Indian crafts. In 1914, long after his retirement as chairman of the U.S. Chippewa Commission, Hall posed with his wife in their Renville County home. Surrounding them was a large collection of Ojibwe beadwork, pipes, feathered headdresses, and war clubs hung on a backing of woven mats, all objects that he had obtained during his work. Among them was a photograph of Wa-we-yay-cum-ig, or Round Earth, an Ojibwe leader from Mille Lacs who, under Hall's in-

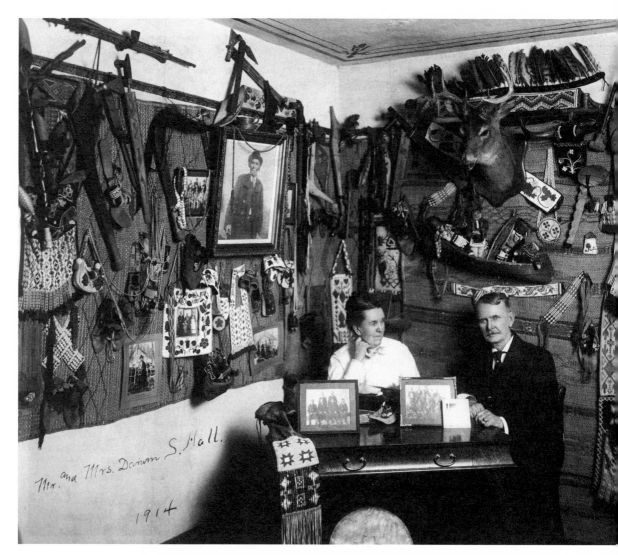

Darwin Hall and his wife in their Renville County home in 1914. Robert G. Beaulieu's 1908 photograph of Wa-we-yay-cum-ig and his family at White Earth hangs in the white beadwork frame in the lower center of the left-hand wall. A number of the objects in Hall's collection were later given to the Minnesota Historical Society.

fluence, moved with his family and members of his community to the White Earth Reservation.

Before his retirement, Darwin Hall was a politician and newspaper editor who became a member of the U.S. Chippewa Commission, a federal agency created in 1889 to persuade Minnesota Ojibwe to take allotments of land on the White Earth Reservation, with the goal of consolidating a variety of bands there. Hall was chairman of the commission at various times in the 1890s and became the commission's sole member in 1897.

Throughout his time with the Chippewa Commission, Hall carried a new Kodak Brownie or a similar camera. During his travels to Ojibwe reservations, he photographed many of the people with whom he met. Most of the photographs are about 3¼ by 3¼ inches, though some are as large as 3½ by 4½. Hall mounted his photographs on decorative cardboard mats and recorded a variety of information on each mount, often dating the pictures and describing the people in them. Most of these photographs are portraits.

A number of the photographs were taken against the backdrop of the doors and clapboard siding of what appear to be government buildings at White Earth. Hall had strong reasons for wanting to emphasize the progressive changes represented by the White Earth Reservation. In these photographs the subjects wore everyday clothing, comparable to that worn by whites. Some of these people may have represented successes for Hall, people he had persuaded to move to White Earth.

In 1897, Hall was ordered to negotiate with members of the Mille Lacs Ojibwe about moving to White Earth. On this trip, he met and photographed Wa-we-yay-cum-ig, the leader known to the U.S. government as "head chief" of the Mille Lacs Band. Wa-we-yay-cum-ig was an energetic opponent of government efforts to force the Mille Lacs Ojibwe to give up their reservation and move to White Earth. He had recently headed a delegation to Washington, DC, to lobby government officials for that purpose.

When Hall arrived at Mille Lacs on September 20, 1897, he found about a hundred members of the band gathered on the south shore of the lake at Lawrence, or present-day Wahkon. Wa-we-yay-cum-ig announced that instead of taking land allotments at White Earth, the members of the band wanted to obtain their allotments at Mille Lacs, as earlier federal officials had promised they could do. Hall told them this was impossible because all but a few thousand acres at Mille Lacs had already been claimed by whites, with the connivance of federal and local officials.

Later that fall, Hall received word that a group of twenty Ojibwe from Mille Lacs was interested in removing to White Earth. When Hall arrived at Mille Lacs, Wa-we-yay-cum-ig interceded to prevent their

Wa-we-yay-cum-ig was photographed by Darwin Hall during Hall's September 1897 visit to Mille Lacs. Hall's handwritten notes describe the leader as a man of "much influence, a man of parts." Wa-we-yay-cum-ig stands in front of a log cabin with a bark-covered roof—a building Hall labeled as his "mansion."

This photograph shows members of the group of Mille Lacs Ojibwe who lived near Knife Lake. To persuade them to move to White Earth, Hall arranged for them to visit the reservation in June 1898.

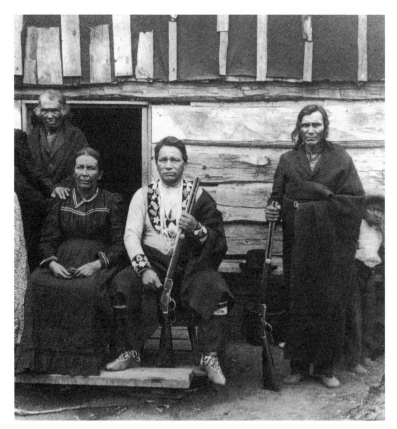

Wa-we-yay-cum-ig (in the white shirt), his wife, Nawajibigokwe, and other Mille Lacs leaders were photographed at Mille Lacs by David I. Bushnell in 1900.

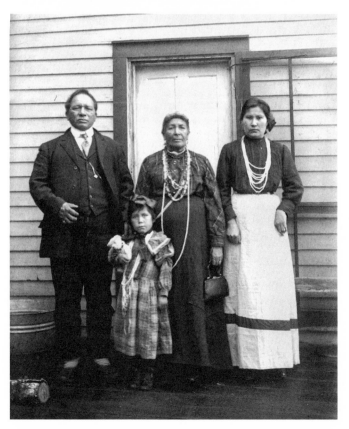

In 1908 or later, Robert G. Beaulieu photographed Wa-we-yay-cum-ig, Nawajibigokwe, and their family at White Earth, five years after their arrival. In contrast to the image of transformation pictured here, the couple followed traditional religious beliefs and were members of the Midewiwin. Frances Densmore found them both to be important sources for her work in documenting Indian culture.

Ah-ah-shaw-we-ke-shick, or Crossing Sky, was photographed by Darwin Hall around 1900 alone and with Ge-se-so-quay, or Cook Woman, in a rare view of an Ojibwe leader with his wife. In both photographs he wears a peace medal.

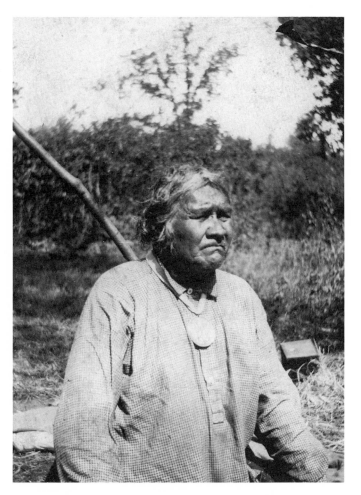

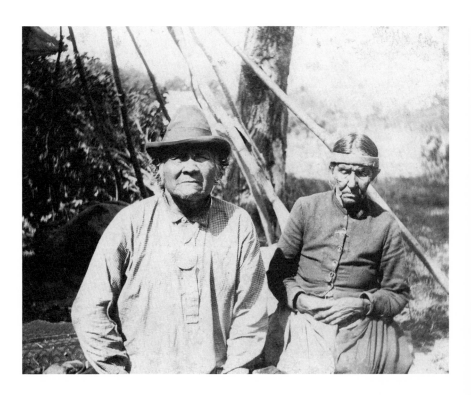

leaving. In 1898 Hall arranged for a Mille Lacs group who lived at nearby Knife Lake in Kanabec County to visit White Earth for the annual June 14 celebration, which commemorated the first arrivals at the reservation. He showed them around the reservation, and eventually six Knife Lake families, consisting of fifteen people, elected to move to White Earth.

During the summer of 1898, a delegation of Mille Lacs leaders went to Washington and managed to extract from the government a promise to pay them for any buildings and other "improvements" they had made to the land they would be leaving when and if they went to White Earth. In September, some members of the Mille Lacs Band began to act more favorably toward Hall's removal efforts, and in May 1899, Wa-we-yay-cum-ig, in a considerable change of heart, invited Hall to return to Mille Lacs for further removal talks.

In response, Hall arranged for a group of twenty-five men and women to visit White Earth. He described their trip: "While at White Earth, the visitors were taken over different parts of the Reservation, met their friends and relations who had moved to White Earth, saw the lakes and the fish caught therefrom, were shown the timber and the beautiful prairie land, they found many roots and herbs, in which they were much interested ... for their medicinal qualities. I went with them, camped with them and saw to it, that the object of the trip was carried out."

Hall also believed he had persuaded a group from Knife Lake to move to White Earth. He wrote that he had not spared himself: "in the hardships of these long trips, there is so much in this work, that requires the exercise of good judgment, that it is almost impossible to delegate any part of it to others."

Wa-we-yay-cum-ig and others from Mille Lacs returned to White Earth in June 1900 for another visit. This time Hall believed he was close to reaching his goal. Hall wrote to Washington requesting authority to build "a fair kind of a house for him as this has been done for some of the other chiefs on this reservation." In July Hall reported that Wa-we-yay-cum-ig and his wife and family, along with others of his community, agreed to take allotments at White Earth. The very next month, the Chippewa Commission was eliminated. The Mille Lacs leader finally moved to White Earth in December 1903 and afterward did his best to persuade others to join him.

Frances Densmore, Maingans the Elder, and Odjibwe

Frances Densmore was an ethnographer, a collector of Native American music, and a photographer. She was originally drawn to study Ojibwe culture because of her interest in music and songs; her two volumes entitled *Chippewa Music* were published in 1910 and 1913 by the Bureau of American Ethnology. She later went on to study Ojibwe homes and the tools and material objects of their everyday lives.

Densmore often took her own photographs when working in Ojibwe communities, but she also hired studio photographers to shoot both portraits and pictures of Ojibwe artifacts. Some of the Ojibwe she consulted in her work were community leaders, who occasionally went to Washington to be photographed in the studio of the Bureau of American Ethnology, the agency that sponsored her work.

In February 1908, Densmore and one of her cultural informants, Maingans the Elder, originally from Mille Lacs but then living at White Earth, were photographed together by Bureau of American Ethnology photographer De Lancey Gill. At the same time, Maingans performed part of the Midewiwin ceremony for Gill's camera and before an audience at a public meeting. According to Densmore, Maingans wanted to take part in her work so that "his native beliefs shall be correctly interpreted to his white brethren." The photographs were published, along with Densmore's detailed description of Midewiwin ceremonies and songs, in *Chippewa Music*. But Maingans was severely reprimanded by other members of the Midewiwin for performing a portion of a Mide ceremony in Washington. The following June, he was not allowed to enter the lodge when ceremonies were performed, and other Ojibwe people blamed his wife's death on his "enacting part of a native religious ceremony for the pleasure of white men." These people did not blame Densmore and apparently had no objections to her publishing material about the Midewiwin. Their concern was with Maingans and his performance.

Densmore's book also included photographs of Odjibwe, another Ojibwe leader at White Earth. Odjibwe was a cousin of Po-go-nay-ke-shick—the famous Hole-in-the-Day—and in his youth had accompanied the leader on war parties in the Upper Mississippi Valley. Densmore wrote that he was "distinguished in generalship by sound judgment and steadiness of purpose rather than for reckless daring." When she met with him, a year before his death, he lived in the Old People's Home at White Earth Agency. Though elderly and blind, his singing voice was still intact, and he sang a number of war songs for her.

Densmore took Odjibwe, along with another singer, Maingans the Younger (whose story is told in chapter 5), to a photography studio in

Detroit Lakes to have their portraits taken. Later she wrote that she wanted to preserve their faces "with the right expression," describing how she arranged her subjects so that they looked acceptable to her. Around the time that Odjibwe's picture was taken in Detroit Lakes, Frances Densmore obtained from him his war shirt and his eagle feathers, which were later photographed in Washington, DC, by De Lancey Gill. Densmore wrote that "Odjibwe's prowess won for him the right to wear 11 war-honor feathers, each indicating that he had taken a Sioux [Dakota] scalp; these were eagle feathers and were worn upright in a band around the head."

Odjibwe's war shirt was made of scarlet flannel. Narrow strips of weasel skin made a fringe along the back of the shirt. Weasels had the reputation of being hunters and fighters, making them worthy of emulation by Ojibwe warriors. A skunk-skin band worn on either the arm or the leg signified courage in general and memorialized particular incidents in a warrior's career. The badge that Odjibwe was entitled to wear on his right arm recorded that he once caught a wounded Dakota by the arm. Densmore met another warrior who wore skunk skins around his ankles because he had kicked two wounded Dakota while on a war party.

Densmore does not describe how she obtained these and other objects from Odjibwe. It must have been difficult for Odjibwe to give them up. Yet Densmore suggests that this clothing was not as precious to Odjibwe as his dream song. Because many people in his family were killed in wars with the Dakota, Odjibwe chose to be a warrior at a young age. When he was old enough, he went to fast in the woods. After four days, he had a dream in which he saw "a woman carrying several guns made of rushes. A party of Sioux [Dakota] approached and the woman gave a gun to each of the Sioux telling them to shoot at him. The Sioux took the guns made of rushes and shot at him. Out of the guns came horseflies which lit on him but could not harm him. Then the woman told him he would be a great warrior and would always be protected." The woman also sang Odjibwe's dream song:

obic'kona'wawan	when they shot, they missed
ini'wun	the man

Later, Odjibwe put great faith in this song and sang it before and during battle. After singing it for Densmore, Odjibwe "bowed his head and said tremulously that he feared he would not live long, as he had given away his most sacred possession." He died the next year.

An Account by Frances Densmore of a Visit to a Detroit Lakes Photo Studio

Once I took two Chippewa singers, Little Wolf [Maingans the Younger] and Odjibwe, with Mrs. [Mary Warren] English, my interpreter, to a neighboring town to have their pictures taken. Little Wolf was wearing a moustache, which I thought, would detract from his picture so I wanted him to have it shaved off before we went to the photographer's. This was a delicate situation but I was firm in my own mind—that moustache must come off! Neither Indian spoke nor understood English, except the time of day or such small talk, so I had to entrust this to the interpreter who was an old lady, but an expert. I mentioned casually, that we would all have hot coffee and doughnuts before going to the photographer's, as we had started early in the morning. There was considerable talk in Chippewa, and [Mrs. English] shut her eyes very tight as she always did when she wanted to concentrate. Little Wolf yielded. He could grow another moustache, but did not go to town often, with all expenses paid. He vanished, and came back for coffee with a smooth

upper lip. The arrangements went happily, but true to form the Indian diplomat asked a favor in return—he wanted his picture taken holding a gun. I parried that he had never been to war but he said that he shot off a gun when he went hunting, and that probably I could borrow one at the hardware store.

In the old days a successful warrior wore a skunk skin around his ankle, and old Odjibwe had such an insignia. As his feet were not to show we put it around his head, and Little Wolf wanted to wear it too, because he had the gun, which looked as though he had been to war. This was in one of the earliest years of my work, these Indians were very poor and had no costumes, and what I wanted most was to preserve those fine old faces, with the right expression. They had only one fancy shirt between them, and we decided that Odjibwe should wear it right side out, so the ermine-tails around the arms would show, and Little Wolf would wear it wrong side out, which really made quite a different-looking shirt of it.

Edward McCann Meets Wadena and Migizi

From 1909 to 1911, Methodist minister and amateur photographer Edward McCann lived in Onamia, a few miles from Mille Lacs Lake. He did not minister to the Mille Lacs Ojibwe, but during his time there he became friends with Frank Pequette, or Pedwaywaygeshig, a respected Indian Methodist minister serving a congregation of Fond du Lac Ojibwe in Minnesota.

One year, Pequette came to visit McCann during the wild-rice harvest and spent a week sharing McCann's cramped quarters—a two-story lean-to attached to his church—and singing hymns with him in his church. While there, Pequette paid a call to two famous Mille Lacs Ojibwe leaders, Wadena and Migizi (or Mee-gee-zee). The two ogimaag were among the strongest opponents of the federal government's at-

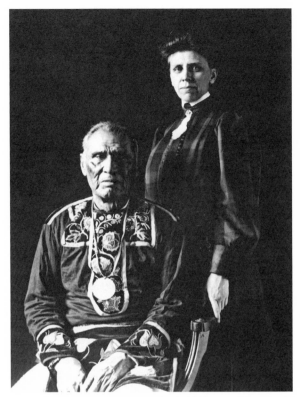

Maingans the Elder was photographed with Frances Densmore in De Lancey Gill's Washington, DC, studio.

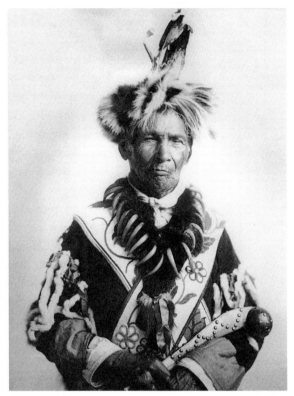

Densmore commissioned this photograph of Odjibwe from John Johnson of Detroit Lakes. The elderly leader is wearing his warrior's outfit and holding his war club. This photograph appeared in Densmore's book *Chippewa Music*.

tempts to move the Mille Lacs Ojibwe to White Earth. Refusing to move to the reservation, they, their families, and other members of the community continued to live on small parcels of land along the south and west shores of the lake.

Like many whites of the time, the minister had many preconceived notions of what Indians were supposed to do and how they were supposed to act. During the visit with Wadena, McCann, who did not know the Ojibwe language, remembered that the leader

rehearsed evidently what was an Indian legend and he went through the motions—paddling the canoe, and then shooting—and oh he made that very dramatic . . . I didn't know what it was all about. And then he had a little piece of wood that he was whittling on, making kind of a little paddle with it. And he used that to point with and finally he

looked over toward me and pointed and he said something in a rather gruff voice and I wondered what he was saying. It looked like he might be ordering me out and scalped, you know, the way he looked.

Pequette later told McCann that Wadena had been telling Pequette to thank McCann "for your interest in us. That was quite different from what I thought it might be." McCann accompanied Pequette on his visit to see Wadena and Migizi. Then, returning the hospitality, he had Pequette invite the two leaders to his quarters for dinner, which he cooked for them himself.

In a 1964 interview, one year before his death, McCann recalled the meal of steak, peas, and mashed potatoes, saying that everyone ate heartily. When he passed a final dish, Wadena, who spoke no English, smiled and gestured with his finger across his throat to indicate that he was "full way up to his neck." During the dinner, McCann took a photograph of Pequette, Wadena, and Migizi, and Pequette took another of McCann and the two leaders. Afterward, McCann also photographed the three other men standing in front of the door to his quarters.

McCann later served as a minister in small towns throughout Minnesota and Wisconsin. Although he knew little about what happened to the Mille Lacs Ojibwe after he left Onamia in 1911, for the rest of his life, until his death in 1965, he spoke with pride about the day he ate dinner with Migizi and Wadena. The photographs that he took during his time at Mille Lacs became family heirlooms for his children and grandchildren.

Two leaders of the Mille Lacs Ojibwe, Wadena and Migizi, eat dinner with Edward McCann in Onamia around 1910.

Wadena, Reverend Frank Pequette, and Migizi stand outside McCann's house in Onamia around 1910.

McCann's Photography

Introduced in the late 1880s, roll film and roll-film cameras were especially suited for amateurs such as the Methodist minister Edward McCann. McCann learned the art of photography from Charlie Gish, the son of an Onamia storekeeper. He soon learned to develop plates and to do contact printing, and he processed film in his room in the church, drawing water from a well outside. Most of his photographs were from cameras that could produce postcard-sized negatives, either on roll film or glass plates.

McCann contact printed most of his pictures on postcard stock and occasionally sold them, sometimes as many as a dozen at a time. He may also have exchanged some of his pictures with other amateur photographers, for he amassed a large collection of handmade postcards. Because many of his negatives have been lost, it is not always possible to say which of his postcards were his own images and which were taken by others.

Living near Mille Lacs gave McCann the opportunity to photograph the Ojibwe people in the area. On one occasion, a group of women who had been out picking berries stopped at a neighbor's house near his church. McCann asked the neighbor woman if she thought they would let him take their pictures. When he came with his camera, one of the Ojibwe women hid her face with a shawl and ran into the neighbor's house. The others were willing to have their pictures taken—provided McCann paid them each ten cents. McCann gladly paid and got a picture of the whole group.

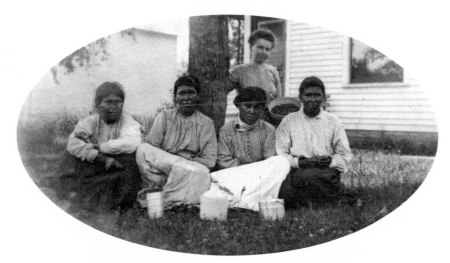

Edward McCann paid each of these berry pickers for the right to take their picture in Onamia around 1910. Mrs. Swanson, an Onamia resident, is in the background.

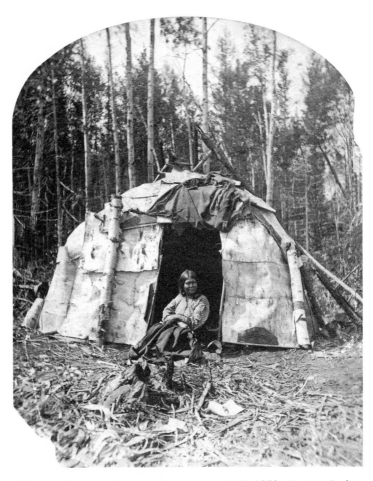

St. Paul photographer Charles A. Zimmerman took this 1870s photograph of an Ojibwe woman and her waaginogaan in northern Minnesota or Wisconsin. The image is part of a series the photographer called "Domestic Life among the Chippewa Indians."

On approaching a wigwam, the custom is to raise the blanket which hangs over the doorway and go in without asking permission or knocking . . . If the inmates look on the newcomer with favor they say when he raises the blanket door and looks in, "Nind ubimin, nind ubim [Nindabimin, Nindabimin] (We are at home, we are at home)," which is a welcome. J. A. GILFILLAN, 1908

3

Nindabimin / We Are at Home

Some of the earliest photographs taken of the Ojibwe people in Minnesota show their birch-bark houses, sometimes with the inhabitants posed in front. These images record the traditional structures in which the Ojibwe lived, as well as how those structures evolved. After many years, photographers gained the technological ability to photograph people inside their houses and were thus able to give viewers a new, intimate look at Ojibwe daily life.

As photographers began to take pictures in a greater variety of settings and conditions, their views of the Ojibwe communities widened. As this chapter shows, photographers who started out taking pictures of Ojibwe people and their houses eventually began recording the Ojibwe "at home," with their families, with their neighbors, in the towns and areas in which they lived, and engaging in community activities unique to the Ojibwe culture.

By the end of the nineteenth century, newspapers developed methods for reproducing photographs through the halftone process. This innovation brought pictures of the Ojibwe and their lives to a wider audience. It also meant that when reporting events such as the 1898 Ojibwe "uprising" at Leech Lake, the newspapers could show more than just woodcut portraits of the key figures involved. They could set the scene by showing images such as those taken by Edward Bromley, who photographed regular Ojibwe people with canoes and engaged in everyday activities.

White Earth band member Robert G. Beaulieu, sportsman and conservationist John W. G. Dunn, and ethnographer Monroe Killy all recorded Ojibwe communities in Minnesota to show Ojibwe people at home in their houses and in their culture.

Ojibwe Houses

Since the Ojibwe traveled throughout the regions in which they lived during the year, they needed portable houses. Rolls of birch bark with bound edges could be carried and used on different styles of buildings. Even into the twentieth century, many Ojibwe people lived in birch-bark houses like their ancestors. The Ojibwe term for birch bark, *wiigwaas*, was the basis for the common name for these houses, *wiigiwaam*, which in turn was the origin of the English word *wigwam*. The most common kind of Ojibwe house was the round-domed *waaginogaan*, a

dwelling made of long poles of a strong, flexible wood, such as ironwood or tamarack, bent over and tied to form a dome shape. Animal skins and, later, blankets and quilts were hung over the doorway. Several layers of cattail-stem mats provided insulation for the side walls. Cattail plants were known as "lodge cover grass." Throughout the nineteenth century, the Ojibwe creatively incorporated a variety of new materials, such as lumber, cloth, and tar paper, in their traditional houses.

In addition to the waaginogaan, the Ojibwe made use of other house forms suited for particular places and activities. One example was the *bajiishka'ogaan*, a house form known to the neighboring Dakota as the tipi; it consisted of a framework of spruce poles covered by birch bark. A peaked lodge, known as a *nisawa'ogaan*, looked like several bajiishka'ogaan joined together with a ridgepole. A square, peaked type of building, called a *gakaaga'ogan*, resembled and was built like a pole barn.

Wigwams were the province of Ojibwe women, who did most of the work in building them and were in charge of them. When the traveler J. G. Kohl visited the Ojibwe along the south shore of Lake Superior in the 1850s, he commissioned members of the local population to build him a house. Kohl not only wanted a place where he could live for awhile; he wanted to observe the means through which such a house was built.

Kohl observed the way in which the women he had hired, while looking after their children, cut a number of young trees and pushed

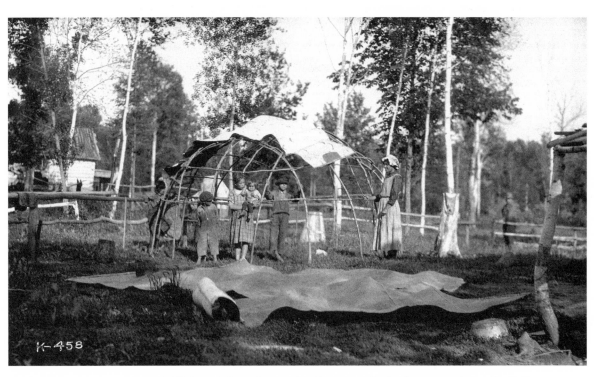

Kenneth Wright, a St. Paul photographer, documented a family constructing a wigwam in 1925.

their bottom ends into the ground, forming a kind of quadrangle with the poles standing perpendicular "like a basket-maker's frame." The ends of the trees were bent over and twisted and tied together to form the dome. Crosspieces of other young trees were also tied to the structure to give it more stability. A kind of rope made of cedar bark was used in tying.

The women then brought nine or ten rolls of birch bark; each roll was about twenty feet long and three feet wide. They covered the house framework from top to bottom, tying the bark to it. They started at the bottom, with each row overlapping the lower one, like shingles.

When the Ojibwe people began to live in log cabins is not known. Certainly fur traders built log structures of various designs among the Ojibwe for hundreds of years. When the U.S. government sought to move Ojibwe people from throughout Minnesota to the White Earth Reservation, it promised that log or frame houses would be built for those who moved. Even when the Ojibwe started to live in log or frame houses, they did not completely abandon their older house styles. Missionary J. A. Gilfillan said that in front of their cabins "nearly every family puts up in summer an old style birch bark wigwam, in which they pass the summer, returning to the log house when the cold weather sets in. They properly prefer the wigwam for its greater coolness, better circulation of air and greater cleanness."

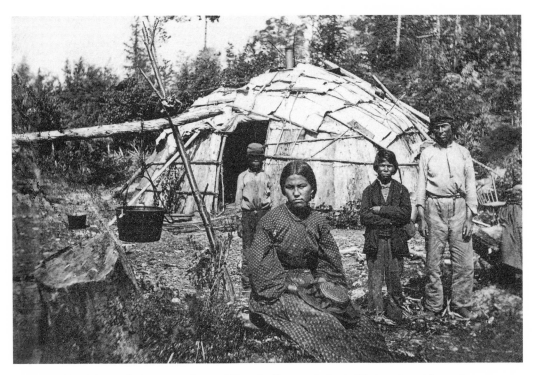

In this image from a stereo view, an Ojibwe family poses in front of their northern Minnesota house in the 1870s.

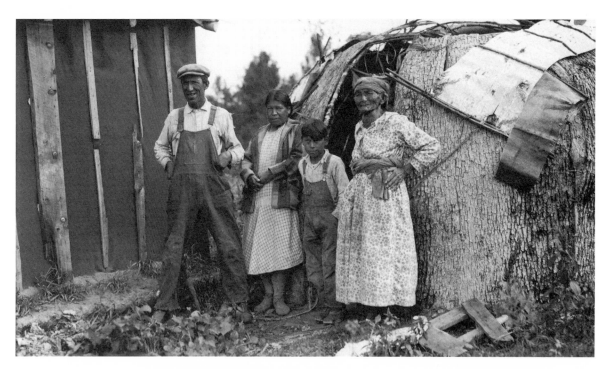

Levi Moose and his wife, one of his sons, and his mother, Grace, are pictured with their summer wigwam and winter home in this photograph taken by John W. G. Dunn in Pine County in 1931.

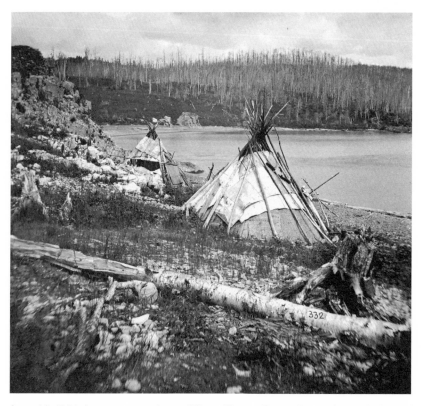

Several bajiishka'ogaanan comprise an Ojibwe village at Beaver Bay, on the north shore of Lake Superior. Photographer Brainerd F. Childs of Marquette, Michigan, captured this scene in the 1870s in the form of a stereoview.

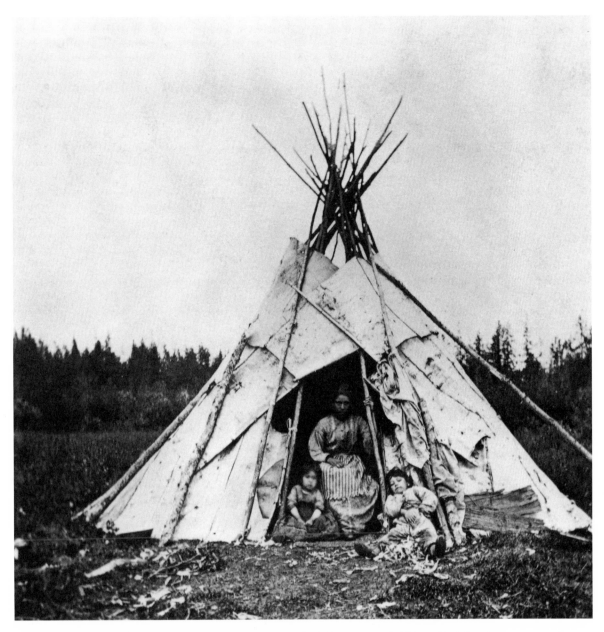

St. Paul photographer William H. Illingworth photographed this woman and children with their bajiishka'ogaan near Brainerd in 1866.

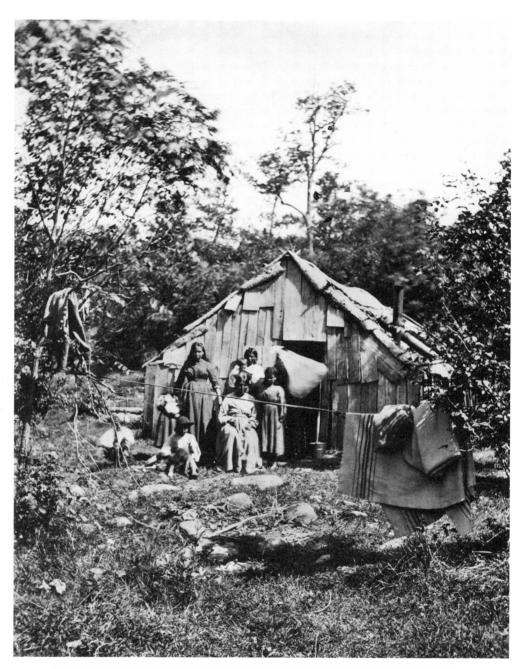

Structures such as this gakaaga'ogan, built like a pole barn, had a more complicated frame-work than a waaginogaan or bajiishka'ogaan, so they might have been used year-round and left standing from year to year. Along the inside walls, they often had platforms made of branches and stakes; these platforms could be used as beds, seats, or storage places for tools. These buildings were often used for boiling sap during the maple-sugaring season, and the steam and the continual thawing of snow and ice may have made the ground wet. In the summer, they provided a cool shelter in which to weave mats. William H. Jacoby photo-graphed this building along the St. Croix River in the 1870s.

"Yes, I Am Almost Cold": Winter in a Bark House

Missionary J. A. Gilfillan, who spent many nights as a visitor in Ojibwe bark houses, described how in the winter, the families slept with their clothes on. Covering their heads with blankets kept their breath near their bodies—a way of retaining heat. They would also lie with their feet toward the center fire.

"The feet are at first exposed to the fire . . ." Gilfillan wrote. "[B]ut as it dies down the sleepers instinctively draw them up under the blanket and tuck it in."

Within an hour or so, the fire would subside and cold air would begin to come through all the cracks in the walls.

"The white traveller who has been hospitably taken in has his thick underclothing on, moc-casins and arctic overshoes, coat and fur overcoat, fur cap pulled over his ears, a warm new blanket enveloping all, head and foot, so that his breath is kept in like all the rest to add the greater warmth; and yet he lies there shivering, unable to sleep."

Meanwhile, Gilfillan said, all around him seem to be sleeping comfortably with only a blanket and sometimes an additional thin quilt covering them.

"Oftentimes, when the traveller is feeling round for wood, a child will rise, throw aside its blanket and stand there in the arctic temperature, cough-ing and again coughing. Its mother will rouse for a minute, and say, 'My little son, are you cold?' and the answer will come, 'Yes, I am almost cold.'"

"The wonder is that they survive a week . . ." Gilfillan wrote, "but they do not seem to mind it."

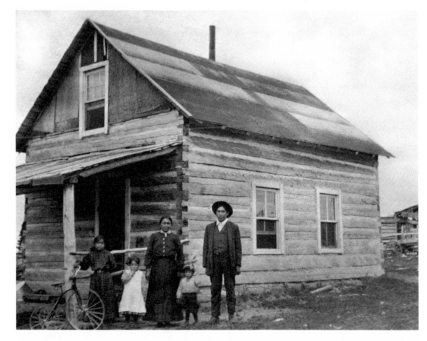

Peter Goodsky, or Wah-se-ge-shik, and his family stand in front of a log cabin at Nett Lake in 1913. According to the 1920 census, Goodsky's wife was named Bay-bah-mah-beak, and they had children named Annie, Frank, and Lillian. Goodsky, who was a Bois Forte band member, worked as a federal employee.

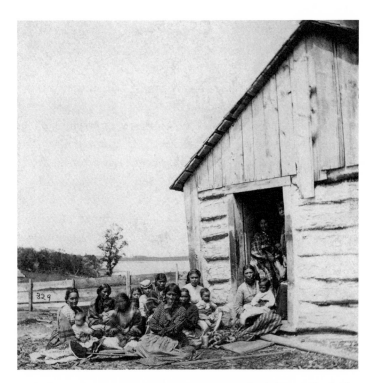

Pictured here may be the house built on the White Earth Reservation in the 1870s to accommodate the Ojibwe leader Wah-bon-ah-quod, or White Cloud, formerly from Gull Lake. Such houses were promised by the U.S. government to persuade Ojibwe people to move to the White Earth Reservation. The photograph was part of a series done at White Earth by the Winona photographer Charles Tenney.

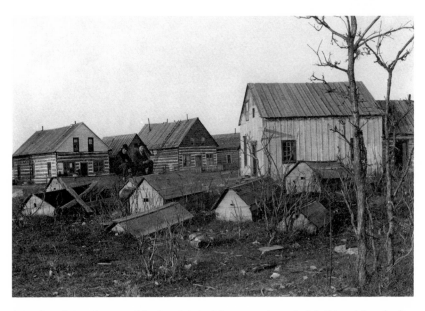

A number of grave houses at the Leech Lake Agency are shown in this Edward Bromley image, taken as early as 1896. Formerly made of bark, these Ojibwe structures erected over graves showed the same evolution as Ojibwe houses, incorporating sawn wood in a traditional practice.

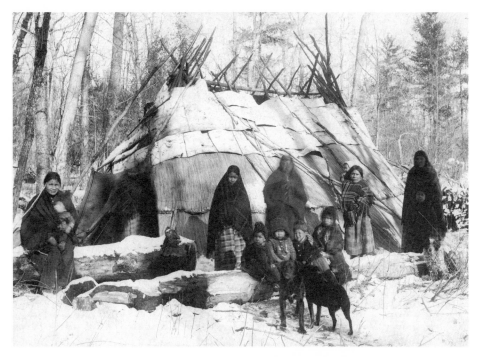

This picture by the Taylors Falls photographer Sanford C. Sargent, possibly taken along the St. Croix River in the 1880s, shows a peaked lodge. It could accommodate several families, each having its own fire circle inside.

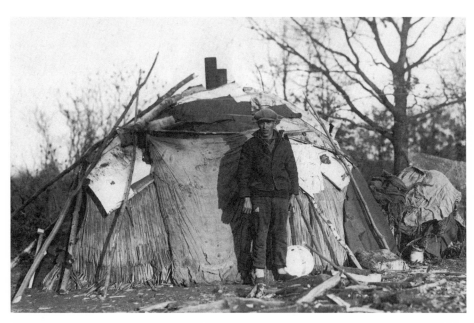

This photograph, taken in the 1920s, demonstrates how the Ojibwe often inventively incorporated new materials into an old style of structure. The house was heated with a stove, rather than open fire, and a material resembling tar paper helped to insulate the outside walls. The caption on the back of the photo, probably written by Harry Ayer (see chapter 1), reads: "John Noon Day and his wife and three children will live here on a point in Mille Lacs Lake this winter. It is a more sanitary home than the average cabin, easily heated, more comfortable than it looks."

Inside the Ojibwe Home

The inside of Ojibwe homes was simple, and the space was flexible. In the center was a fire circle for warmth and for cooking. Kettles were hung over the fire with a forked stick or chain. All around the fire on the floor inside the house were laid cedar boughs, covered with mats made of cedar bark or bulrushes. This is the surface on which people sat and on which they laid their bedding for sleeping. During the day the bedding was rolled up along the wall.

The openness of space inside the house did not dictate a randomness of arrangement of the people who used that space. Each member of the family had an assigned place in the house, just as in many white people's houses people have their own rooms. The placement of each person in the house was based on sex and age, roles that also determined the activities that a person took part in. The best seat in the house was considered to be that opposite the door on the other side of the fire. If the host and hostess wished to show a visitor great respect, they would move away from their seat, as J. A. Gilfillan put it, "saying to the visitor in cheerful words to sit there, smoothing out the mat for him, and brushing away any dust, so that it will be clean."

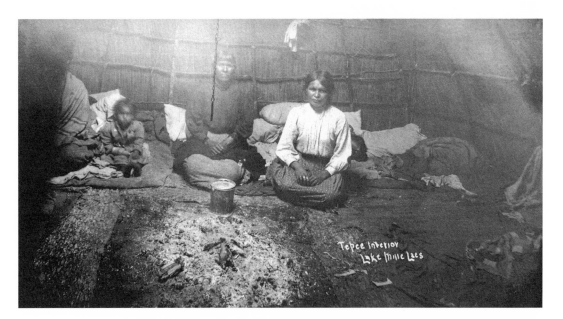

This photograph of three women and a child sitting in a bark house near Mille Lacs was probably taken around 1910. The women are neatly dressed in the kind of clothing Ojibwe people—like many other Americans—wore at this time. Mats along the wall and on the ground, blankets, bedding, and many personal possessions are visible in this photograph. The chain in the center of the photo is intended for hanging a kettle over the fire. The photo's maker—probably Otis Smith of Cloquet—marketed the image as a postcard. Despite his own caption, the structure was probably either a waaginogaan or a gabled bark house. All of Smith's photographs of Ojibwe people at Mille Lacs were made as postcards on special photographic paper, with short captions written directly on the negative.

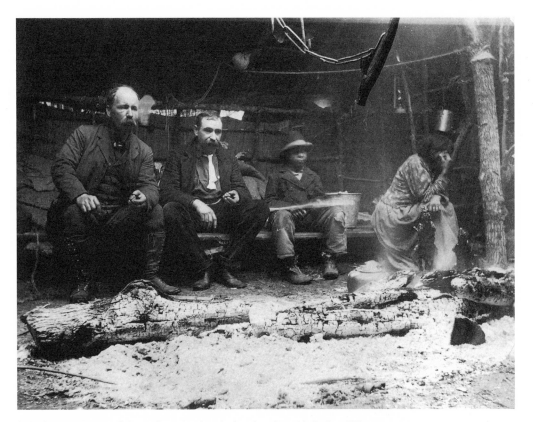

This photograph, one of the earliest showing the interior of any kind of an Ojibwe structure, was taken in March 1900. The photographer is unknown, but the picture belonged to T. Milton Fowble, a private St. Paul surveyor who worked for the Mississippi River Commission, surveying the Mississippi River along the north side of Lake Winnibigoshish, around its junction with Cut Foot Sioux Lake. It may have been a memento of work he did for the government, since Fowble is sitting at left in the picture. He labeled the picture "Waiting for Muskrat Dinner" and said the woman on the right, who appears not to have wanted her picture taken, was "cooking rats." The caption may be intended to be funny, since many whites found the idea of eating muskrats humorous.

In March, many Indian groups living in Minnesota hunted muskrats for their furs. Once they removed the furs, they sometimes ate the meat. The small boy in the picture could be holding the kind of paddle used for cooling and granulating syrup during maple sugaring. Both Fowble and the man sitting next to him appear to be holding pieces of food, possibly bread, in their hands.

The foreground of the picture is much lighter than the background, suggesting that the photographer may have overcome lighting difficulties by removing some of the bark panels on the roof. Or this dwelling may have simply been some kind of an open-sided lean-to.

Minagunz, or Little Spruce, and his wife, Wahzushkoonce, are shown at their home in Grand Portage in a photograph taken by Frances Densmore in 1905. The house appears to have been a log cabin, and it contained much evidence of the Ojibwe culture. In her diary describing what was her first field research among the Ojibwe, Densmore listed the things she noticed in the house, many of which are visible in the photograph: a page from the Christmas issue of the *London Illustrated News* (on the wall behind Minagunz), four clocks (all of them showing the wrong time, she said), guns in racks along the wall, tomato cans being used as cuspidors. Densmore also mentioned the mats on which Minagunz and his wife sat, the deerskin folded to be made into moccasins, herbs of various kinds tied in the process of drying, and covered lard pails holding other traditional medicines. Also evident in the picture are a coffeepot on the shelf at left, a saw hanging on the wall in the center, and a lantern and the wood stove at far right. Minagunz is beating on a drum tied with a green star on its face; the striking part of the drumstick is cross shaped. Densmore also wrote down the words of the song Minagunz sang while he drummed: *Manitou hanagana wabenigo* ("Manitou is looking at me").

Edward Bromley

Edward Bromley was both a direct successor to the early studio photographers and one of the first photojournalists. At first, his photographs, like those of his predecessors, Joel Whitney and Charles A. Zimmerman, provided nonspecific, generic images of native scenes. But as time went on, Bromley's work became more like what would now be called news photographs, depicting specific events, such as the so-called Leech Lake Uprising in 1898, and giving newspaper readers more information about the Ojibwe than the images of previous photographers had.

Bromley is best known as a collector and preserver of the work of earlier photographers, including Joel Whitney, Benjamin Upton, and

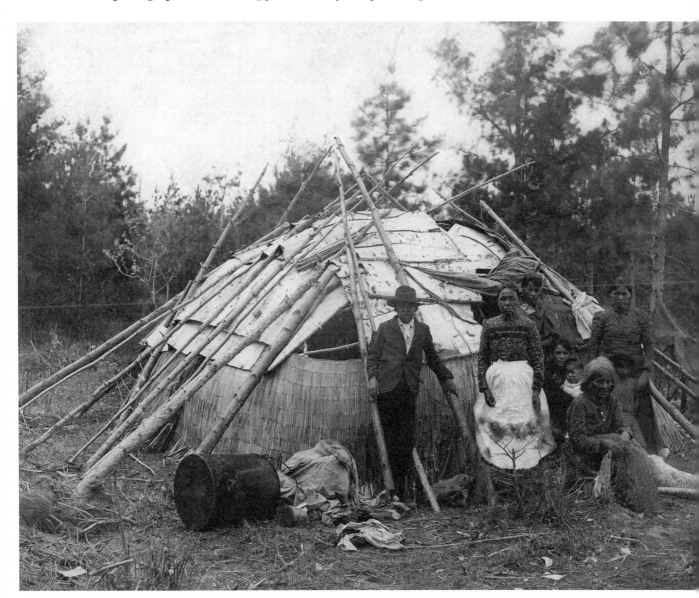

A residence of Leech Lake band members around 1896 by Edward Bromley

William H. Illingworth. Bromley also pioneered the photographic book in Minnesota with his work *Minneapolis Album,* published in 1890, which contained photographs by this first generation of Minnesota photographers. He began taking pictures for his own pleasure, perhaps inspired by the documentary value of the photographs he was collecting. After many years as a reporter on various newspapers in Minneapolis, St. Paul, and elsewhere, he joined the *Minneapolis Journal* in 1894 as a writer and photographer. He also did work for the *Journal*'s subsidiary, the *Minneapolis Times.* Bromley used a variety of cameras in his work, including a 4-by-5 plate camera that allowed a number of plates to be changed inside the camera, and a smaller film camera that he could conceal for taking candid snapshots.

The halftone process, developed in the 1880s, allowed for the printing of photographic images. In the early 1890s, it was applied for the first time to the high-speed presses that produced newspapers. Until

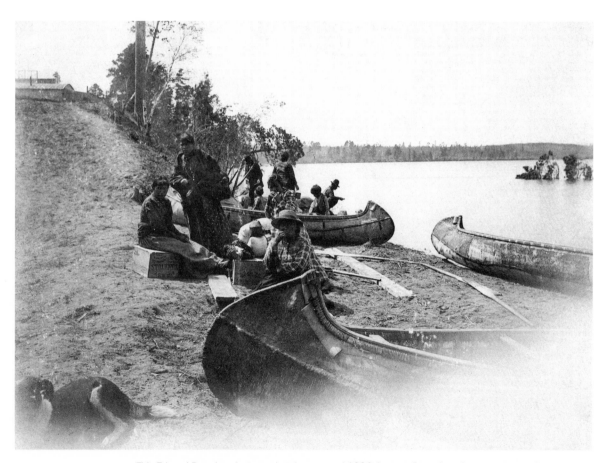

This Edward Bromley photograph, taken around 1896, is one of two that shows women and canoes at Leech Lake. The photographs would be used to illustrate not only Bromley's feature article on the Walker area but also stories about events at Leech Lake and elsewhere in northern Minnesota.

then photographs had to be converted to woodcuts for use in news-papers or books. In 1895, the *Journal* and *Times* were two of the first newspapers in the country to use halftones on their pages, and Brom-ley's photographs were some of the earliest used in the papers.

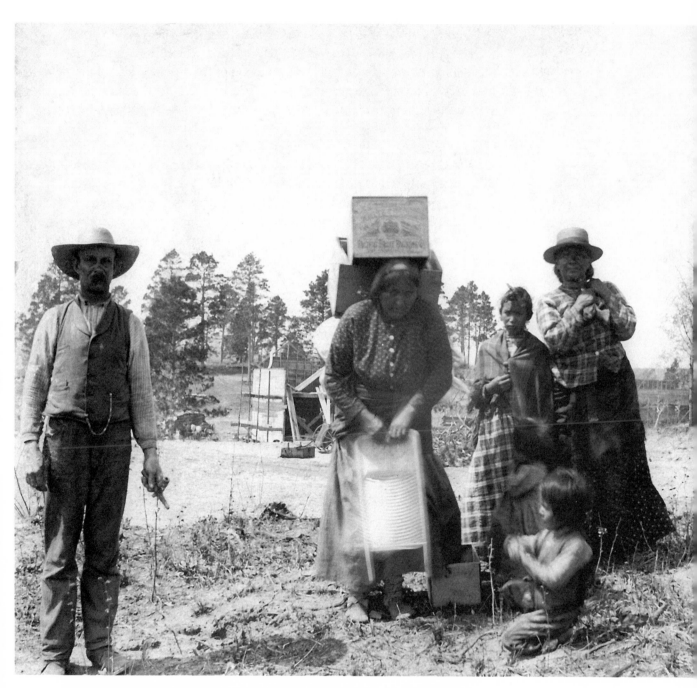

Bromley used this photograph, taken around 1896 and showing women carrying groceries and supplies they had bought at the Leech Lake Agency, to illustrate many of his articles about the Ojibwe.

In the 1890s, Bromley visited the Ojibwe and produced illustrated feature stories about them. One of the first, which appeared in the "Summer Resort Number" of the *Times* on May 24, 1896, described his visit to the new town of Walker on Leech Lake. In it he quoted extensively from previous travelers' accounts of the Indian population and wrote: "Today the Indians on Bear Island are as exclusive as they were in 1835 and are styled the blanket Indians. A visit to their homes will be a very profitable way to spend the day. They come nearer in dress, manners and customs to the ideals one pictures of the American savage than any other band in the vicinity."

With the article and elsewhere in the "Summer Resort Number" were a variety of photographs that Bromley had taken on his trip, including one of an unnamed Ojibwe family in front of a wigwam. Two other pictures featured birch-bark canoes. One showed three canoes and a group of people along the shoreline at Walker. It was labeled "the aboriginal mariners and their craft." Another showed two women facing each other in a partially beached canoe. It was captioned: "agency Indians starting for their wigwams."

Newspaper Coverage of an Incident at Leech Lake

The "Battle of Sugar Point" or the "Leech Lake Uprising" of 1898 has often been called the "last Indian uprising" in the United States. It was a major media event of its time, drawing reporters and photographers from all over the country to the homes of the Leech Lake Ojibwe. Photographs of Leech Lake, the Ojibwe, and the soldiers involved in the incident were front-page news in newspapers across the country for many days in late September and early October 1898. The way newspaper photographers in Minnesota covered the event marked a change in their methods of recording events in Ojibwe communities.

The incident began with Bug-ah-na-ge-shig, (the name meant Hole-in-the-Day or Hole-in-the-Sky, though it was seldom translated at the time), a cousin of the famed leader Po-go-nay-ke-shick and a man of spiritual power, who lived on Sugar Point at Leech Lake. Sometime early in 1896, he was either arrested or held as a witness in a case where liquor had been provided to some people at Leech Lake, at a time when selling liquor to Indians was illegal. He was taken to Duluth for the trial, which ended inconclusively. Afterward he was discharged but given no money to travel back to Leech Lake. As one newspaper later reported, he walked home, arriving at Walker footsore, ragged, and in a starving condition. He was fed by citizens of Walker and went to his cabin at Sugar Point, vowing that he would never be arrested alive again.

Later, when Bug-ah-na-ge-shig was again needed for a criminal trial in Duluth, he refused to go. In early September 1898, he was arrested and locked up overnight in the Indian agency before being sent to Duluth. The next day, while he was being escorted to the steamer that would take him to the train station at Walker, a group of over twenty Leech Lake people rescued him and took him to safety on Bear Island.

The U.S. commissioner of Indian Affairs sent inspector Arthur M. Tinker to investigate the situation, and federal marshal Richard T. O'Connor of St. Paul sent troops amid rumors that the Indians were arming themselves. Bug-ah-na-ge-shig still refused to put himself in the hands of the government, even after a persuasive conversation with Inspector Tinker and Marshal O'Connor on Bear Island.

In response, General John M. Bacon, Major Melville C. Wilkinson, and eighty men of the Third Infantry from Fort Snelling went by barge from Walker to Sugar Point. On October 5, the troops set themselves up at Bug-ah-na-ge-shig's cabin, after arresting and handcuffing the few people they found there. Because it was then close to lunchtime, the troops were ordered to stack their arms. In the process, an inexperienced soldier accidentally discharged his gun. Immediately, two Ojibwe, hidden in the bushes, fired their own weapons. In the ensuing volley, six soldiers, including Major Wilkinson, were killed. Some Ojibwe surrendered, while the rest disappeared across the lake. General Bacon prepared for a systematic campaign against those who retreated, sending companies of men to various places around Leech Lake.

On October 10, the U.S. commissioner of Indian Affairs arrived at the agency from Washington, DC, and called for a council, which was held on October 14. Because large numbers showed up, the council was held outdoors. Several leaders spoke for the Leech Lake people. One, May-dway-we-nind (One Called from a Distance), declared that the Ojibwe had decided they could not rely upon the laws of the whites for assistance. The whites had repeatedly spilled Indian blood on the reservation, he said, but there was not a single instance when they had been prosecuted. Other grievances, such as the theft of timber from Indian lands, were discussed.

After a few days, the tribal leaders negotiated an agreement whereby the Ojibwe would lay down their arms. In return, no one would be punished for his part in the incident. Previously due annuities would be paid as soon as possible.

Throughout the several weeks of battles, negotiations, and speeches, Twin Cities newspapers regularly featured stories and photographs of the events. An image in one local newspaper demonstrated the enjoyment the press corps seemed to get out of the uprising. Its caption described it perfectly: "The Members of the Press Club Celebrated on

Tuesday Evening the Safe Return of the War Correspondents from the Scene of the Recent Indian Skirmish. They Dressed in Indian Costumes in Honor of the Occasion, and Had a Royal Good Time."

Many of the earliest photographs used by the *Minneapolis Times* were studio portraits of the major native leaders in the region, including Ma-ji-ga-bow (Standing Forward), who was described as "a peaceful Bear Island Indian." On October 2, the *Minneapolis Times* ran an article headlined "Ugly Reds," illustrated with photographs that Edward Bromley took on his 1896 trip to Leech Lake. On October 6, the day after the gunfight, the *Times* ran Bromley photographs of a Leech Lake family in front of a wigwam and of a group of people sitting in front of the Indian agency, both probably taken on Bromley's 1896 trip.

Bromley may have been one of the photographers covering the events for the *Minneapolis Times*. It wasn't until several days later that the *Times* included photographs of the troops at Leech Lake, along with Bromley photographs of Indian policemen and of two native men captured by the U.S. Army. And it would be almost two more weeks before the *Times* ran photographs of the actual scene of the battle.

On October 15, the *Minneapolis Journal* published a group of photographs showing troops at Leech Lake, together with the same photograph of Ma-ji-ga-bow that had been used earlier by the *Times*. On October 23, the *Times* ran a photograph taken by Bromley or another photographer showing one of the meetings that had occurred nine days before between local Ojibwe leaders and government officials. It showed Niganibines or Flat Mouth (see chapter 2), one of the Ojibwe leaders, speaking to the council. Under the photograph was the brief note "Flatmouth Speaks." None of what the leader said was included in the caption, though his words had been used in the earlier account of the council. Though few of these images could be called news photographs by today's standards, they did show newspaper readers actual scenes from the events, rather than just formal pictures of the participants.

Even though the newspapers ran only a limited number of photographs, many other pictures were taken. These photographs, which often included indoor and outdoor portraits of the main participants, seem to have been taken as mementos for the participants instead of for the newspapers. For the newspapers, emblematic images of Indian leaders seemed to serve their purposes better than news photographs. On November 24, the *St. Paul Dispatch* ran a retrospective of the events, illustrated entirely with studio portraits.

The council held on October 14, 1898, helped resolve the so-called Leech Lake Uprising. This photograph, taken by Edward Bromley or another photographer, shows May-dway-we-nind speaking in the center of the group; Flat Mouth is seated behind him. To his right is a group of newspaper reporters, busy taking notes. One reporter stated that the speakers addressed the reporters directly during the council "and made their points so that we would best appreciate them."

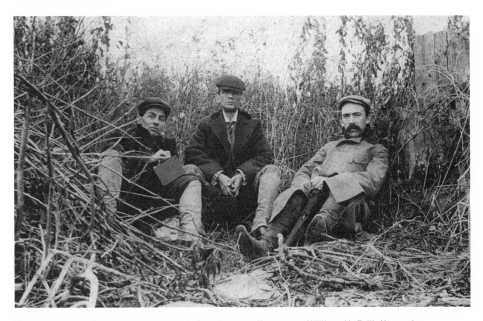

Three reporters who covered the events for Minneapolis papers, William H. Brill, Kenneth Beaton, and Harry Knappen, were recorded in a photograph taken at Leech Lake. Brill is shown holding a box camera; he may have taken some of the surviving images of the events at Leech Lake.

One of the most famous surviving photographs from the Leech Lake incident never appeared in the newspapers. It shows Bug-ah-na-ge-shig, or Hole-in-the-Sky, standing with a blanket and gun in front of the framework of what appears to be a maple-sugaring lodge. He is said to be wearing a necklace made of Krag-Jörgensen shells, picked up on the battlefield at Sugar Point. Credited to James S. Drysdale of Walker, the photograph was mounted on a large board and sold to whites, with a printed label describing Bug-ah-na-ge-shig's association with the battle at Sugar Point.

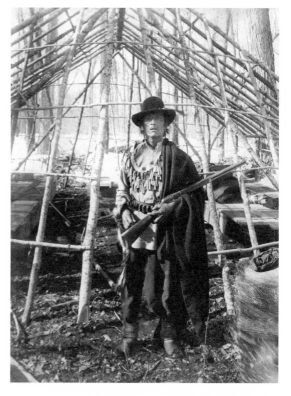

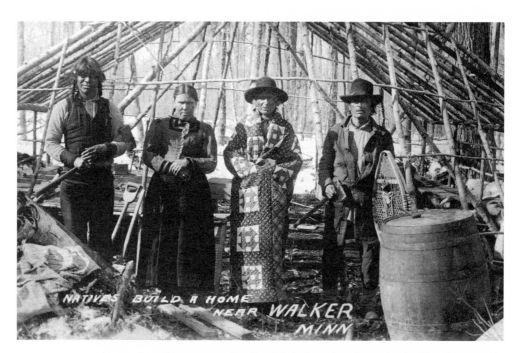

Apparently on the same occasion, Drysdale took another picture showing Bug-ah-na-ge-shig with other Ojibwe, perhaps family members. This picture was sold as a postcard that did not identify Bug-ah-na-ge-shig but that had a misleading description: "Natives build a home near Walker."

Bromley Covers Other Ojibwe News Stories

After 1898, Bromley continued to visit Minnesota's Ojibwe communities, and he became a familiar face particularly at White Earth. On June 15, 1903, the *White Earth Tomahawk* reported that Bromley was representing a Minneapolis newspaper at the annual festival and noted that he was known among the Chippewas of Minnesota as "Mus-in-ahkey-see-gay-we-nin-nee (He Who Copies Faces)."

For the next several years Bromley produced a series of articles for the *Minneapolis Times* based on his visits to Ojibwe reservations. Illustrating these articles—even those not about Leech Lake—were many of the same pictures he had taken at Leech Lake in 1896. For example, one article, published in June 1902, covered the federal government's attempts to move the Mille Lacs Band of Ojibwe to White Earth. But it included one of Bromley's photographs of canoes beached on the shore of Leech Lake, a woman carrying provisions from the Leech Lake agency, and the Leech Lake grave houses. They were all labeled with captions implying that they might have been taken at Mille Lacs. It is evident that the grave houses image was heavily retouched. In the background of the original photograph are a number of log buildings surrounding the Leech Lake Agency, but these buildings were not shown when the image ran with the Mille Lacs article. Also cropped out were two figures in suits sitting on the roof of one of the grave houses. These photographs simply supplied atmosphere for the articles rather than recording specific events.

An August 31, 1902, article about Mille Lacs included one image that might meet modern standards for news photographs of an actual event. It showed members and leaders of the Mille Lacs Band posing with Major James McLaughlin next to a dead steer, which was to serve as food for the assembled Mille Lacs people. With the photo was the short caption "Scene at the Beef Issue." Bromley explained the situation in the article:

The day the major was known to be on the ground a delegation of his copper hued wards waited upon him and intimated that some fresh beef would be very acceptable . . . Early the next morning the same delegation arrived at the Potts Hotel armed with a Winchester rifle and one small axe. They were willing to act as executioners if Agent Michelet would produce the victim. He sallied forth with them and found a steer that was acceptable. It was led to a spot near the council house, and then Major McLaughlin was asked to shoot it. He acquiesced and before you could say Jack Robinson the animal which had been cavorting at the end of a long rope dropped in its tracks and was pounced upon by the waiting redskins.

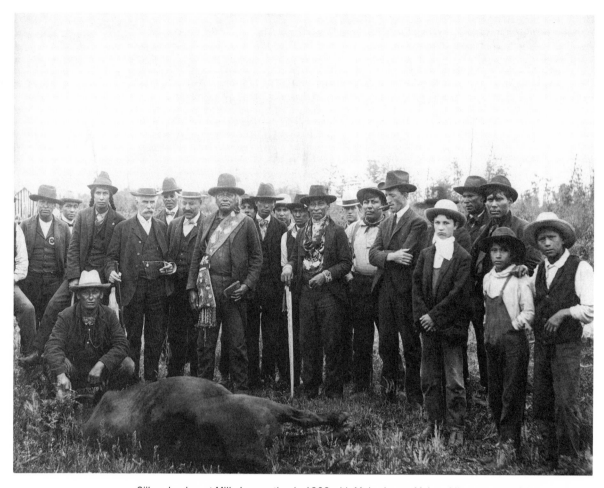

Ojibwe leaders at Mille Lacs gather in 1902 with Major James McLaughlin, an agent of the federal government who had come to negotiate for the band's removal to White Earth. In front of them is a steer presented by the government to feed the Mille Lacs people at the negotiation. Supposedly the Mille Lacs leaders requested that McLaughlin shoot the steer himself, which explains why he is holding a rifle.

Bromley noted that McLaughlin had hit the animal behind the ear: "[T]here is no doubt that his skill with the rifle created a very favorable impression and was the best introduction that he could have had to the good marksmen with whom he was to treat," Bromley wrote.

Bromley's suppositions about the Mille Lacs people and his jocular tone in describing their encounter with McLaughlin were typical of the way newspaper articles treated Indian people, but they belied the seriousness of the situation: the federal government was trying to move an unwilling people from their homeland. Despite McLaughlin's best efforts, he was able to persuade only a portion of the Mille Lacs people to move to White Earth.

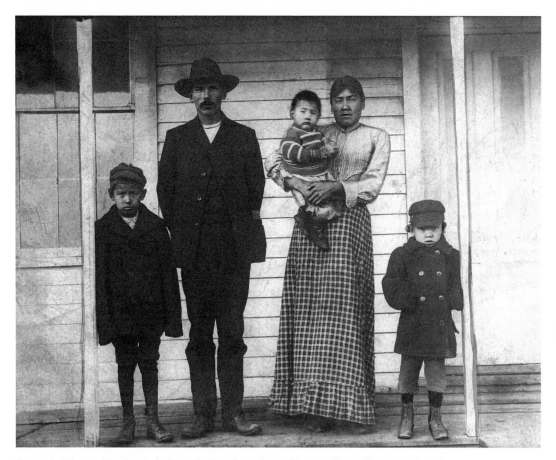

George Lufkins and family—including wife Maggie and possibly sons Henry, George, and John—in front of a frame structure at White Earth around 1900. By this time, many Ojibwe lived in frame houses, although this may have been an agency building. Bromley wrote on the back of the picture: "each one in the group except the baby is entitled to 80 acres of fine land." But many who came to White Earth received considerably less land, and government corruption often cost them what land they did receive. Before publication in the newspaper, this photograph was heavily retouched with ink to make the details of the people's faces and clothing and of the building stand out when it was made into a halftone.

Robert G. Beaulieu

Robert G. Beaulieu, the first known Minnesota photographer of Ojibwe ancestry, lived and photographed at White Earth beginning around 1910. Born in 1858, he was a member of a large Ojibwe-French family. His father, Clement H. Beaulieu, was a fur trader at Crow Wing in the 1850s and 1860s and moved with his brother, Paul H. Beaulieu, to White Earth after its founding in 1867. They were active in the business and social life of White Earth. Clement, in particular, was influential in community decision making and had outside ties with white government officials and businessmen.

Although there is evidence that Clement valued his Ojibwe heritage and taught this appreciation to his children, he also made sure they

were educated about their Euro-American heritage. When he lived at Crow Wing, he brought in a schoolteacher for them. Later on, at least two of his sons, Charles and Clement, Jr., were sent to Fay's Academy in Elizabethtown, New Jersey, where they received lessons in the violin and in English, French, German, and Latin. By the time Clement died in 1893, his sons were all accomplished in a variety of occupations. They too were active in the White Earth community.

Historian Melissa Meyer has shown that White Earth around 1900, like many small communities, had several informal parties or factions that contested decisions facing the community as a whole. Clement Beaulieu and other members of his family were members of a "progressive" party, while others belonged to a "traditional" group. Sometimes these parties were classified as "mixed blood" and "full blood."

White Earth people themselves used these racial classifications, although they were not necessarily present in other Ojibwe communities. As Meyer noted, cultural choices such as religion, clothing, and housing types often determined which people were assumed to belong to which group. When asked by government officials if a person was a full blood, White Earth residents would likely say yes if the person had braided hair, wore a breechcloth, had a tipi in his yard, or was a member of the Midewiwin. Similarly, a person wearing a white collar and pants and attending a Christian church might be assumed to be a mixed blood.

Robert G. Beaulieu amassed a collection of 140 or more photographs of people and places around White Earth, particularly White Earth village, where he lived. Many of the pictures he took himself. Although the photographs attributed to him are technically excellent (he took them with a 5-by-7-inch view camera on a tripod), the only other evidence that he worked as a professional photographer was the fact that he was listed as such in the 1920 census of White Earth village.

Robert's older brother Gus H. Beaulieu and his cousin Theodore H. Beaulieu published several newspapers, including *The Progress* in the 1880s and *The Tomahawk* beginning in 1903. Clement H. Beaulieu, Jr., was a minister and writer. Charles H. Beaulieu was an Indian agent at Leech Lake. Like his brothers, Robert was likely educated in schools off the reservation. In his early adulthood he lived on land near his father, helping him operate a store. In 1887 government hearings on White Earth, his father reported that Robert was postmaster and assisted his brother Gus, who was sheriff at the time, in serving writs and subpoenas.

News items in *The Tomahawk* suggest Robert was artistic and musical. A May 14, 1903, item says: "R. G. Beaulieu, the artist, painter, and cartoonist, left for Detroit [Lakes] today." On December 27, 1917, Charles H. Beaulieu (who became editor after Gus's death) wrote, in a list of resolutions for the coming year: "If Bob Beaulieu will agree to cease being sad over spring and summer rains, the impurities of mud

and other impurities, then ye editor will agree to build out of his 'excess profits' from journalism, a cement sidewalk from Bob's residence to the White Earth Opera House." Another possible clue to one of Beaulieu's occupations was given on November 27, 1924, when the newspaper stated: "R. G. Beaulieu left during the past week to resume his duties as scaler at the Webster Lumber Company's saw mill east of town." A number of the photographs in Robert's collection do, in fact, record logging operations on the reservation.

Robert himself appears in several of his own photographs. A picture of the White Earth brass band shows him with his cornet. In a photo of

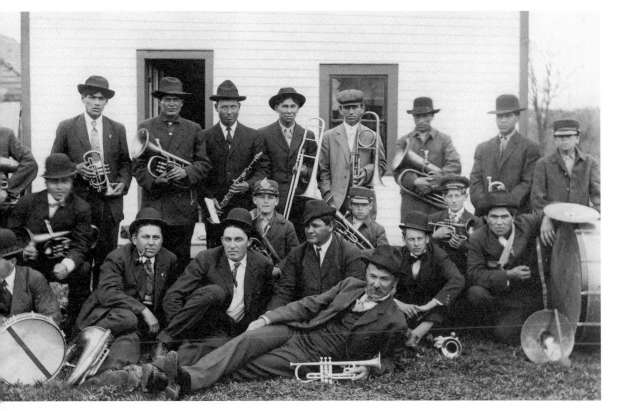

Robert G. Beaulieu lies in the foreground of this photograph of the White Earth brass band, taken around 1920.

the Chippewa State Bank, Beaulieu is standing in the doorway, and the 1930s label for the picture states that he was an officer of the bank. The fact that Beaulieu is in these photos might contradict the idea that he was the photographer. However, another photograph from around 1915 shows Robert Beaulieu's second cousin once removed Clarence R. Beaulieu standing next to what was said to be Robert's large-format camera and holding the bulb release. Clarence or some other assistant could have tripped the shutter for those pictures in the collection that include Robert.

In terms of style, framing, and subject matter, there is little to distin-

Charles Mee, Robert G. Beaulieu, and Charles Moulten stand in front of the Chippewa State Bank at White Earth in the 1920s.

guish Robert Beaulieu's photographs from those taken in many small Minnesota towns by competent professional or amateur photographers. They seem to reflect his place and that of his family in the White Earth community. Many of the people Beaulieu photographed appear to have been part of the mixed-blood faction at White Earth. Many of the photographs show buildings in White Earth village: stores, a bank, a hotel, the newspaper office, the movie theater, and the interior and exterior of St. Columba's Episcopal Church. Other photographs record parades, baseball games, and horse races during the annual June 14 celebration.

Although Beaulieu appears not to have done studio work, a number of his photographs were portraits. In general, these images were sharply focused front views of their subjects—some in groups in front of their houses, others alone in front of a cloth or blanket backdrop or

Around 1920, Robert G. Beaulieu photographed Aindusogeshig, Chief Daily, a leader from Mille Lacs, in front of a blanket backdrop outside. The leader had recently moved from Mille Lacs to White Earth. The white on his coat may be evidence that it was snowing the day the photo was taken. Although Beaulieu was not a studio photographer, many of his photographs were portraits.

in some outdoor setting. The people and their clothes reveal a mixture of cultural choices. Many are wearing contemporary American apparel and are posed in front of clapboard-sided frame houses. A few photographs show people wearing beaded clothing, but these pictures often appear to have been taken during the June 14 celebration. Beadwork also supplements contemporary clothing.

Only a few of Beaulieu's photographs show the so-called traditional aspects of Ojibwe subsistence that were emphasized by so many white photographers. Except for one photograph of a man threshing rice in a barrel, there is only one image of rice harvesting. Only three photo-

graphs, those done of Kate and Joe Big Bear, record maple sugaring. No photographs document hunting and fishing. There are no pictures of bark canoes. There are no images showing the Midewiwin or other aspects of Indian religion.

Beaulieu's reasons for taking photographs are hard to gauge, since few of them appear to have been published in his lifetime. Several of his portraits were used in Frances Densmore's books, though he was not credited as the photographer. Densmore may have gotten them from Gus and Clement, Jr., who helped her with her work.

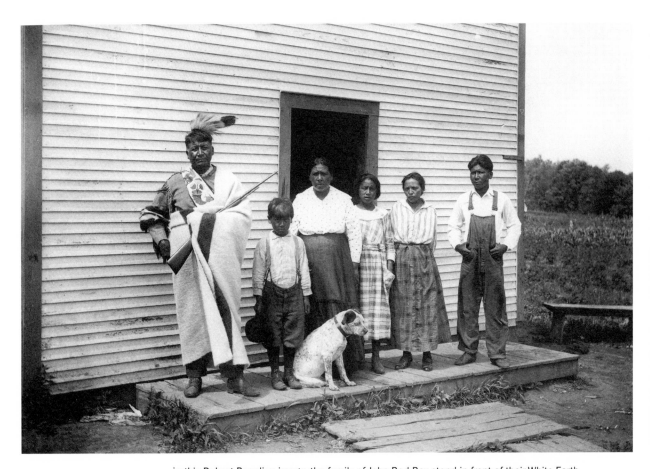

In this Robert Beaulieu image, the family of John Bad Boy stand in front of their White Earth home, around 1925. The 1920 White Earth census lists John and Angeline Bad Boy with four children: George, nineteen, William, fifteen, Julia, thirteen, Michael, six. Another source suggests that the girl second from right may be a member of the Big Bear family, which lived nearby. Angeline Bad Boy was a member of that family, and the girl may have been her niece.

John W. G. Dunn

John W. G. Dunn was a canoeist, sportsman, and conservationist who photographed the Ojibwe of the St. Croix region. He had a more detailed view of the Ojibwe than many strangers who visited this area, in part because of his friendship with the region's white game warden, who was well acquainted with local Ojibwe families. Though he visited Ojibwe houses and observed the way the people lived, he photographed them outside their houses, on their doorsteps—the same way many whites photographed Ojibwe people they did not know intimately.

Dunn was born in Philadelphia in 1869 and spent three years studying civil engineering at the University of Pennsylvania. The year before he was to graduate he was forced to drop out of school because of poor health. To help his recovery, he devoted himself to fishing and hunting with his father and brothers in Maine, where the family later built a summer home. He began to describe his experiences in articles for a New York magazine entitled *Shooting and Fishing*.

In 1896 Dunn moved to St. Paul and began working in insurance and real estate. He soon found many places to enjoy the outdoors in his new home state. In 1912 he first fished along the St. Croix River with his two sons. In 1914 he bought some shoreline at Marine-on-St. Croix, where he built two summer cabins. This haven served as a base for many boat and canoe trips along the entire length of the St. Croix River.

Dunn became interested in photography while still a teenager and pursued the hobby during his outdoor experiences in Maine. When he came to Minnesota, he continued to take photographs. His son, James Taylor Dunn, wrote, "He liked to carry out the entire photographic procedure himself, developing the pictures (which were sometimes sold as postcards at his cabin in Marine), mounting, and then binding the photos together with his journals into yearly canvas-covered albums."

Dunn's first contact with the Ojibwe came as a result of his relationship with Sheridan Greig, game warden for an area of Pine County along the St. Croix near Danbury. Once a year, from 1926 to 1931, Dunn visited Greig at his home in Ogema Township near Lake Lena, in part to hunt rabbits with bow and arrow. As game warden, Greig was acquainted with many of the nearby residents, including members of the Lake Lena Ojibwe community. In one of his diaries, Dunn wrote that many people would come to Greig for "advice and help when they are in trouble, both Indians and whites. Even those whom he has pinched & fined a number of times for violating the game laws. It shows how they respect him." In later years, members of the Lake Lena community recalled Greig with somewhat more ambivalence. They told stories of the ways in which Ojibwe who hunted out of season tried their best to avoid being caught by Greig and how Greig tried his best to catch them.

As an avid bow hunter who had made his own bows, Dunn first spoke with the local Ojibwe because he was interested in learning about Ojibwe bow-hunting practices. He often asked men to hold his bow and show how they would shoot with it. He also solicited their advice on making bows and arrows. One such conversation was with Pansy resident John Blackburn on November 13, 1926. Dunn wrote that Blackburn

> *held the arrow between the forefinger and the thumb & the other three fingers along the string . . . He said hard maple made a good bow without seasoning, that iron wood was very good but hard to get straight, rock elm also, but had to season a long time. He made his arrows with blunt points to shoot rabbits & squirrels, because they would not stick in the trees or go very far. He was a very interesting old fellow & [I] would like to have staid longer & gotten some photos, but it was very dark & raining part of the time.*

Dunn came back to visit Greig in January 1927 and again in January 1928. On January 11, 1928, he photographed two people who came to get trapping licenses: John Clark and his brother-in-law Pete Nickaboine. The next day he and Greig's daughter Delphine walked over to the village to see a man named Be-san-e-gezik, or Clear Sky, also called John Benjamin, who tanned deer hides that Greig's wife made into hunting shirts. According to Dunn, Be-san-e-gezik and his wife "had a nice neat looking house inside . . . A house out side was covered with large sheets of birch bark & in the yard was a teepee frame of bent hoops. We got a photo of his squaw & grand son, a nice looking [K]id of 2 years or so. The old man would not have his picture taken."

While walking back through the village, Dunn stopped at the home of Jim Razor, where he "got a picture of him . . . shooting the bow. Said he used to be a good shot." Dunn also photographed Razor and his granddaughter sitting on the steps of their house.

From there Dunn and Delphine stopped at the home of Jim Stevens, the acknowledged leader of the community. Dunn photographed Stevens wearing overalls and standing in front of his house. He also saw the interior of Stevens's home when they entered it so Dunn could change the film in his camera. Dunn noted:

> *House looked very neat & the walls covered with photos of his Indian friends & relations. The big drum was here, but he said it was bad luck to take it down. The sticks to hold the drum were on a shelf. They were painted a gray & the ends curved like round hockey sticks & all wrapped round with bright colored streamers. He had two big medals that were given to his Grandfather, one was marked 1794 or 1784. The*

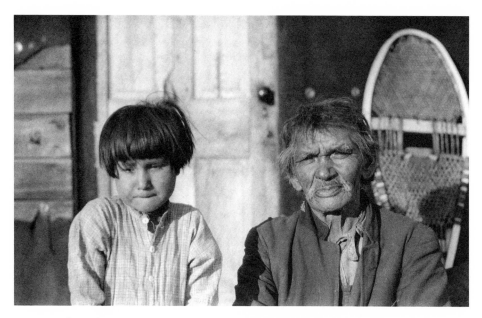

Dunn photographed Jim Razor and his granddaughter on the steps outside their home in January 1928.

old man got them on a visit to Washington. Jim had also been there on
tribal matters. He had a small dried owl skin used in their dances. The
head black & white speckled.

Finally, Dunn and Delphine stopped at the home of Doris Boswell, Stevens's daughter. Dunn described the house as "a very neat place & both her & her little girl very nice looking, got a photo of them." Like the others, this photograph was taken outside in front of Boswell's house. In 1987 Boswell remembered that when Dunn came by and asked to photograph her, she was baking bread. This explains the lumps visible on her hands in the picture. Dunn made no mention of this activity in his diary.

A few days after this walk, on January 15, Be-san-e-gezik appeared at the Greig house to get the deer hide he was going to tan. This time he agreed to be photographed shooting Dunn's bow. Dunn wrote that he was "a good looking Indian and the 'Medicine Man' in the village . . . He does not talk when I am near mostly grunts. When I let him look into the Graflex & I went & waved my arms so that he could see me in the ground glass, he was much amused, & laughed."

In September 1931, during a rare visit to the village in the summer, Dunn met and photographed members of the Moose family, including John Moose and his wife and their son, Levi Moose, and his wife and son, as they all stood next to a wigwam they used in the summer.

In September 1932, Dunn photographed some members of the community on a canoe trip down the Namekagon and St. Croix with Greig.

While passing by Pansy, they encountered Blackburn. In the late afternoon on September 2, Dunn photographed Blackburn and his daughter processing some wild rice they had harvested. At the mouth of the Lower Tamarack River, Dunn photographed some children of Jim Songetay, who lived there. Later downstream they encountered Songetay harvesting rice alone: "He had a spear under his arm to pole the boat with & two sticks about 3 ft. long. One he used to bend the rice over the boat & the other to beat the grain out. He had quite a lot already in the bottom of his boat. When it is first harvested looks very feathery, but loses this later on when heated & parched, when the hulls are gotten rid of by the aid of the wind."

On October 31, 1934, while deer hunting with Greig's son, Bob, Dunn visited the old village Gibaakwa'iganing, encountering Pete Nickaboine, one of the last residents of this village. Dunn photographed Greig and Nickaboine among the few houses left in the village.

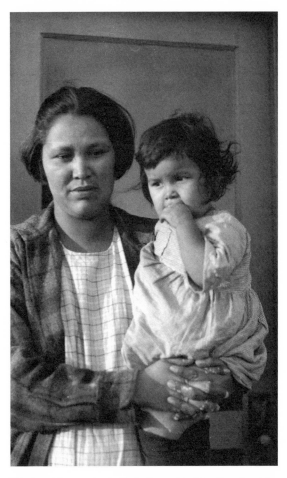

This Dunn image shows Doris Boswell holding her daughter Esther in the doorway of her house in Lake Lena in January 1928.

Monroe Killy

From the early 1930s through the 1950s, Monroe Killy produced a large body of ethnographic still photographs and films in a number of Ojibwe communities in Minnesota. Killy's work was that of a self-described amateur ethnographer who most of his life had a technical job in photography. Although a skilled photographer, he did not pursue photography of the Ojibwe as a professional.

Killy's interest in Indians arose in part from his experiences as a child. Like many white Americans, he played "cowboys and Indians"—and he always wanted to be the Indian. In 1930 he began deer hunting and fishing with his father near native communities at Leech Lake and other parts of northern Minnesota, where he sought artifacts for his collection of arrowheads and other Indian-related objects. From the first, he photographed the Ojibwe people holding or wearing the items they were selling.

Killy admits that he "prowled" through an Indian community, going from door to door looking for older people who might have things to sell or might be interested in talking to him. He often looked for frame or log houses that had a wigwam outside, a sign older Ojibwe people were living there. Some of the first people he photographed, using a 116-size folding Kodak camera, were Leech Lake residents Jack King and his wife. They lived in a one-room frame house outside of Onigum, on the north side of Agency Bay, and Killy met them in January 1931. One photograph, lit by a flashbulb, shows Mr. and Mrs. King sitting inside their house. Other pictures, taken outdoors in the snow, show King wearing a beaded outfit, a roach hairpiece, and an eagle-feather war bonnet; he also holds an eagle-wing fan. Several of the photos show King posing in front of an American flag. "He wanted that for a background," Killy said in a 1987 interview. "He brought that out and told me he would like to have that … so we got two people to hold that up."

Other photos show King standing on a wooden box with his hands outstretched, holding a pipe in a classic pose. Killy said, "One reason for that [pose] was to better show the fringes hanging down from the jacket." As for the wooden box, Killy explained that King complained of his feet being too cold against the snow.

Killy said King didn't mind having his photograph taken: "I didn't try to poke a camera in his face the first time I met him, like the typical tourist, and ask to take his picture. I tried to develop a little more rapport with him, you know, become acquainted with them, not being too nosy, but interested, and being I expressed an interest in their way of life, they came to respect me a little more I suppose than somebody who would drive up in front of their house and slide to a stop and pull out a camera."

In the summer of 1931, Killy returned to Leech Lake to photograph the exterior of the King house. Killy was at Leech Lake several times that year, once for a July 4 celebration at Walker and also in September, when he made his first pictures of people harvesting and processing wild rice. These pictures were taken along Sucker Bay, off Leech Lake. One photograph, slightly blurred, shows a woman parching rice; another shows a family at one of the encampments, where members would stay during the harvest. Killy simply drove to the place where people were known to be harvesting and introduced himself.

By 1932 Killy had met Joe Day, the young man who would serve as his paid guide and interpreter in his work around Leech Lake. Day lived with his parents and originally made his living through hunting and fishing. Later, he worked as a mechanic in Walker. In June 1932 Day brought Killy and Killy's father in his motorboat from Onigum to Squaw Point, where a Mide ceremony was being performed. Killy was there at the invitation of Jim Greenhill, one of the leaders of the Mide at Leech Lake, but he was not allowed to photograph during the ceremony. "A non-Indian does not go barging into a sacred enclosure during a ceremony," Killy explained. "You just don't do that."

However, he was able to take some pictures of people inside the enclosure during a pause in the ceremony. One of his photographs shows another Mide leader, John Smith, who, like Greenhill, had sold Killy Ojibwe objects. Another photograph showed Greenhill taking his seat

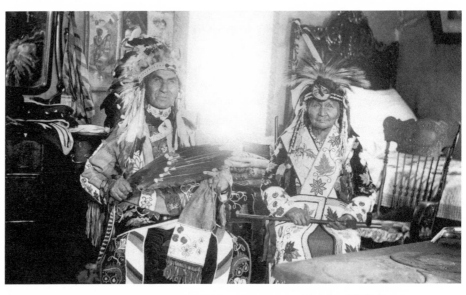

Jack King and his wife, Me-tig-o-gwan, are pictured in the bedroom of their Leech Lake home, wearing examples of Mrs. King's beadwork. Behind the couple is a large chest where they stored their collection of clothing made by Mrs. King, who was an expert bead worker. On the wall behind them are a number of calendars, including one showing the romantic image of Indians popular at the time. In a 1987 interview, Killy recalled, "They had the neatest house. Those pine boards were just white."

after a speech right at the beginning of the ceremony. The picture shows blankets and cloth hanging from the upper structure of the enclosure, gifts from people being initiated into the Midewiwin. Also during the 1932 trip, Killy's father photographed Monroe, Joe Day, and Joe's father, Richard Day, in front of the Day family home. In 1941, Killy returned to Leech Lake and photographed Richard and Mary Day posing with their grandchild.

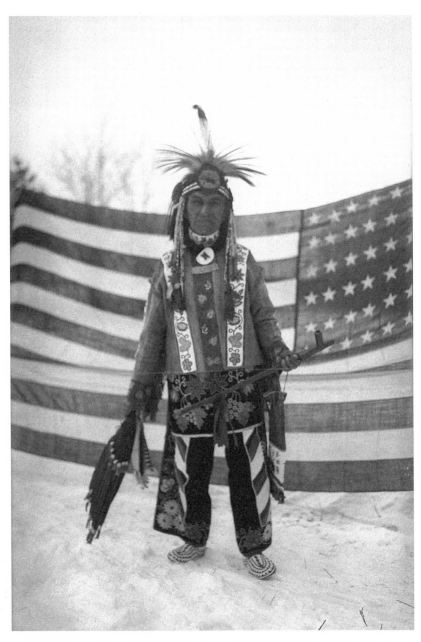

Jack King, of Leech Lake, photographed by Monroe Killy in 1931. Killy took the picture to get a record of some Ojibwe craft items that King was selling him. King requested that the picture be taken in front of an American flag.

Killy met Greenhill again on a visit to Red Lake in July 1933. The occasion was the July 4 dance and celebration, an event that could go on for three days. People would come from reservations all over Minnesota and the Dakotas for the celebration. Killy photographed Greenhill in his dance costume (see chapter 5), as well as other people in costumes dancing or watching the dancers. Another photograph shows three men on their way to the dance, one of them wearing skunk-skin garters that Killy later purchased. Killy also photographed an aspect of the celebration called "dancing the stores," when people in costume would dance in front of the local businesses, a way of obtaining contributions of food, money, and supplies.

The dance at Red Lake was one of a few powwows Killy photographed. He said that at public events like these no special permission was needed to make pictures, especially of people in groups. People who didn't want to be photographed could just turn away or put objects in front of their faces, and several people apparently did.

Another of Killy's photographs from Red Lake shows a woman making fry bread, possibly among the tents set up for visitors to the July 4 celebration. This picture demonstrated Killy's growing interest in people engaged in ordinary activities—ones that suggested something of the Ojibwe past.

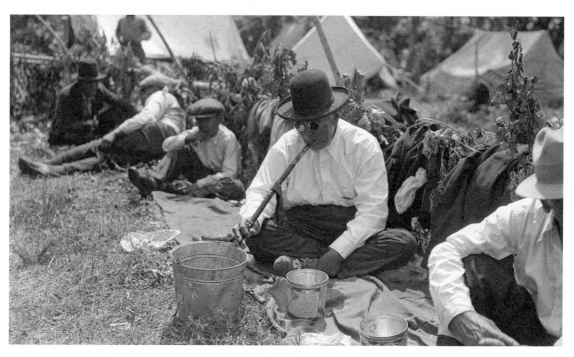

John Smith, a Mide leader at Leech Lake, photographed during a break in a ceremony by Monroe Killy in 1932. The pails in front of Smith contain maple-sugar water, a refreshing beverage.

During the 1930s, he became interested in documenting the kinds of subsistence activities that Frances Densmore had photographed or written about in her book *Chippewa Customs,* such as wild-rice harvesting, maple sugaring, and the preparation of hides. Killy met Densmore on several occasions, and she encouraged his photographic work. "She suggested that . . . I try to follow this as much as I possibly could and learn about how the Indians used to live," Killy recalled. "And . . . if possible get any photographs of the activities and of their life." She also said that "one of these days not too far in the future none of this will be left any more. No one will be doing that."

Killy's interest in this kind of ethnographic photography led him to make moving pictures. He shot 100 feet of 16-milimeter black-and-white film of dancers at Red Lake in 1932. In the 1930s and 1940s, he used color film to record the subsistence activities still being practiced by many Ojibwe, documenting the wild-rice harvest, maple sugaring, moccasin making, and a variety of other handicrafts. Due to lack of funds, he was never able to add sound to these movies. While making the movies, Killy continued to carry a still camera, often recording the same events with both media.

Richard Day, his wife, Mary, and a grandchild at Leech Lake in 1941. They were the parents of Monroe Killy's guide, Joe Day.

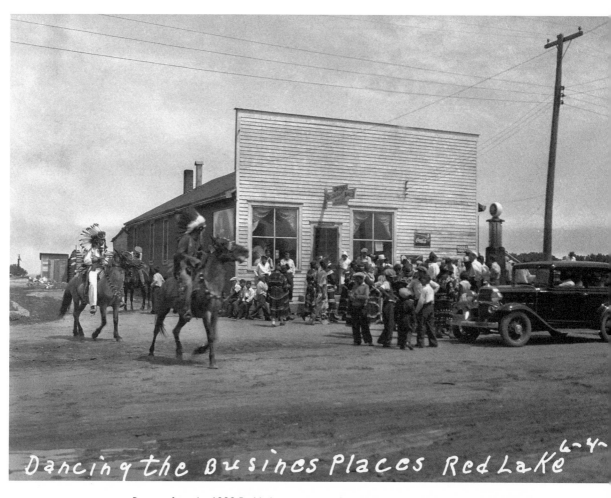

Dancing the Busines Places Red Lake

Dancers from the 1933 Red Lake powwow perform in front of a local store to solicit donations in this Monroe Killy photograph. The activity continued the tradition of the "begging dance," a ceremonial request for aid from those with wealth.

Of Home · 105

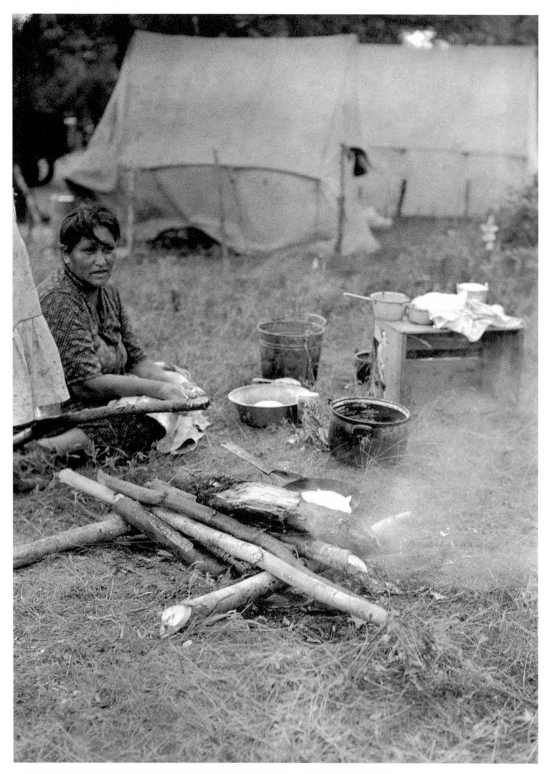

A woman at Red Lake makes bread in a frying pan over an open fire in this view captured by
Monroe Killy in 1933.

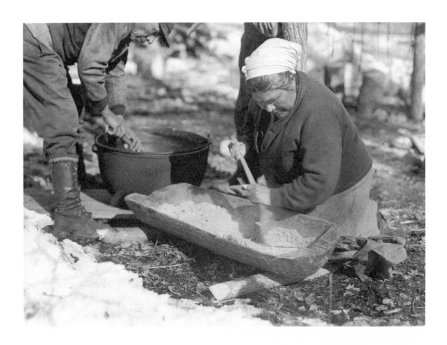

Fred and Mary Day, photographed by Monroe Killy at their sugar bush at Mille Lacs in 1946. Although Killy's intention was to record the maple sugar making, some of his photographs resemble candid family snapshots, recording the relationships between couples. In response to a question from Killy, Mary Day described how her family had carried out a particular sugaring technique.

Fred Day asked his wife, "You didn't really do it that way, did you?"

"Yeah, that's the way we used to do it," Mary replied—right at the moment that Killy snapped the shutter.

By inquiring in communities, he would find out who was harvesting or sugaring. Then he would show up at their camp and ask if people would mind him photographing or filming them. He would work while they continued what they were doing, only asking them occasionally if they would hold still for a minute while he got particular shots. He knew that what he was doing was really an intrusion in their lives, even though he tried to keep out of their way. Few people turned down his request to photograph or film them.

Generally after he was through photographing or filming, Killy would ask the people what he owed them and would pay them what they asked. He also tried to give everyone he photographed copies of the pictures, either delivering them the next time he visited or sending the people copies in the mail. For one of his films, "Sugar Bush," quite a bit of which was shot at Mille Lacs, he set up a showing at the schoolhouse on the reservation. "We finally ended up with a couple of dozen people to see it," he recalled. "And did they get a kick out of it! They giggled and whispered when they saw themselves on the screen."

World War II and service in the Signal Corps interrupted Killy's work. After the war, he returned to several reservations, in part to fill in sequences of the events he had earlier documented, and found things had changed quite a bit. Many of the elders he had known had died. Many of the younger men had been in the service and were not interested in the traditional culture. He also believed that people were reticent to talk about the old days because "they had been anthropologized to death."

However, he did find some people at Mille Lacs willing to show him traditional activities. Martin Kegg, for example, allowed Killy to film during sugaring in 1946. Killy also photographed Martin's wife, Maude, making and coiling *wigob,* or basswood fiber, for use as twine. At the same time, he took candid photographs of the Keggs' children, together with their parents and separately.

Killy's motivation for photographing the Ojibwe was largely a single-minded interest in the people and their culture, not a hope for profit. He offered his photographs for use in newspapers and magazines, and they were sometimes published, but he seldom asked for money. He did not seek to record a complete view of Ojibwe life but said his work was guided by the belief that many practices he was recording would soon cease, an expectation shared by white Europeans for centuries. Many of his pictures are not just records of activities but lively portraits of Ojibwe people and their families.

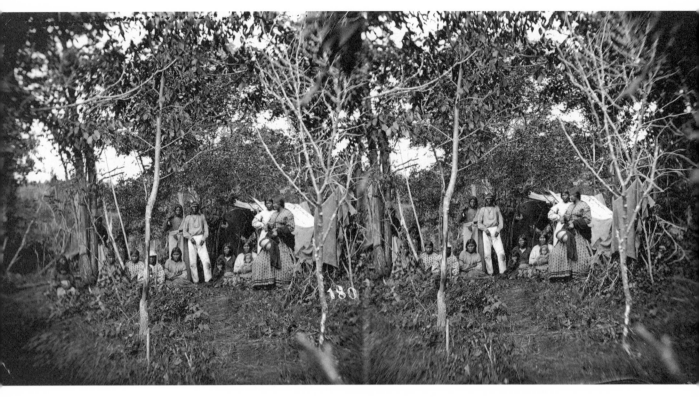

Minneapolis photographer William H. Jacoby captured this spring or summer scene along the St. Croix River in the 1870s in the double negative made by a stereo camera.

4

Biboonagad / A Year Goes By

For centuries Ojibwe life followed a well-defined seasonal pattern, some-times called the seasonal round, as the people made use of the rich as-sortment of resources present in their environment. The yearly schedule is evident in many of the Ojibwe names for the months of the year. For example, April is *iskigamizige-giizis,* the maple sugar–making month. July is *miinike-giizis,* the blueberry month. August is *manoominike-giizis,* the rice month. During these times, Ojibwe people could be found in the places where these and other resources were in good supply. They went to some of the same places in a defined region year after year.

Perhaps the most commonly photographed topics were ones that seemed traditional, romantic, and fascinating to non-Indians. The em-phasis in many of these photographs is on the technical aspects of har-vesting food, making things, surviving. The full seasonal round was not easy to photograph. Some activities, such as maple sugaring, ricing, and canoemaking were easy to record, since they took place outdoors in the bright sunlight of spring or summer. Others, such as hunting and trap-ping, which often took place in winter, appear to have been too difficult for most photographers to document.

Many of these photographs are part of series designed to show Ojibwe seasonal activities in detail and in sequence. Some of the indi-viduals pictured have recurring roles, demonstrating a range of cultural traditions for various photographers. The resulting images show Ojibwe people who were technically skilled, inventive, and artistic. They also seem enormously patient in dealing with photographers' demands.

One thing often missing from these picture series was how the Ojibwe seasonal round evolved in the nineteenth and twentieth cen-turies. Photographers were less inclined to photograph Ojibwe people working for lumber companies, farms, and resorts, traveling by train, and using automobiles, all of which came to be part of the seasonal pattern.

Another thing that photographers could not photograph were the Ojibwe spiritual beliefs about the world in which they lived, their grat-itude for what was made available to them. Throughout the seasonal cy-cle, feasts celebrated the beginning of each food's season. Ethnographer Frances Densmore noted that the Ojibwe people would offer "a portion of the first fruit or game to the manido. This was done by giving a feast at which the host 'spoke to the manido,' and offered petitions for safety, health, and long life … Everyone was given a little of the 'first fruit' and

then partook of the feast." These feasts were a reflection of profound beliefs that no photograph can fully grasp.

Included in this chapter is a discussion of Densmore's relationships with Mary Razer and Nodinens, two knowledgeable Ojibwe women who shared information about seasonal activities with her and, in doing so, influenced her photography. Densmore's photographs of these women capture the Ojibwe activities and people as they actually lived. She had them pose doing the things they would have done without her there. In contrast, photographer Roland Reed created vivid, impressive images of Ojibwe hunting, fishing, and doing other activities using props and costumes and with the help of Ojibwe people. His aim was to show Ojibwe life not as it was at the time but how he believed it was before it was influenced by white culture.

Ziigwaan Spring

For many Ojibwe, the return of the crows in March signaled the return of spring. According to missionary J. A. Gilfillan, it was an eagerly anticipated sign that "grim winter was over," that the worst and most precarious season of the year had passed. The crows also signaled that sugaring season would soon begin. Maple sugaring was a social occasion in which friends and relatives, separated during the winter, reunited.

Nodinens, who grew up at Mille Lacs in the 1840s, told Frances Densmore that when the sap began to run in the maple trees, families would wrap up their possessions and set out for the sugar bush, the sugar maple groves they harvested sap from year after year. Her family's maple grove was near Mille Lacs. At the time of sugaring and afterwards, men would fish on the lake. While the lake was still frozen, the men cut holes in the ice, covered their heads to keep the light from shining into the water, and speared fish. As soon as the little creeks opened, the boys would catch small fish. Many fish were dried for later use. Trapping muskrats was another activity that happened during sugaring season. By the time spring was over, the families had many birchbark containers of sugar and many dried fish, the snows had melted, and the buds had formed on the trees. From the sugar bush, the families might continue fishing on the lake or they might travel to the place where they planted their gardens each year.

MAPLE SUGARING

Easily stored and transported, maple sugar was a year-round staple food and seasoning beloved by the Ojibwe. In the absence of salt, which they seldom had, Ojibwe used maple sugar with fruits, vegetables, fish, and meat.

All the tools for the harvest—birch-bark buckets for collecting the sap, kettles for boiling it, and trays for graining the sugar—were stored at the sugar bush in a small, bark-covered structure. Each family's sugar bush also had the framework for a house or lodge in which the sugar would be made. On arriving, women would cover the framework with rolls of birch bark. The maple sap was boiled inside or near such buildings. Of all the steps in the sugaring process, sap boiling was the one most frequently portrayed in early artwork and photos.

If the men were hunting or fishing, the Ojibwe women and children tapped the trees by themselves. Children had a big role in the sugaring process. When Maude Kegg was a girl living with her grandmother at Mille Lacs around 1900, it was her job to stand by the fire and make sure the kettles did not boil over. If they started to, she would dip in a fir bough to stop it.

On reservations, Indian agents tried to discourage the Ojibwe children's participation in the sugaring process. White Earth agent Timothy J. Sheehan wrote in his diary in 1885: "Indian children are now having vacation and are nearly all out making maple sugar with their Parents. Am informed by Mr. Heume school superintendant [*sic*] that many of the children go back to their wild and untamed habits while in the sugar bush or making maple sugar. I at once order the Capt. of Police to get his Police together and go and see that all those children were got together to commence school at once." Despite such efforts, maple sugaring continued to be a family activity for many Ojibwe.

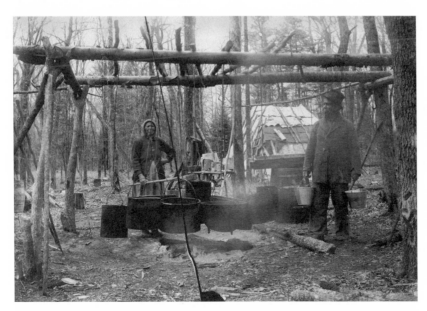

Joe and Kate Big Bear were photographed at their sugar camp at White Earth around 1910 by Robert G. Beaulieu, another White Earth band member.

Darwin Hall took this portrait of a woman named Angeline at her sugar bush at White Earth around 1900. Hall was a member of the Chippewa Commission, which sought to persuade Ojibwe from all over Minnesota to move to the White Earth Reservation. It is possible he took this picture to show other Ojibwe that they could still do sugaring at White Earth and that the government would supply them with large kettles with which to do it.

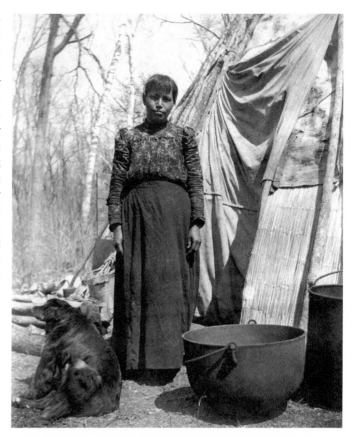

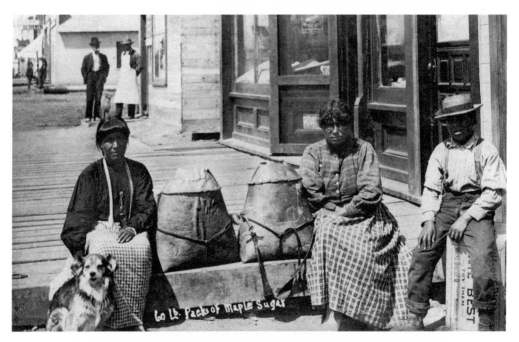

As early as the fur-trading days, the Ojibwe supplied maple sugar to white people. Later, after white farmers had settled in the region, the Ojibwe sold their sugar to local storekeepers. With the money they received, they could buy flour, tea, lard, and other provisions. Photographer Otis Smith took this picture, possibly at Onamia near Mille Lacs, around 1910.

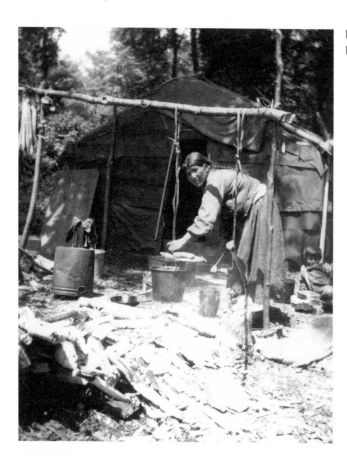

Maggie Sam at her sugar bush at Mille Lacs around 1920

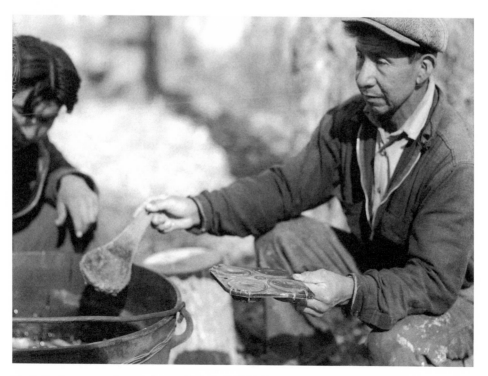

Martin Kegg pours maple sugar into molds in April 1946. Monroe Killy took this photograph at Mille Lacs.

SPRING FISHING

Fishing was usually done at the times of year when Ojibwe families lived in lakeshore villages, but it could support families all year round. They often dried or froze fish, especially in the fall, when they stored them up for winter use.

The most efficient method of catching fish—one generally employed by Ojibwe women—was to use gill nets. Nets were placed in the water at night, removed in the morning, and hung up to dry during the day. Densmore recorded that the Ojibwe sometimes washed their nets with a decoction of sumac, which destroyed the fish odor. Powdered calamus and sarsaparilla roots sprinkled on the nets helped to attract fish.

In the late nineteenth century, fish became an increasingly important food supply. William Campbell, a member of the Chippewa Commission, reported in an 1894 letter that his efforts to persuade Sturgeon Man, a prominent member of the Leech Lake community, to move to White Earth were stymied by Sturgeon Man's wife. When speaking with the woman, Campbell mentioned the government's food warehouse at White Earth. "She says she will never move away from her own 'warehouse' as she terms Leech Lake," he wrote. "She ran and got me a basket of fish which she had just got from the lake and said 'what do you think of my warehouse?'"

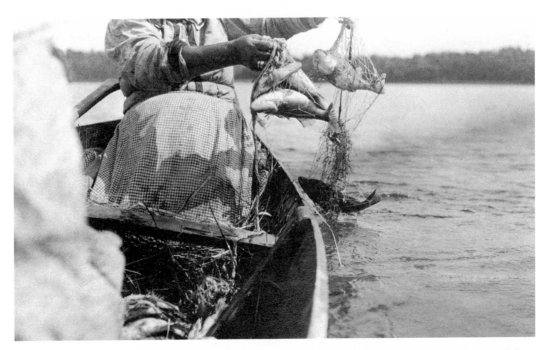

Mary Razer draws her gill nets from the water in this Frances Densmore photograph from around 1917. Razer, a Mille Lacs woman who lived on the White Earth Reservation in the 1910s and 1920s, was one of Densmore's most important sources of information and subjects for photography.

Monroe Killy took this picture of suckers being smoked in a tipi-like structure at Nett Lake in 1946.

In the late nineteenth century, many Ojibwe men took part in annual spring log drives, supplementing their income by working to move the logs cut during winter downriver to the mills. Many were skilled drivers whose services were greatly valued. Photographers seldom recorded this activity, however.

Pictured in this log-drive photograph are members of the Ojibwe community who lived in the St. Croix River region of Minnesota and Wisconsin around 1900. The name of this particular river was not noted, although it may be the St. Croix or one of its tributaries. The only specific names recorded were George Summers, Jack Pike, and Chief Blackbird, individuals who were part of the St. Croix Band in Wisconsin. Pike, who has descendants living in Minnesota's Lake Lena community, is the young man standing in the center of the picture with his arms folded. His apron suggests that he was part of the crew that fed the men. Later on, because of his experience on the river, he became a champion at the sport of birling, or log-rolling.

Niibin Summer

Summer was a comfortable time for Ojibwe families because the season brought so many useful resources. For much of the summer, many Ojibwe gathered on the shores of lakes to cultivate their gardens and to fish in the waters. The season was often the most social time among Ojibwe families.

The products of summer were not only food but also the goods that the Ojibwe used all year round. Summer was the time for gathering medicinal plants, collecting bulrushes for mats, and harvesting birch bark and cedar roots for canoes.

GARDENS

Among white people, the Ojibwe were not known as farmers and gardeners, perhaps because they did not practice the kind of intensive cultivation that white people did. It is not surprising, then, that there are few photographic or artistic portrayals of their gardens. Yet gardens were an important source of food for the Ojibwe people.

In 1831, Indian agent Henry R. Schoolcraft was traveling down the Namekagan River, a tributary of the St. Croix in northern Wisconsin, when he came to Puckwaéa Village. He had a unique opportunity to view the surroundings because all the inhabitants were away, as recorded in one of his journals:

> *We found it completely deserted, according to the custom of the Indians, who after planting their gardens, leave them to go on their summer hunts, eating berries, &c. We found eight large permanent bark lodges, with fields of corn, potatoes, pumpkins, and beans, in fine condition. The lodges were carefully closed, and the grounds and paths around cleanly swept, giving the premises a neat air. The corn fields were partially or lightly fenced. The corn was in tassel. The pumpkins partly grown, the beans fit for boiling. The whole appearance of thrift and industry was pleasing.*

Nodinens remembered her own family's garden: "The camps extended along the lake shore, and each family had its own garden. We added to our garden every year, my father and brothers breaking the ground with old axes, bones, or anything that would cut and break up the ground. My father had wooden hoes that he made and sometimes we used the shoulder blade of a large deer or a moose, holding it in the hand. We planted potatoes, corn, and pumpkins. These were the principal crops."

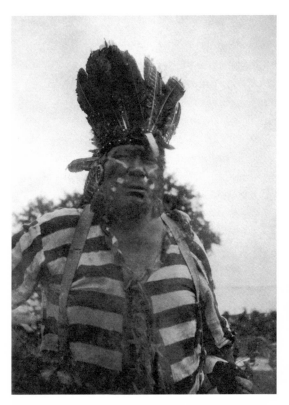

In a photo from the Harry Ayer collection, taken around 1920, Gitche Nodin (Great Wind), or Big Pete, was shown dressed for a dance or powwow.

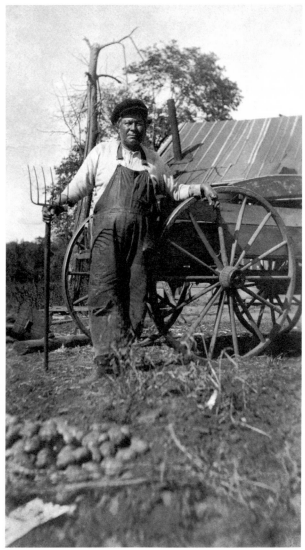

Gitche Nodin is shown near his potato field at Mille Lacs, around 1920. Recorded on the back of this photograph, taken or collected by Harry Ayer, was a handwritten note: "He is one of the leaders here. You will notice he has some potatoes in the foreground . . . He is close to 70 years old, but doesn't look it." The writer also noted that Gitche Nodin was very knowledgeable about the stories of the trickster, Nenabozho.

CANOEMAKING

Canoemaking was one of the most frequently photographed aspects of Ojibwe life simply because white people seemed to find the process endlessly fascinating.

One of the earliest detailed descriptions of Ojibwe canoemaking methods was given in an 1826 account by Thomas L. McKenney, the U.S. commissioner of Indian Affairs who had come to negotiate a treaty with the Ojibwe at Fond du Lac, Minnesota. McKenney hired Okeemakeequid, an Ojibwe leader and canoemaker from Lake Vermilion, to build him a birch-bark canoe. After reaching an agreement, McKenney watched Okeemakeequid and his assistants—including a number of women and children—work.

The ground being laid off, in length and breadth, answering the size of the canoe (this was thirty-six feet long, and five feet wide in its widest part), the stakes are driven at the two extremes, and thence on either side, answering, in their position, to the form of the canoe. Pieces of bark are then sewn together with wattap, and placed between those stakes, from one end to the other, and made fast to them. The bark thus arranged hangs loose and in folds, resembling in general appearance, though without their regularity, the covers of a book with its back downwards, the edges being up, and the leaves out. Crosspieces are then put in. These press out the rim, and give the upper edges the form of the canoe. Next, the ribs are forced in—thin sheathing being laid between these and the bark. The ribs press out the bark, giving form and figure to the bottom and sides of the canoe. Upon these ribs, and along their whole extent, large stones are placed. The ribs having been previously well soaked, they bear the pressure of these stones, till they become dry. Passing round the bottom, and up the sides of the canoe to the rim, they resemble hoops cut in two, or half circles. The upper parts furnish mortising places for the rim; around and over which, and through the bark, the wattap is wrapped. The stakes are then removed, the seams gummed, and the fabric is lifted into the water, where it floats like a feather.

As shown in this case, canoemaking was a cooperative venture, involving women, men, and sometimes children. Generally, the men did the part of the work that required a crooked knife, such as shaping the wood for ribs, floor, bow, and stern. Densmore wrote that "much stress was laid on the proper whittling of the ribs, and it was said that only a few men of the tribe (in the old days) could make these of really excellent shape. If these were faulty the canoe was easily upset." Women did the sewing, using an awl made of bone or metal to puncture holes in the bark. When all the bark panels were sewn to the cedar framework,

they coated the seams and stitching on the bottom and sides of the canoe with a pitch made of spruce resin boiled, as one person told anthropologist M. Inez Hilger, "until it pulls like taffy, after which it is fried in grease mixed with powdered charcoal made of cedar."

"A good canoe maker," wrote Densmore, "was highly respected in the tribe, as the work required skill and experience, and the welfare and safety of the tribe was largely dependent on the proper building of its canoes. Young men were allowed to assist in the work, but canoe making was regarded as a craft which 'must be learned by observation and experience.'"

All parts of the canoe were measured in reference to parts of a canoemaker's body. One common unit of measurement was the handspread—the distance from the tip of the thumb to the tip of either the little finger or the middle finger. The space between ribs was one handspread. The depth at middle distance between bow and stern was the distance from elbow to the tip of the thumb. According to Densmore, the ordinary length of a canoe was three double armspreads, with a width of about 36 inches. A seventy-five-year-old man at Lake Vermilion told Hilger: "As a young lad I had often watched my father make canoes and in that way learnt how to do the fine details. My father was considered an expert canoe maker: he had learnt it from his father who also had the reputation for canoe making. I made my first one when I was 14 years old; an old woman directed me and showed me exactly how to put the parts together."

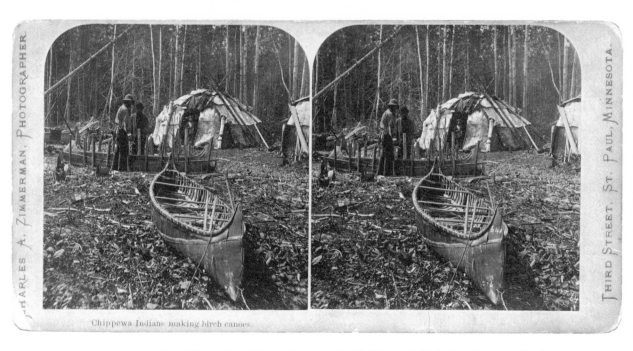

One of the earliest pictures of canoemaking is this one by St. Paul photographer Charles A. Zimmerman, possibly taken at the annuity payment at Odanah, Wisconsin, in 1870.

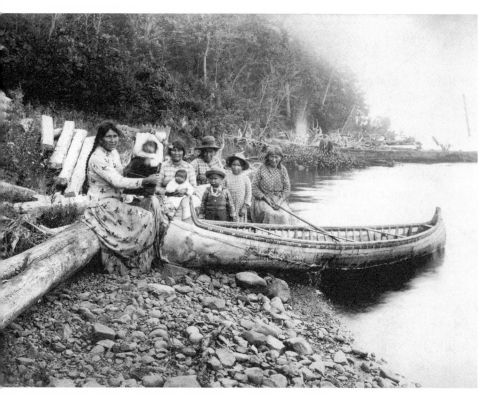

S. C. Sargent of Taylors Falls photographed this group of women and children and their canoe, probably along the St. Croix River, around 1885.

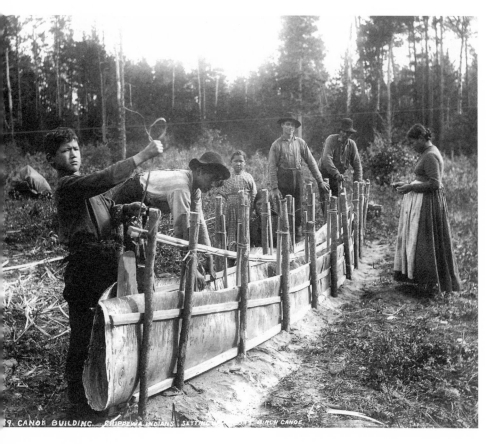

Around the 1890s, St. Paul photographer T. W. Ingersoll produced a series of photographs of what appears to be a family making canoes, probably in the region of the St. Croix River. The young man in the foreground was working under the direction of elders, both men and women, who knew the craft.

Making Canoes and Boats at Mille Lacs, 1939

Harry and Jeanette Ayer hired local Ojibwe to build a birch-bark canoe outside their Mille Lacs Indian Trading Post at Vineland in 1939. Harry is believed to have been the photographer who recorded the process in snapshots, which were later published in the *Minneapolis Tribune*. Ayer wrote in a note sent to the anthropologist M. Inez Hilger: "Due to the fact that there had been no birch bark canoes made at the Indian trading post for some 20 years, it was difficult to find anyone who still remembered the measurements all of which are taken from between various parts of the body, i.e., the span of the hand from thumb to little finger, the distance from the index finger to elbow, or the distance of the span of extended arms." They finally got the measure-

Master craftswoman Gwetes holds the rolls of spruce-root fiber used to bind bark panels to each other and the canoe framework.

Jim Hanks, Sr., holds one of the curved wooden pieces that gave shape to the bow and stern of the canoe.

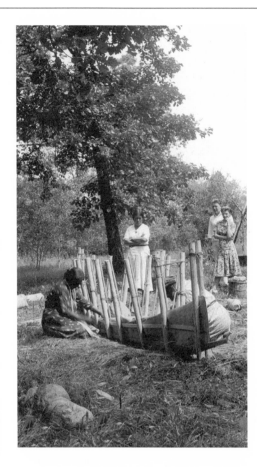

Women assemble the bark within a building framework and bind the pieces of bark together as part of a 1939 canoemaking demonstration at the Ayers' Mille Lacs Indian Trading Post. Pedwaywayquay, Dick Gahbow's wife, is on the far left. The other Ojibwe women are Gwetes and her daughter-in-law Jennie Reece.

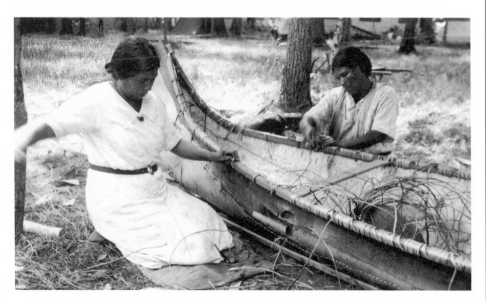

Two women work together to bind the gunwales of the canoe. According to Harry Ayer, the women worked in pairs "to retain an even strain so curves along the length will be true."

ments from Dick Gahbow (Me-zhe-zhow-a-ge-shig). A "master craftswoman" named Gwetes (or Qua-dence) built the canoes, assisted by several other women and her son, Jim Hanks, Sr.

Both Dick Gahbow and Jim Hanks, Sr., also worked for Ayer's Mille Lacs Boat Factory, which manufactured modern motorboats. In an interview with Frances Densmore, recorded in a Densmore article published in the *Christian Science Monitor* in 1931, Ayer explained that he saw their work as a logical extension of Ojibwe boat-making traditions, even though only men worked in the factory. He praised the workmanship of his employ-ees, saying that they were very careful, very attentive to detail. They preferred, he said, work that involved both their heads and their hands and that required them to solve problems of design, saying that life to them "should be one big problem after another." He stated that this made the Ojibwe loggers good at unlocking logjams that sometimes occurred during spring log drives.

Ayer hired only men and paid them between $2.50 and $4.50 a day for eight hours of work in winter and nine hours of work in summer. The factory reportedly closed down during ricing season and for Midewiwin ceremonies.

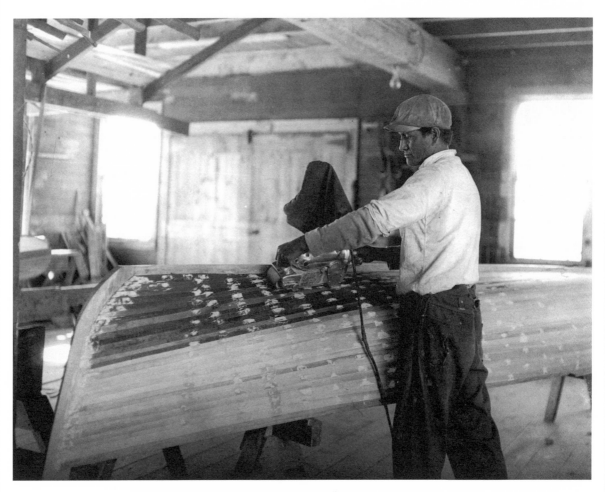

Jim Hanks, Sr., sands a boat in the Mille Lacs Boat Factory, where he and other band members built fishing boats in the early 1930s.

PREPARING HIDES

Ojibwe women treated hides, used for moccasins and clothing, throughout the year, but this activity was most often photographed in summer months. Then the women worked outdoors, where photographers could record them easily.

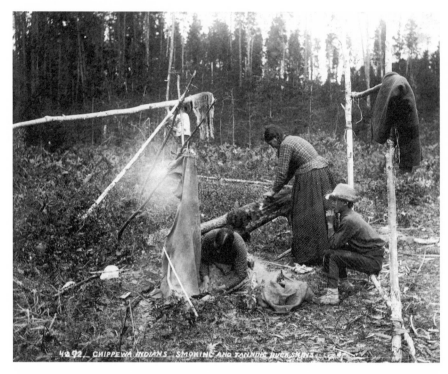

A woman smokes a hide to help preserve it and to give it a darker color in a photograph by T. W. Ingersoll. The woman and boy are the same ones in Ingersoll's photograph of canoemakers taken around the same time.

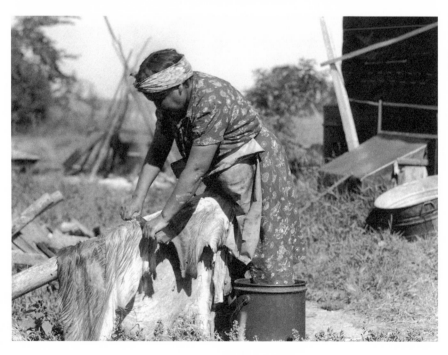

Ida (Mrs. Jim) Drift of Nett Lake scrapes a hide in this August 1946 photograph by Monroe Killy.

WEAVING

Ojibwe women used bulrushes, cedar bark, and cattails for weaving mats. Bulrushes were most commonly used for floor mats. Cattails were woven into mats for covering wigwams; such mats could be made impervious to rain and helped insulate the walls of the wigwam. Cedar-bark mats were more common in northern Minnesota than in other parts of the state.

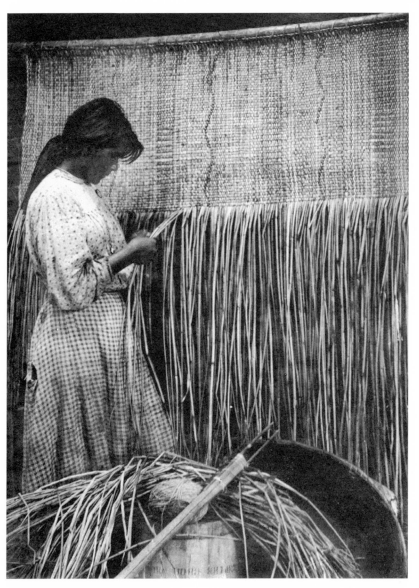

An Ojibwe woman weaves rush mats in this image, taken by an unknown photographer around 1910.

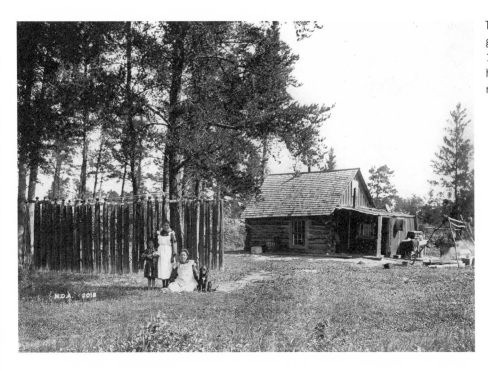

This Harry Ayer photograph, taken as early as 1910, shows bulrushes hanging to dry in preparation for weaving.

BERRY PICKING

The Ojibwe harvested the many kinds of berries that ripen in Minnesota throughout the summer. A common refreshment for Ojibwe travelers was the shadbush, or Juneberry. "Take some Juneberries with

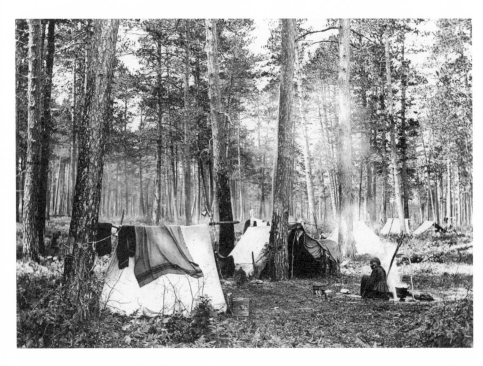

An Ojibwe summer camp, perhaps during blueberry season, is shown in this photograph by St. Paul photographer T. W. Ingersoll, taken around 1890. The place, said to be called Berry Banks, may have been located along the St. Croix River or its tributaries, possibly in the area of Burnett County, Wisconsin, which was known as a productive berrying area at that time. The region had been heavily logged, opening it up for the growth of berry bushes.

In August 1937, Russell Lee, a photographer for the federal Farm Security Administration, came to the region of Little Fork, in Koochiching County, near the Canadian border, to photograph the Ojibwe blueberry harvest. At the time, the Little Fork River had recently been logged, providing room for a vigorous growth of blueberry bushes. The families traveled to the location in cars and trucks and camped on the north side of the river, just outside the town of Little Fork. Pickers filled crates of blueberries and then, for ten cents per quart, sold the fruit to local merchants, who shipped them by train to city markets.

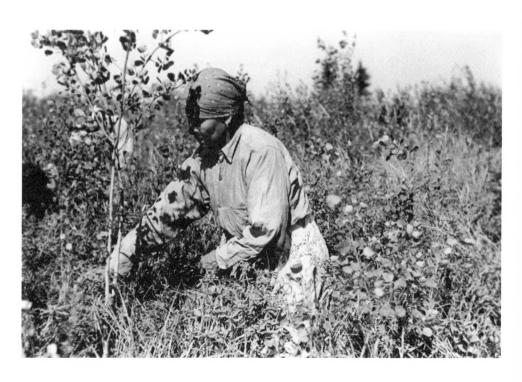

Russell Lee took photographs of blueberry pickers near Little Fork, including pictures of their tents and some of their other activities. Lee did not record the names of the berry pickers, but a few names are mentioned later in local newspaper articles about an accident that occurred near the campsite. On August 22, 1937, a car going south from International Falls collided with a truck that was unloading empty berry boxes for the pickers. One of the two people in the car was killed instantly. Roman Williams, an Ojibwe man from White Earth who was living at Red Lake, helped take the surviving victim to the hospital in International Falls. Unfortunately, she died on the way. The newspaper articles also mention George McKee, an Ojibwe man from White Earth who was living at Walker. Williams, McKee, and their families may be among those shown in Lee's photographs.

you," is a common saying among the Ojibwe. A certain song contains the words "Juneberries I would take to eat on my journey if I were a son-in-law." Mille Lacs band member Maude Kegg recalled that in the early 1900s her family went berry picking along the Mississippi River and sold the berries in Bernard. "That's the way they made their living, selling berries and buying lard, flour, sugar, whatever they needed," she said. "After we got through picking berries, we went home and the garden was almost ready then."

AGRICULTURAL WORK

From the earliest days of white settlement in the Minnesota region, Ojibwe people worked for white farmers and were paid in cash and produce. In 1882 a Taylors Falls newspaper stated: "If it was not for the Chippewa Indians, I do not know what we would do for help in haying and harvesting."

Katie (St. John) Henry of the Pine County Ojibwe community is shown picking beans on a Wisconsin commercial farm in this family photograph from her son John Dunkley and his wife Marian, of Pine County.

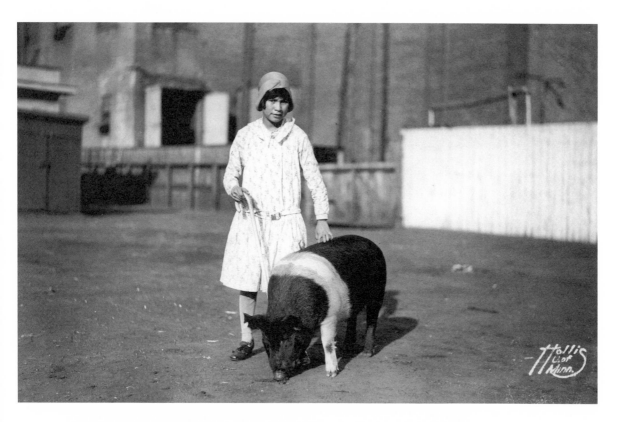

In the early 1930s, Batiste Gahbow (later Sam) of the Mille Lacs Band, a member of 4-H, raised a pig that received a blue ribbon at the Junior Livestock Show at the stockyards in South St. Paul. The top photograph shows Batiste and her pig at South St. Paul. In the bottom photograph, she and her father, Dick Gahbow, pose with the pig at their farm at Mille Lacs.

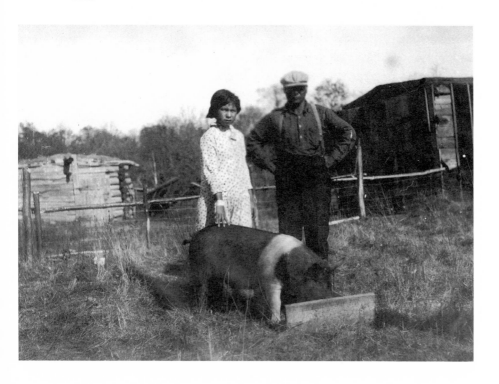

Dagwaagin Fall

In late August and early September, wild rice growing in the wetlands was ready to harvest. Wild ricing, like maple sugaring, was a great social event for Ojibwe families. Once they had harvested the wild rice and the crops from the gardens, the families took part in fall fishing and prepared equipment such as bark and woven mats for winter.

WILD RICE

In 1673, Father Jacques Marquette, on his way to the Mississippi River, gave an early, crude description of the wild-rice harvest of the Indian people of the western Great Lakes. "In the month of September," he wrote, " . . . they go in canoe across the fields of wild rice. They pull the stalks from one side and then the other as they advance. The grain falls easily if it is ripe. In a short time they have a good supply of it."

In one of his journals, the fur trader George Nelson described the wild-rice harvest as he saw it among the Ojibwe of the St. Croix River area in 1802: "The process is: two persons embark in a Canoe with each two small sticks made for the purpose. As they set face to face, the one who steers in ordinary cases steers also in this. He gathers, with his sticks all that can be safely brought into the Canoe—the person setting in the Bow, with his sticks, beats off all the grain—they then proceed a little further, & so on 'till they find they [have] enough, when they go to the shore where they unload & return for more."

A good wild-rice harvest could provide an Ojibwe family with a valuable food supply for the coming winter. During the fur-trade era, this meant the men could forego hunting for larger animals, like moose and deer, in favor of the smaller animals, such as beaver, muskrat, and otter, so desired by fur traders. A surplus of wild rice could also be sold to the fur traders, who brought little with them. After the fur-trade era, the Ojibwe continued to sell their surplus wild rice to whites.

Each year families went back to the same wild-rice fields. Their intention to return was announced to the community when women went to these fields in the middle of the summer and tied some of the rice into sheaves. It was also said that some people tied all the rice they planned to harvest, to keep it less vulnerable to wind and to create wider passageways for the canoes between the stalks of rice.

Once the rice was brought to shore, it was spread on a birch-bark sheet to dry or parched in a kettle over a fire. Then it was threshed to remove the hull. The rice was poured into a lined hole in the ground, and someone walked on the grain while steadying him- or herself between two poles that were placed parallel to the ground, like railings. Or a

number of people would stand around the pit and pound the rice with pestlelike sticks.

Rice was winnowed using flat birch-bark trays and the wind. Anthropologist Albert Jenks described the process:

The women at Lac Court Oreille [Wisconsin] reservation, as I saw the process in the autumn of 1899, put a peck of the threshed grain in a birch-bark tray, which is about 3 feet long, 2 feet wide, and 7 or 8 inches deep. They then grasp both ends of the tray, and by a very simple yet clever movement gradually empty the chaff. The tray is lifted several inches and carried slightly outward. This upward and outward movement is checked quite suddenly and the tray, while being drawn toward the body of the laborer, is let down again. The light chaff is thus spilled over the outer edge when the tray is at its highest point and just as it is suddenly jerked toward the laborer. However, because of the rapidity with which this shaking is done, the movements appear neither sudden nor jerky, and the chaff falls almost constantly.

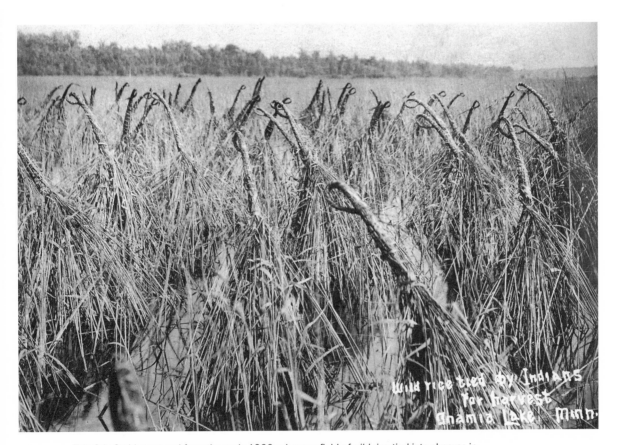

This Otis Smith postcard from the early 1900s shows a field of wild rice tied into sheaves in preparation for the harvest.

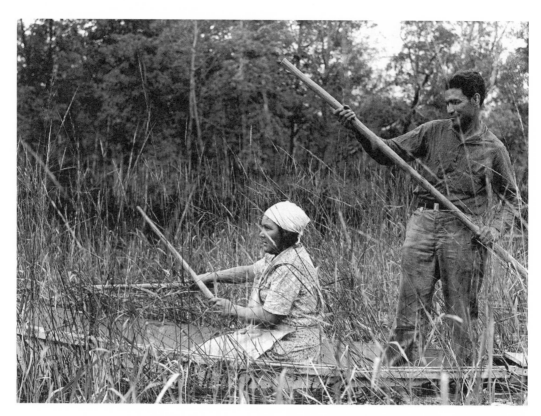

Grace Rogers and Joe Aitken harvest wild rice near Walker in 1939 in a photograph taken by Monroe Killy.

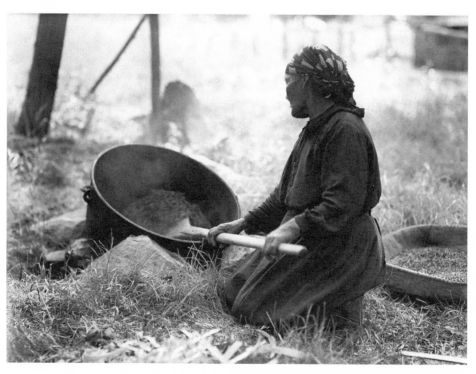

Mary (Mrs. Peter) Fields at Nett Lake parches rice in a photograph taken by Monroe Killy in 1946.

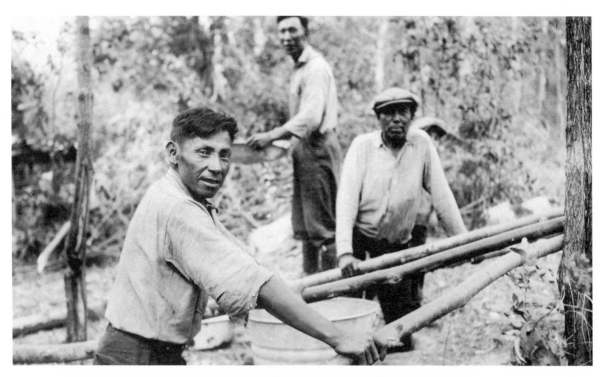

The wild-rice harvest was a group activity, as this photograph, taken at the Northwest Angle around 1930, shows. The man at left holds poles to steady himself while walking on rice that has been poured into a lined hole in the ground; walking on the kernels removes their hulls.

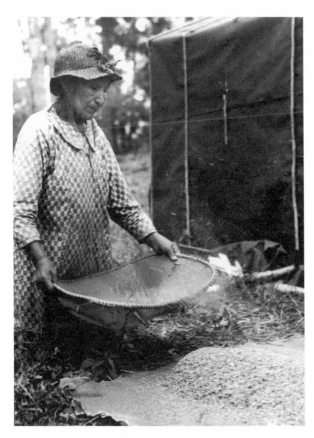

Catherine Gwinn winnows some rice during the harvest of 1937 at Upper Rice Lake, near Zerkel, east of Red Lake in Clearwater County. This image was part of a series taken by an unnamed photographer and published in the *Minneapolis Tribune*.

FALL FISHING

In the fall, the Ojibwe used gill nets to fish for tullibees and whitefish. Maude Kegg remembered going fishing with her grandmother on a lake near Mille Lacs in the early 1900s. She and her grandmother took the net out in a rowboat, then returned to shore.

"It wasn't very cold so we lay down there on the shore where she could watch the net," she said. In the morning, they pulled in the nets with their catch.

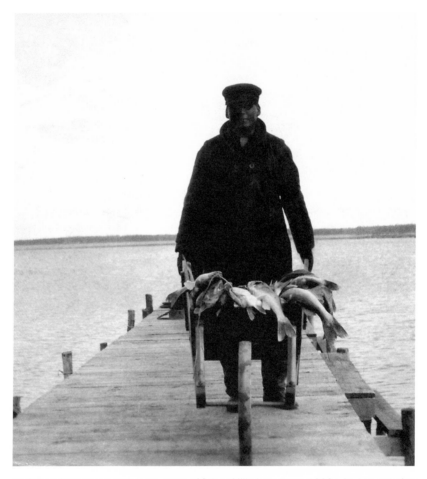

An Ojibwe fisherman brings in his catch of fish at Mille Lacs in the 1920s. During and after World War I the State of Minnesota encouraged band members and whites to fish commercially as a way of getting more people to eat fish.

Biboon Winter

Nodinens told Frances Densmore that when the lakes froze and the snows came, Ojibwe families would go to their wintering grounds in the woods. There they put up their bark houses and made them comfortable for the winter. At this time of year the work of sustaining the family was evenly divided between men and women. The men would go hunting for deer, moose, and other large animals, traveling on snowshoes. The women would stay in the camps, repairing the men's clothing, cooking meals, and butchering and drying the meat from the hunts. They would also trap small animals such as rabbits or small birds for food and furs.

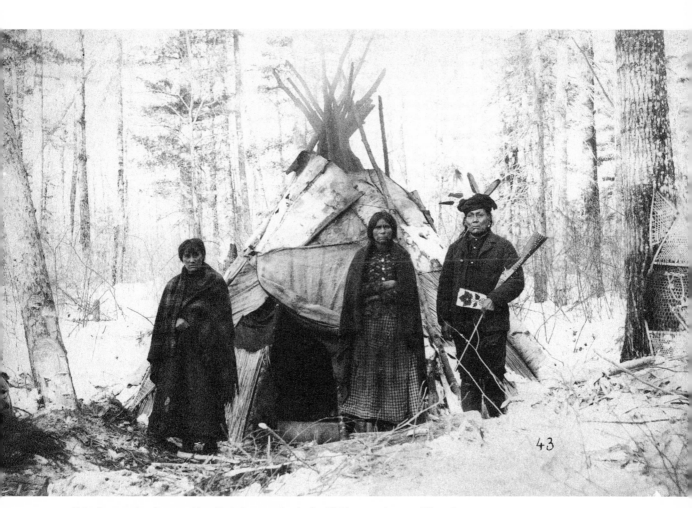

This picture, taken by an unidentified photographer in the 1880s, may show an Ojibwe family's winter camping place, located in the woods where game would be readily available. Nothing is known of the people pictured.

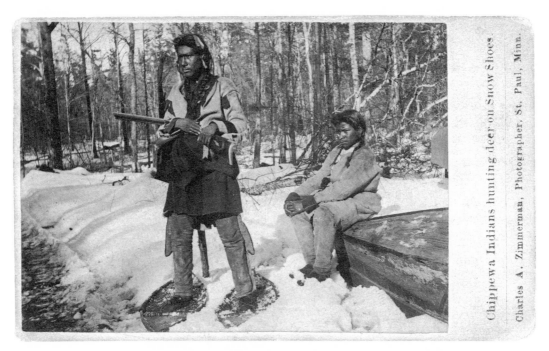

Perhaps the earliest Ojibwe hunting photographs included this posed picture taken in the 1860s or 1870s by St. Paul photographer Charles Zimmerman. Zimmerman marketed this picture of "Chippewa Indians hunting deer on Snow Shoes" as a carte de visite and as a stereo view. For a long time it was the only photographic record of an important Ojibwe seasonal activity.

Mary Razer

In 1917, anthropologist Frances Densmore returned to the White Earth Reservation for her longest stay in many years. Her work this time was "conducting a study of the material culture of the Chippewa Indians." She stayed through the end of September, visiting various parts of the reservation and talking to assorted people who were willing to share their knowledge of Ojibwe culture. She found her sources through contacts she had made in her earlier work on music. George Big Bear, a singer who contributed several songs to Densmore's book *Chippewa Music* and the son of Joseph and Kate Big Bear introduced Densmore to his mother-in-law, Mary Razer, also known as Papagine, or Grasshopper. Razer became one of Densmore's most valuable resources for information on Ojibwe culture.

Razer's greatest contribution to Densmore's work may have been in her ability to demonstrate some of the activities that other people simply remembered or talked about. For example, on August 20, Densmore noted in her diary that she "went to White Earth Lake. Saw Mrs. Razer take up fish nets." The photographs that Densmore took that day show that Densmore and Mary Warren English, her interpreter, went out with

This Densmore image shows Mary Razer inspecting and mending her fishing nets.

Razer in her boat as she brought in her gill nets filled with fish. Densmore then photographed Razer as she dried the fish over a fire and dried her nets and inspected them. Like most of the photographs taken by Densmore around that time, these were produced in a 3¼-by-5½-inch postcard format, using roll film, probably with a folding or box camera.

Densmore used most of these photographs in her 1929 book, *Chippewa Customs,* as part of a general description of Ojibwe fishing and other technology. She did not identify Razer as the subject of these photographs, although she quoted Razer elsewhere in the text. Throughout, she integrated Razer's words into a general description of the pattern and beliefs of Ojibwe technology.

Densmore also photographed Razer peeling and then drying water-soaked basswood bark—two steps in the process of making twine. This twine was used to tie wild rice into sheaves so the grains would be protected from wind and waves. Densmore photographed the rice tying process. In taking these and subsequent pictures of ricing, she produced a series of photographs to record the various steps in each process—a new technique for documenting the customs and technology of the Ojibwe people. Before this time, many verbal accounts of Ojibwe life had described different activities—such as canoemaking—in detail. But the earliest art and photography of the Ojibwe generally showed single scenes to summarize an entire activity.

On September 2, 1917, Densmore wrote in her diary, "Went to Tamarack Lake to see ricing." It is possible she was referring to Tamarack

Lake between Detroit Lakes and Ponsford in Becker County, although there are several other lakes named Tamarack in the area. The location appears to have been the ricing grounds of Mary Razer and her family. On this occasion Densmore photographed Razer spreading rice on a mat to dry. Another photograph taken around the same time shows George Big Bear and his family threshing rice.

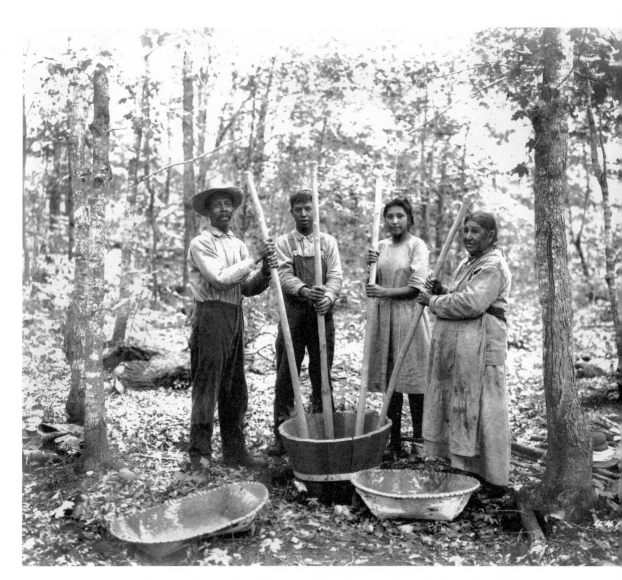

Five years after working with Densmore, Mary Razer demonstrated wild-rice harvesting techniques for Seattle-based photographer Asahel Curtis. This photograph, one of thirteen ricing images Curtis took at Tamarack Lake in 1922 using an 8-by-10-inch view camera, shows Mary Razer at right with her son-in-law George, her grandson Benedict, and an unknown young woman. Curtis, brother of the famed photographer Edward Curtis, had been hired by the Northern Pacific Railway Company to take publicity photographs showing locations along the company's rail line in Minnesota.

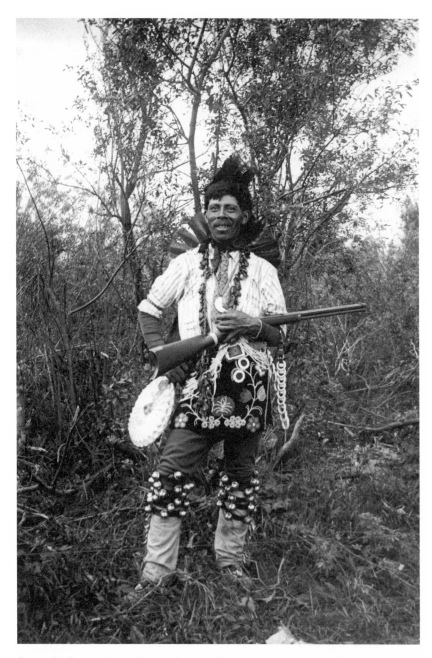

George Big Bear, a singer who contributed to Frances Densmore's book *Chippewa Music*, in a photograph probably taken around 1910, at the time of one of White Earth's June 14 celebrations. The photograph may have been taken by White Earth resident Robert G. Beaulieu.

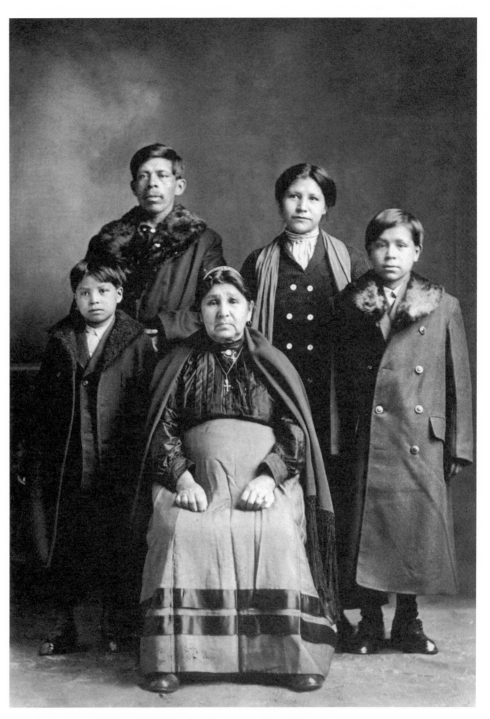

Mary Razer (center) is surrounded by George and Margaret Big Bear with their two sons, Benedict (left) and Herman (right). This studio photograph, taken between 1915 and 1920, belongs to the John and Marian Dunkley family.

Mary Warren English, photographed by Robert G. Beaulieu between 1910 and 1920. English acted as Densmore's interpreter during her 1917 stay at White Earth. Her brother, William Warren, was an Ojibwe historian. As children and grandchildren of fur traders and Ojibwe people, they were used to playing an intermediary role between the Ojibwe and white outsiders. English had worked as a schoolteacher among the Ojibwe for many years.

Later in September, Densmore had a "hard trip to Ponsford," where she saw rice being gathered, though she did not specify who she stayed with or what lakes she visited. She took a number of photographs at this time, many of which she used in her book on plant use. The images showed general views of the rice fields, ricers poling their boats and harvesting their rice, and people processing on shore.

Densmore returned home to Red Wing on October 27, and in November she went to Washington, DC, where De Lancey Gill photographed many of the objects that she had collected during the summer. She returned to Minnesota in May 1918, and in July she was back at White Earth working on "industries etc."

On July 29 Densmore wrote in her diary, "Cut birch tree." Even though birch bark was usually cut in June, Densmore took a series of photographs showing Mary Razer cutting the bark, removing it from the tree, and making containers from it. Her 1928 report *Uses of Plants by the Chippewa Indians* indicates that she asked Mary and her husband, Frank, to cut down a tree so she could see the entire birch-harvesting process. She described what happened next: "Mrs. Razer habitually follows the old custom of placing tobacco in the ground when gathering any of the products of nature, so the old ceremony was performed in all sincerity ... Mrs. Razer offered tobacco to the cardinal points and the zenith, murmuring petitions, and buried it at the foot of the tree ... She then wielded the ax and cut the tree, the cut being 28 inches above the ground, after which her husband complete[d] the felling."

This occasion was one of the last recorded contacts between Mary Razer and Frances Densmore. Ten years later, in Densmore's books on Ojibwe customs and use of plants, Razer's contribution was evident, but Densmore said only a few things that gave a sense of who she was. For example, when describing how the Ojibwe beadwork patterns appeared to reflect the beadworkers' personalities, Densmore said that Razer was "serious, steady, and always industrious. Her original patterns are more constrained, a larger proportion are strictly conventional, and there is evidence of painstaking care throughout her work."

Densmore's photographs suggest that Mary Razer, George Big Bear, and their family not only were experts in the techniques and processes they demonstrated but also knew how to clearly demonstrate them for outsiders. They seemed to know the power of the camera and how to approach it. Densmore's photographs are evidence not just of her research and photography skills but also of her collaboration with these skilled cultural interpreters.

Nodinens on the Seasonal Round

Another important resource for Densmore was Nodinens, a woman who had grown up at Mille Lacs in the 1840s and 1850s and had moved to White Earth many years later. It is possible that Densmore first met Nodinens through the Big Bear family. Her diary mentions that she saw the Ojibwe woman on June 18 and 19, 1917, and again the following summer. During this time, with Mary Warren English's help, Nodinens gave Densmore a detailed description of the "industrial year," or seasonal round, of the Ojibwe. That description appeared "practically in the words of the interpreter" in Densmore's *Chippewa Customs,* along with a portrait of Nodinens. The book also included a photograph of Nodinens weaving a belt.

Nodinens's account of the seasonal round has become a classic, cited by many to typify a traditional Ojibwe way of life.

When I was young everything was very systematic. We worked day and night and made the best use of the material we had ... My home was at Mille Lac[s] and when the ice froze on the lake we started for the game field. I carried half the bulrush mats and my mother carried the other half. We rolled the blankets inside the mats; and if there was a little baby, my mother put it inside the roll, cradle board and all. It was a warm place and safe for the baby ...

My father was a good hunter and sometimes killed two deer in a day. Some hunters took a sled to bring back the game, but more frequently they brought back only part of the animal and the women went next day and packed the rest of the meat on their backs. It was the custom for a man to give a feast with the first deer or other game he killed. The deer was cut up, boiled, and seasoned nicely, and all the other families were invited to the feast ... Toward the last of winter my father would say, "one month after another month has gone by, Spring is near and we must get back to our other work" ...

When we got to the sugar bush we took the birch-bark dishes out of the storage and the women began tapping the trees. Our sugar camp was always near Mille Lac[s], and the men cut holes in the ice, put something over their heads, and fished through the ice ...

We went to get wild potatoes in the spring and a little later blueberries, gooseberries, and June berries ... We dried berries and put them in bags for winter use. During the summer we frequently slept in the open.

Next came the rice season ... Then we returned to our summer camp and harvested our potatoes, corn, pumpkins, and squash, putting them in caches ... When the men returned from the fall trapping we started for the winter camp.

Nodinens weaves a belt in this photograph by Frances Densmore, most likely taken during their second meeting in 1918.

Roland Reed

During his lifetime, photographer Roland Reed was called both an artist and a documentarian. In 1907 and 1908, motivated by a sense of how native people should be photographed and what was important about them, Reed produced a series of images of Ojibwe life that had little to do with the real life of the local native population. Working in the traditions of nineteenth-century genre painting, he created a series of striking scenes that he marketed under a variety of titles. In such pieces as "The Wooing," "The Trapper's Daughter," "The Parting," and "The End of the Chase," he portrayed Ojibwe life as it was no longer and, in some cases, as it probably never was.

Reed's work exemplifies many of the problems that photographs of Indian subjects present. Which is more authentic: a photograph that presents Indian people as photographers find them or one that attempts to strip away all white influence from the subjects, portraying them as the photographer believed they were before they were touched by white cultures?

Reed did not pretend his pictures documented the actual lives of the Indian people as he met them at the time. Late in his career, he summarized the philosophy behind his photographs:

> *For nearly fifty years, it has been the author's purpose to portray the North American Indian in a manner that would as nearly as possible, present a permanent and authentic historical record of this fast disappearing people . . . In these portrayals of the Indian . . . the author has endeavored to reproduce the Indian not as he now is, but, as he appeared in the days before he was forced to surrender his good land, before his game was destroyed and he was confined to barren reservations, before he was forced to wear the unpicturesque garb of the white man, before his stalwart physique had been undermined by the white man's diseases and fire-water, and before his spirit was broken.*

Reed was born in Wisconsin in 1864 and very early in his life became interested in American Indians. But it was not until the 1890s, after a number of years of traveling around the United States and Canada, that he became a photographer. He worked in towns along the Great Northern line from Minot to Kalispell, teaching the art of crayon-pastel and sketching from nature. While traveling in the Rocky Mountains, in the area that is now part of Glacier National Park, he became acquainted with the Piegan Blackfoot Indians. These experiences led Reed to become a photographer: "In my wandering I had seen some results from the camera, and first old Kodaks. This method of portrayal of whatever sort interested me very much and I was told by my friends to

get into it. So I began to look around for a chance. I knew if I could master this seemingly easy way of making pictures I would have no trouble in getting all the Indian pictures I wanted."

In 1893, Reed got a job with Daniel Dutro, a photographer in Havre, Montana. With Dutro, Reed took pictures of the native people along the Missouri River, then supplied photographs to the news department of the Great Northern Railway. He also did some studio photography— "some portrait work for our bread and butter." In 1900, after a brief stint in the Alaska gold fields and more studio work in Montana, he went to Ortonville, Minnesota, to set up a studio. Within a few years he decided to move his studio to Bemidji, "the center of a real Indian country."

After doing studio work for several years to save money, Reed set out to photograph the Ojibwe people around Red Lake. On his first visit, he was asked to leave the reservation. Eventually, however, he gained the people's confidence after, according to his account, he photographed the dying son of a leader in the community.

In 1907, Reed closed down his studio in Bemidji to devote himself to photographing the Ojibwe. In the next two years, he took some of his best-known pictures. He had the help of John G. Morrison, a prominent member of the the Ponemah community: "He was my interpreter when I made the Fisherman, the Moose Call, the Hunters, Ringing Bells, Reflections, at the Spring, and others. He showed me where mistakes could be made in assembling wearing apparel and accoutrements pertaining to each activity. It was through his advice and knowledge that I was able to secure a set of negatives of such historical value."

Reed believed so firmly in the historical value of his work that he sent many of his prints to be copyrighted at the Library of Congress in Washington, DC. In the next two decades, he also photographed the Blackfoot, Hopi, Navaho, Blood, Cheyenne, and Flathead peoples, using many of the same techniques as he had among the Ojibwe, and copyrighted those photographs as well.

Reed sold many of his Blackfoot images to the Great Northern Railway. Around 1916, he published an illustrated catalog in which he offered his sepia-toned prints for sale at prices ranging from $1.75 to $5.00, depending on the size. A one-page introduction to the catalog by Eugene S. Bruce of the U.S. Forest Service described what may well have been Reed's own belief about his pictures: "A few years hence these pictures will be of inestimable value, for they portray individuals, scenes, incidents and characteristics that are seldom and more seldom seen each day and tomorrow will be history; a history that will be little better than tradition without the pictures that a few foresighted . . . are now preserving."

Despite his belief in the historical value of his photographs, Reed did not want anyone to think he simply happened along the scenes he

recorded. He worked hard to get his pictures and wanted people to know about it. For one thing, as his early experiences with the Ojibwe showed, it took a great deal of diplomacy to get his pictures:

> *In approaching the Indian for the purpose of taking his picture, one must respect his stoicism and reticence. On going into a tribe with photographic paraphernalia, although I hire ponies, wagons, guides, an interpreter and other essentials, I never once suggest the object of my visit. When the Indians out of curiosity, at last inquire about my work, I reply casually: "Oh, when I'm home I'm a picture-making man."*
>
> *Perhaps, within a few days an Indian will ask: "You say you are a picture-making man, could you make our pictures?" I reply noncommittally: "I don't know, perhaps." "Would you try?" beseeches the Indian. "Sometime when I feel like making pictures," I say.*
>
> *More time elapses. Presumably the picture-making man has forgotten about making pictures until an Indian friend reminds him of his promise. And then the time for picture-making has come. They are imbued with the very spirit of the subject I am trying to depict and they pose in all earnestness.*

How Roland Reed Began to Photograph the Ojibwe

I was told by old King Bird, the head of a large village at the east end of the lake [Red Lake] to get out at once and not come back. At that he left giving me no chance to talk it over . . . But instead of going out I went in deeper and before dark pulled up in front of the Cross Lake Indian School at Ponemah. There I found a small old shack which I moved into. The Indians were very curious to know what I was there for. They would have nothing to do with me and were as much opposed to my coming as old King Bird. But I stayed on thinking some thing would happen to soften their distaste for me, and it did at last. One morning two small girls came in and asked if I would take a picture of their little brother who was very sick and going to die. I went over to their camp and took a picture of the little fellow. The next day I left for Bemidji. I was away for several months and then an opportunity came and gave me another trip to Ponemah. I took along the pictures of the sick boy. As soon as the father found out I was back he came over to see if I brought the picture. I showed it to him, he took it and walked away with his back to me, and there he stood for some time. He called an Indian boy over and they talked for a while, then they both came over to me, and the boy asked me how much the picture would cost the father. Instead of answering I asked how the boy was. He said the boy died, then I said I was so glad that I was here in time to make the picture before it was too late. You tell him it is a present from me and the only reason I am here is because I like the Indians and would like to be friends. That fine old father gave me his hand, and from that time on I was welcome to any part of Cross Lake Point.

In describing one of his Minnesota photos, "The Moose Call," Reed told how he induced the subject to pose with the expression he wanted: "I fooled the Ojibway subject by telling him I wanted to photograph a moose, and that I'd give him $10 if he'd bring one onto the lake. He was so intent on earning that $10 that he immediately gave me just the pose I wanted simply because he didn't know it was a pose at all."

In fact, however, the photograph probably involved much more preparation than Reed said, since the man is recorded in clothing that few Ojibwe would have worn on a daily basis around 1907.

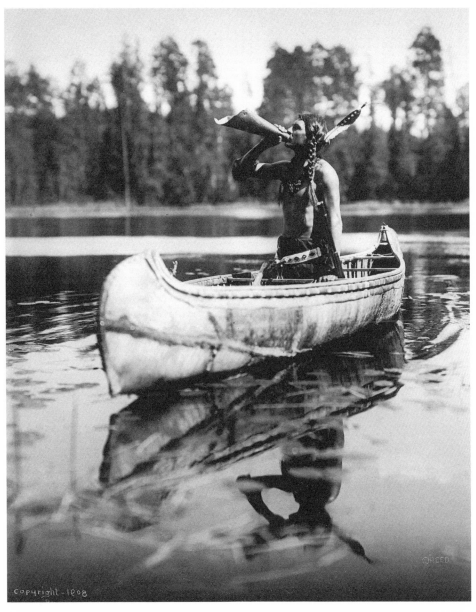

Reed said he paid an Ojibwe man ten dollars to pose for his well-known photo "The Moose Call."

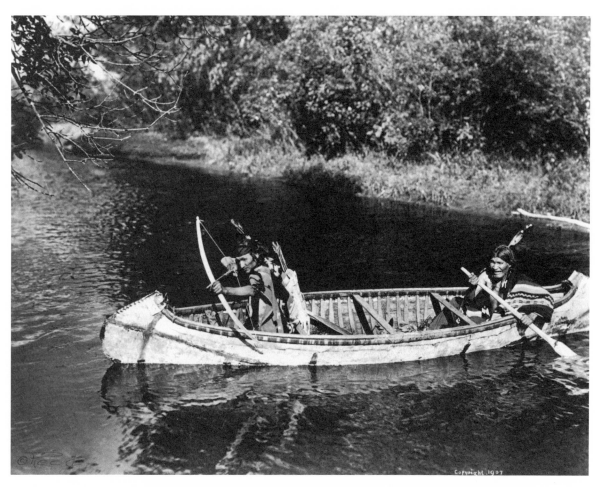

"Ne-tah-gainu (The Death)" or "The Hunters," a view that Reed choreographed as carefully as a shot in a movie. As motivation, he placed silver dollars in the branches of a tree on the nearby shore and told the men that every one they hit with an arrow they could keep.

One of Reed's most famous scenes of Ojibwe life, known variously as "Ne-tah-gainu (The Death)" or "The Hunters," shows two hunters in a birch-bark canoe—one steering the canoe, the other about to shoot an arrow at some target outside the picture's frame. At least two versions of this photograph survive. In a 1916 interview with Reed, the writer Caryl B. Storrs described how Reed contradicted Storrs's impression of the picture: "It is so natural, so splendidly graceful and alert, so intense with feeling, so marvelous in facial expression, that one thinks how lucky Mr. Reed was to have happened along with his camera just as the old Indian was shooting at some newly sighted game. 'It took me just eight days to get that picture,' says Mr. Reed. You look from the picture to the man who made it, back at the picture and then back at the man again. Each look is a question, and he answers them all with a smile."

In another account, Reed told how he hired two Ojibwe from the area around Red Lake to dress up in what he described as "full hunting regalia"—clothing they would not likely have worn at the time—and paddle up and down a good-sized creek that flowed into Red Lake. He said, "I had the bow Indian stolidly discharging an arrow at a certain buoy each time the birchbark passed it. 'More life to it, Yellow Face,' I cried, 'you wouldn't shoot a deer in that fashion!' 'I am not shooting a deer, Big Plume,' he replied, 'I am shooting a tree.' 'Imagine a deer,' I rejoined, 'think you see a deer swimming, trying to get away.' 'How can I see a deer when there is no deer, Big Plume,' he quietly came back at me."

Reed paid the two men a regular wage for the first three days they put into making the picture. But then, to help motivate his subjects, he placed a number of silver dollars in the crevice of the tree on the nearby shore.

"Make one more round, Yellow Face, while the light lasts," I shouted, "and listen. Shoot at these silver dollars as you pass the buoy. Every one you knock down is yours." On the next round the archer's eyes blazed with a savage light, his body quivered with all the thrill of the hunt as he centered five silver dollars with seven whizzing shafts. When it was over and the air still hummed with the twang of his bowstring, I was out five dollars, but I had one of the few very animated Indian photographs in existence.

In his 1916 interview with Storrs, Reed described the stratagem of putting the money in the trees, but added: "I wanted to get him interested in what he was shooting at, and not in my camera ... but it was more than a week before I got what I was after. Look at the expressions on their faces; you see they finally forgot me. Once I waxed a little impatient; the result was that they both got mad and left, and I had to chase them 15 miles around the shore of Red Lake and plead with them to come back."

Paradoxically, to people viewing Reed's pictures at the time they were taken, their carefully posed nature came across as "natural." For example, in a caption for "The Moose Call," in 1916, *The Minnesotan* magazine noted that "in every one of Mr. Reed's pictures the Indians are naturally performing some act of their aboriginal lives, never 'getting their picture took.'" The accompanying article by W. B. Laughead (the man who invented and popularized much of the Paul Bunyan legend) asserted that Reed's pictures actually broke some of the stereotypes of Indians, presenting them as they actually were—or at least as they ought to be.

Study Reed's pictures. He lets the Indian speak to you for himself. His ideal is to remove the veil of time and false tradition and show you the real Indian. His pictures are not tableaux posed to fit an artist's concept. See how natural they are. Like all art of the first magnitude, they are extremely simple. But before the picture was taken the artist had to have an accurate knowledge of what was the correct costume and equipment for the occasion and be satisfied with nothing else. He must overrule the Indian's desire to "dress up" and "pose." He must have the correct type, the appropriate background, and wait for the right light and atmospheric condition. He must win the co-operation of the Indian and eliminate his self-consciousness. Think what these simple red men have done. Did you ever try to "act natural" before a camera—after days and weeks of rehearsal?

The suggestion was that all the careful preparation and posing that Reed put into his pictures actually resulted in a more natural, unposed photo than any done by photographers who shot their pictures more spontaneously. In other words, the illusion was everything: "Reed's Indians are thinking Indian thoughts and feeling Indian feelings. Without moping or striking attitudes, they pluck at the heartstrings, for Reed has given us a glimpse of the Soul of this tragic race, with whom we have lived for three centuries and never known."

Although viewers of Reed's day thought these pictures looked more natural than studio portraits of native people, today we might say the opposite. Reed's pictures, for pretending to be natural, look all the more posed, all the more stylized and stilted. The studio portrait, on the other hand, has no pretensions to "naturalness"; there is no sham in it because its conventions are more recognizable.

Reed had little interest in recording the lives of contemporary Ojibwe. The people in his photographs were hired cultural actors, part of the raw material that he used to create his illusions. In the process, he made images that were technically beautiful, that captured scenes never before pictured on film, but that had little to do with the Ojibwe of his time.

Opposite: This Reed photograph, taken around 1908 and entitled "The Fisherman," shows one technique the Ojibwe used to catch fish. The fishermen used a torch to attract fish to their boat or canoe and then speared them. But this activity would usually have taken place at night, not in the daytime as pictured here.

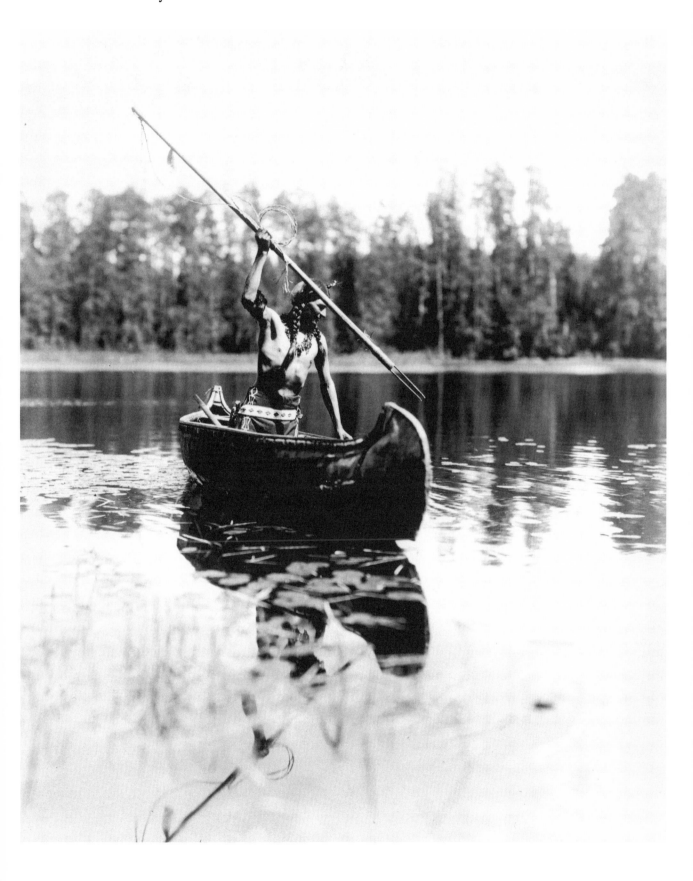

Like an artist working on a painting, Roland Reed retouched his carefully posed view of an Ojibwe man spearfishing.

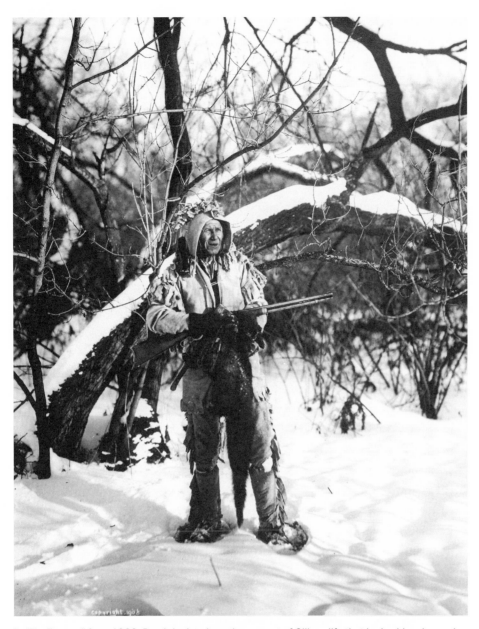

In "The Trapper," from 1908, Reed depicted another aspect of Ojibwe life that had seldom been photographed.

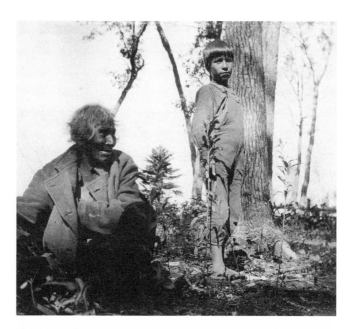

Mozonce and a young boy photographed at Mille Lacs by Darwin Hall around 1900. Hall's caption for the photograph does not include the name of the boy, explain his relationship to Mozonce, or hint at why they are together in the picture.

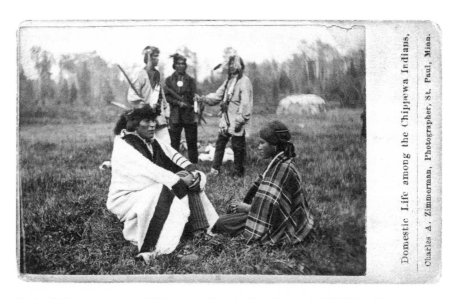

Charles A. Zimmerman posed "Chippewa Indians in Camp" around 1870. This odd early photograph seems to suggest relationships between individuals, but the relationship between the man and woman in the foreground, and the identity of the three men behind them, is unclear.

5

Bimaadiziwin / The Circle of Life

The word *bimaadiziwin* refers to the cycle of life, from birth to death, as well as to the proper way to live life as a considerate, respectful human being, a part of a family and a community. It defines how relationships between Ojibwe people should be conducted.

Photography excels at recording material objects and external characteristics but does not do well with concepts like bimaadiziwin. This chapter shows the various ways in which different photographers portrayed the Ojibwe circle of life, the record they left of Ojibwe lives and Ojibwe meanings. This includes photographs taken at ritual celebrations that enhanced the important relationships among Ojibwe people. Shown here are contrasts between the ways white photographers portrayed Ojibwe individuals and the ways the people portrayed themselves in their own photographs.

From the earliest photographs of Ojibwe people taken by whites, it is hard to find adequate and balanced representations of people's lives. In the early 1900s, white photographers took studio portraits of Ojibwe individuals who were well known in white communities—men such as Shay-now-ish-kung of Bemidji and Kah-be-na-gwi-wens of Cass Lake. Like the studio photographers from the mid- to late 1800s, these photographers took their subjects out of their communities, often posing them against painted backdrops and wearing clothing that was not their own. In these settings, Ojibwe people—almost always men—were stock characters playing the role of stereotypical Indians. Studio portraits of people standing against a painted backdrop give few clues to these people's relationships, lifestyles, spiritual beliefs, or values. Life histories can be constructed from such pictures, but they are usually stories about how the subjects dealt with the stereotypical roles that whites were giving them through photography.

Later, white people such as Edward Bromley and Monroe Killy (see chapter 3) and Stella Prince Stocker actually visited Ojibwe communities and took photographs that showed typical Ojibwe settings and activities. To record the human aspects of Ojibwe life, they and many other photographers attended dances and powwows. These important social occasions, where the Ojibwe and visitors gathered in an indoor or outdoor circle to listen to music and to dance, gave strangers and friends the opportunity to create and renew bonds. But white photographers' images of these events show only their surface manifestations, not their essence or meaning, and the way white photographers

recorded these events often emphasized their own stereotypical views of the Ojibwe people. Their pictures could not show the rich role that such events played in Ojibwe life and the personal relationships and bonds being built and renewed on these great social occasions.

Photographer Ross Daniels ventured out into the Ojibwe communities in Pine County to take postcard photographs to market to whites. But Ojibwe families also hired him to take portraits of them in his Pine City studio. Thus, his photographs reflect not only a white photographer's view of the Ojibwe community but also the Ojibwe people's views of themselves.

When Ojibwe people began deciding what should be recorded in photographs—in both studio portraits and snapshots they took themselves—they recorded very different views of their lives. For example, while a white photographer might include women and children in a picture to demonstrate the ingenuity of cradleboards or to give a sense of scale to a canoe or a bark house, an Ojibwe photographer would focus on the women and children and the relationship between them. Ojibwe family pictures, like those of the John and Marian Dunkley family, capture relationships between parents and children, between other relatives, and between generations. Overall, these pictures give a richer and more accurate sense of Ojibwe lives, and perhaps a better sense of Ojibwe meanings, than the earlier stiffly posed studio portraits of Ojibwe ogimaag.

Shay-now-ish-kung, Known as Chief Bemidji

"Chief Bemidji," who lived on the shore of Lake Bemidji in northwestern Minnesota, was one of a number of Ojibwe people around 1900 who were celebrated in widely distributed photographs. He was not really a chief in the sense that the word was often used, and his Ojibwe name was not Bemidji (which means "the lake where the river flows directly across the water," a reference to the fact that the Mississippi River flows through the lake on its way from Lake Itasca through Minnesota). His real name was Shay-now-ish-kung; born in Cass Lake around 1833, he was a member of the Ojibwe band at nearby Leech Lake. Later, at the time the region began to fill with whites, he moved to the south shore of Lake Bemidji. He came to be seen as a kind of founding Ojibwe father for the new town of Bemidji, a revered symbol of the place's past, a white people's ogimaa. He was considered to be "a friend to the whites" and an intermediary between his people and the settlers when difficulties arose. After his death in 1904, the city of Bemidji held a large public funeral.

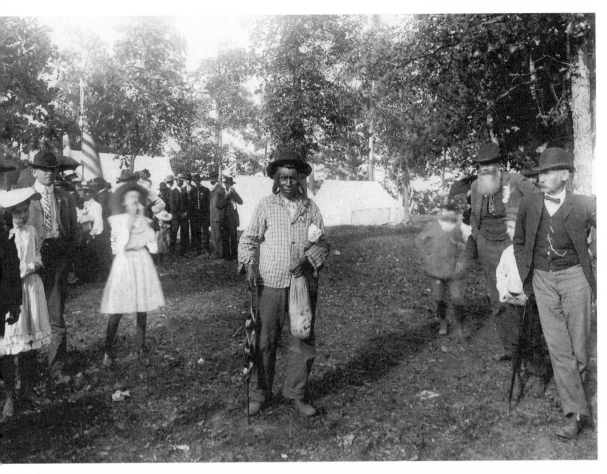

This image by an unknown photographer depicts Shay-now-ish-kung as a still, intense presence in the midst of the confusion of a public place, perhaps a park in Bemidji, possibly on the Fourth of July. An early Bemidji resident remembered that Shay-now-ish-kung and other Ojibwe came into town to shop and enjoy holiday celebrations.

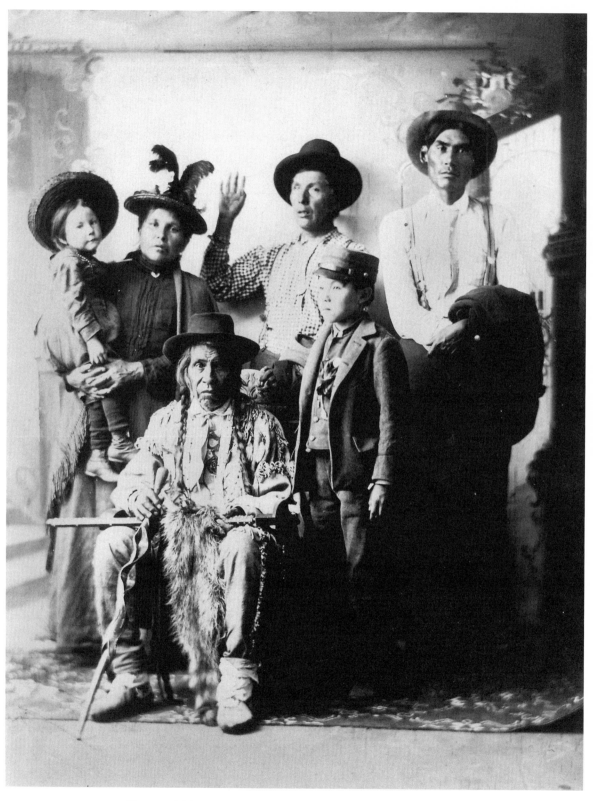

Shay-now-ish-kung and a group said to be his family were photographed in the studio of
Niels Larson Hakkerup, who worked in the region of Bemidji and Cass Lake around 1900.

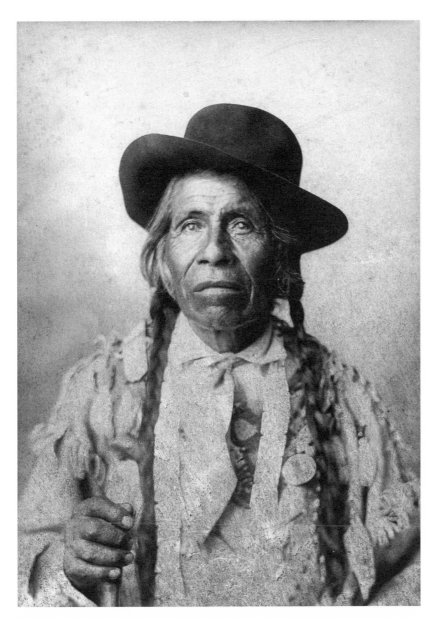

Shay-now-ish-kung 's hat and clothing and the similar backdrop suggest that Hakkerup may have taken this individual studio portrait of Shay-now-ish-kung on the same day he photographed the man with a group of five others.

Kah-be-na-gwi-wens, Known as Chief John Smith

For many years, a man known to whites as Chief John Smith or "Old Wrinkled Meat" was one of the most widely photographed Ojibwe people in Minnesota. His Ojibwe name was Kah-be-na-gwi-wens (also spelled Kah-be-na-qua-yence or many other variations). He was said to have been born in 1802 or even earlier and was believed to be one of the oldest living Americans. His wrinkled face contributed to his popularity as a photograph subject.

Kah-be-na-gwi-wens lived near the town of Cass Lake, where he was considered a local character. One Cass Lake businessman constructed a wigwam inside his store for Kah-be-na-gwi-wens to live in when he came to town. It was said that Kah-be-na-gwi-wens played poker and the Ojibwe form of gambling known as the moccasin game with his friends.

In the early twentieth century, newspaper articles published in the Twin Cities, Duluth, and smaller towns played up Kah-be-na-gwi-wens's physical characteristics, his activities, and his amusing sayings. Several articles suggest that he was reluctant to be photographed. A May 4, 1913, *Minneapolis Journal* article, for example, reported that "most Indians refuse to be 'snapped' in their native haunts, believing an evil spirit exists in the camera. Captain John is no exception, especially if the photographer be a stranger."

In fact, Kah-be-na-gwi-wens appears to have embraced having his picture taken as a way of making a living. Photographers took pictures of Kah-be-na-gwi-wens wearing a variety of clothing, including eagle feathers, Plains Indian headdresses, Navajo blankets, and top hats and evening dress. The more incongruous the clothing, the better. He was probably photographed dozens of times during the ten or fifteen years before his death in 1922. Tourists coming to Cass Lake often encountered Kah-be-na-gwi-wens selling copies of the postcards of himself, and when people wanted to take his picture, he charged a fee.

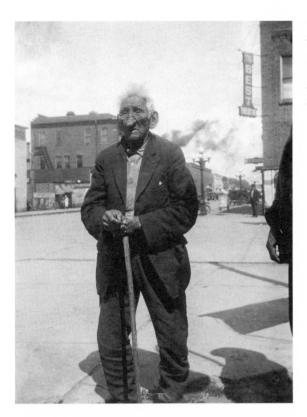

Kah-be-na-gwi-wens, also known as Chief John Smith, was one of the most frequently photographed Ojibwe people in Minnesota. This rare photograph shows him in what may have been his everyday clothing, rather than the novelty clothing photographers often had him wear.

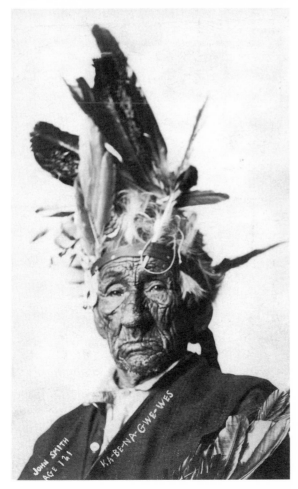

Photographers took pictures of Kah-be-na-gwi-wens wearing not only Ojibwe clothing but also Plains Indian and Navajo items. In this postcard from around 1910, he appears to wear several different headdresses, including possibly an Ojibwe one with eagle feathers.

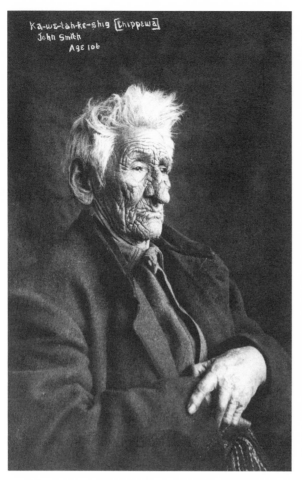

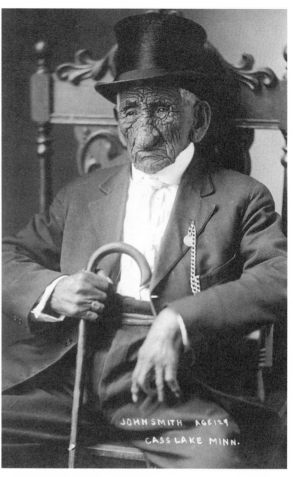

Kah-be-na-gwi-wens in a dignified, unadorned Otis Smith photo- graph taken around 1912

Kah-be-na-gwi-wens in evening wear, possibly taken by C. N. Christiansen of Cass Lake around 1920

Maingans the Younger

Maingans the Younger, or Albert Little Wolf, grew up at Mille Lacs but moved later to White Earth. He was a key source of information and help for ethnographer Frances Densmore as she worked on her book *Chippewa Music*. In addition to singing many songs for her, he shoveled the snow from around the door to her White Earth office—despite the fact that his lower legs had been amputated. He had a pair of artificial legs, but often he just walked around on his knees.

A letter written to then governor Lucius F. Hubbard by missionaries and Mille Lacs leaders asking for aid on Maingans's behalf documents the incident in which Maingans lost his legs:

Mahegons (Little Wolf) is a member of White Earth agency, Minn. & bands of Mississippi Indians of the age 23 years. In the winter of 1868 [he] lived at Long Lake 20 miles east of Crow Wing Minnesota with his aged grandfather & grandmother with no neighbors either white or Indians nearer than Crow Wing. A terrible snow storm and blizzard came on which lasted a week and buried their little hut deep in the frozen snow, where the boy and his grandparents were freezing and starving with no matches to make a fire. To save the lives of these old people the boy though only nine years of age dug his way out of the snow, braved the bitter cold and raging blizzard with his feet already frozen and started to Crow Wing for help. His suffering during the night and day [as] he was walking that . . . 20 miles, how he buried himself in the snow when exhausted and lost in the darkness and storm; how he aroused himself and tried the terrible journey again with the pinching cold and pinching hunger both preying upon him; we will not try to describe. But he finally arrived at the house of John McGillis in Crow Wing and fell on the floor with both of his feet frozen and lost forever. A party went back to rescue the old people but found them both frozen to death.

In the years that followed the amputations, Maingans went through great pain and suffering. "When the pain was most severe," Densmore wrote, several songs, "one after another, 'rang in his head.' He spoke of the condition of intense pain as a dream condition, implying that the intensity of the pain produced a state bordering on unconsciousness." Maingans attributed the strength that allowed him to survive the loss of his legs to the constant use of a remedy called *bizhikiwashk* or "cattle herb medicine." This was a medicine used by warriors, the main ingredient of which was Seneca snakeroot. Warriors would chew the medicine and spray it from their lips onto their bodies and their war equipment. Later, Maingans became a healer who used songs to cure

the sick. Densmore recorded and translated some of their lyrics in *Chippewa Music*. Maingans was also a member of the Midewiwin and sang many Mide songs for Densmore. Two of the songs seem to express something of Maingans's own life as much as they do Ojibwe traditions.

Dabi'nawa'	Toward calm and shady places
Nin'dinose'	I am walking
Muk'ade'wakûm'ig	On the earth
Aoda'nawĭñe'	To the spirit land
A'nimadja'	I am going
Hĭn'dinosĕ'	I am walking

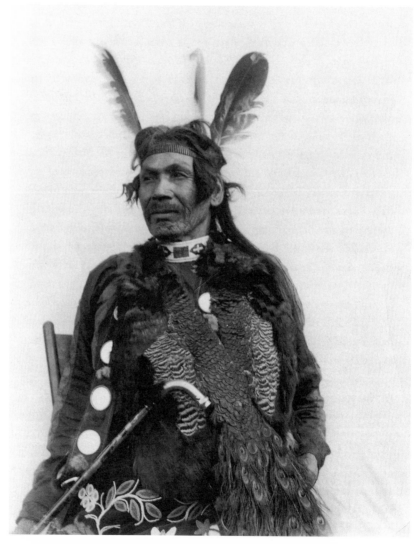

Maingans the Younger was photographed in a dance costume around 1910. This portrait may have been taken by White Earth photographer Robert G. Beaulieu. Whoever took the picture did not require the singer to shave his mustache as Frances Densmore had done on another occasion, when he was photographed with his friend Odjibwe (see chapter 2).

Shagobay of Shakopee

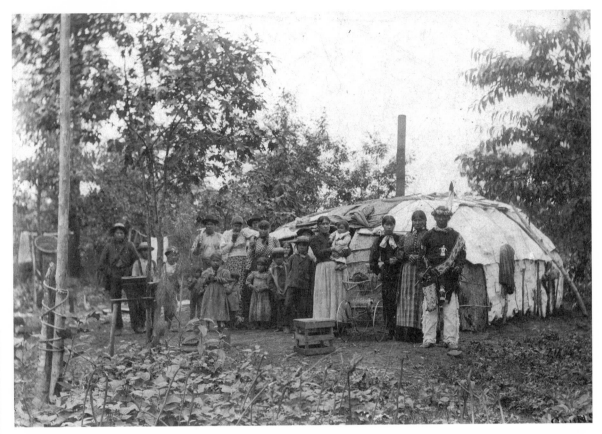

Shagobay (far right), a spiritual leader of the Mille Lacs Ojibwe, is pictured around 1890 with his family. Also known as Shakopee, he lived just south of Mille Lacs, on a lake that now bears his name. On the center of his chest is a thunderbird, which may be a symbol of Shagobay's power obtained in a dream or vision. Such symbols were rarely displayed or photographed.

At the time this picture was taken, the Mille Lacs people were struggling to remain on their reservation. Lumber companies, government agents, and settlers were all pressuring the band to relinquish their land and move to White Earth. Shagobay's property was later deeded to whites, but, despite many attempts to evict the leader and his family, he lived there until his death in the 1920s. The photograph was taken by Ralph Bruns, a local white photographer who recorded many scenes around the town of Onamia, a few miles from Lake Shakopee.

The Circle of the Drum

In the 1870s, the Minnesota Ojibwe were introduced by the Dakota people to the songs and teachings of the large drum now frequently used for dancing and ceremonies. Although prior to this time the Ojibwe and Dakota had sometimes been enemies, Ojibwe people now gathered at reservations and communities all over Minnesota to meet with visiting Dakota.

Before the late nineteenth century, Ojibwe people had drums of various kinds and had their own dances and ceremonies making use of them. Small hand drums were used by healers. Larger drums containing water were part of the Midewiwin. But the arrival of the large dance drum ushered in a new era of cross-tribal alliances and sociability. The spread of the drum throughout Minnesota in this period was often interpreted by local whites as the beginning of an "uprising," fueled by the fear that people of various tribes would join forces to drive the settlers from the state. For example, in June 1878, the *Taylors Falls Reporter* published a garbled article under the heading "Indian Scares. The Indians Disturbed." The article stated that "Indians are learning a new war dance" and were gathering at Chengwatana, or nearby Pine City.

But the drum was a symbol of peace. The sharing of these drums was based on the vision of Tailfeather Woman, a Dakota who had fled a murderous contingent of American soldiers. She hid for four days in a lake and during that time had a vision of the Great Spirit, who taught her about the ceremonial dance drum and the songs to go with it. The drum was to be used as an instrument of peace that would be passed on to all tribes and bring an end to bloodshed. It would also cause white soldiers to lay down their arms and stop killing Indian people. It is not known exactly where and when Tailfeather Woman lived. Some suggest that the soldiers she described were part of the U.S.–Dakota War of 1862 or the Battle of Little Bighorn in 1876.

The drums brought by the Dakota were considered to be living beings. They were treated with respect, given offerings of tobacco, and carefully cared for by a drum keeper, supporting drummers, and other members of a drum group. Among the Ojibwe, drums are not supposed to be photographed or treated disrespectfully. Since receiving the gift of the Dakota drums, Ojibwe drum keepers made others and passed them on to other tribes.

At White Earth, the drums may have been passed on at a June 14 celebration. The date marked the arrival of the first Ojibwe from the area of Gull Lake and Crow Wing to the reservation in 1868. A celebration was inaugurated by Enmegabowh, the Episcopal minister, around 1872 and was first held on the grounds of his church. The drum and associ-

ated dances later led to more elaborate events at White Earth village—events that have continued to draw Ojibwe, Dakota, and white visitors on the weekend closest to June 14. Other Minnesota reservations host larger powwows as well as smaller, more private drum-and-dance events and ceremonies. Red Lake, for example, holds its annual powwow in July—formerly on July 4, now on the first weekend of July. Reservations such as Mille Lacs and Nett Lake built circular dance halls based on the Plains tribes' earth lodges or similar halls. Many such halls had log or pole frames and a covered opening in the center. During dances, the drum sat in the center or on one side and people danced around the circle. The original dance halls were used for many years until they became weathered and worn. In some communities, they have been replaced by modern dance halls that have similar circular forms.

In Tailfeather Woman's vision, dancing and music brought people together, reconciling them under the influence of music's rhythms. The dances and powwows brought Dakota and Ojibwe together, and they served as important community events. Over the years, they also brought whites to visit Indian communities and admire aspects of Indian culture and to take hundreds if not thousands of photographs.

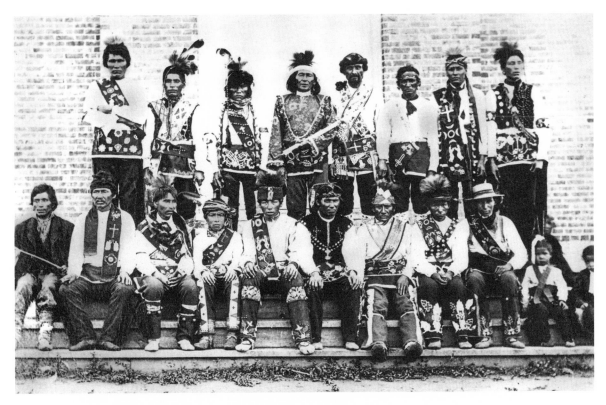

A view of men in ceremonial clothing at White Earth in 1886, possibly at an event such as the June 14 celebration

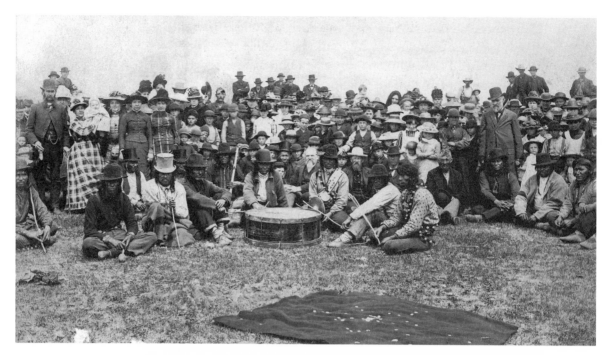

Sha-bosh-kung, a leader of the Mille Lacs Ojibwe from the 1860s to 1890, is among those seated around the drum in this picture taken at Little Falls in the 1880s. This was a difficult period for the community, as government officials, lumbermen, and settlers sought to take away Ojibwe lands along the south shore of Mille Lacs. Sha-bosh-kung and his community found help among the townspeople of Little Falls, who wrote letters to government officials and protested the attempts to force the Mille Lacs Ojibwe to leave their reservation.

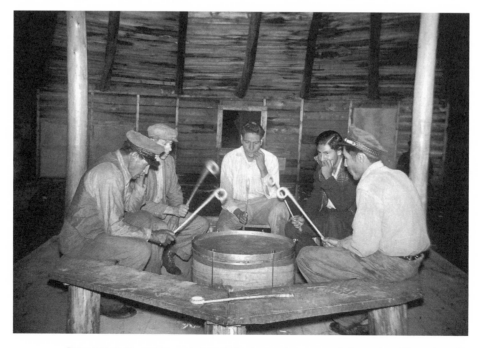

Drummers in the old dance hall at Nett Lake used a commercially produced bass drum instead of a ceremonial dance drum. This photograph was taken by Monroe Killy in June 1937.

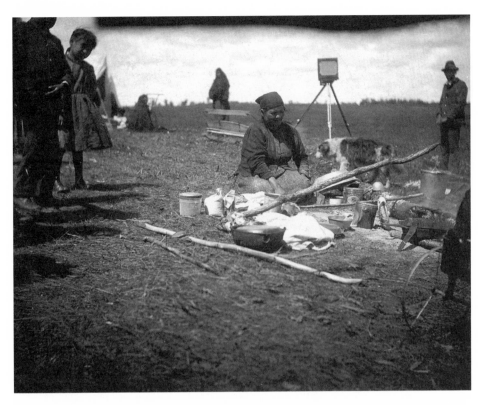

Events like the June 14 celebration drew both Indian and white visitors as well as photographers who recorded the dancing, the crowds, and people camping. This photograph taken by Edward Bromley, probably at White Earth and probably around 1900, carried the handwritten label, "the culinary department in an Ojibway Camp." It is likely the picture was taken at a June 14 celebration. In the background is a tripod holding a large-format camera, possibly one of Bromley's.

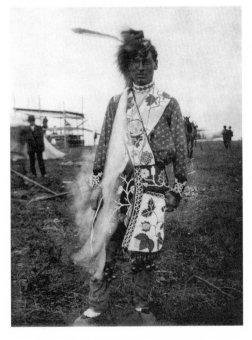

Beaded bandolier bags, such as the ones worn by this dancer at Detroit Lakes in 1912, were made by Ojibwe women and exchanged at events such as the White Earth June 14 celebrations.

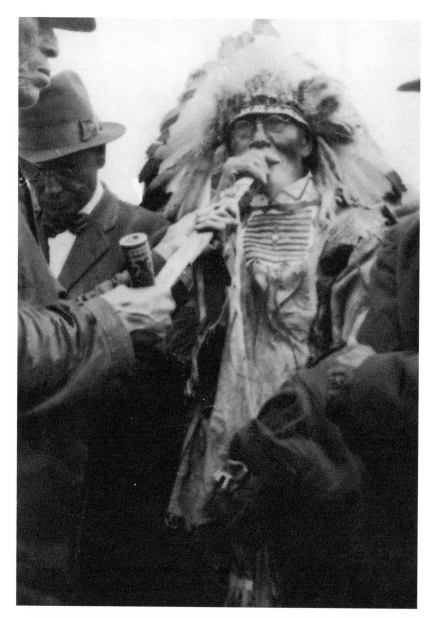

Smoking the peace pipe was a part of many White Earth June 14 celebrations, especially when Dakota groups were present. Many of the Dakota visitors wore Plains Indian head-dresses and gave them to their Ojibwe hosts, which is how many Ojibwe leaders came to wear them.

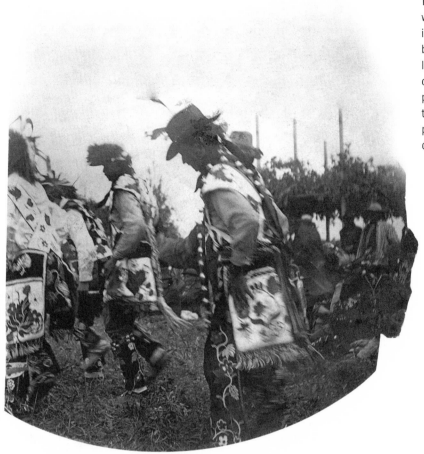

The June 14 celebration at White Earth was a chance to dance and dress up in the finest clothing. Dancers wear beaded clothing in this Edward Bromley photograph around 1905. Kodak cameras in the late 1880s produced photographs with a round format, although it is not known if this partial photo was made by one of those early cameras.

Many women attending June 14 events wore fashionable dresses and hats, as shown in this White Earth snapshot from the 1920s.

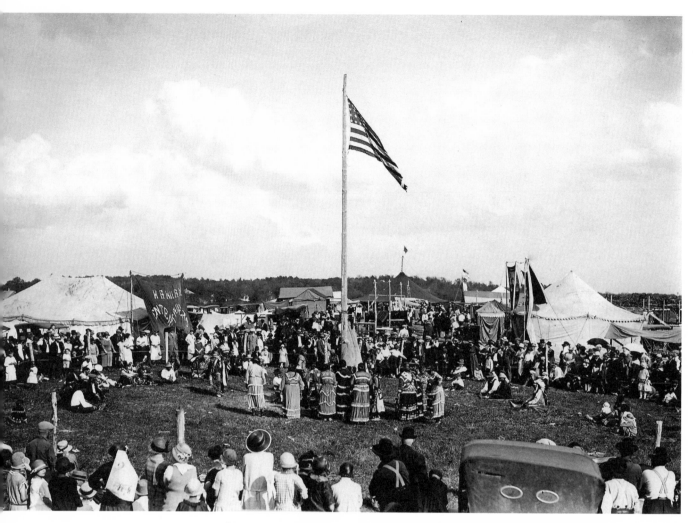

Ojibwe women move around the center of the dance circle—possibly during a women's dance—at White Earth on June 14, 1924. Blankets, quilts, and other items were exchanged as part of the women's dance.

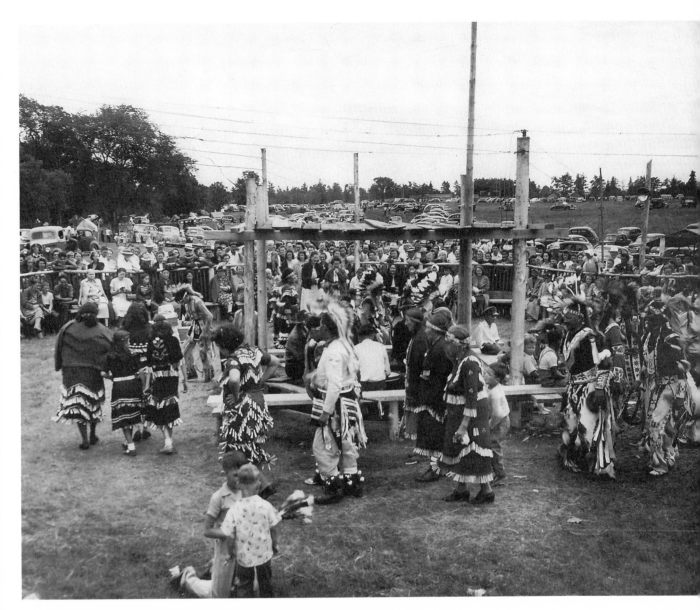

A powwow at Red Lake, photographed by Monroe Killy on July 4, 1949

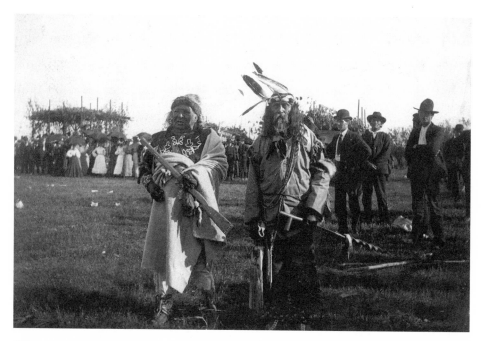

Ojibwe community leaders were a popular subject for photographers who came to the White Earth June 14 celebrations. Wadena, one of several leaders of that name, is shown on the left; on the right is Joseph Critt, or Charette, also known as Wainchemadub, a Civil War veteran and another leader at White Earth.

Jim Greenhill, one of the leaders of the Mide at Leech Lake, photographed by Monroe Killy at Red Lake on July 4, 1933

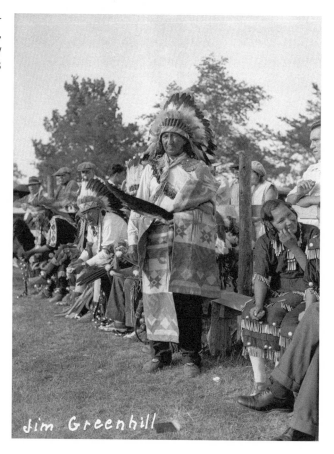

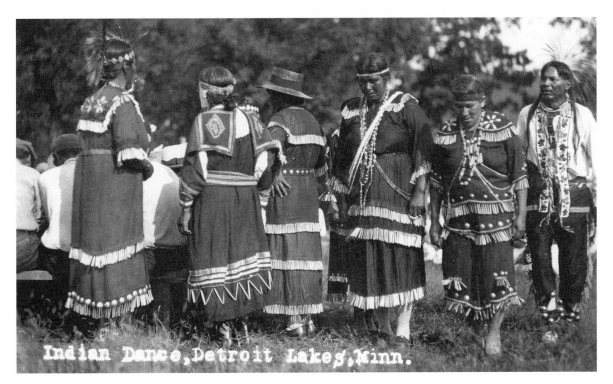

Indian Dance, Detroit Lakes, Minn.

A group of dancers in jingle dresses at an event at Detroit Lakes or nearby White Earth, around 1925. Many women at dances and powwows wore ornate beaded and fringed dresses, some with rows of jingles made of the metal lids of snuff cans.

The dance halls at several reservations dated from the 1870s, the time of the arrival of the Dakota ceremonial dance drum. Frances Densmore photographed what may be the framework for a Midewiwin lodge to the right of the dance hall at Naytawaush on the White Earth Reservation around 1910.

Margaret Fineday posed in her jingle dress for Monroe Killy at Ponsford in August 1946.

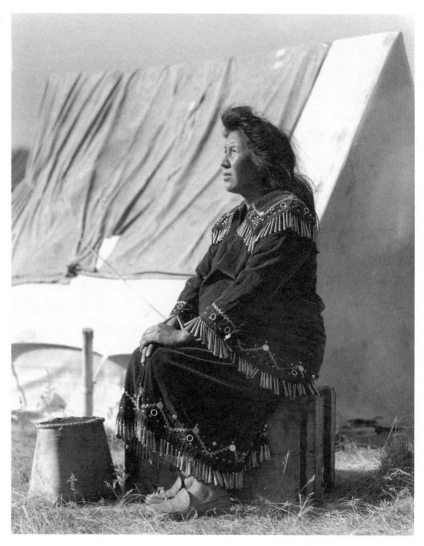

The original 1870s dance halls were still in use, despite being in a state of disrepair, into the 1940s. A note on the back of this Nett Lake photograph, probably by W. E. Culkin, says that this building was used as a meeting house as well as the dance hall and that the American flag was flown from the top when a council was called or in session. Other sources suggest that flags were also flown during powwows and ceremonies.

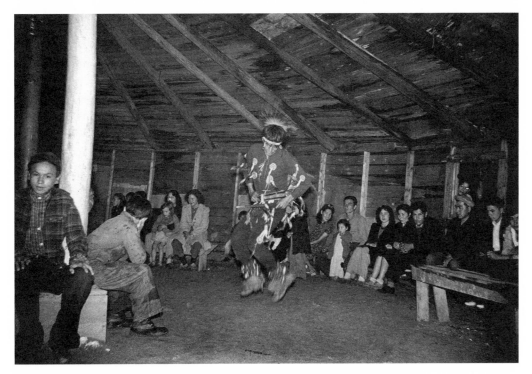

Monroe Killy photographed this view inside the old dance hall at Nett Lake in September 1941.

Stella Prince Stocker's Snapshots

Like Roland Reed, Stella Prince Stocker found her artistic fulfillment in the Ojibwe, though not in photography. Instead Stocker wrote a sentimental play about early explorers and the seventeenth-century Ojibwe. Her photographs were incidental to her writing, a means of doing research.

Stocker was a university-trained musician and composer living in Duluth. In one account, Stocker mentioned her "Indian blood" without going into detail. Apparently her interest in Indian music was sparked in part by Frances Densmore's *Chippewa Music.* She also said that she became interested in Indian people when she visited the Chicago World's Fair—perhaps a reference to Indian displays at the World's Columbian Exposition of 1893.

Around 1916, Stocker began visiting Minnesota Ojibwe communities, possibly starting with Nett Lake. She later visited Fond du Lac, Mille Lacs, White Earth, and Red Lake. Throughout her trips, she kept a sporadic diary and recorded some of what she saw in small, square snapshots, which she pasted on the black pages of her photo album. The photographs appear to have been taken with a tourist camera, such as a Kodak Brownie. The aspects of Ojibwe life that she chose to photograph were those most in keeping with her musical and theatrical in-

terests; she was especially drawn to dances and ceremonies, when the Ojibwe dressed in beaded clothing to celebrate their past and present.

Stocker's visits to Ojibwe communities must have been brief. She does not appear to have established any long-lasting connections with the people in these communities, though this is difficult to judge because she died in 1925, only nine years after her first known visits. In an undated newspaper article, Stocker said that while in one Ojibwe community she was adopted and given the name Omesquawigigoque, or Red Sky Woman. An accompanying photograph shows her wearing a Plains Indian beaded headdress and bandolier bag. The newspaper went on to call her a "chief in their tribe," clearly an exaggeration on Stocker's part or the journalist's. One of her photographs, taken at Nett Lake, shows a woman sitting on the doorstep of her house and is labeled "Bamashiqua, my god mother," suggesting that Stocker may indeed have been adopted by one Ojibwe family.

Stocker went to Nett Lake to observe dances that took place at the time of the wild-rice harvest. She took no photographs of the harvest itself or of the dances she wrote about, though she did photograph the dance hall. Mostly her snapshots were portraits of people she met, particularly children and some of the elders in the community, including the leader Debwawendunk, who was a popular subject for several white photographers. In many ways Stocker's photographs resemble the portraits taken by Darwin Hall in the late 1800s (see chapter 2); however, Stocker's attitudes were quite different from Hall's.

From the first, Stocker was a strong advocate of what she saw as traditional Indian culture. In a short, undated essay entitled "Dance of the Indian Wild Rice Gatherers," Stocker described the attitudes of Nett Lake agency workers who told her that the dances were a "nuisance" and were being "put down at all the agencies." She wrote that she reacted with anger and that "the Indian blood in my veins grew hot." She went on to say that whites were "haughtily trying to force the Indians to be just like ourselves," while "robbing them of what is more valuable to them, their lands, which we have persistently stolen from them." Whites were also trying to take traditions away from the Ojibwe.

"[A] more innocent amusement cannot be found perpetuating the feeling of good fellowship and displaying a magnificent generosity absolutely foreign to the nature of a white man," Stocker wrote of the rice-harvest dances. "Let us beg the Indian agents not to interfere with this and other tribal ceremonies."

Stocker soon found a way to present her ideas about Indian culture to a wider audience. One day in May 1916, she received a telephone call from Frank Pequette, a well-known Ojibwe Methodist minister. Stocker had probably met him on a visit to Nett Lake. Pequette informed Stocker that within several days there would be a dance at Vineland on

Mille Lacs and that if she wished to attend it, someone would meet her at the train depot in Onamia. Several years later she wrote:

> *Of course I went, and by afternoon of the next day I found myself watching the most picturesque group of Indians I have ever seen. The long point of land which reaches out into the lake, with its little island as pendant, the great trees, the brilliant costumes of the Indian dancers—all made a vivid impression upon my imagination. That which excited me most was some information which I obtained from a white settler who has for thirty years managed the Indian trading store not far from the encampment. From him I learned that it was on this very spot that Sieur du Lhut rescued the Catholic priest, Father Hennepin. It was here that the Sioux [Dakota] and Chippewas fought their last great battle, at which time this village of Kathio passed out of the possession of the Sioux and was henceforth occupied by the Chippewas. As distinctly as if already in shape my story appeared to me. It was not a story, however. It was a historical play and the hero was Sieur du Lhut.*

Stocker's diary entries about the trip describe some of the dances she saw, including the dancers' costumes and the painting on their faces, and mentions the photographs she took—mainly of people gathered for the dance. Many of the photographs were portraits of people sitting or standing, often wearing dance costumes. The diary also notes that she read historical accounts of early explorers in the region and that upon her arrival at Vineland she saw the historic marker erected in 1900 by the archaeologist Jacob Brower, bearing the following names and dates: "Radisson 1659/Duluth 1679/Accault 1680/Battle of Kathio 1750."

This experience led her to write *Sieur du Lhut: Historical Play in Four Acts With Indian Pageant Features and Indian Melodies,* an unfortunately saccharine play about an imaginary romance between the French explorer and an "Indian maiden." Inspired by Densmore's *Chippewa Music,* Stocker included a portrayal of the moccasin game and some actual Indian music in the play.

In June, at the invitation of the White Earth Indian agent, Stocker visited White Earth for the annual June 14 celebration. No notes survive from her trip there—only more small, square snapshots and some even smaller rectangular ones. These pictures show the June 14 parade, men in black coats and hats, people wearing all different style of headdresses, musicians beating on bass drums, and men on horseback with beaded saddles. Then there are pictures of the dancers, with knees bent and feet flying, moving around a drum and a flagpole, surrounded by drummers, and a picture of the drum itself. One photograph shows the back of a woman entering a tent; a note on the photograph says the

woman was Dakota and that Stocker had followed her, "asking her to let me take her picture. Finally snapped this."

Stocker was especially drawn to people who had provided information for Frances Densmore's work. Her photographs show the Mille Lacs leader Wa-we-yay-cum-ig and his wife in beaded costumes, as well as Maingans the Younger, who sang for Densmore.

All of these small, sometimes sharp, sometimes blurry photographs are straightforward and have little pretense. Stocker simply pointed the camera and pressed the shutter. The events she chose to portray may have fed stereotypes, but the photographs were honest and unassuming. Stocker simply wanted a record of what she saw. She did not use photography to depict the Ojibwe in the romantic, idealized way that Reed did (see chapter 4); she let her fantastical play about Du Lhut and Indian people of the past do that.

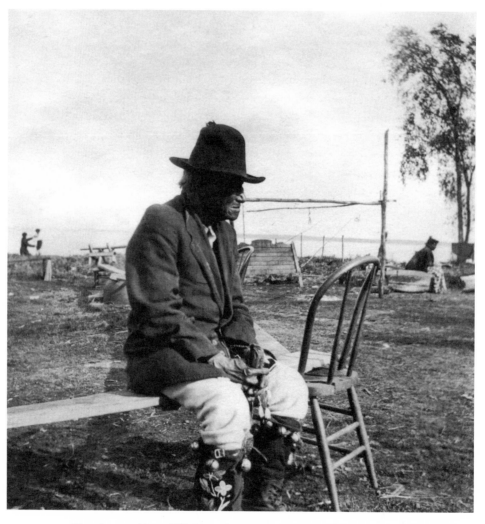

Shagobay, an elder at Mille Lacs, photographed by Stella Stocker at a community celebration in 1916

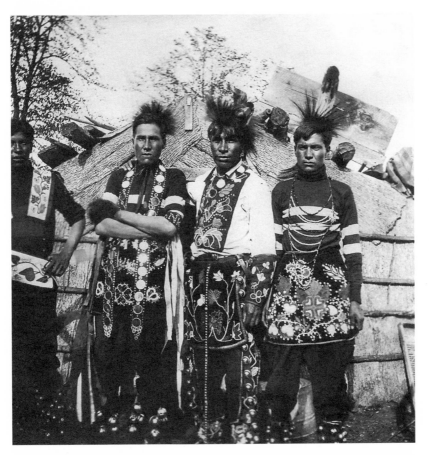

Four dancers at Mille Lacs in 1916, including two identified by the photographer, Stella Stocker: Sam Kegg (second from left) and Jim Mitchell (second from right)

The Beginnings of Ojibwe Family Pictures

By the late 1800s, while white people had more and more opportunities to take pictures of Ojibwe people, Ojibwe people themselves were incorporating photographs into their lives. Ojibwe families went to nearby towns to have their pictures taken. Though these were meant to be family pictures, the white photographers sometimes sold them commercially to white tourists and other customers. Many of the photographs were produced as cabinet cards, printed photographs mounted on a 4¼-by-6½-inch piece of decorative cardboard so they could be displayed on a mantelpiece or hung on the wall.

In 1878, a writer for the *Hastings Gazette* encountered Augustus Cadotte, an Ojibwe-French resident of Sunrise in Chisago County and the operator of a ferry across the St. Croix River. Cadotte, said the writer, "took great delight in showing me his family photographs, and those of some relatives." The article noted that "the ladies' coiffures were fixed up in modern style" and that their poses resembled those of white people photographed in studios.

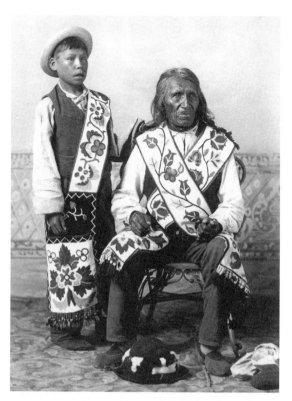

An early history of Thief River Falls identifies this Jacob Borry photograph as a picture of Ponyhoof and Poh-ah-be-one without stating which name applied to the man and which to the the boy.

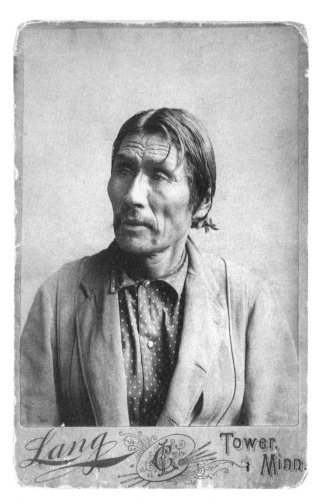

Way-ko-mah-wub, a leader of the Vermillion Ojibwe community, photographed at the Lang photography studio in Tower around 1885

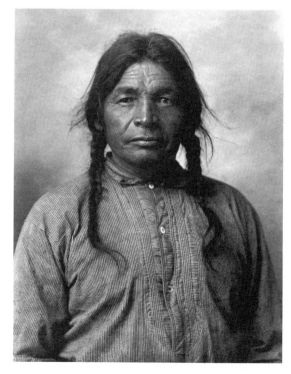

An early history of Thief River Falls identifies this Ojibwe man as Mac-cakee, or Big Frog.

Ross Daniels's Studio Portraits of Ojibwe Families

In his studio in Pine City in eastern Minnesota, just before Word War I, Ross Daniels took a series of group photographs of Ojibwe people who lived in Pine County, an area now known as Aazhoomog or Lake Lena. To this day, many of his photographs are found in the family albums of the descendants of those he photographed.

Daniels was born in Harmony, Minnesota, in 1885. In 1905 his family moved to Sandstone, in Pine County, and in 1913 bought a farm south of Pine City. Daniels opened a photography studio at the north end of town, on the south bank of the Snake River.

Like many photo studios of the time, Daniels's studio, as recorded in a panoramic photo and in some of the portraits he took in it, was lit with a skylight and had at one end several canvas backdrops painted with lavish curtains, a tree trunk, and some foliage. He also had several ornate chairs for the use of his subjects. For studio portraits he used glass plates with a 5-by-7 camera on a wheeled wooden stand. For photographs in the field, Daniels apparently used a 5-by-7 camera on a tripod.

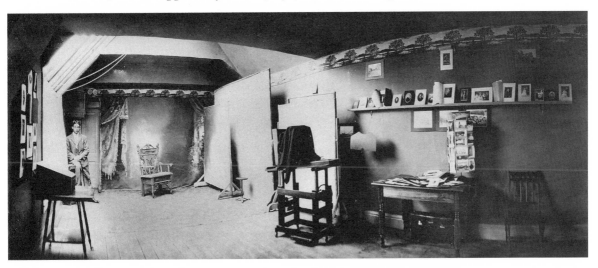

This panoramic photo shows the Ross Daniels studio in Pine City around 1915. Daniels himself stands at the far left near the painted backdrop against which he took many of his portraits.

The extent of Daniels's business in the white community of Pine City is not known. The photograph of the interior of his studio shows that he displayed a variety of images there, including wedding and family photographs and views of town buildings. How he came to photograph members of the Lake Lena community is not known. One clue is that Daniels's uncle, Frank R. Duxbury, was a real estate dealer in this region of Pine County and lived near the village named after him, in the eastern part of the county.

A few of Daniels's photographs record some of the nearby Indian villages, such as Aazhoomog. Some of these outdoor photos were clearly

taken to be sold to white customers. On several that he took in the Aazhoomog area, Daniels imprinted labels such as "Indian burying grounds, Pine Co. Minn." and "Indian camp Pine Co. Minn. Daniels Photo." These photographs showed scenes that would be generic to a white audience. One postcard, showing a group of people in a wagon with a birch-bark canoe in it, bore the label "Indians on the move, Sandstone, Minn."; it belonged to a genre of humorous postcards of Indians that were popular at the time. Although these photos appear to have been taken on 5-by-7 glass plates, the photographs were printed on postcard paper—another indication that Daniels took them for commercial purposes.

Most of Daniels's studio photographs of Ojibwe people are portraits of individuals or families and appear to have been commissioned by Ojibwe customers for their own use. These images show Ojibwe people in a mixture of native clothing styles and fashionable American clothing of the time. Many of these clothes may have been costumes worn at the instigation of the subjects themselves. The bandolier bag worn by Jim Razor in one photograph is an item worn by Ojibwe people on special occasions. The cradleboards that appear in several of Daniels's photographs (see chapter 1) were still commonly used on a daily basis in the Ojibwe community. Although many of the men in these photographs wear clothing they might have normally worn, such as leather moccasins or rubber shoes, they also wear coats, hats, and pants with rolled-up cuffs that may have been borrowed from the photographer or from someone else. Several of the women and children in the photographs wear long coats and hold gloves, fashionable clothes associated with driving in the open automobiles of that era; they may have been provided by the photographer.

Still, not all non-Ojibwe items are props. Jack Churchill and John Clark are shown seated against a painted backdrop; Churchill holds an accordion, and Clark, a violin. The men were known in the area for playing these instruments at weekly square dances. Both men wear the type of knitted leggings that, though not based on traditional Ojibwe patterns, were made by Anishinaabe women of the area, including these men's wives.

Many of Daniels's photographs were not printed and mounted as cabinet cards but instead were printed on postcard paper, the same as Daniels's outdoor views. The pictures were not sold as postcards to white customers; the postcard format was simply an inexpensive, convenient, and popular style of presentation, and it allowed subjects to send their images to friends and neighbors. Many such postcards, with messages from the subject to a friend, are found in present-day Ojibwe family collections. It is likely that Daniels would have charged less for postcards than for mounted cabinet cards.

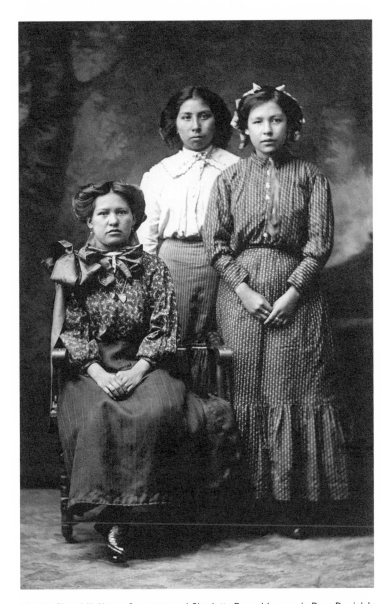

Maggie Churchill, Nancy Songetay, and Charlotte Reynolds pose in Ross Daniels's studio around 1915. In a 1988 interview, Churchill's sister, Marian Dunkley, explained that these three women were cousins who as children had played together. The fathers of Churchill and Reynolds were cousins, and Churchill's mother and Songetay's father were siblings.

Grace and Fred St. John and some of their children in a Ross Daniels photograph from around 1915

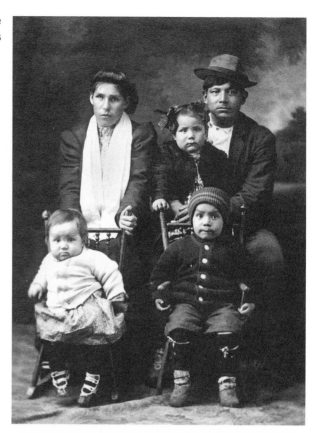

Ross Daniels made this portrait of Pete Moose at his studio around 1915.

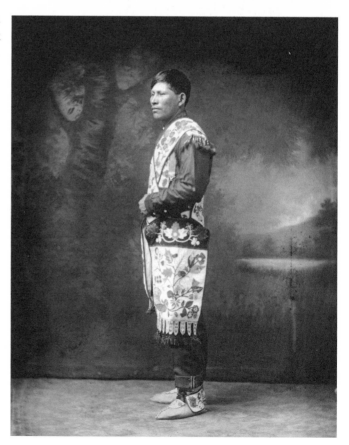

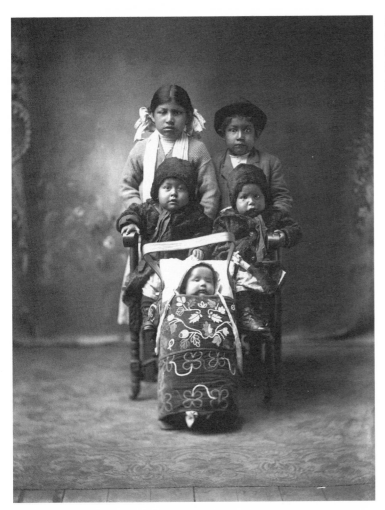

Around 1917, Ross Daniels photographed the children of Annie Pewaush Clark Sutton, including Grace Sutton (later Matrious) in the cradleboard, Julia and Dan Clark in the back, and the twins, Jim and Ellen Sutton, in the middle.

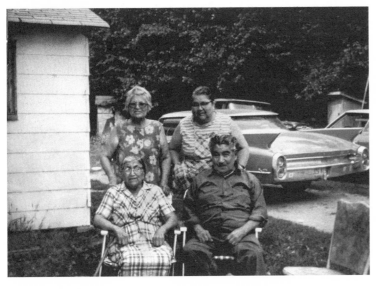

Decades after Ross Daniels photographed them in his Pine City studio, Julia and Dan Clark (seated, front) and Ellen and Grace Sutton (back) posed at Aazhoomog (Lake Lena) in the 1960s in front of a period Cadillac. The photo was taken by Grace's daughter, Alvina Aubele, at her aunt Ellen's house.

Ojibwe Family Photograph Collections

When people photograph their own families, their own places in those families and the communities in which they live are reflected in the images. In order to understand the meaning of such photographs it is necessary to learn in detail the social history of the community. In the case of small communities, this social history includes genealogies, family relationships, and personal histories. Collections of family photographs are the family members' way of recording their personal, family, and community histories. Few family photographs are available in public collections, but when they are—if information is available about the families pictured—these images are an invaluable record of a community's complex dynamics.

Family photograph collections do not often distinguish between pictures taken by professional photographers and those taken by members of the family. But who took the photographs is less important than the people and events they show. A collection of a family's photographs can include pictures taken by professionals or other nonfamily members.

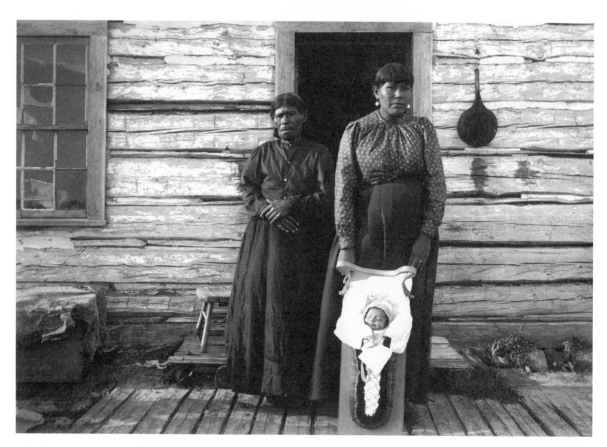

An unknown photographer recorded what may be three generations of an Ojibwe family in northern Minnesota around 1900.

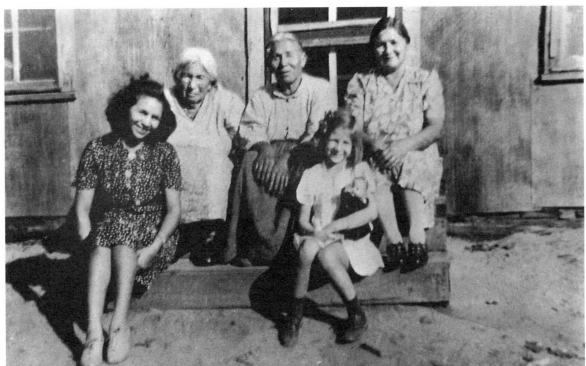

Five Generations -1943- Dorothy V. Hodder, Mrs. Henry Buffalo, mrs john Rabbitt, Nadine Hodder Chase, Elsie R. Beaulieu

Five generations of women from the area of Leech Lake are recorded in this 1940 John Clement Beaulieu family snapshot. Mrs. Henry Buffalo (second from left) was the mother of Lily (Mrs. John Rabbit, or Tebishcoyaushequay, center). Lily Rabbit's daughter Elsie (far right), who was married to John Clement Beaulieu, was the mother of Dorothy V. Hodder (far left), who was the mother of Nadine Hodder (later Chase), the girl holding the doll. Where this photograph was taken is not known, but in 1920 and 1930 Lily Rabbit and her granddaughter, Dorothy, both lived in Cass County on the north side of Leech Lake in the area of Ottertail Point.

One Family's Photograph Collection

John and Marian Dunkley's collection of family photographs provides glimpses into the history of the Pine County Ojibwe community in the early twentieth century. The pictures show people intimately connected to their heritage both through their cultural background and in their community's ties to the region. The view of Ojibwe history evident in such family photographs is markedly different from that in the work of many white photographers.

John Dunkley's father, Jack, was born around 1887 in the St. Croix Valley region. Jack's father was an Irishman, probably a logger. His mother was Mary Nickaboine from Mille Lacs, who married John Sutton after her first husband's death. In the region's logging camps, Jack learned English and his occupation of teamster. His main job was to

haul logs from the place they were cut to the riverbanks, where the logs would be floated down the river to mill towns each spring.

Around 1910, Dunkley married Katie St. John, daughter of Ed and Josie St. John, who lived along the river in Crosby Township at Yellow Banks, now part of St. Croix State Park. Before World War I the St. John and Dunkley families moved from the St. Croix Valley to take land allotments at White Earth. Both families lived south of Bagley near Naytawaush. Jack Dunkley continued to hold a variety of jobs, working for logging companies, hunting, building and repairing roads, and hauling supplies to the Twin Lakes Store in Naytawaush.

The Dunkleys' son John was born at White Earth in 1914. A few years later the couple separated. Jack Dunkley then married Catherine Goodman and raised another family. Katie St. John Dunkley, her parents, and her children all returned to Pine County around 1923, living first at Yellow Banks. She later married John Henry.

Katie, John Henry, and their family drove to White Earth for a visit in 1929. From there John Henry drove on to the Dakotas, where he had been offered work on a threshing crew. Having no money or a car to return home to Pine County, Dunkley and his mother and brother, with their sister still in her cradleboard, set off on foot. They walked first from Bagley to Cass Lake and stayed there about a week with Katie's relations. Taking turns carrying the baby, they continued walking through Remer, Aitkin, and Hinckley. Dunkley recalled that at one point along the way some people driving by asked to take a picture of Dunkley's mother holding the baby in the cradleboard. They paid her seventy-five cents or a dollar. Throughout the journey, kind people offered them food. The family slept by the side of the road and at least once in the house of a friendly person. On the day they reached Hinckley, they went to a farmhouse and asked if they could sleep in the barn. That night, it rained for the first time. The next morning, eleven days and more than 220 miles after they had started their journey, they reached home.

Although the government supplied some rations to people living at White Earth, in many ways the reservation offered fewer opportunities than in Pine County in the 1920s. For the people living at Yellow Banks, nature yielded a great deal of sustenance. Deer were an important source of protein. People cut the meat into strips and smoked it over an open fire; the dried meat could be used in making soup or stew. They also speared fish in the river, including sturgeon, catfish, walleye, and bass. Sometimes they would fish at night with a light. Floating down the river, they would spear redhorse, which were particularly good for smoking.

The St. Croix River area offered a variety of good places for ricing; Pokegama and Cross lakes were good ricing locations in earlier years, until dams raised the water levels and killed the rice. There were groves

of sugar maples in the area of eastern Pine County. Blueberries grew among the jack pines. All along the river from Yellow Banks to St. John's Landing the blueberries, blackberries, and Juneberries were thick. They would ripen in the last part of June around Yellow Banks, but farther north, near Nickerson, they ripened in August or September. People in the area needed to get only flour, sugar, tea, and coffee from stores. They received potatoes, onions, carrots, rutabagas, and parsnips from nearby farmers in return for helping with the harvest.

In the 1920s, the land at Yellow Banks belonged to a man living in Pine City, and he permitted John Dunkley's family to stay there. Early in the 1930s, however, the owner died, and the state took over the land. When a Boy Scout camp was started a short distance from the Dunkley's home, the family was forced to move to the area around Aazhoomog. There John Dunkley met Marian Churchill, the daughter of John Churchill and Charlotte Songetay Churchill, who owned land in that area. John and Marian were married in 1933.

Marian Dunkley graduated from Sandstone High School in 1934. One of the earliest pictures of her in the family's photo collection shows her standing by her father. The label on the photo reads "Danbury Reservation General Foreman and Timekeeper." At that time, in the mid-1930s, the Bureau of Indian Affairs in Cass Lake was building a road through a nearby swamp. John Churchill was the foreman on the project, and Marian was the timekeeper. Throughout her life, Marian was also recordkeeper for the local school district.

Marian regularly kept a diary until her death in 1988. In it she tracked many important details in her life—what the family was doing, visits with neighbors, births, deaths. At traditional naming ceremonies she would record the names of people who attended. She also kept a record of debts and the bills she had paid. She wrote down people's Social Security numbers and directions for how to obtain new Social Security cards if someone lost one.

John Dunkley did not have a school education, but he was skilled with his hands and took on many different jobs throughout his life. During the 1930s, when work was scarce, he held a variety of manual jobs. Shortly after he and Marian married, John worked for a farmer who lived four or five miles away. For fifty cents a day, he would walk to the farm morning and evening to milk the cows, leaving before dawn to get there in time. He earned enough money to buy some lumber to build a house near the Churchills. He and Marian obtained most of the furnishings for the house from the Montgomery Ward catalog.

After a Works Progress Administration camp was established near Big Yellow Banks in 1935, Dunkley got a job there and spent nine years helping to construct the roads, buildings, fish ponds, and other infrastructure of what would become St. Croix State Park in 1943. The park

encompassed the area where he spent much of his childhood. He helped do the surveying, cutting the brush, and laying out the roads. For this work he was paid fifty dollars a month.

The Dunkley family sometimes supplemented their income through pulping—cutting, stripping, and stacking aspen trees for use in making paper. The whole family participated, camping out in the summer in tents, as they would for berry picking. They cut the trees into eight-foot lengths, peeled them, and stacked them so that trucks could later pick them up.

Both John and Marian Dunkley were believers in education, and three of their children became teachers; the eldest, Duane, became the commissioner of education for the Mille Lacs Band of Ojibwe. Marian was clerk and treasurer for the board of the Lake Lena local school district. The family moved to Hinckley in 1948 when their eldest child, Duane, was ready to go to high school. John Dunkley got a job with the railroad there, maintaining the track and changing ties and rails. The family moved into a two-bedroom apartment over an implement store in the center of town, where they lived for twelve years. They paid eighteen dollars a month, not including electricity or heat, and hauled their own wood for the furnace.

Throughout the various phases of their lives, the Dunkleys accumulated a large collection of photographs. The earliest of these were from their families' collections and include photographs of relatives, some taken by Ross Daniels and photographers in nearby Grantsburg, Wisconsin.

In looking through the collection in 1990, John Dunkley joked that Eugene Reynolds, Marian's father's cousin, appears to be in most of the photographs, including early photos taken in Grantsburg as well as snapshots taken by the Dunkleys in the 1950s. Also in the collection are some portrait postcards John and his family received from friends at White Earth, including Margaret Big Bear, the daughter of Mary Razer and the wife of George Big Bear.

In some ways the photo collection can be seen as a reflection of Marian's conviction that keeping good records was important. She was a strong believer in writing captions on photos, as she explained in a 1987 interview. Often her labels gave both the English and Ojibwe names of the people in the pictures and noted their relationship to her or to others. Her photo albums combined older studio pictures with more recent ones taken by the Dunkleys themselves.

Sometime in the 1930s, the Dunkleys received or borrowed the first of several cameras. The earliest of the cameras they used produced approximately 2¼-by-4¼-inch negatives. Later in the 1950s they used cameras producing 2¼-by-3¼ and 2¼-by-2¼-inch negatives. These formats were common to folding cameras and black leather-covered

box cameras that John remembered the family having at one time. Some of the more recent photographs were produced on 127 film in a 1½-by-1½-inch format, probably with one of the plastic Brownie cameras popular in the 1950s. Photographs from the 1960s were taken with a Kodak Instamatic.

One of the earliest photographs of John and Marian Dunkley together was taken in 1936, probably by a relative. The couple was seated on a section of culvert on the site of the road project that Marian's father supervised and for which she served as timekeeper.

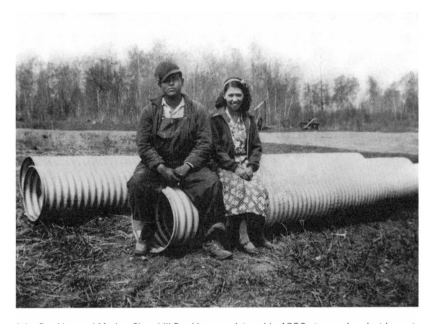

John Dunkley and Marian Churchill Dunkley are pictured in 1936 at a road project in eastern Pine County. Dunkley's overalls were the common clothing for hard-working Ojibwe men of the area.

The bulk of the family's pictures were taken after Duane's birth. Marian was the primary photographer. "She took pictures whenever anybody came to visit," her daughter Geri Germann said in a 1990 interview. "If we hadn't seen them for a long time she would say 'Well now before you leave we have to take a picture with you'. . . your family or your kids or your new car or whatever."

Once the Dunkleys moved to Hinckley, the flat rooftop next to their apartment became a favorite picture-taking spot. On this site, John and Duane posed with a deer they had shot. In another photograph John Dunkley stands holding his shotgun, and Marian and their younger daughter, Marcella (Marcie), stand beside him. Marian also sometimes photographed visitors sitting on the raised edge of the roof.

While they lived in Hinckley, the Dunkley family continued to visit relatives in the old village. One sequence of photographs from April

1952 shows various relatives, young and old, standing in front of some of the government-built frame houses that were common then. One photograph shows Eugene Reynolds, now an old man with a cane and overcoat. Another shows Marian's sister, Maggie Churchill, with her husband, John Sutton, and Marian and Maggie's mother, Charlotte Songetay Churchill. Sutton was the son of John Dunkley's grandmother's second husband's brother, Henry Sutton.

Another sequence of photographs, which may also have been taken in the 1950s, includes a number of indoor views of houses in the village. In one photo, Grace St. John leans on a treadle sewing machine. Three other photos show John Dunkley's stepfather and other relatives harvesting beans in a farmer's field. In another photo, John Henry and Fred St. John take part in a dance in the old dance hall.

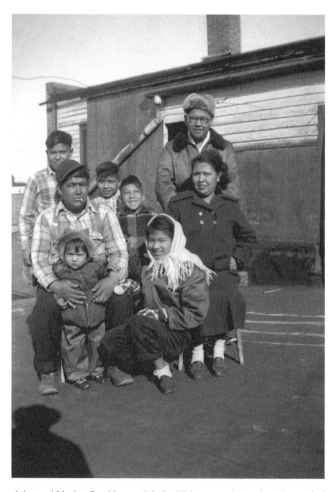

John and Marian Dunkley and their children are pictured on the roof of a building in Hinckley, where they lived in the 1950s. From left to right, Doug and Duane are in the back row and Jack and Donovan are in the center. In the front row are Marcie and Geri. The photograph was taken by a family member or friend.

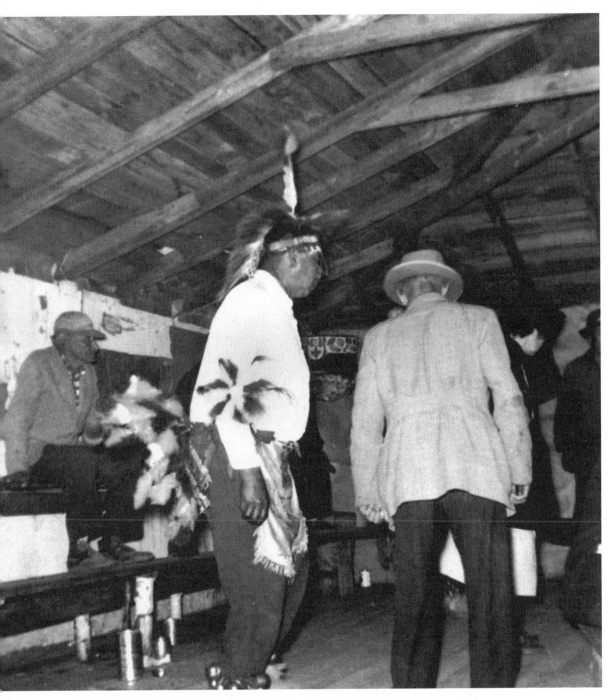

John Henry (center) and Fred St. John (right) were photographed inside the old dance hall at Lake Lena in the 1940s.

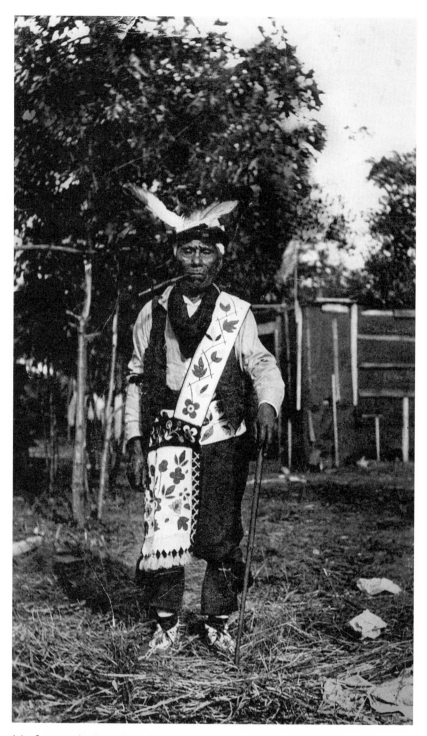

John Songetay is pictured in a beaded outfit at an event, possibly in Danbury, Wisconsin.

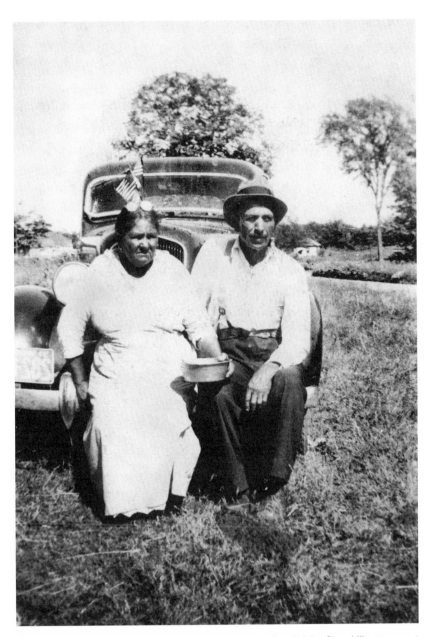

John Songetay's daughter Charlotte is shown with her husband, John Churchill, at an event in the Lake Lena area in the 1930s.

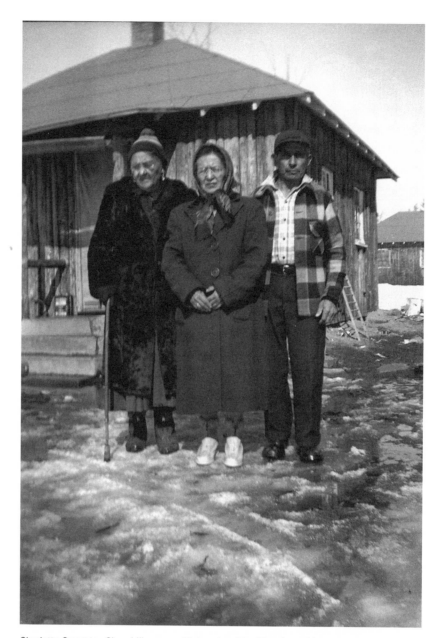

Charlotte Songetay Churchill poses with her daughter Maggie and her daughter's husband, John Sutton, in the 1950s at the home of Nancy Staples, Charlotte's daughter, in Danbury, Wisconsin.

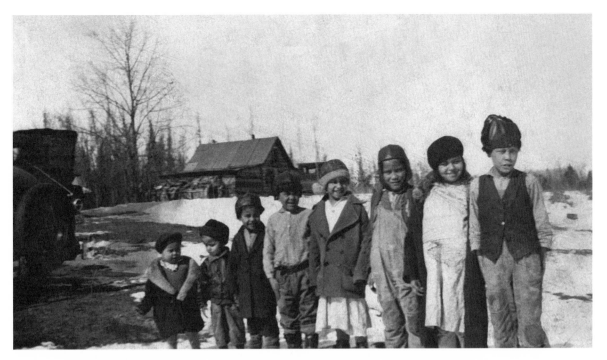

The children of John and Emma Thomas and George and Mary Benjamin of Aazhoomog in Pine County were photographed in the 1930s. From left to right are Richard Thomas, Evelyn Benjamin, John Thomas, Delphine Benjamin, and Sylvester, Olaf, Leroy, and Lucy Mae Thomas. Emma Thomas and Mary Benjamin were sisters of Marian Dunkley, who may have taken the photograph. When snapping views of children, she often arranged them by height.

Richard Thomas, the oldest of the Thomas children, is shown in a four-generation Polaroid photograph from the 1990s.

Rick + Randon Richard + Sonny

Father, son, grandson + great grand son

Henry Field dries nets at Nett Lake in this 1948 Monroe Killy photograph.

6

Anishinaabeg / The People

To appreciate the Ojibwe individuals shown in this book, we must understand their individual stories and experiences. Their photographs are part of a rich record of struggle, survival, and triumph through many generations.

But some photographs are enigmas because details about the setting, the subjects' clothing, and the subjects' names are not fully documented. It is tempting to treat these images as outside the range of documentary records and instead look at them with just the imagination, which contains all the general characteristics known or believed about the Ojibwe. There is a common belief that photographs can be read and that if they are read carefully enough their meaning can be understood. But most of the time, without adequate details, people will read information into photographs and interpret them according to

On one of his research trips to Minnesota, folklorist William Jones, who was himself of American Indian ancestry, recorded this hazy view of two people in a bark canoe on a northern lake. Using what was probably a rudimentary camera, Jones seems to have achieved the same effect that professionals like Edward Curtis sought through more expensive means and greater pretensions.

their own stereotypes. Part of the challenge of looking at Ojibwe photographs is to reserve judgment, to avoid jumping to conclusions, and to respect the people in the photographs, even if we do not have any evidence of their lives beyond what is shown in the photograph itself.

The photographs in this chapter are each beautiful but enigmatic views of the Ojibwe people, the Anishinaabeg of Minnesota. In some cases, it has been possible to learn more about these photographs. In other cases, the photographs contain interesting but incongruous details that make their meaning less than obvious; these photographs are difficult to place within the comfortable realm of stereotype. Instead, they are open-ended invitations to inquiry, to proceed from what is known, from the details, toward explanations and understandings, even if ultimate certainty is not possible.

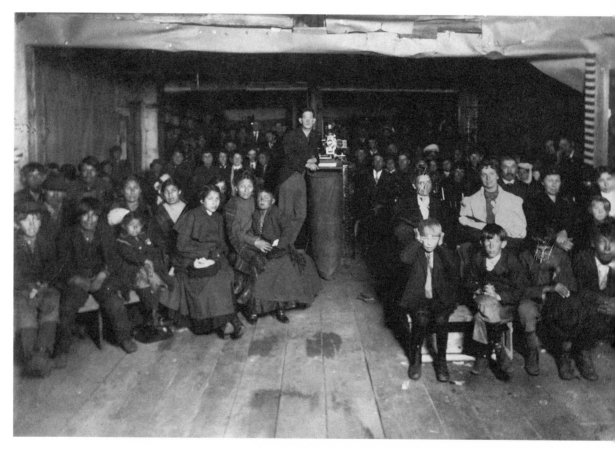

This scene of a movie audience inside the Red Lake Indian School was taken around 1904, probably with a flash. The boy in the front row holding his hands over his ears perhaps was anticipating the sound of the explosive powder used to light the scene. The paper covering the ceiling is peeling. There is no record of the movie the group was about to see. No single photograph can encapsulate the experiences of Ojibwe children at government schools, though the fact that someone scratched out the faces of some of the people in the photo suggests undercurrents in the social life of such schools worth investigating.

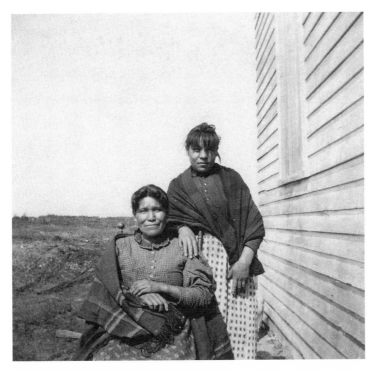

Darwin Hall did not record the names of these two women he photographed at White Earth. It is not known if he was interested in the patterns of the cloth used in their clothing or in the way they held their shawls around them, but he did record these details.

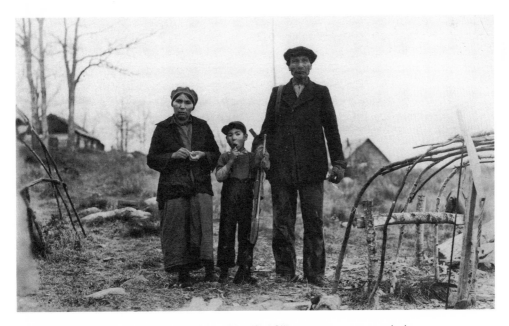

Ernest Oberholzer took this photograph of an unidentified Ojibwe man, a woman, and a boy at Rainy Lake in the 1920s or later. On either side of them are wooden frameworks, perhaps for shelters or houses. The season is probably fall. The boy looks like he is wearing a beanie or a baseball cap, and he has a lollypop in his mouth.

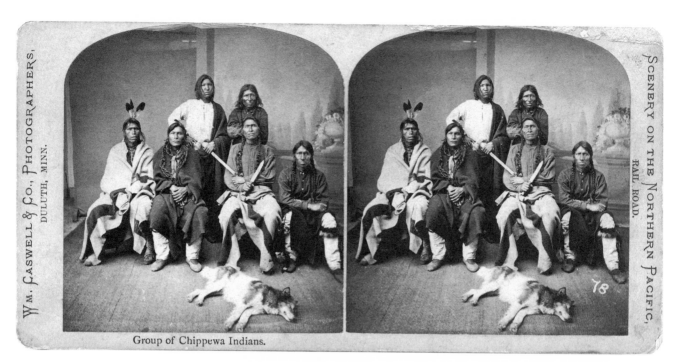

Group of Chippewa Indians.

This photograph of a group of Ojibwe men was taken in the Duluth photography studio of William Caswell and Company around 1871. It was marketed as a stereo view under the general subject: "Scenery on the Northern Pacific." Construction of the Northern Pacific railroad began just west of Duluth in 1871. Most of this studio's other photographs under this label were probably outdoor views throughout northern Minnesota.

The Ojibwe group is posed in front of a vaguely scenic backdrop. Two men are standing, four are seated, and all are wearing blankets, fringed leggings, and moccasins—clothing similar to that worn by Ojibwe leaders in photographs from the mid-1800s taken in places like St. Paul. At least one of the men wears a few feathers. The man on the right-hand side of the first row may be wearing skunk-skin garters on his legs. In the foreground, providing an additional sense of depth, a wolf-like dog seems to be sleeping. The label on the photograph says simply, "Group of Chippewa Indians." Some people have tried to deduce who these men were and how they happened to be in the photographer's studio in Duluth. Such explanations, recorded with copies of the picture, usually describe these people as "early residents" of Duluth, or Indians who visited the city to see Indian agents or traders.

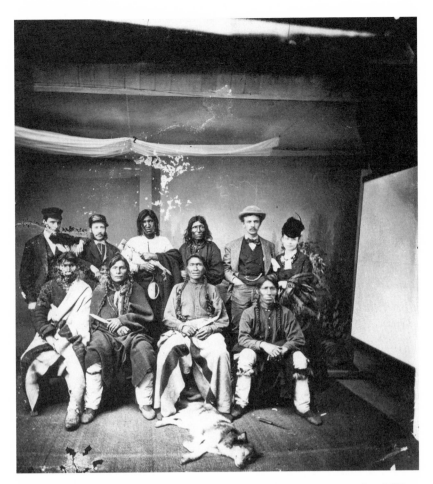

Another photograph of the same Ojibwe group, also taken in the Duluth studio of William Caswell and Company, provides some insight into the occasion recorded in the previous stereo view, despite the peeling emulsion in the negative from which the print was made. It shows the same Ojibwe men, plus three white men and one white woman. This image shows more of the photographer's studio paraphernalia than the stereo view. More of the rough carpet or mat on the floor is visible. In addition to the painted backdrop, there is a rolled-up white cloth above the people. At the very top of the picture is a band of white light, perhaps from a skylight. The screen at right may have been set up to reflect the overhead light onto the figures.

In the stereo view, the Ojibwe man second from the right in the first row holds a knife; in this image, that knife lies on the floor to the right of the dog, which has now shifted a little.

The man wearing the white hat in the back row is said to be Charlemagne Tower, Jr., the son of a Philadelphia financier. He came to Minnesota in 1883 as president of the Duluth and Iron Range Railroad, a company in which his father had invested. One copy of this photograph has a caption that reads: "These white people were of the Charlemagne Tower family, Philadelphians who came to build the D. & I. R. The Indians are in the picture for atmosphere—to impress the Philadelphians back home."

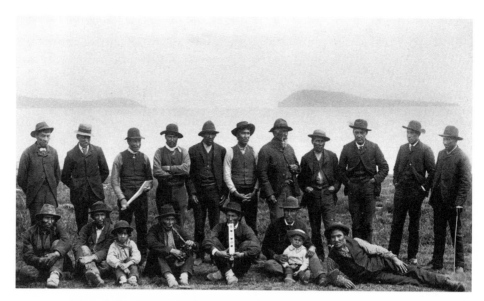

In June 1889, photographer George A. Newton of Duluth accompanied the Indian agent from La Pointe, Wisconsin, as he went to pay annuities of money, blankets, and cloth due to the Grand Portage Ojibwe. Newton took a number of impressive pictures of Ojibwe men. At this point in their history, they would not likely have worn blankets, so this photograph, looking toward the bay, appears to show them in their usual clothing.

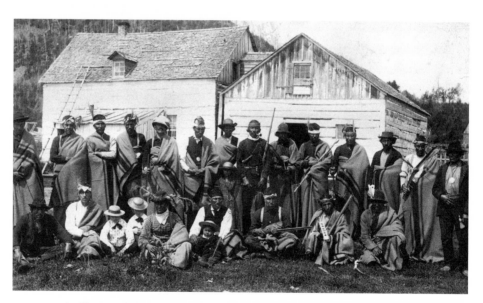

In this second picture by George A. Newton, the same Ojibwe men of Grand Portage are humorously dressed up, as one writer put it, as "wild Indians," wearing blankets that had just been given out as an annuity payment. Some of those pictured were visitors, who joined in the fun. It is not known why Newton took photographs of the group in contrasting styles of dress. Among the Ojibwe pictured were a number of Grand Portage community leaders, including Mike Flatte, standing second from left.

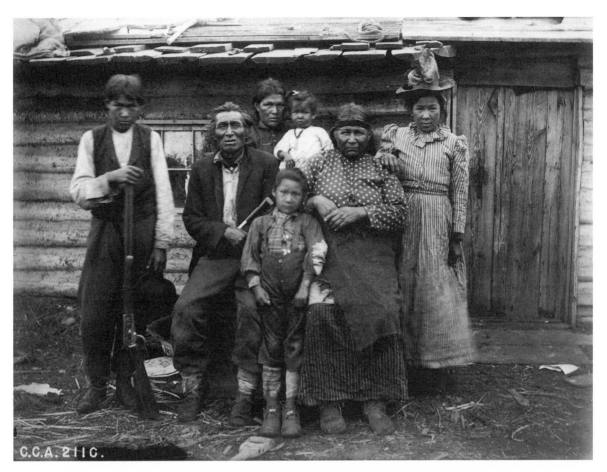

C.C.A. 211 C.

A family at Elbow Lake on the White Earth Reservation was photographed by Frank L. Hoxsie, working for Christopher C. Andrews, State Fire Warden of Minnesota, in April 1904. So far it has not been possible to determine the names of these people. At the time, Andrews, a pioneer in forest preservation, was concerned about the frauds perpetrated by lumber companies that cut down growing pine trees on Indian reservations under contracts to remove only fallen trees. On this occasion, Andrews and Hoxsie went to the area of Elbow Lake for the spring log drive. Andrews would later write that 70 percent of the logs he examined were from green trees. Underneath this photograph in his annual report, Andrews wrote, "Almost the sole wealth of the Chippewa Indians is their pine forests. If these forests were managed properly the Indians would always have a comfortable support. Under the present practice they will become beggars."

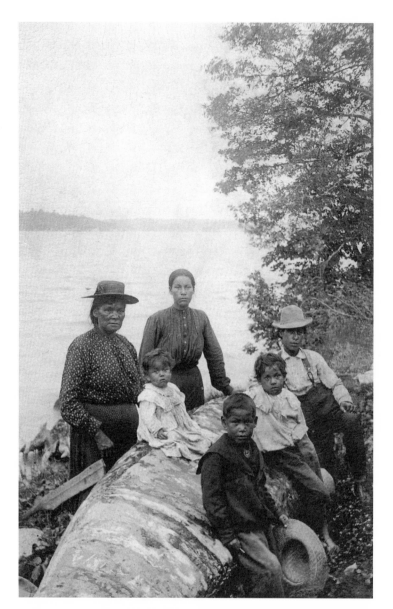

In this Cass Lake scene, the woman at left wears what looks to be a man's hat. The boy at right wears a sailor suit and holds a straw hat in his hand. They are grouped with others around an upturned birch-bark canoe. In the world of stereotypes, such juxtapositions are not supposed to happen.

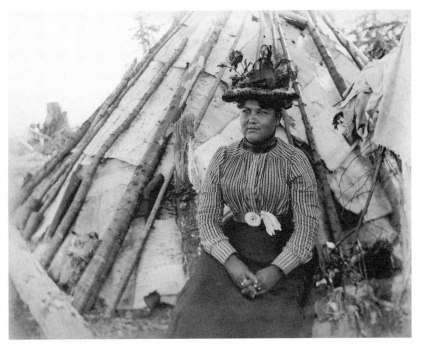

In this photograph, taken near Grand Marais around 1905, this woman's fashionable outfit and hat might seem incongruous when viewed in front of the bark structure behind her. Yet when this photograph was taken, Ojibwe people might very well have worn clothing like this, depending on the occasion and their wealth. Only the expectations of the viewer make it seem an odd combination.

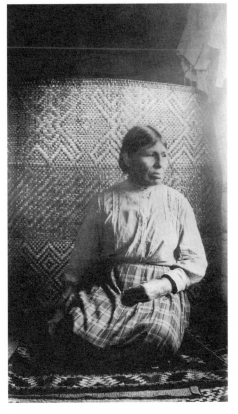

Mary Spruce of the Grand Portage Ojibwe was photographed in 1922 by artist Dewey Albinson. He used the photograph as a reference for a painting, incorporating the design from the woven mat into the painting's background.

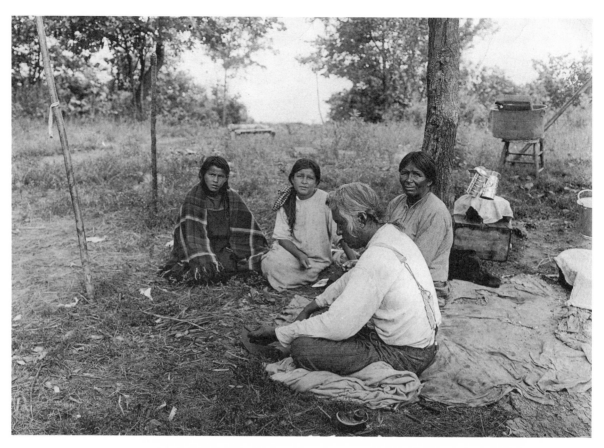

An unidentified Mille Lacs family, photographed around 1910 by an unknown photographer, sits on the ground in positions Frances Densmore described as proper for Ojibwe men and women: the man has his legs crossed; the girls are leaning to one side with their knees together. A washtub and wringer sits on a chair in the background. The purpose of the poles in the ground at left has not been identified.

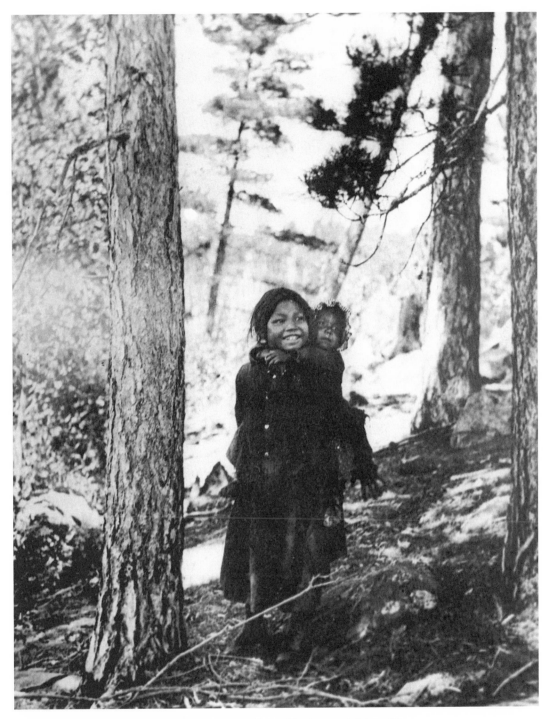

A young girl flashes a brilliant smile as a baby clings to her in this photograph taken at Tower in 1915. The unidentified photographer provided no more details about the circumstances in which the picture was taken. It is tempting to see this picture as representing a sense of humor or a zest for life among the Ojibwe, and this is a reasonable possibility. On the other hand, perhaps a moose ran in back of the photographer or her uncle said something funny while the picture was being taken.

In the cutover land around Mille Lacs, bark houses stretching away in the background, three young Ojibwe men in the foreground appear to be playing the moccasin game. Sitting in various postures on a log, three others seem to be uncomfortable, although this is not a certainty. They may all be waiting for the photographer to take the picture and go away. The sorry details of how the Mille Lacs people and their reservation were treated at the time are not recorded in this photograph, except that any marketable timber had been stripped from this land.

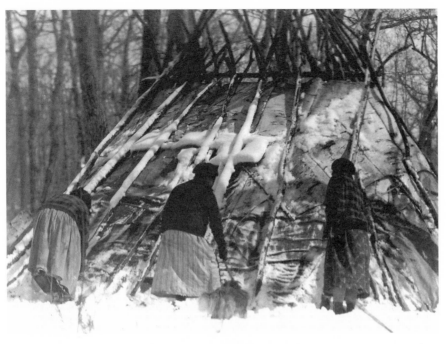

Mushkauwubequay (Mrs. John Mink), Maggie Skinaway, and Mary Bigwind clear away snow from the roof of a peaked lodge at a sugar camp near Mille Lacs around 1925. For those who knew the women, this view brings back fond memories.

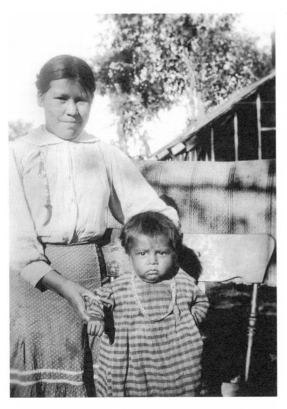

This photograph of an unidentified young woman and a small child was probably taken at Mille Lacs in 1918 by Hilding Swanson, a state legislator and a lawyer who sometimes represented Mille Lacs band members in court. On several occasions, he sent copies of his snapshots to the people he photographed.

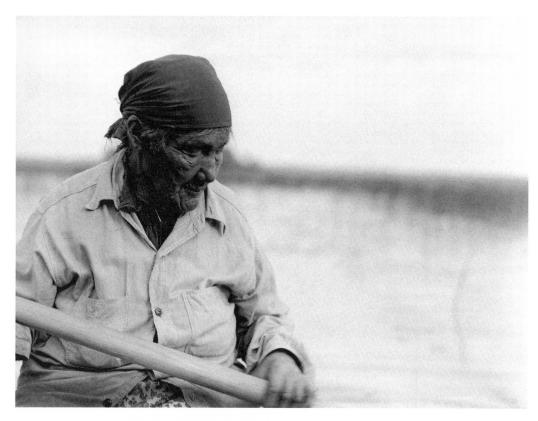

Monroe Killy photographed Mary (Mrs. Peter) Fields during the wild-rice harvest at Nett Lake in 1939. Her face, her clothing, her scarf, and the way she holds the pole are all beautiful, but what is beyond her and outside the photograph is also important.

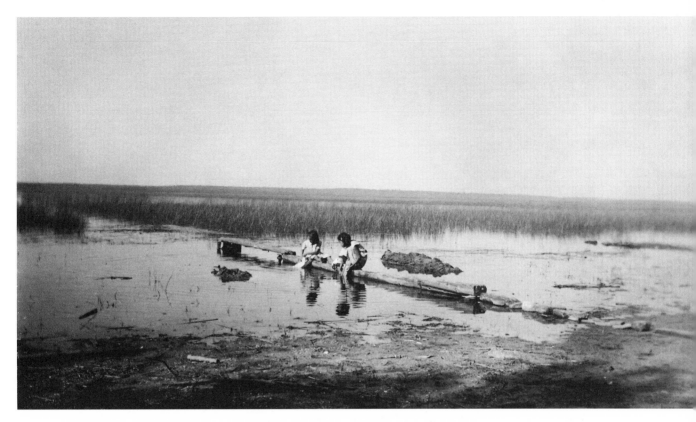

Nett Lake in the 1930s: two girls wash clothes on a narrow dock. The surface of the lake stretches off into the distance.

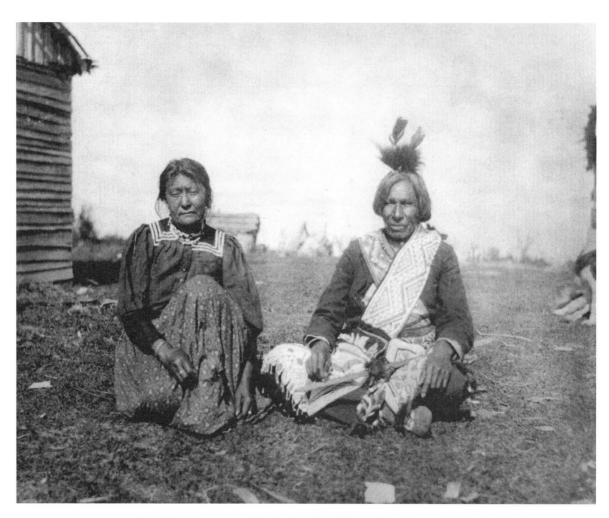

One of three men representing the Bois Forte Ojibwe in Washington in 1901, Debwawendunk or Moses Day is shown at right in a photograph taken at Nett Lake by William Jones around 1904. The woman at left is his wife, Sahkahmequaybeake.

7

Manaaji'iwewin / Respect

Manaaji'iwewin refers to the respect due all living beings, including beings that other peoples might describe only as things. It also describes an understanding of the power of a person or thing and sometimes the fear and avoidance of that person or thing. In the case of photography, it means to understand the power of the medium and to sometimes fear what it can do.

In the winter of 1901, three men from the Bois Forte Reservation in northern Minnesota, including Debwawendunk (or Moses Day), Mayjishkung (or John Johnson), and Bashitanequeb (or Charles Sucker), went to Washington, DC, to represent their people. While there, they were photographed by De Lancey Gill of the Smithsonian Institution. Gill took two photographs, one showing the men in Indian clothing. Sometimes Gill would provide feathers and apparel to visiting Indian people, but it is believed that the clothing worn by the men from Bois Forte was the kind the Ojibwe men would have worn at home on special occasions, such as dances and ceremonies. The other photograph shows the three men in what was known at the time as "citizen's" clothing, the everyday dress of whites and what these men likely would have worn on the train from Minnesota to Washington.

These two Gill photographs may have been intended as before and after shots. Similar late nineteenth-century photographs were often taken to emphasize how government officials and missionaries were transforming Indian life. When young Indians were sent to boarding schools, for example, photographers often took before and after pictures to show how discarding their native clothing "civilized" the children.

But one detail of these Gill photographs—a detail not immediately apparent to a casual viewer—destroys any symmetrical before-and-after meaning. In both photographs, Mayjishkung, the man on the left, holds an otter-skin medicine bag used in the ceremonies of the Midewiwin. The leader of the ceremony would use the bag to "shoot" life-giving forces into the members of the order. Those shot would fall to the ground, only to be revived when shot again with the same otter-skin bag. The presence of the medicine bag in both photographs is an interesting, ironic detail. It is also a commentary about the whole practice of photography and the way it has recorded Indian people in general and Ojibwe people in particular.

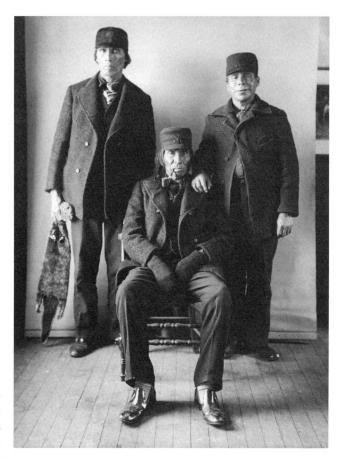

Two contrasting photographs taken by De Lancey Gill show Mayjishkung (One Equal to an Emergency or One Who Does Things) or John Johnson and Day-bway-wain-dung (or Debwawendunk, Sound in the Distance) or Moses Day, both from Nett Lake, and Bashitanequeb (Steps Over) or Charles Sucker from Vermilion River. The three men represented the Bois Forte Ojibwe in Washington, DC, in 1901.

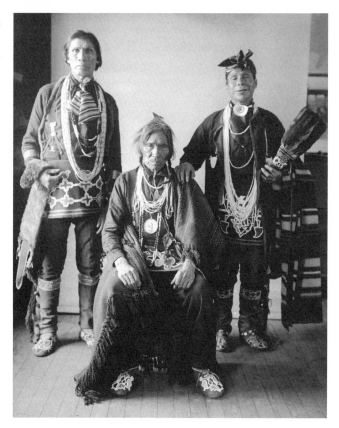

A common view of photography is that it is a predatory act. Photographers are often said to "shoot" their subjects, to "capture" them on film. As Susan Sontag has pointed out, the pervasive cultural model of photography is an aggressive one, predatory, automated, "ready to spring." Furthermore, she suggested that picture taking is "a semblance of rape." In contrast to the Ojibwe medicine bag, the camera does not "shoot" life-giving forces to bring about human well-being, it "shoots" to capture faces, people, things, identities. Thus, in these photographs, two kinds of power are juxtaposed: the power of the medicine bag and the power of the camera. The photographs represent a kind of cross-cultural visual pun as well as disparate views of the practice of photography.

Commentary about photographs often emphasizes the power of the photographer but seldom mentions the power of the people being photographed. The possibility that subjects might have taken an active role in the photographic process, shaping the image in particular ways, is not usually understood or acknowledged. For example, photographers have often presented the Ojibwe and other Indian people as the photographers imagined they were in the past; the photographers often clothed the people or presented them in ways that emphasized a so-called traditional, tribal image. But photographers weren't the only ones who wanted these kinds of pictures. The Ojibwe people themselves sometimes took part in this image making, presenting themselves in ways that appealed to their own sense of a tribal past or present. The purpose behind the resulting photographs is sometimes clearly evident, sometimes hidden.

It is impossible to know exactly what Mayjishkung's intention was when he stood for Gill's photographs. But it is important to note that in the photograph in which he wears beaded clothing, the bag lies draped easily over his wrist. In the other photograph, in which he wears citizen's clothing, he grasps the bag tightly in his right hand. Gerald Vizenor discussed the power of photographers and photographs to transform Indian people into distorted symbols. Yet even in photographs, he notes that the real people made into the subjects of such representations survive, in their eyes and hands—"the traces of native survivance."

The challenge in considering historical photographs of the Ojibwe people is to look beyond the stereotypical images both positive and negative, to look for those stories in the eyes and hands. Survivance is both survival and resistance. In the case of Mayjishkung, the way he holds the medicine bag, the symbol and tool of his beliefs and power, is an assertion of resistance to the power both of government officials to create scenarios of cultural transformation and of photographers to affirm those transformations.

Is this what Mayjishkung had in mind? W. E. Culkin, a white visitor to Bois Forte in 1914, wrote in a condemning tone in a Duluth newspaper article: "May-jish-kung is an old time conservative—a veritable stand-patter Indian and bitterly resents innovation. He stands for the past for all things while he sees them coming on all sides . . . Of all the company he stood apart alone, erect, his brown eyes blazing."

Culkin went on to imagine that from the look in Mayjishkung's eyes, the Ojibwe leader hated white people and dreamed of a day when the Ojibwe would recapture their ascendance over their country. This interpretation seems as stereotypical as many others. But perhaps Mayjishkung, for a few moments in a photographer's studio, asserted some control and resistance, changing the meaning of what would have otherwise been a simplistic message of transformation. The way he holds the medicine bag, the symbol and tool of his beliefs, may represent his resistance to government officials' attempts to transform culture and of photographers to affirm those transformations.

Mayjishkung's triumph in the face of a studio camera is not something that is supposed to have happened. Photography is supposed to have made Native people tremble, to fear its power. Anyone who studies the interaction of a group of non-European people with the process of photography is apt to think about or be asked about this fear of photography.

A common myth in Western European societies is that somewhere in the world there are primitive people who once feared or who now fear the power of photography. Writers speak of "remote corners of the world where picture taking is taboo," as Graham King put it. Tribal peoples supposedly see photographs and the process of photography as magical. They are said to fear that when they are photographed their spirits are stolen from them—that photographs are not representations but a part of the thing portrayed, containing the original's essence. Hence, if harm befalls the image, the person portrayed will also be harmed. Anthropologist Edmund Carpenter wrote that this idea is prevalent throughout New Guinea, saying: "it's commonly feared that if one's image falls into the hands of an enemy, he may use it mischievously. Sorcerers believe they can render even the mightiest helpless . . . or injure another by introducing his likeness into an unpleasant situation. A sorcerer who possesses any part of his victim, anything once him—hair clippings, footprints, etc. has him at his mercy."

Frances Densmore reported a similar belief among American Indian groups: "There seems to be inherent in the mind of the Indian a belief that the essence of an individual or of a 'spirit' dwells in its picture or other representation. To this belief was due the reluctance of the old-time Indian to be photographed, his reason being that harm would come to him if harm befell his portrait."

Densmore may have meant to include the Ojibwe in this characterization, though no explicit example of this belief has yet been found in the Ojibwe culture. Still, these ideas are consistent with Ojibwe beliefs about human representation. These beliefs can be traced in the visual images produced by these people in the past.

Before the middle of the nineteenth century, the most common traditional human representations of people among the Ojibwe were pictographs—drawings or carvings on wood or stone. Pictographs served as everything from graffiti to mnemonic devices for remembering songs and rituals. Most commonly they were used as a message system. As ethnographer Joseph N. Nicollet wrote in 1837: "They use this figurative language strictly for their needs as they travel or hunt or wage war in order to make known their whereabouts and the events they witnessed to show where they came from, where they are heading, and what they plan to do, and to tell of the things they saw, etc. They left these messages at forks in rivers, on lake shores, and along portage trails."

Nicollet recorded a grammar of this Ojibwe pictographic system. Human figures were rudimentary. A symbol of a *doodem* (the root of *indoodem,* meaning "my clan"*),* or totem, above or below the figure identified the person the figure represented; this animal totem indicated the person's clan. If the person were a man, a penis would be drawn on the animal figure, not on the human one. If the person were a woman, the human figure would have two spots on its chest, representing breasts, and at least the outline of women's clothing. Generally, totemic symbols were also drawn or carved on grave markers to indicate the identity of the deceased.

The only people who were represented exclusively with human figures, rather than animals, were those from outside the society who did not belong to any totemic groups. John Tanner, a white captive who lived among the Ojibwe, said that they believed "all other Indians to have totems, though . . . they are in general . . . ignorant of those of hostile bands, the omission of the totem in their picture writing, serves to designate an enemy. Thus, those bands of Ojibbeways who border on the country of the Dahcotah, or Sioux, always understand the figure of a man without totem, to mean one of that people." White men were shown without totems and generally identified by their style of clothing and hats.

As a message system, pictographs had the advantage of being both public and private. The information communicated in a message was only of use to someone who knew the people shown. For example, one message Nicollet recorded indicated that a man of the bear totem and a woman of the eelpout totem left a son and daughter in their house; they took another son with them when they went to the "two lakes," where they were drying the meat of a deer the husband killed. The exact iden-

tity of the particular family would be clear only to someone who knew the family's totems and the number of children they had. Strangers who shared one of the totems might find the message to be of use, but it would not reveal the precise identity of the people involved. People could safely assume that a certain amount of information would be kept private, even though the message was left in a public place.

Totemic symbols were not an exhaustive description of any particular Ojibwe person, nor was the totemic system the most important way to define people. Totems were simply the most public kind of framework into which people were placed. Beyond that, each individual had many other ways of defining himself or herself individually and in relation to others.

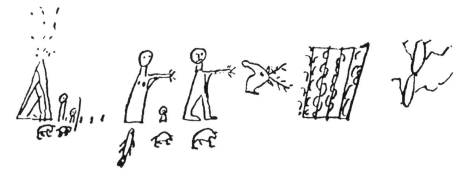

This pictographic message, copied by the French geographer Joseph Nicollet in 1837, said that a man of the bear totem and a woman of the eelpout totem left a son and daughter in their house and took a son with them in going to the "two lakes," where they were drying the meat of a deer the husband had killed.

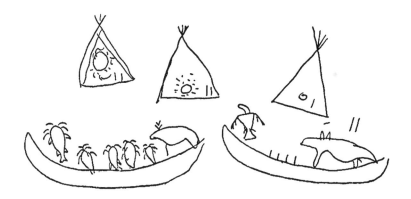

This complex pictographic message, recorded by Frances Densmore in *Chippewa Customs*, says that, among other things, three canoes started out on a journey. The occupants of two canoes camped at a particular location for two days and had plenty of food. The occupants of the other canoe stayed for only one day, found no food, and went away. Of the two families that stayed, one consisted of a mother of the bear clan and a father and children of the catfish clan and the other consisted of a man of the eagle clan and a wife of the wolf clan.

Occasionally Ojibwe appear to have made pictorial representations of their personal names, though few such examples have survived. Perhaps such symbols were tantamount to speaking one's name in public, which some people were reticent about doing. It was also considered impolite to address people by their names; instead, kinship terms were used in talking to both family members and strangers. No explicit symbols represented family relationship. However, if a message depicted people in canoes, the arrangement of the figures could imply sex and relationship, since men more often sat in the front of a canoe and women in back. A person depicted at the back of a canoe and having a dodaim different from the others in the canoe might be assumed to be

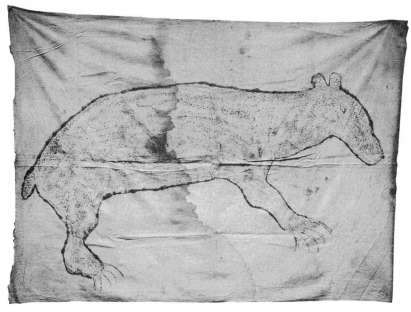

An Ojibwe person's bear dream symbol on cloth given to Frances Densmore

The pictographic signature of the leader Po-go-nay-ke-shick (Hole-in-the-Day or Hole-in-the-Sky), the father of a later chief of the same name, was recorded by Joseph Nicollet in 1837

the mother, because women were identified by the totem of their birth clan, while the children's totems would be the same as their father's.

These pictographic symbols reveal something of what it meant to be a "person" among the Ojibwe, that is, the way in which the individual was defined in relation to other members of society. The symbols did not identify individuals as separate and unique but as members of a group, people with obligations and privileges related to that group. For example, members of the same dodaim shared food and showed concern for each other in cases of need. The pictograph represented this relationship, not any unique personal identity.

By symbolizing people through their relationships to each other, totemic symbols referred to one of the basic structuring ideas of Ojibwe culture: the belief that all creatures are related and should have concern and respect for each other. This same idea was also the basis of the symbols that many Ojibwe carried to represent the power-giving dreams that they had when they were young. These symbols represented their relationships with protective spirits who guided them throughout their lives. The symbol might be displayed, but its meaning and the dream through which the person initially established this relationship were never discussed publicly. Doing so could damage the relationship.

How might the Ojibwe have viewed the earliest photographs—such as Joel Whitney's studio portraits of Ojibwe leaders—in comparison to these pictographic symbols? From the European American point of view, the photographs might have been seen as more realistic than the totems. But the totemic symbol is realistic in the sense that it records an important aspect of each person's tribal life. Exactly what aspects of a person were represented in photographs? And, just as important, what was left out?

The earliest photographs of Ojibwe isolated the Ojibwe leaders in studios, spaces designed, created, and owned by photographers. These photographs depicted people as separate and distinct individuals, standing alone, not as part of a community the way totemic symbols did. The individual was presented as divorced from all relationships, unattached, without privileges or obligations. In a sense, these photographs presented individuals as the mythical economic man of capitalist society, an individual free of all encumbrances, the sort of person that many whites hoped native people could be persuaded to become. This image was quite different from what it meant to be a person among the Ojibwe.

The photograph is also an imitation of the physical person. It closely resembles the people it portrays, though in a flat, miniature form. This view of photographs corresponded to another Ojibwe belief: that a miniature imitation of a person or animal could be used to gain some

control over that person or animal. During the winter, when all ordinary means of hunting had failed, Ojibwe people sometimes performed a ceremony that Nicollet called a *manitokazowin*. They would implore a benevolent spirit to bring success in hunting and trace symbols of the desired animal on a board or a piece of birch bark. The symbols were an outline of the animal's body with a line connecting its mouth and its heart, showing the way in which the power of the person performing the ceremony would reach the animal's spirit.

John Tanner called all of these symbolic representations *Muz-zin-ne-neen,* meaning "the picture of a man," and said that such symbolic representations were not only used in hunting but also in "the making of love, and the gratification of hatred, revenge, and all malignant passions." In cases of love, Tanner reported, a young Ojibwe woman might pay an older woman with some spiritual power "to purchase from her the love of the man she is most anxious to please. The old woman, in a case of this kind, commonly makes up a little image of stained wood and rags, to which she gives the name of the person whose inclinations she is expected to control; and to the heart, the eyes, or to some other part of this, she, from time to time, applies her medicines."

This drawing represents an Ojibwe love-charm song recorded by Frances Densmore of several women singing. The words to the song are: "I can charm the man. He is completely fascinated by me." In the drawing, the line to the man's heart shows how the charm would exert its power.

If someone wanted to bring harm to another person, Tanner said, the symbolic representations "might be pricked with a pin, or needle, in various parts, and pain or disease is supposed to be produced in the corresponding part of the person practised upon," a ritual resembling voodoo.

Early photographic portraits, then, did not delineate a person's relationships to other people as totemic symbols did but instead presented a kind of symbolic miniature version of the individual comparable to the human and animal representations used in hunting and sorcery, means used to gain control over people and animals. Given that such objects were one of the culture's few ways of depicting people as separate individuals outside of the totemic system, it would have been logical for the Ojibwe to regard photographs of individuals in the same way and fear them the same way the photo-fearing native of Euro-American anthropological myth did.

But there is no evidence that the Ojibwe feared photography, though it may have surprised them, like most people, when they were first exposed to it. Among the earliest photographs of Ojibwe are portraits of people such as Po-go-nay-ke-shick, or Hole-in-the-Day, and Naganab, both of whom appear to have had a sophisticated sense of ways personally important messages could be expressed through photography. And later on, as photo technology became cheaper and more widespread, the Ojibwe found ways to record important family relationships, shaping photographs in a manner more in keeping with their own cultural ideals. The photographs Ross Daniels took at his studio in Pine City are an example of the way Ojibwe used photographs to record family groups and relationships. Even later, Ojibwe people obtained simple cameras to make their own family pictures in the same way that white people did.

Nonetheless, some Ojibwe today, like people in other native societies, do believe that certain things should not be photographed. These beliefs have little to do with so-called superstitions. In many cases, these beliefs are a recent development and are a reasonable reaction to the way in which photographs function in modern society. It can be argued that the fear of photography may be more a product of the modern camera culture than a belief of so-called primitive people confronting the modern world. The fear of photography may be more common among people who know what photography can do than among people who have not seen its power.

European Americans often believe that a photograph never lies. The photograph's authority comes from the belief that, as Susan Sontag said, a photograph is "the registering of an emanation (light waves reflected by objects)" and is "not only an image (as a painting is an im-

age), an interpretation of the real; it is also a trace, something directly stenciled off the real, like a footprint or a death mask."

Since photographs are in this sense a material vestige of a thing or a person, they are sometimes considered the property of that thing or person or those who respect that person. Many ordinary people, as well as celebrities like Marlon Brando or Jacqueline Kennedy Onassis, have tried to avoid being photographed, believing that the process would be directly harmful in some way.

The people involved suggest that when their photo is "taken" without their consent, something of value to them is being appropriated. Yet this resistance to being photographed is related only partly to beliefs about an identity between image and object. It also has to do with the way in which the photographs are used. Celebrities object to being photographed because the images are often given a particular meaning and put into contexts that seem untruthful, or at least atypical, to them. It may also be that the camera freezes them into unflattering poses—poses that are untruthful because they reveal only a part of their personalities.

In twentieth-century America, it is said that people who choose to become part of public life give up their right to control the quality and quantity of things that are written and shown of them, at least in other uses besides advertising. Nineteenth-century American Indians became unwilling celebrities—or curiosities, the nineteenth-century equivalent of celebrities. Like Jacqueline Kennedy Onassis and other celebrities, they had no way of controlling what was written about them or the ways they were pictured.

Among the Ojibwe, questions about the taking and use of photographs reflect broader questions about intangible property. The idea that a person owns his image in some ways is comparable to the idea of intellectual property, such as knowledge of the medicinal uses of plants or familiarity with religious rituals. In the Midewiwin, knowledge of rituals and their meanings can be obtained only by those who are members, who have paid the price and have been properly initiated. Whites frequently have sought and obtained knowledge of the Midewiwin without being properly initiated into it. Chagobay, Nicollet's guide on his visit to the Ojibwe country in 1836, showed him some of the secrets of the Midewiwin. The Leech Lake leader Eshkebugecoshe, or Flat Mouth, later performed a ceremony in which Chagobay was pardoned for this breach of trust. Frances Densmore unwittingly brought harm to Maingans the Elder, another member of the Midewiwin, in February 1908. In a description of her first recordings of Ojibwe music at White Earth in 1907, Densmore wrote of Maingans the Elder. She persuaded the man to perform a portion of the ceremony before an audience at a lecture she gave and also before De Lancey Gill's camera. In response,

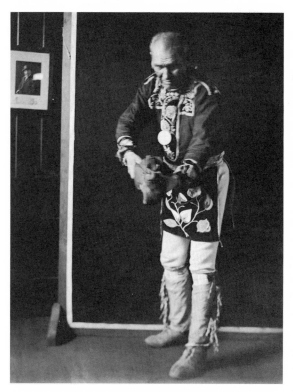

De Lancey Gill of the Smithsonian Institution took this photograph of Maingans the Elder performing part of the Midewiwin ceremony in 1907.

the other members of the Midewiwin did not allow Maingans to take part in the ceremonies at White Earth the following June. Shortly after, when the man's wife died, according to Densmore, this was attributed to his performance "for the pleasure of white men." They may have been objecting not to the photograph but to the fact that Maingans had sung and danced a segment of the ritual in the wrong circumstances for nonmembers.

Throughout the early 1900s, white people took photographs of Mide ceremonies being performed in Ojibwe communities, perhaps with the permission of some Mide members. But in the 1930s, photographing the Midewiwin ceremony was not acceptable. In 1932, Monroe Killy asked for permission to photograph within the Midewiwin enclosure at Leech Lake but was allowed to do so only during a rest period in the ceremony. It is likely that taking pictures of the Midewiwin ceremony would not be allowed today.

The response to the photographs of Maingans the Elder illustrates that the Ojibwe were conscious of the context in which knowledge is used. Photography, like other mechanical methods of recording Ojibwe culture, can give people knowledge without assuring that they exercise it responsibly or with the proper sense of respect.

In 1913, Moses Day, one of the three Bois Forte men that Gill photographed, returned to Washington, DC, and Frances Densmore recorded some of the Mide songs he knew. Densmore wrote in *Chippewa Music* that "before singing the first song De'bwawen'dunk made a short speech in Chippewa, speaking to the four Mide 'manido,' explaining that he was not going about the city belittling their religion, and begging that they be not offended because circumstances made it impossible for him to smoke the customary pipe before singing."

Was Debwawendunk's apology for the way he had performed these songs also an apology for the uses to which these recordings might eventually be put? Would all those who heard and possibly learned these songs from the recording show the same respect that he had?

Some Ojibwe object to the dance drums being photographed. These drums are living entities, and to photograph them might show disrespect. When John W. G. Dunn appeared at Jim Stevens's home in Lake

Lena in 1928 with his Graflex camera, Stevens declined to take down his large drum from its shelf, saying it was bad luck to do so. But the drums have been photographed, often by photographers who probably thought they did not have to get permission because they were at a public dance. The keepers of the drum may not have known the drums were being photographed. One anonymous, unlabeled photograph in the Minnesota Historical Society collections shows a drum and a child sitting inside a cloth tent, perhaps during a break in a ceremony. The picture may have been taken by a visitor who did not know permission might be required.

Other photographs of drums may have been taken with the permission of the drum keepers. But exactly what did that permission entail? Did the person giving permission anticipate all subsequent ways the photograph might eventually be used? Does permission given for a picture to be taken actually mean permission to use the picture in any way a user may one day see fit? Does putting the photograph in an advertisement or hanging it in a restaurant do honor to the drum? Does the use fee paid to the archives that has the photo of the drum indemnify the spirit of the drum for the damage done when someone sees the picture and calls the drum a "tom-tom"? Does showing the drum to others do the drum or its keepers any good?

For white people, early photographs of the Ojibwe and their cultural items were fetishes, symbolizing the hunting and capture of American Indians. Once images of Ojibwe were recorded on film by white people, they were poked and prodded and put to many uses the subject, or sometimes the photographer, could not have imagined. The photographs did not serve the individuals pictured but served white people's beliefs. All of this was contrary to the nature of the specific moment the photographs record. Anthropologist Ira Jacknis wrote, "Photographs can only be seen in a generalized way by means of their verbalized accompaniment or lack of it. With no words to guide use, we are as free as we wish to conjure identifications or contexts, creating the meaning from what we bring to the image. The verbal labels attached to the picture limit the range of possible meanings." Anthropologist Sol Worth wrote that unless viewers understand that photographs are coded symbols made by photographers, viewers "attribute" meaning to the photograph. They think the things pictured in the photo have all the meanings—whether practical or symbolic—that they are believed to have in real life. Meaning is "put onto the picture from outside the picture itself" and is often based on "sociocultural or psychological stereotyping."

Adopted by European Americans as a cultural icon, Native Americans—in person and when recorded visually on paper—exert a particular fascination for white people. Almost any old photograph of someone identifiably "Indian," whether it be a commercially produced image or

a family photograph, would probably find a ready market among private collectors and archival collections, regardless of time, place, or subject recorded. It is hard to know what such images actually mean to the people who collect them. But it is clear that given a lack of specific knowledge of such photos, many viewers are forced to resort to their own ideas about how to interpret the subjects pictured, writing their own captions for the photographs. If no attempt is made to place these photos within a context that seeks to undermine old stereotypes, such photos simply confirm all the prejudices and culturally determined ideas that white people have about Indian people.

Joel Whitney's early portraits of Ojibwe leaders presented a distorted view of these people by showing them outside of and isolated from their communities and by portraying them in articles of clothing and with objects that may not have been their own. In the form of cartes de visite, Whitney's photographs at least may have celebrated the dignity of Ojibwe chieftainship, though in a stereotypical way. But others used Whitney's images in less complimentary ways, and the photos showed up in surprising contexts that were bolstered by the prejudices of their viewers. For example, an illustrated documentary novel and travelogue entitled *Dakota Land: or, The Beauty of St. Paul, An Illustrated, Historic and Romantic Work on Minnesota and the Great North-West* by Colonel Hankins, published in 1869, just at the time when it was possible for tourists to reach St. Paul by train, contained engravings of various aspects of local scenery, including a number of Indian portraits based on Whitney photographs. All of the portraits had short captions with varying degrees of accuracy. Most were of Dakota people. One photograph of Kwiwisens (or Po-go-nay-ke-shick, Hole-in-the-Day)—who, it has been argued, had a sophisticated knowledge of European imagery—had a racist, derogatory caption that said: "The number of Eagle Plumes on his head indicate how many murders he has committed; but tell us of no good he ever did."

Often the way photographs of Ojibwe were used, especially by newspapers, was less blatantly racist but still insidious. Editors, pursued by the daily need to illustrate their stories, cannibalized their picture files for images already used for one story and made them fit others.

Edward Bromley, the Minneapolis newspaper reporter and photographer, visited several Ojibwe reservations in northern Minnesota in the 1890s. But many of the photographs he took were not actually used to document stories about the individual places or persons he photographed. Instead they became generic, all-purpose, newspaper symbols of the Ojibwe. An example was a photograph taken at Leech Lake in 1896 showing birch-bark canoes beached on the shores of the lake and several women seated on wooden boxes looking at the camera. The photograph was later used to illustrate articles on the so-called "Leech

Lake Uprising" in 1898 and an article on the removal of Mille Lacs people to White Earth (see chapter 3). None of these uses actually dealt with the specificity of the original moment in the photograph.

The photographer concerned about his or her pictures being misrepresented might suggest that the photographs should be run without captions. This strategy was practiced particularly by those who believed that photography is a fine art and that photographs are chiefly interesting as expressions of a photographer's talent. People who omit captions or labels may be less racist, but they share something of nineteenth-century attitudes. They have little interest in the specific time, place, and person portrayed simply because art is supposed to transcend these specifics. The image's ability to transcend the social and cultural context of the scene or person it shows is assumed to be a virtue. Photos that depend on context—context that might need to be explained in words—are valued less than the generic, discrete, all-purpose image.

But without explanatory captions, such images are left open to inaccurate interpretation. Euro-American racism and ethnocentrism are still allowed to shape the way people look at these photographs. For these reasons, it could be argued that Native Americans or others were right in fearing that harm would come to them if their pictures were taken. These images often simply bolstered existing prejudices. They were used in derogatory contexts. A photograph of a drum or a Mide ceremony could be used in a context that distorts or does violence to their secret and sacred meanings.

Could these images be placed in other contexts that accurately portray Ojibwe life? Is it possible to strip away the damaging and inaccurate texts that these photographs have worn since they were made and replace them with new contexts that have respect for their subjects? Can photography in general be made to serve other purposes? Is it possible to take a respectful photograph of a drum?

Some have suggested that the effort to fix meaning in photographs is entirely futile simply because of the nature of photographs. Sontag, for one, wrote scornfully of those "moralists" who believed that "words will save the picture": "What the moralists are demanding from a photograph is that it do what no photograph can ever do—speak. The caption is the missing voice, and it is expected to speak for the truth. But even an entirely accurate caption is only one interpretation, necessarily a limiting one, of the photograph to which it is attached. And the caption-glove slips on and off so easily."

Yet if this is the way photography often works in our society, it is possible that it can be otherwise. The way in which modern society uses photographs is a cultural pattern. The myth of the photographer as an aggressive hunter of images who must be allowed to pursue his or her prey shapes our attitude toward how we permit photographs to be used.

But there are other metaphors for describing the actions of photographers and other ways of using photographs.

Many of those who write about photography have noted that there are really two kinds of contexts in which photographs can be made and used: one public and one private. The art critic John Berger wrote that "the private photograph—the portrait of a mother, a picture of a daughter, a group photo of one's own team—is appreciated and read in a context which is continuous with that from which the camera removed it . . . Such a photograph remains surrounded by the meaning from which it was severed. A mechanical device, the camera has been used as an instrument to contribute to a living memory. The photograph is a memento from a life being lived."

Although the Ojibwe might have every reason to be suspicious of photographers, many Ojibwe have appreciated and do appreciate historical photographs of their people, even ones taken by white photographers. Despite the photographers' mixed motives, their images, like those Ojibwe took of each other, were and are valued by the subjects' descendants as important pieces of their own history, a record of familiar faces.

Roland Reed said that his first opportunity to photograph people at Red Lake came when he took the picture of a young boy who later died; Reed gave a copy of the picture to the grateful father (see chapter 4). In such situations the process of photography bears little resemblance to the use of fetishes in sorcery. Such photographs are the modern equivalent of the mourning bundles that many Ojibwe once carried after the death of loved ones. Commissioner of Indian Affairs Thomas McKenney's artist James Otto Lewis painted a picture of an Ojibwe woman holding such a bundle. According to a variety of sources, a locket of the deceased's hair was wrapped with articles of his or her clothing. Family members would carry the bundle, which anthropologist M. Inez Hilger called a *wiwapi'djigan,* for a year, addressing and talking about it in the same way that they had the deceased person. At the end of the year, the family might hold a feast and give the clothing away. Such bundles were a symbolic image of a loved one, an opportunity for continued remembering and grieving. They are also a metaphor for a different kind of photography.

Family photographs, when owned by family members, exist in a living—and loving—context. They do not need labels or captions because the owners of the photographs know all about the people pictured. Opening the family album is an occasion for retelling stories, commenting on the moments pictured and the clothing worn. Family photographs are shaped by a social process and made to serve ends the family considers desirable. Similarly, portraits or wedding photographs taken by commercial photographers, though perhaps only minimally shaped by family members, become incorporated into a family context in the

same way. This is certainly the case with the photos Ross Daniels took of Ojibwe from the Pine City region. The photographs he took were put on the wall or into a family album. The identity of the photographer is not important; the fact that these are images of family members is.

As soon as such photographs leave the hands of the family, the pictures and the people in them are suddenly devoid of their context. These family photographs—when sold in second-hand stores and at auctions—usually have little value for people unfamiliar with the subjects. An exception is when the photographs record celebrities, Indian people, or unusual subjects, such as a masquerade party in which everyone is dressed in odd costumes. In the latter case, memories about the people dressed in those costumes are irrelevant. What is important to the new owner of these family photos are the odd costumes. The photo-

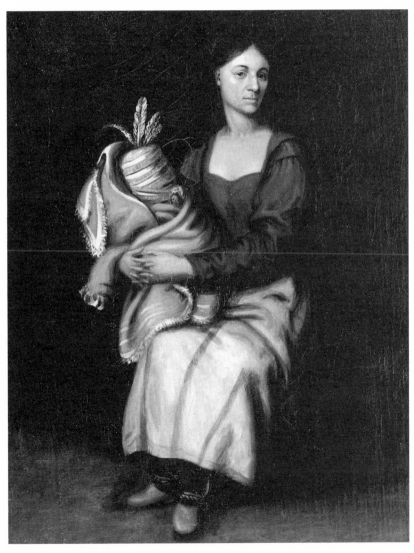

This Henry Inman painting, based on an earlier work by James Otto Lewis from the 1820s, depicts an Ojibwe woman holding a mourning bundle.

graphs have become images not of specific people but rather of people wearing odd costumes. "The contemporary public photograph," as John Berger noted, usually presents an event, a seized set of appearances, which has nothing to do with us, its readers, or with the original meaning of the event. It offers information, but information severed from all lived experience. If the public photograph contributes to a memory, it is to the memory of an unknowable and total stranger.

On the other hand, as Berger puts it, "the private use of photography, the context of the recorded moment is preserved so that the photograph lives in an ongoing continuity. (If you have a photograph of Peter on your wall, you are not likely to forget what Peter means to you.) The public photograph, by contrast, is torn from its context and becomes a dead object that, exactly because it is dead, lends itself to any arbitrary use."

Context is crucial to the understanding of many public Ojibwe photographs. Some of the context has to do with the culture of the people pictured. The people's gestures, the clothing they wear, the objects they hold, the items sitting on their shelves in the background—all may have special meanings to Ojibwe that they would not have to most European Americans.

For example, anthropologist Irving Hallowell, who did research among the Ojibwe of Manitoba, wrote about how he photographed an elderly man and woman as some of their relatives watched. Just before Hallowell was to take the picture, the woman "reached over toward the old man's fly as if to unbutton it." All those who watched went into "peals of laughter." The two were cross-cousins of opposite sex who were expected to have a kind of teasing, joking, bawdy relationship. Had Hallowell actually taken a photograph at this moment, the resulting image might have been understandable to many who had a general knowledge of Ojibwe culture.

However, general cultural knowledge does not always give us a complete understanding of the experiences of the people in photographs or of their relationships to each other. A woman holding a child in a photograph is assumed to be that child's mother or, if old enough, grandmother, though this is not always the case. Photographs are so specific that no one, no matter how knowledgeable about the culture and history of a people, may be able to accurately interpret the specific experiences, unless he or she was there when the photograph was made or knows the subjects.

The dynamics of the relationship between photographer and subject are sometimes puzzling. Photographers who are strangers to those they photograph may make unreasonable demands on their subjects. At the very least, because of the speed of the camera, photographers may not bother to build a relationship with the subject. Some photographers even try to avoid establishing a relationship for fear of encum-

bering themselves with obligations. Such attitudes leave their mark on the image.

Stella Prince Stocker, an amateur photographer from Duluth, mentioned in her diary that she tried to photograph a woman at the June 14, 1916, celebration at White Earth. The woman did not want to be photographed, and as Stocker pointed the camera at her, she turned around and went back inside her tent. The resulting photograph, pasted in Stocker's photo album, records the woman's back.

A photograph's details are not self-explanatory. When Doris Boswell came to the door of her house in 1928, holding her young daughter in her arms, and greeted the photographer Dunn, she had bread dough on her hands—dough that was forever, though ambiguously, recorded in Dunn's picture. Without Boswell's testimony in 1987, few people would know what was on her hands—a detail that illustrates Vizenor's statement about the stories of survivance in the eyes and hands of Indian people.

Similarly, facial expressions are ambiguous, despite viewers' tendencies to ascribe to a person's face the emotion they feel about the subject's situation. The girl with the brilliant smile in a photograph taken

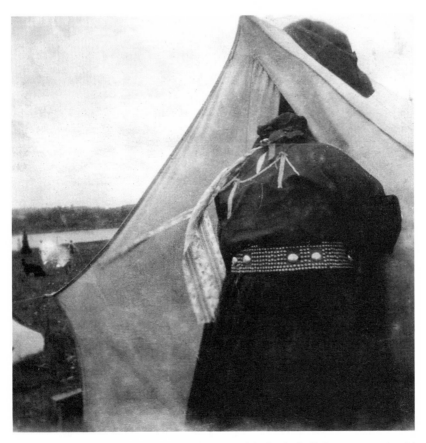

In 1916, Stella Prince Stocker snapped this image of the back of a Dakota woman who did not want to be photographed, at a June 14 celebration.

near Tower (chapter 6) may have had many reasons for smiling. If a person appears to be frowning, the expression could be simply a transient facial movement. It could also be a comment on the photographic process or a frown directed at someone behind the photographer. There are many possibilities.

In a famous essay, anthropologist Clifford Geertz, citing the philosopher Gilbert Ryle, pointed out that the difference between a wink and the twitch of an eye is all in the context. A person recorded on film with a single closed eye may be winking or may simply have a piece of sand in his or her eye. And if the eye is, in fact, closed in a wink, the meaning of that wink is not photographable, Geertz noted. Knowing the circumstances that surround the making of the photograph—the words spoken, the weather, the presence of other people in the room—is important. Without this information, it is not possible to know what the details mean. No matter how powerful the imagination, it is not possible for the cultural outsider to experience these photographic records of the Ojibwe in the same way as the people who were there at the time, for all that the viewer may know of the general history of the Ojibwe. And yet, all too often, viewers draw firm conclusions about photographs without any specific understanding of the people or communities pictured because they assume that a general historical understanding can apply to all specific cases.

In his introduction to *Crying for a Vision: A Rosebud Sioux Trilogy,* a 1976 book of three white photographers' images of Lakota people liv-

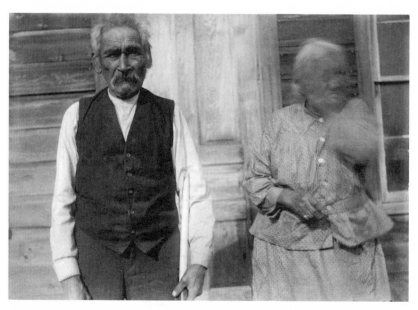

O-de-ne-gun (Shoulder Blade, left) was photographed by Robert G. Beaulieu at White Earth around 1905. O-de-ne-gun told Frances Densmore several trickster stories describing the origins of the earth. The identity of the woman at right and what she was doing when Beaulieu snapped the shutter are not known.

ing on the Rosebud Sioux Reservation in South Dakota, historian Herman J. Viola wrote that the book "is a sensitive portrayal of reservation life as it really exists—the isolation, the boredom, the frustration, the poverty." In his review of that book and Viola's introduction, historian David L. Beaulieu said, "Non-Indians viewing these photographs should not assume they can understand the meaning of the pictures for the Rosebud Sioux without sharing the experience and culture of these people . . . We cannot understand the meaning of these photographs unless the cultural and experiential 'language' which surrounds each picture is understood. Such a language, unfortunately, cannot be translated. It has to be experienced. For the Rosebud people, the pictures in this book speak for themselves."

In his review, Beaulieu contrasted Viola's view of these photographs to the one Ben Black Bear, Jr., discussed in the book's foreword (written in Lakota and English). Black Bear compared the book's photographs to winter counts, the pictorial records kept by Lakota tribal historians. Each summer, elders of particular Lakota communities would meet, talk about the occurrences of the past year, and agree on the most important event. The keeper of the winter count would add a pictorial record of this event—using symbols like those in the Ojibwe pictographic system—to a buffalo hide where all previous symbolic records were put.

Black Bear noted that the keeper of the winter count was considered a wise man, "equal in every respect to the other leaders of the tribe, a man who had a good understanding of the people and knew their innermost thoughts because he lived as they did." Tribal historians possessed a skill that they used "for the benefit of the whole tribe." They kept a history of the people for as far back as history could record it.

For Black Bear, the photographs taken of the Rosebud Sioux were "an achievement similar to the winter count." The three photographers lived among the people, lived as they did, and got to know the thoughts and attitudes of the people. These men took photographs of the people based on their knowledge of and identity with them. Because of their pictorial nature, winter counts were not narratives but symbols of the past. The actual narratives were kept in the minds of tribal historians and other Lakota people. Winter counts were also highly selective, recording particular events that the Lakota themselves believed represented their total history.

In the same way, photographs are not narratives; they are not the total history of a people but a record of very particular events that may or may not represent that total history. For Black Bear, a key to the relationship between the photographs of the Lakota and winter counts was that, like the keepers of winter counts, the white photographers had lived among the Lakota people, had gotten to know them and to share their attitudes. "These men took photographs of the people based on the knowledge and identity they had with the people," he wrote. They

had taken photographs that, for Black Bear, actually did fairly and accurately represent the Lakota people.

Among the Ojibwe, Monroe Killy, a white photographer, appears to have created this kind of record of the people and the culture. Though Killy began photographing the Ojibwe because of his interest in collecting beadwork and other handiwork, through repeated contact with particular families he ended up taking photographs that were as informal as family pictures. The people in the photographs seemed to be at ease with Killy, and Killy seemed to respect them as people, not as stereotypical symbols of Ojibwe-ness.

But even Killy's photographs are not narratives. For those who are not members of the community, its photographs are as ambiguous as the symbols on a winter count. But, unlike such symbols, photographs give viewers an illusion of understanding, the belief that if they stare at the photograph long enough, read it carefully enough, they can figure it out. Without the aid of tribal elders or other knowledgeable people, those looking at photographs would not know the particular event represented, its wider significance, or in what ways it may or may not be

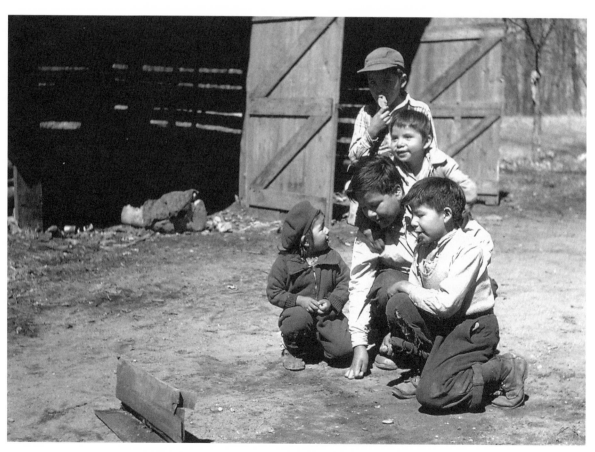

Monroe Killy photographed the children of Martin and Maud Kegg playing marbles while waiting for sugar at the family sugarbush in April 1946.

typical of the total history of a community. For the significance of the photograph, the viewer needs to learn from the collective knowledge of the community.

Among the Ojibwe, as among other Native American groups, the concept of respect has long been important; respect for the potential of other people, for animals, and for entities and things that other cultures consider to be inanimate. In 1889, speaking to the government commission, the White Earth leader May-zhuck-ke-ge-shig stated, "The Indians understand fully the meaning of the word 'respect.'" In a 1977 book, Fond du Lac elder Betty Gurno stated that respect was "Number One. That was implanted in you when you were born." In the same book, teacher Vern Zacher stated, "You show respect by giving back a little when you've taken something away. You have to respect the lake because you are going on that lake and taking something from it. You offer tobacco for good luck—for respect." Such respect is also due to photographs because, in many ways, they contain the spirit of the people and the things they record. Misusing photographs harms the people pictured, their families, their culture.

What does it mean to respect photographs? It means understanding that every photographic image is valuable because it is unique—the product of unique circumstances and the record of unique individuals. It means resisting the tendency to turn image and subject into commodities that can fit any message for any purpose. It means avoiding quick generalizations about subject or image based solely on facial expression, clothing, or any circumstantial nature of the image of which we have no personal knowledge. Photography is a valuable tool for recording societies and cultures. But, in principle, photographs record the experiences of individuals at particular moments in time. Studying photographs, carefully looking for meanings in the details, leads away from generalities to the specific histories of people and communities. Skipping such study is an intellectual shortcut, a way of substituting viewers' stereotypical responses for the need to analyze the image. But when the specificity of the photographic image is recognized, stereotypes are broken.

Photographs can be used in various ways to various ends. They can be pictographic symbols, communicating messages to those who are prepared for them. They can be fetishes, designed to gain control over those they depict. They can commemorate those who are gone. Or they can be symbols of a carefully considered history grounded in the knowledge of the community. Those who make photographs and those who use them bear a heavy responsibility. This responsibility is not to the camera, or to some imagined muse of history, but to the people past and present who are the subject of these photographs.

Acknowledgments

I am grateful to have had the opportunity to work on this book and to have had the help of so many people over the years. First, I thank all the Ojibwe people who have helped me, including Doris Boswell, Esther Towle, John and Marian Dunkley, Jim Clark, David Matrious, Alvina Aubele, Albert and Bernice Churchill, Bernida Churchill, Geri Germann, Duane Dunkley, Richard Thomas, Diane Gibbs, Betty Kegg, Ruby Klitzke, Joyce Shingobe, Larry Smallwood, and Elisse Aune. Angie Northbird and Collins Oakgrove gave me and other students valuable lessons in Ojibwe language and culture during three quarters at the University of Minnesota in 1988–89.

Monroe Killy's narration of his photographic work in Ojibwe communities in the 1930s and 1940s was a great help. His persistence and good humor have been a constant inspiration. Other photographers taught me much about photography, including Allen Downs of the University of Minnesota and my father, Henry Gilbert White, an avid amateur. Former Minnesota Historical Society Press designer and photographer Alan Ominsky taught me a great deal about the process of picture taking when I worked with him in the early 1970s.

Over the years, many former and current staff at the Minnesota Historical Society patiently provided me with help and information, including Jean Brookins, Rhoda Gilman, Virginia Martin, and Bonnie Wilson. It was Bonnie, the MHS photo curator, who first encouraged me to try to find out from Ojibwe people themselves about Ross Daniels's photographs. Deborah Miller has been a great friend and a great facilitator for this project from its beginnings. Without Greg Britton's nudging, the book would never have been finished. The excellent work of editor Shannon Pennefeather, copy editor Amy Rost, indexer Denise Carlson, and designer Will Powers has made this a better book. Without the information Alan Woolworth compiled and generously shared over the years, many significant details would be lacking from this book. He has been an inspiring mentor since I was a teenager.

For their advice at the beginning of this research, I thank Timothy Roufs, Kent Smith, Barb and Joe Spado, Kate Regan, and Jim Jones. Early on, Larry Aitken pointed out how important it was to simply name the people in photographs. Virginia Rogers provided valuable genealogical information. Pat Maus of the Northeast Minnesota Historical Center was very helpful during my research in her collections over the years. Staff

members of Minnesota county historical societies provided a great deal of help: Becker (Harriet Davis and Virginia Weston), Beltrami (Wanda Hoyum), Cass, Crow Wing, Itasca (John A. Kelsch), Isanti (Marylin McGriff), and Morrison (Jan and Mary Warner). James C. Underhill provided valuable information about Henry F. Nachtrieb.

Nina Archabal and Carolyn Gilman provided leads for my research on Frances Densmore's photography. Tom O'Sullivan gave me helpful criticism and encouragement. Leon Kramer of Kramer Gallery in St. Paul allowed me to examine the Roland Reed papers in his possession and has lent several Reed prints for scanning. James Taylor Dunn allowed me to study the photographs, negatives, and papers of his father, John W. G. Dunn. He also consistently encouraged my research. Most recently I have been grateful for the detailed comments of scholars Brenda Child, Curtis Dahlin, Michael McNally, and John Nichols.

A 1988 Phillips Fund Grant from the American Philosophical Society helped support some of my initial interviews and research. In 1989, I was awarded a dissertation fellowship from the Wenner-Gren Foundation to support my interviews with Ojibwe people about these photographs. This grant also helped pay for the exhibit of photographs at the Azhumoog/Lake Lena Community Center, which I put up with the cooperation of district representative David Matrious in 1989.

Janet Spector, my advisor at the University of Minnesota, was a good friend and supporter of this project during my years at the university. Anthropologist and linguist Timothy Dunnigan taught me important things about the Ojibwe culture and about anthropology. Gwen Morris, a fellow Minnesota graduate and also a student of the Ojibwe people, has provided frequent encouragement and aid at key times.

My mother, Helen McCann White, continues to inspire me with her love for writing and for history and with her impatience with nonsense and vague writing.

Finally, I want to thank my wife, Ann Regan, and our son, Ned, for having withstood this experience so well, for helping it along, and for making it easier.

Notes and References

ABOUT THE PHOTOGRAPHS

The photographs in this book were scanned from originals in the Minnesota Historical Society (by Eric Mortenson) and from originals in other collections (by others, including the author). The original images vary greatly in technical quality and in their state of preservation. Retouching in Adobe Photoshop (version 7) removed scratches, spots, and in some cases fingerprints, usually most evident in the sky and other portions of the background, to allow viewers to focus on the original images without distraction. Little substantial retouching was done on the main subjects of the photographs, except in a few cases where the original was heavily damaged. In other cases, the damage—such as peeling emulsion—was so extensive as to preclude substantial retouching.

OJIBWE ORTHOGRAPHY

Throughout this book I followed the spelling system of John D. Nichols and Earl Nyholm, *A Concise Dictionary of Minnesota Ojibwe* (Minneapolis and London: University of Minnesota Press, 1995). In the case of words not found in that work, other sources include Frederic Baraga, *A Dictionary of the Ojibway Language* (1878; repr., Minnesota Historical Society Press, 1992). As for Ojibwe personal names, spellings are more difficult to standardize without knowing the meaning of a particular name. In many cases I chose to follow a common contemporary spelling from the era of the person photographed rather than attempt a precise translation or modern spelling.

SOURCES

Information provided with Ojibwe photos in archives, libraries, and family collections is often incomplete. Dates assigned to particular photographs may be no more than educated guesses based on the format of the picture and the clothing of its subjects. No matter how much research is done, it is always possible that more information can be found. I would appreciate hearing from any readers who have additional details about the photographs in this book. Contact me through the publisher or through the website www.weareathome.info.

In addition to the valuable information provided by Ojibwe families, sources used in researching the photographs in the book have included the many genealogical and local history records at the Minnesota Historical Society: state and federal censuses, birth and death records, annuity rolls, newspapers, county and local histories, state archives records, and personal papers. Another very useful source is the website www.ojibwe.info, which offers detailed genealogical information on a large number of Ojibwe families in Minnesota. Ancestry.com has also been an important resource for census information.

Detailed photo credits and sources for information are keyed to book pages below. For Minnesota Historical Society (MHS) photographs, negative numbers are provided unless no negative exists, in which case the catalog number is cited. Readers interested in finding these and other photographs online can do so at the historical society's Visual Resources Database: collections.mnhs.org/visualresources/. Images from other repositories in Minnesota can be viewed at the Minnesota Digital Library's Minnesota Reflections site: reflections.mndigital.org/.

Further information on many points in the book appears in Bruce M. White, *Familiar Faces: The Photographic Record of the Minnesota Anishinaabeeg* (PhD diss., University of Minnesota, 1994).

ii MHS 6501-A. Shown with a view camera such as the one Robert G. Beaulieu—a White Earth Indian Reservation band member and one of the earliest Ojibwe people known to have become a photographer—used to take many glass-plate images of scenes and people on the reservation is Clarence R. Beaulieu. Clarence, the son of Robert's second cousin, Theodore H. Beaulieu, may have helped Robert in his work, especially in a number of photographs that included the photographer as one of the subjects. See note for page 91, below.

2 MHS 28335

3 The photograph of Doris Boswell is from a negative in the J. W. G. Dunn photo collection, Jan. 12, 1928, MHS. The picture appears on page 98 of this book.

4 There are many histories and other general books on the Ojibwe or Anishinaabeg of Minnesota. See William Warren, *History of the Ojibway People* (St. Paul: Minnesota Historical Society Press [hereafter, MHS Press], 1984); M. Carolissa Levi, *Chippewa Indians of Yesterday and Today* (New York: Pageant Press, Inc., 1956); Timothy G. Roufs, *The Anishinabe of the Minnesota Chippewa Tribe* (Phoenix, AZ: Indian Tribal Series, 1975).

6 A variety of books have examined the ways in which American Indian people have been photographed. In particular, see Paula Richardson Fleming and Judith Luskey, *The North American Indians in Early Photographs* (New York: Dorset Press, 1988). Provocative essays on American Indian photographs are found in Lucy Lippard, ed., *Partial Recall: Photographs of Native North Americans* (New York: The New Press, 1992). A critical approach to the work of Edward Curtis is found in Christopher M. Lyman, *The Vanishing Race and Other Illusions: Photographs of Indians by Edward S. Curtis* (Washington, DC: Smithsonian Institution Press, 1982). A rare detailed discussion of the process of photographing the Minnesota Ojibwe is found in Patricia Albers and William R. James, "Images and Reality: Post Cards of Minnesota's Ojibway People, 1900-80," *Minnesota History* 49 (Summer 1985): 229-40.

7 Susan Sontag, *On Photography* (New York: Farrar, Straus, Giroux, 1977), 14, 24; Gerald Vizenor, *Fugitive Poses: Native American Indian Scenes of Absence and Presence* (Lincoln and London: University of Nebraska Press, 1998), 154, 158, 160; Marshall McLuhan, *Understanding Media: The Extensions of Man* (New York: McGraw-Hill Book Co., 1965), 189.

9 Paul Byers, "Cameras Don't Take Pictures," *Columbia University Forum* 9 (Winter 1966): 27-31. On the phrase "taking pictures," see for example an article in the *St. Paul Pioneer*, Feb. 29, 1892, p7, which discusses the question of why people's pictures are so different from their expectations.

10 Sontag, *On Photography*, 171; Margaret B. Black-

man, *Window on the Past: The Photographic Ethnohistory of the Northern and Kaigani Haida*, Mercury Series, Canadian Ethnology Series, Paper 74 (Ottawa: National Museum of Man, 1981).

14 Jim Clark's memories and stories have been published more recently in *Naawigiizis: The Memories of the Center of the Moon* (Minneapolis, MN: Birchbark Books, 2002).

17 On the Mille Lacs case, including the testimony of myself and other historians and anthropologists, see James McClurken, comp., *Fish in the Lakes, Wild Rice, and Game in Abundance: Testimony on Behalf of Mille Lacs Ojibwe Hunting and Fishing Rights* (East Lansing: Michigan State University Press, 2000).

20 The photograph was purchased from a secondhand store in Chisago County, Minnesota, in 1999 by the author. The quotation is from Joseph A. Gilfillan, "The Ojibways in Minnesota," *Collections of the Minnesota Historical Society* 9 (1901): 55-128. A leader of the Grand Portage Ojibwe in the mid-nineteenth century was Little Caribou or Adikons. A descendant of his, Joseph Caribou, lived there in the late 1800s and was known as a chief. See U.S. House of Representatives, *Chippewa Indians in Minnesota*, 51st Cong., 1st sess., doc. 247, serial 2747, p51; *A History of Kitchi Onigaming: Grand Portage and Its People* (Cass Lake: Minnesota Chippewa Tribe, 1983), 42.

21 For a discussion of dikinaaganan, see Frances Densmore, *Chippewa Customs* (1929; repr., St. Paul: MHS Press, 1979), 48-51; M. Inez Hilger, *Chippewa Child Life and Its Cultural Background* (1951; repr., St. Paul: MHS Press, 1992), 21-25.

22 Top, MHS 42442; bottom, MHS E97.33 r7. On the "rice makers" of the St. Croix Valley, see Warren, *History of the Ojibway People*, 38. On Ernest Oberholtzer's relationship with the Ojibwe of the Rainy Lake region and his photographs of them, see Joe Paddock, *Keeper of the Wild: The Life of Ernest Oberholtzer*, 267-89 (St. Paul: MHS Press, 2001).

23 Top, MHS 62031; bottom, MHS 62030. The *Minneapolis Journal* photo appears to be part of a series of photos taken at Grand Marais around this time, including MHS E97.1 r76, E97.1 r90, 38771, and 62245, which appears on page 211 of this book. For more on William H. Brill, see below, p85, and U.S. Census, 1900, Ramsey County, St. Paul, Ward 10, District 151, where he is listed as a newspaper reporter.

24 Top, MHS 31242, published June 29, 1902; bottom, MHS 47938

25 MHS 63016. Ole B. Olson is listed in the 1910 census as a storekeeper, Beltrami County, Kelliher, District 24, sheet 1A. Another view of Olson's Store, around 1910, is found in MHS MB4.9KR r6.

26 Top, MHS 34741; bottom, MHS 35423. See Hilger, *Chippewa Child Life*, 24; Harlan I. Smith, "An

27 Ojibwa Cradle," *The American Antiquarian* 16: 302–3.

27 MHS 2955-B. For more on Nachtrieb and the Minnesota Zoological Survey, see John Dobie, "Commercial Fishing on Lake of the Woods," *Minnesota History* 35 (June 1957): 272–77.

28 Top, MHS 70157; bottom, MHS 7880-A; identification from Geri Germann. See also Wind family in U.S. Census, 1930, Pine County, Ogema Township, District 58-33, Sheet 1B.

29 MHS 35796

30 MHS 35445. Monroe Killy album 243 in MHS gives Mrs. Chicag's name as Susie. See MHS death certificates for John B. Chicag, May 27, 1960, 17047; Susan Chicag, Feb. 18, 1961, 16498; Gerald Wayne Chicag, Feb. 24, 1977, 4552. Gerald's parents were Jerry and Mary (Boness) Chicag.

31 MHS 1982. For more on Ojibwe women's clothing, see Peter Grant, "The Sauteux Indians about 1804," Louis F. R. Masson, ed., *Les Bourgeois de la Compagnie du Nord-Ouest* (Quebec: A. Cote et Cie, 1890), 1:318–19; Densmore, *Chippewa Customs*, 31–33.

32 Left, MHS 33390; right, MHS 29813. For more on Wah-bo-jeeg, spelled Waub-o-jeeg, see Warren, *History of the Ojibway People*, 232, 235, 324.

33 On Ojibwe leadership, see James G. E. Smith, *Leadership among the Southwestern Ojibwa* (Ottawa: National Museums of Canada, Publications in Ethnology, No. 7, 1973); Mark Diedrich, *Ojibway Chiefs: Portraits of Anishinaabe Leadership* (Rochester, MN: Coyote Books, 1999), 5–25. For accounts of various visits to St. Paul by Ojibwe delegations, see *St. Paul Pioneer*, Jan. 21, 1863, p2; *Minneapolis Journal*, Apr. 30, 1922; State of Minnesota, *Executive Documents*, 1862: 520–25. On cartes de visite, see Beaumont Newhall, *The History of Photography* (New York: Museum of Modern Art, 1964), 49–50.

34 Joel Whitney's career as a photographer is discussed in *Joel E. Whitney: Minnesota's Leading Pioneer Photographer* (St. Paul: Minnesota Historical Photo Collectors Group, 2001); Beaumont Newhall, "Minnesota Daguerreotypes," *Minnesota History* 34 (Spring 1954): 30–33; *Minnesota Democrat*, July 21, 1852, p1; *The Minnesotian*, June 25, 1853. For Peezhikee's statement, see Thomas L. McKenney, *Sketches of a Tour to the Lakes* (1827; repr., Minneapolis, MN: Ross & Haines, Inc., 1959), 462.

35 Left, MHS 36725; right, MHS 33395. On Charles Zimmerman's career, see Bonnie G. Wilson, "Working the Light: Nineteenth-Century Professional Photographers in Minnesota," *Minnesota History* 52 (Summer 1990): 49.

36 Left, MHS 36726; right, MHS 33398. Grant, "Sauteux Indians," 1:317.

37 Top, MHS 77788; bottom, MHS 63962

38 Left, MHS 36745; right, MHS 33401

39 Left, MHS 8327; right, MHS 63973. On Po-go-nay-ke-shick's life story, see Mark Diedrich, *The Chiefs Hole-in-the-Day of the Mississippi Chippewa* (Minneapolis, MN: Coyote Books, 1986).

40 MHS 14134. On the Treaty of 1867, see Melissa Meyer, *The White Earth Tragedy: Ethnicity and Dispossession at a Minnesota Anishinaabe Reservation, 1889–1920* (Lincoln: University of Nebraska, 1994), 42–50.

41 MHS 8316. *Mankato Weekly Record*, Jan. 3, 1860. On James E. Martin and his photography, see *St. Paul Pioneer and Democrat*, July 9, 1858; *St. Paul Daily Press*, May 31, 1864; *St. Paul Pioneer*, Dec. 2, 1864; *St. Paul Daily Press*, Mar. 11, 1869.

42 Here and below, on Naganab, see Richard E. Morse, "The Chippewas of Lake Superior," *Collections of the State Historical Society of Wisconsin* (Madison: State Historical Society of Wisconsin) 3 (1857): 346, 348; Densmore, *Chippewa Customs*, 110; U.S. House of Representatives, *Chippewa Indians in Minnesota*, 192; Diedrich, *Ojibway Chiefs*, 107–14.

43 MHS 29831

44 On Ojibwe men's and chief's clothing, see U.S. House of Representatives, *Chippewa Indians in Minnesota*, 75, 127; Grant, "Sauteux Indians," 1:317; Densmore, *Chippewa Customs*, 31, 138–39, 183, 191–92; Warren, *History of the Ojibway People*, 258, 265; Marcia Anderson and Kathy Hussey-Arntson, "Ojibwe Bandoleer Bags in the Collections of the Minnesota Historical Society," *American Indian Art Magazine* 11 (Autumn 1986): 47, 56. The Ojibwe word for tobacco pouch is given in Gilfillan, "Ojibways in Minnesota," 101–2. Baraga, *Dictionary of the Ojibway Language*, 1:265, gives the Ojibwe word for tobacco pouch as *kishkibitâgan*; Chrysostom Verwyst, *Chippewa Exercises: Being a Practical Introduction into the Study of the Chippewa Language* (Minneapolis, MN: Ross & Haines, Inc., 1971), 119, as *Kishkibitagan*. Modern spelling from Nichols and Nyholm, *Concise Dictionary*, 49.

45 Left, MHS 30787; right, MHS 13092

46 Top, MHS 36691; bottom left, MHS 28723; bottom right, MHS E97.1W p11. On Wah-bon-ah-quod's life, see Diedrich, *Ojibway Chiefs*, 23–32. On face painting, see Grant "Sauteux Indians," 1:317.

47 Becker County Historical Society, Detroit Lakes, MN. On Enmegabowh's life and work at White Earth, see Michael McNally, *Ojibwe Singers: Hymns, Grief, and a Native Culture in Motion* (New York: Oxford University Press, 2000), 48, 53, 74, 76, 82, 96, 98; Meyer, *White Earth Tragedy*, 41–42, 97–98; Rebecca Kugel, *To Be the Main Leaders of Our People: A History of Minnesota Ojibwe Politics, 1825–1898* (East Lansing: Michigan State University Press, 1998), 107–9.

48 MHS 53226. On Charles Tenney's photographs taken

at White Earth, see *Winona Republican*, Aug. 19, 1873. Many of the Tenney photographs were donated to the MHS by Archer B. Gilfillan, son of the missionary Joseph A. Gilfillan; see card-file donor record dated Oct. 4, 1933. On May-zhuck-ke-ge-shig's life, see Diedrich, *Ojibway Chiefs*, 153–59; *White Earth Tomahawk*, Mar. 17, 1904; *Thirteen Towns (Fosston)*, Dec. 2, 1910; *Duluth News-Tribune*, Jan. 8, 1911. A copy of this photo once belonging to Thornton Parker, a surgeon with the Indian Department, is labeled "Head Men at White Earth," National Archives, White Earth Indian Reservation (Old West). Other Tenney photos in the MHS collection include a portrait in front of a bark house, 34172, a portrait with rail fences, 29832, a council, 34859, women in front of a warehouse, E97.1 r85, Civil War veterans, 83647, and agency buildings, 34819, 34836, 34834.

49 MHS 19642

50 Top, MHS 33403; bottom, Smithsonian Institution, National Anthropological Archives (hereafter, NAA), 503B. On Niganibines's life, see Diedrich, *Ojibway Chiefs*, 139–52; on his father, 43–50.

51 Top, Dunn photo collection, Jan. 12, 1928, MHS; bottom, MHS 40724. See also Jim Cordes, *Pine County and Its Memories* (North Branch, MN: Pine County Board of Commissioners, 1989), 301–6.

52 Copied by author from original once belonging to Doris Boswell.

53 Left, MHS 39196; right, MHS 19153. MHS, *History News* (May 1963); U.S. Census, 1900, Roseau County, Warroad Township, Indian Population, District 339, sheet 8; Gerald Vizenor, *The People Named the Chippewa: Narrative Histories* (Minneapolis: University of Minnesota Press, 1984), 143.

54 MHS POR 3172 p2. Information on Darwin Hall and his work with the Chippewa Commission on this and the following pages comes from the correspondence and other records of the U.S. Chippewa Commission, 1897–1900, in RG 75, National Archives, Washington, DC (hereafter, Chippewa Commission).

55 For more information about Wa-we-yay-cum-ig, see McClurken, *Fish in the Lakes*, 395, 413, 416, 417, 418, 421, 439; Hall to W. A. Jones, Oct. 7, 1897, p112–27, Hall to Jones, Sept. 18, 1899, p87, Chippewa Commission.

56 Top, MHS 80230; bottom, MHS E97.1 r158

57 Top, Peabody Museum of Archaeology and Ethnology, Harvard University, Cambridge, MA; bottom, MHS 6452-A. On Wa-we-yay-cum-ig and Nawa-jibigokwe, see Frances Densmore, *Chippewa Music*, (1910–13; repr, 2 vols. in 1, Minneapolis, MN: Ross & Haines, Inc., 1973), 15, 21, 36 68, 88–92; Densmore, *Chippewa Customs*, 180–83.

58 Top, MHS 102024; bottom, MHS 102023

59 Hall to Jones, July 1, 1899, p26–28, Hall to Jones, June 18, 1900, p214, Chippewa Commission; *White Earth Tomahawk*, Dec. 18, 1903, Mar. 17, 1904.

60 For photos and information about Maingans the Elder and Odjibwe, see Densmore, *Chippewa Music*, 1:24–25, 37–38, 69–77. On De Lancey Gill and his work, see Fleming and Luskey, *North American Indians*, 178.

61 Densmore, *Chippewa Music*, 2:67–68.

62 Densmore's account of the picture-taking session is recorded in her 1955 reminiscence, "I Heard an Indian Drum," Densmore Papers, MHS. Labels on the originals of these portraits, now in the NAA, name the photographer as J. Johnson and the town as Detroit, now known as Detroit Lakes. R. L. Polk's *Minnesota Gazeteer* for 1920 lists a photographer named "Jno. Johnson" in the same town. On the two men, see Densmore, *Chippewa Music*, 1:119, 2:60. Here and below, based on interviews with Edward McCann, August 1964, tapes and transcripts in MHS. For more on Frank Pequette, see his obituary in *Duluth Herald*, Nov. 27, 1937; also Oct. 10, 1934.

63 Left, Smithsonian NAA, 537B1; right, Becker County Historical Society, Detroit Lakes, MN. The Odjibwe photo is the frontispiece for vol. 2 of *Chippewa Music*.

64 Left, original postcard in possession of the author; right, MHS 59723

65 Original postcard in possession of the author. Robert Taft, *Photography and the American Scene: A Social History, 1839–1889* (1938; repr., New York: Dover Publications, Inc., 1964), 384–402; Hal Morgan and Andreas Brown, *Prairie Fires and Paper Moons: The American Photographic Postcard: 1900–1920* (Boston, MA: David R. Godine, 1981), xiii–xv.

66 MHS 1561. Gilfillan, "Ojibways in Minnesota," 62–63. Nichols and Nyholm, *Concise Dictionary*, 3, records the verb *abi*, meaning to "be at home." Modern spelling supplied by John Nichols. A similar greeting today would be *namadabin*, "sit down."

67 On Ojibwe house forms, see Densmore, *Chippewa Customs*, 12, 22–28; Hilger, *Chippewa Child Life*, 137–41.

68 MHS 2015-A. Names of Ojibwe house forms are found in Nichols and Nyholm, *Concise Dictionary*, 24, 48, 97; Johann Georg Kohl, *Kitchi-Gami: Life Among the Lake Superior Ojibway* (1860; repr., St. Paul: MHS Press, 1985), 9–10.

69 MHS 82908. Gilfillan, "Ojibways in Minnesota," 62.

70 Top, MHS 5967-A; bottom, MHS 579-B

71 MHS 10726

72 MHS 6656-A. Jacoby's life is described in a sketch by Alan Woolworth for the Minnesota Biographies Project, MHS.

73 Northeast Minnesota Historical Center, University

of Minnesota-Duluth (hereafter, NEMHC). See U.S. Census, 1920, Koochiching County, T65 R22, Nett Lake, District 60, sheet 5A. Gilfillan, "Ojibways in Minnesota," 67–68.

74 Top, MHS 34694; bottom, MHS 10512. Ojibwe grave houses are discussed in Hilger, *Chippewa Child Life*, 82–83.

75 Top, MHS 17328 bottom, MHS 40078. For more on S. C. Sargent, see an account of a Methodist minister who accompanied him on a photo trip: Elijah E. Edwards, "Dies Boreales or Life at the Dalles, Taylors Falls, Minn.," Jan. 29, 1886, Edwards Papers, DePauw University Archives, Newcastle, IN.

76 MHS 37966. On the interior of Ojibwe houses, see Gilfillan, "Ojibways in Minnesota," 62–63, 67–68; Densmore, *Chippewa Customs*, 28–29.

77 MHS 50910. Information about Fowble's work as a surveyor was found in his obituary, *St. Paul Pioneer Press*, Jan. 5, 1945, p5. Survey books relating to Fowble's work were examined in 1986 in the library of the U.S. Army Corps of Engineers, St. Paul, MN. One notebook, A1–278, appears to be in the same handwriting as that on the back of Fowble's photograph. On muskrat hunting, see Gilfillan "Ojibways in Minnesota," 71.

78 MHS 48826. Densmore's account is recorded in Charles Hofmann, *Frances Densmore and American Indian Music* (New York: Museum of the American Indian, Heye Foundation, 1968), 24–29; see also Nancy L. Woolworth, "Miss Densmore Meets the Ojibwe: Frances Densmore's Ethnomusicology Studies among the Grand Portage Ojibwe in 1905," *Minnesota Archaeologist* 38.3 (1979): 106–28. Densmore spelled the words of the song in various ways in different accounts. For a more extensive discussion of Densmore's photography, see White, "Familiar Faces," 249–65.

79 MHS 10515. Bromley's career was discussed in *Minneapolis Journal*, Apr. 30, 1922.

80 MHS 25595; published in the "Summer Resort Number" of the *Minneapolis Times*, May 24, 1896, and later with other articles in the same newspaper on Oct. 2, 1898, and June 15, 1902. Edward Bromley, *Minneapolis Album: A Photographic History of the Early Days in Minneapolis*, Frank L. Thresher, ed. (Minneapolis: H.C. Chapin, 1890), repr., *Portrait of the Past: A Photographic History of the Early Days in Minneapolis* (Minneapolis, MN: Voyageur Press, Inc., 1973).

81 MHS 47909. *Minneapolis Journal*, Apr. 30, 1922; Ted Curtis Smythe, "A History of the Minneapolis Journal, 1878–1939," PhD diss., University of Minnesota, 1967. Smythe states that the *Journal* published halftone cuts beginning on July 4, 1896, "which may be the first regular use of such cuts in American journalism" (p106). In fact there were halftone cuts used in the *Journal* earlier than that, including the issue of May 24, 1896, "Summer Resort Number" section. The *Times* appears to have used halftones even earlier: see *Minneapolis Times*, July 14 ("Times Cycle Number"), July 21 (p7), and July 28, 1895 ("Times' Yachting Number"); Feb. 16, 1896, p29.

82 Here and below, on the so-called Leech Lake Uprising, see *St. Paul Dispatch*, Nov. 24, 1898; William Watts Folwell, *A History of Minnesota*. 4 vols. (St. Paul: MHS, 1961), 4:321.

83 The Oct. 14, 1898, council is discussed in *St. Paul Pioneer Press*, Oct. 15, 1898.

84 Reporters' celebration, *Minneapolis Times*, Oct. 13, 1898, p5.

85 Top, MHS 34887; bottom, MHS 49128. *Minneapolis Tribune*, Oct. 14, 1898.

86 Top, MHS 8324; bottom, MHS 10717. Louis H. Roddis, "The Last Indian Uprising in the United States," *Minnesota History* 3 (Feb. 1920): 273.

87 *Minneapolis Times*, Aug. 31, 1902, magazine section, p8; McClurken, *Fish in the Lakes*, 426–32.

88 MHS 34862

89 MHS 40271. The Lufkins family is listed in the U.S. Census, 1900, Becker County, White Earth, District 21, sheet 9B. On the various land frauds at White Earth, see Meyer, *White Earth Tragedy*. Here and below, on the Beaulieu family, see Gerald Vizenor, *Escorts to White Earth, 1868–1968: 100 Year Reservation* (Minneapolis, MN: The Four Winds, 1968), 155, 187; Gerald Vizenor, *Interior Landscapes: Autobiographical Myths and Metaphors* (Minneapolis: University of Minnesota Press, 1990), 8–19.

90 Arthur P. Foster, "Identification of the Robert G. Beaulieu Collection of Photographs, 1900–25, of White Earth Reservation, Becker Co." (1938), typescript, MHS, audio-visual collection donor records. Some of Beaulieu's photographs are at Becker County Historical Society. On Beaulieu, see U.S. Census, 1920, Becker County, White Earth Village, District 20, sheet 9B, which says that Beaulieu was a photographer with his "own shop." On the divisions at White Earth, see Meyer, *White Earth Tragedy*, 118–34. See also sketch on Beaulieu by Alan Woolworth, Minnesota Biographies Project, MHS.

91 MHS 6509-A. Clarence R. Beaulieu was the son of Theodore H. Beaulieu, the second cousin of Robert G. Beaulieu; Clarence later left Minnesota to become a clerk in the U.S. Indian service on the Tulalip Indian Reservation in Washington: U.S. Census, 1930, Snohomish County, Tulalip Indian Reservation, District 21-138, sheet 6B. Alvin H. Wilcox, *A Pioneer History of Becker County Minnesota* (St. Paul, MN: Pioneer Press Company, 1907), 225; *Compendium of History and Biography of Northern*

Minnesota (Chicago: Geo. A. Ogle & Co., 1902), 398.

92 MHS 6476-A

93 MHS 6506-A. The rice threshing photo is MHS 38617.

94 MHS 6504-A. Additional identifications are from copy of photo in Becker County Historical Society. U.S. Census, 1920, Becker County, White Earth Township, District 20, sheet 9A. The Big Bear family is listed on the same census sheet.

95 For more information on John W. G. Dunn, see James Taylor Dunn, "Ten Days At the Greig Farm, Danbury-January 1928," *Dalles Visitor;* "John W. G. Dunn: Fisherman, Photographer and Nature Lover," *Dalles Visitor,* 1989, microfilm, MHS; also James Taylor Dunn, *John W. G. Dunn: Fisherman, Photographer and Nature Lover* (Marine on St. Croix, MN: The J. W. G. Dunn Library of the St. Croix Watershed Research Station, 1996). On Sheridan Greig, see Cordes, *Pine County,* 309.

96 Accounts of Dunn visits to Aazhoomog are found in the entries in his diary, MHS.

97 Dunn photo collection, Jan. 12, 1928, MHS

98 Dunn photo collection, Jan. 12, 1928, MHS

99 Information on Monroe Killy's life and career is found in interviews conducted by Bonnie Wilson, Jan. 1987, MHS, and by the author, Apr. and May 1987, tapes and transcripts in author's possession. A number of Killy photographs were published in Roufs, *The Anishinabe of the Minnesota Chippewa Tribe;* also *Shared Passion: The Richard E. and Dorothy Rawlings Nelson Collection of American Indian Art* (Duluth, MN: Tweed Museum of Art, 2001), 23, 34, 80, 121.

100 MHS 35496. U.S. Census, 1930, Cass County, Turtle Lake Township, District 11-56, sheet 1B.

101 MHS 35502

102 MHS 35600

103 MHS 35469. U.S. Census, 1930, Cass County, Shingobee Township, District 11-48, sheet 8A.

104 MHS 35616. On the begging dance, which is related to this practice, see Densmore, *Chippewa Music,* 2:47-48; also Thomas Vennum, "The Ojibwa Begging Dance," in *Music and Context: Essays for John M. Ward,* Anne Dhu Shapiro, ed. (Cambridge, MA: Dept. of Music, Harvard University, 1985), 54-78.

105 MHS 35184

106 Top, MHS 35312; bottom, 35706. Monroe Killy described the story of the second photograph in a July 2006 conversation with the author. U.S. Census, 1930, Mille Lacs County, Isle Village, District 48-11, sheet 5B.

108 MHS 7299-A

109 The chapter title contains the word for winter, *biboon,* indicating that the passage of a year was completed at the end of winter. For this word and

the names of the months, see Nichols and Nyholm, *Concise Dictionary,* 31; Densmore, *Chippewa Customs,* 18.

110 As described later, the Nodinens account is recorded in Densmore, *Chippewa Customs,* 119-23; Gilfillan, "Ojibways in Minnesota," 9:70.

111 MHS 6517-A. Maude Kegg's account of sugaring is in her book *Portage Lake: Memories of an Ojibwe Childhood* (Edmonton: University of Alberta Press, 1991), 12-21. For the quote from Timothy J. Sheehan, see Sheehan Diary, Apr. 10, 1885, MHS.

112 Top, MHS 29869; bottom, MHS 19571

113 Top, MHS 35778; bottom, MHS 35319

114 Densmore photo album, p22, MHS; Campbell quote, William Campbell to Henry M. Rice, Jan. 13, 1894, Chippewa Commission; Densmore, *Chippewa Customs,* 114.

115 MHS 35194

116 MHS 16067. White, *Familiar Faces,* 331-32, 335-37, 349.

117 Henry R. Schoolcraft, *Personal Memoirs of a Residence of Thirty Years with the Indian Tribes* (Philadelphia, PA: Lippincott, Grambo and Co., 1851), 368; Nodinens account, Densmore, *Chippewa Customs,* 119-23.

118 Left, MHS 35839; right, MHS 35741. These pictures were taken prior to Mar. 13, 1921, his date of death; MHS death certificates, 1921, 7594.

119 Thomas L. McKenney and James Hall, *The Indian Tribes of North America, with Biographical Sketches and Anecdotes of the Principal Chiefs* (Edinburgh: J. Grant, 1933-34), 1:253-54; Densmore, *Chippewa Customs,* 150-52.

120 MHS 7575. Hilger, *Chippewa Child Life,* 117; Densmore, *Chippewa Customs,* 150-51. The stereo view was one of a number of Zimmerman views that formed the basis of engravings depicting scenes at the annuity payment and published in *Harper's Weekly,* Aug. 5, 1872, 725.

121 Top, MHS 11644; bottom, MHS 2178. Ingersoll's work is discussed in Patricia Condon Johnston, "Truman Ingersoll: St. Paul Photographer Pictured the World," *Minnesota History* 47 (Winter 1980): 122-32. In a conversation with the author at the MHS in 1980, Ingersoll's son Ward described his father's interest in photographing along the St. Croix River. Several of Ingersoll's Ojibwe photographs, including this one, were used to illustrate Walter James Hoffmann, "The Menomini Indians," Bureau of American Ethnology, *Annual Report, 1892-93* (Washington, DC: GPO, 1896), plates xxxvi, xxxvii, based on the resemblance between Ojibwe and Menomini canoes, as discussed on p293 of the Hoffmann report.

122 Top, MHS 19972; bottom, MHS 35847. *Minneapolis Tribune,* May 10, 1940; note sent to Hilger on Mille

Lacs Indian Trading Post stationery, Aug. 16, 1940, Hilger Papers, NAA. Census listings for the various people involved in building this canoe, including Gwetes or Qua-dence, Jim Hanks, Sr., Jennie Reece, Dick Gahbow, and his wife Pedwaywayquay, are all on one page in the 1930 U.S. Census, Mille Lacs County, Kathio Township, District 48-12, sheet 4B.

123 Top, MHS 35853; bottom, MHS 40010

124 National Archives, Washington, DC. Frances Densmore article in *Christian Science Monitor*, Oct. 30, 1931, copy in Densmore Papers, NAA.

125 Top, MHS 11299; bottom, MHS 35219. Ida Drift, MHS death certificates, Sept. 22, 1991, 027821.

126 Top, MHS 17321; bottom, MHS 64918. The bottom photo is one of a series of photos taken by Harry D. Ayer when he was a photographer in St. Paul, prior to moving to Mille Lacs to operate the trading post; pictures listed in Harry Ayer Papers, vol. 52, MHS.

127 MHS 14924. Kegg, *Portage Lake*, 42–47. An important account of Ojibwe berry picking is found in Chantal Norrgard's "Ojibwe Subsistence in Transformation: Berrying in the Lake Superior Region, 1870-1942" (unpublished), presented at the American Society for Ethnohistory Annual Conference, 2005. For berry picking in the Upper St. Croix River valley after logging, see Dick Riis, *Danbury Diamond Anniversary History* (Danbury, WI: Danbury Diamond Anniversary Committee, 1987), 36–37. See Frances Densmore, *Strength of the Earth: The Classic Guide to Ojibwe Uses of Native Plants* (1928; repr., MHS Press, 2005), 321, for reference to Juneberries.

128 Top, Library of Congress LC-USF33-00255-M3; bottom, Library of Congress, LC-USF33-01262-M1. On the heavy blueberry crop in the area of the Little Fork River in the summer of 1937, see *The Littlefork Times*, July 22, July 29, Aug. 4, 1937; on the logging of the river, see Aug. 19, 1937.

129 Top, Library of Congress LC-USF33-011253-M5; bottom, Library of Congress, LC-USF33-011248-M1. For accounts of the automobile accident and the names of some of the Ojibwe berry pickers, see *The Daily Journal (International Falls)*, Aug. 23, 24, 1937. Roman Williams was listed in the 1910 U.S. Census, Becker County, White Earth Township, District 21, sheet 12A, age 3, the son of George R. and Mary J. McKee; also 1920 U.S. Census, Becker County, White Earth, sheet 7A, age unknown. George McKee was listed in 1930 in Becker County, Pine Point Township, District 3-29, age twenty-four, the son of Robert and Jane McKee.

130 John and Marian Dunkley photo collection (hereafter, Dunkley collection). *Taylors Falls Journal*, Aug. 24, 1882.

131 Top, MHS 53419; bottom, MHS 34389

132 Marquette quote translated by the author from *Mémoire sur les moeurs, coustumes et relligion des sauvages de l'Amérique Septentrionale, par Nicolas Perrot; publié pour la première fois par le R. P. J. Tailhan* (1864; repr., Montreal: Editions Elysee, 1973), 190. For the Nelson quote, see George Nelson, *My First Years in the Fur Trade: The Journals of 1802-1804* (St. Paul: MHS Press, 2002), 56.

133 MHS 10664. Albert E. Jenks, "Wild Rice Gatherers of the Upper Lakes," Bureau of American Ethnology, *Annual Report, 1897-98* (Washington, DC: GPO, 1910), 1057-58.

134 Top, MHS 35520; bottom, MHS 35240

135 Top, MHS 65176; bottom, MHS 34279. A published version of the Gwinn photo, along with other photographs, is found in *Minneapolis Tribune*, Sept. 26, 1937, Sunday magazine. In the 1930 U.S. Census, Catherine Gwinn was a resident of Naytawaush, Twin Lakes Township, Mahnomen County. According to MHS death records (008141), she died there on Mar. 30, 1940.

136 MHS 75641; this image was retouched to correct for a large faded spot in the middle of the original. On World War I fishing at Mille Lacs, see Bruce M. White, "Early Game and Fish Regulation and Enforcement in Minnesota, 1858-1920," an unpublished report prepared for the Mille Lacs Band of Ojibwe, 1995. The Kegg story is from Kegg, *Portage Lake*, 80-83.

137 MHS 3422. Densmore, *Chippewa Customs*, 119, 123; Densomre diary, NAA.

138 MHS 6845. Densmore, *Chippewa Customs*, 2; Densmore to Stella Stocker, Aug. 22, 1917, in Stocker Papers, NEMHC; Densmore diary in NAA; Joseph Big Bear, MHS death certificates, Jan. 18, 1930, 509. George Big Bear and his wife and children are listed in the 1920 U.S. Census, Becker County, White Earth Township, District 20, sheet 9A.

139 MHS 13197

140 MHS 1903. Another Curtis photograph of Mary Razer and her grandson Benedict Bigbear is MHS 14925; for more on Curtis, see Richard Frederick and Jeanne Engerman, *Asahel Curtis: Photographs of the Great Northwest* (Tacoma: Washington State Historical Society, 1986). The Washington State Historical Society has nine Curtis photographs of Ojibwe people and scenes. Thirty negatives of his Ojibwe work taken during his Minnesota trip have been lost or destroyed. Two Curtis photos of Ojibwe in Minnesota were published in *National Geographic*, Mar. 1935, 285.

141 MHS 53604. For George Big Bear songs, see Densmore, *Chippewa Music*, 1:49, 50, 81, 87, 152, 161.

142 MHS 59018

143 MHS 6503-A. Densmore, *Chippewa Customs*, 4-5.

144 The plant report has been reprinted as Densmore,

Strength of the Earth; see p386–87 for Razer harvesting birch bark

145 Densmore photo album, MHS. Densmore, *Chippewa Customs,* 119–23; Densmore diary, NAA.

146 On this and the following pages, see reminiscences and notes in the Roland Reed Papers in the possession of Kramer Gallery, Minneapolis, MN. Another useful source on individual Reed photos is an advertising leaflet from around 1916: "Photographic Art Studies of the North American Indian by Roland Reed," copy in Reed Papers and MHS; see also list of photographs in probate record for Roland Reed estate, San Diego County, file no. 21888, copy in Reed Papers. The quotation is from a typed one-page manuscript titled "Introduction." See also Patricia Condon Johnston, "The Indian Photographs of Roland Reed," *American West* 15 (Mar.-Apr. 1978): 45–50.

147 Reed's arrival in Bemidji, his trips to Red Lake, and John G. Morrison's role in aiding him is described in a series of handwritten manuscript pages, Reed Papers.

148 Red Lake account from manuscript in Reed papers; description of picture-taking methods from obituary by W. C. Rich, Jr., written for the *Minneapolis Journal* in 1935, Reed Papers.

149 MHS 54141. Reed gave several versions of how he took the picture known as "The Hunters," one in an interview with Caryl B. Storrs, *Minneapolis Tribune,* July 24, 1916, p4, another in a handwritten manuscript in the Reed Papers, a third quoted in the Rich obituary, Reed Papers. In the manuscript, Reed says that the incident took place on a creek flowing into Red Lake; the version quoted by Rich mentions "a lake in northern Minnesota." In the Reed manuscript and Storrs article, Reed described placing half dollars in the branches of the tree; in the Rich version, he says they were silver dollars. In other respects the stories are similar.

150 Kramer Gallery; copy, MHS 62679. Caryl B. Storrs interview.

151 W. B. Laughead, "Roland Reed," *The Minnesotan,* Nov. 14–20, 1916.

153 Kramer Gallery; also available as a printed postcard, MHS 62678

154 Beltrami County Historical Society; postcard originally owned by John G. Morrison, Reed's guide at Red Lake

155 MHS 79438

156 Top, MHS 62032; bottom, MHS 32984

157 For discussions of bimaadiziwin, see A. Irving Hallowell, *Culture and Experience* (New York: Schocken Books, 1967), 294; McNally, *Ojibwe Singers,* 24.

158 Shay-now-ish-kung is discussed in Charles Vandersluis, *Once Covered with Pine: Early Bemidji* (Minneota, MN: Country Candy, 1987), 2:83–85, 87–89.

159 MHS E97.1B p21

160 MHS 63017. More on Hakkerup and other early Bemidji photographers is found in Vandersluis, *Once Covered with Pine,* 129–30.

161 MHS 102239

162 Many photographs of Kah-be-na-gwi-wens and a detailed story of his life can be found in Carl A. Zapffe, *The Man Who Lived in 3 Centuries: A Biographic Reconstruction of the Life of Kahbe nagwi wens* (Brainerd, MN: Historic Heartland Association, Inc., 1975). Contemporary writings about his life include *Duluth News Tribune,* Oct. 1, 1911; *Minneapolis Journal,* May 4, 1913; *Minneapolis Tribune,* Aug. 9, 1916, p10; see also his own supposed life story, said to have been narrated by himself and interpreted by his adopted son, Thomas E. Smith: *Chief John Smith, A Leader of the Chippewas Age 117 Years: His Life Story* (Walker, MN: Thomas E. Smith and A. A. Oliver, Cass County Pioneer, [1919?]).

163 Top, MHS E97.1K r16; bottom, MHS E97.1K r19

164 Left, MHS 62063; right, MHS 62065. For more on Christiansen, see *In Our Own Back Yard: A Look at Beltrami, Cass and Itasca Counties at the Turn of the Century* (Bemidji, MN: North Central Minnesota Historical Center, 1979), 72–75.

165 For the account of Maingans's experiences as a child, see copy of a statement attested to by John Johnson, Rev. Aloyisus, and Shob bas kaung, with letter from Mahegans to Lucius F. Hubbard, Nov. 29, 1883, file 491, Governor's Archives, MHS; Densmore, *Chippewa Music,* 1:119. Modern spelling of bizhikiwashk supplied by John Nichols.

166 MHS 62029. Densmore, *Chippewa Music,* 1:108–10.

167 MHS 48379. For more on Shagobay or Shakopee, see U.S. Census, 1920, Kathio, District 60, sheet 13A.

168 Accounts of the various Ojibwe drums, including the dance drum, in Thomas Vennum, Jr., *The Ojibwa Dance Drum: Its History and Construction* (Washington, DC: Smithsonian Institution Press, 1982), 29–75. *Taylors Falls Reporter,* June 21, 1878. For the beginnings of the June 14th celebration at White Earth, see *Minneapolis Journal,* June 20, 1903.

169 MHS 6784

170 Top, Morrison County Historical Society, Little Falls, MN; bottom, MHS 35464. For more on Shabosh-kung, see McClurken, *Fish in the Lakes,* 74 and throughout the book; Mary Warner, *A Big Hearted Paleface Man: Nathan Richardson and the History of Morrison County* (Little Falls, MN: Morrison County Historical Society, 2006), 101–6.

171 Top, MHS E97.32 r5; bottom, MHS 27511

172 MHS 91256. Other photographs of a pipe ceremony at White Earth can be found in the Stella Stocker photo album, NEMHC.

173 Top, MHS 48280; bottom, MHS E97.1 r244

174 MHS 55837

175 MHS 37752

176 Top, MHS 8281; bottom, MHS 35439

177 Top, MHS 46044; bottom, MHS 13171

178 Top, MHS 35417; bottom, NEMHC

179 MHS 35605. See Stella Prince Stocker papers at NEMHC, including various manuscripts and her photo album and journals.

180 "Dance of the Indian Wild Rice Gatherers," undated typescript, Stocker papers.

181 Stella Prince Stocker, *Sieur du Lhut: Historical Play in Four Acts* (Duluth: Huntley Printing Co., 1916).

182 NEMHC

183 NEMHC. The Hastings article was reprinted in *Taylors Falls Journal*, June 21, 1878. On cabinet cards, see Taft, *Photography and the American Scene*, 323.

184 Left, MHS 33577; top right, MHS E97.1 r38; bottom right, MHS 40026. On Way-ko-mah-wub, see U.S. House of Representatives, *Chippewa Indians in Minnesota*, 64; Newton H. Winchell, *Aborigines of Minnesota* (St. Paul: MHS, 1911), 731; Jeffrey J. Richner, *People of the Thick Fur Woods: Two Hundred Years of Bois Forte Chippewa Occupation of the Voyageurs National Park Area* (Lincoln, NE: Midwest Archeological Center, Special Report No. 3, 2002), 18; also Ina Kokko Simonson, *The Centuries of the Chippewa* (n.p.: The Author, 1976), part 3. On the Thief River Falls photos, see *Thief River Falls and Surrounding Territory* (Grand Forks, ND: Olaf Huseby, [1909 or 1910]), 5–6; Mary Croteau, *Where Two Rivers Meet: A Diamond Jubilee History of Thief River Falls* (Thief River Falls, MN: 1971), 1–3, 18.

185 MHS 53484. Information on Daniels's career from notes of the author's interview with Alberta Stout, Daniels's niece, in 1988.

187 MHS 53941. Opinions differ about the name of the Reynolds daughter. Most likely she is Charlotte Reynolds, Kiwatin, who was born in 1900 and died in March 1917; Chippewa Annuity Rolls, Non-removal, Mille Lacs, 1918, National Archives, RG 75; see also U.S. Census, 1910, Pine County, Orna Township, Indian Population, District 122, sheet 1A.

188 Top, MHS 7874-A; bottom, MHS 7884-A

189 Top, MHS 7885-A; bottom, Alvina Aubele

190 MHS 32139. On family photographs, see Christopher Musello, "Studying the Home Mode: An Exploration of Family Photography and Visual Communication," *Studies in Visual Communication* 6 (Spring 1980): 23–42; Graham King, *"Say Cheese!": Looking at Snapshots in a New Way* (New York: Dodd, Mead & Co., 1984).

191 MHS 19129. More on this family in U.S. Census, 1920, Cass County, Minnesota National Forest, T144 R29, District 112, sheet 1A; U.S. Census, 1930, T144 R29, District 11–71, sheet 1A; on John Clement

Beaulieu, who donated this photograph to the MHS, see Vizenor, *Interior Landscapes*, 15–16; on Jack Dunkley, see *Bagley Farmers Independent*, Jan. 6, 1983.

192 Here and below, information on the John and Marian Dunkley family from interviews by the author between 1987 and 1993, tapes and transcripts in author's possession.

195 Dunkley collection

196 Dunkley collection

197 Dunkley collection

198 Dunkley collection. More on John Songetay in Cordes, *Pine County*, 287.

199 Dunkley collection

200 Dunkley collection

201 Top, Dunkley collection; bottom, Thomas Family, given to author by Richard Thomas. The Thomas and Benjamin families lived near each other in 1930, as suggested by the U.S. Census, Pine County, Ogema Township, District 6, sheet 3A, families 45 and 46.

202 MHS I.69.108

203 William Jones Collection, American Philosophical Society, Philadelphia, PA. On William Jones's work as an anthropologist and a photographer, see White, *Familiar Faces*, 245–47.

204 MHS 57077

205 Top, MHS 66520; bottom, MHS 91927

206 MHS 63971

207 MHS 30596; photograph with explanatory label in NEMHC

208 Both views, NEMHC. Copy of the second view also available: MHS 20243. On George Newton, see memo to author from Alan Woolworth, Mar. 18, 1991; U.S. Department of Interior, Census Office, *Report on Indians Taxed and Indians Not Taxed of the United States* (Washington, DC: GPO, 1894), photos opposite page 354.

209 MHS 11407-A. On Andrews, see *Sixth Annual Report of the Chief Fire Warden of Minnesota for the Year 1900* (St. Paul, MN: Pioneer Press Co., 1901), photo opposite 5, 36; C. C. Andrews Papers, vol. 55, diary entries for Apr. 19 and Apr. 29, 1901. In earlier published reports, Hoxsie's initials were given as F. L. The only F. L. Hoxsie in St. Paul at the time was Frank L., a bookkeeper with the North Western Investment Company and perhaps also an amateur photographer: R. L. Polk, *St. Paul City Directory* (1901), 765.

210 MHS 40025

211 Top, MHS 62245; bottom, MHS 66893. Dewey Albinson, "A Grand Portage Story and Some Other Tales from the North Country," typed account in MHS, [p17–18]. For a reproduction and discussion of Albinson's painting, see James Hull, "Inner Peace and Kindliness Shown in Ojibwa Portrait,"

North Shore Heritage (1972), microfilm copy, MHS.

212 MHS 75293

213 MHS 48711

214 MHS 20402

215 Top, MHS 6959; bottom, MHS 62529. Author discussion with Jim Clark.

216 MHS 35260. See Mary Fields, MHS death certificates, Mar. 15, 1971, 006945.

217 MHS E97.31 r150

218 William Jones Collection, American Philosophical Society, Philadelphia, PA. U.S. Census, 1900, St. Louis County, Bois Fort Indian Reservation, District 321, sheet 1.

219 Spelling of Ojibwe title supplied by John Nichols. The word *manajiwin*, without the double a, is used frequently in a variety of contexts; see Rainy River School Board, "Connecting with the Community," 2003-4. Nichols and Nyholm, *Concise Dictionary*, 77, does not list it but includes the verb *manaaji'* meaning to "spare [someone], go easy on [something]." Mary Black-Rogers in a draft of her 1984 paper, "Ojibwa Power Interactions: Creating Contexts for 'Respectful Talk,'" lists the verb *ma.na.zam*, meaning "treat with respect," and discusses the circumstances requiring respectful behavior among the Ojibwe. These leaders also represented their people earlier when the Rice Commission visited the reservation to implement allotments; see U.S. House of Representatives, *Chippewa Indians in Minnesota*, 63-64, 182-84.

220 Top, NAA 581B2; bottom, NAA 581B1

221 Sontag, *On Photography*, 14, 24; on "shooting" in the Midewiwin, see Densmore, *Chippewa Music*, 1:43-48, also J. N. Nicollet, *The Journals of Joseph N. Nicollet: A Scientist on the Mississippi Headwaters, with Notes on Indian Life, 1836-37* (St. Paul: MHS, 1970), 204.

222 Three articles by William E. Culkin describe his visit to Nett Lake, including "Tribal Dance of the Ojibway Indians," *Minnesota History* 1 (Aug. 1915): 85-86; "How the Nett Lake Ojibways Preserve Some of Their Ancient Customs," manuscript in Old Settlers Association of the Head of Lake Superior, Duluth, MN, box 1, NEMHC; and "Tribal Dances of the Ojibway Indians," *Duluth News Tribune*, July 12, 1914. See also King, *"Say Cheese,"* xi; Edmund Carpenter, *Oh, What a Blow That Phantom Gave Me!* (New York: Holt, Rinehart and Winston, 1973), 164; Frances Densmore, *Chippewa Customs*, 79-80.

223 Nicollet, *Journals*, 266; John Tanner, *A Narrative of the Captivity and Adventures of John Tanner*, Edwin James, ed. (1830; repr., New York: Garland Publishing Inc., 1975), 273.

224 Top, Schoolcraft Papers, Library of Congress, reproduced in Nicollet, *Journals*, 269; bottom, Densmore, *Chippewa Customs*, 177

225 Top, NAA 596D45, also reproduced in Densmore, *Chippewa Customs*, plate 32; bottom, Joseph Nicollet Papers, Library of Congress, reproduced in Zapffe, *Man Who Lived*, 31, and Nicollet, *Journals*, 80, see also 186-87. On the use of kinship terms in talking to both family members and strangers, see Hilger, *Chippewa Child Life*, 153-55.

226 On sharing food, see Hilger, *Chippewa Child Life*, 153-55. On the unwillingness to display dream symbols, see Densmore, *Chippewa Customs*, 79-83.

227 NAA 596D47, reproduced in Densmore, *Chippewa Customs*, plate 33. See also Nicollet, *Journals*, 212; Tanner, *Narrative*, 189n.

228 Sontag, *On Photography*, 154, 158-59.

229 Nicollet, *Journals*, 19.

230 NAA 537a1. Frances Densmore, "The Study of Indian Music," Smithsonian Institution, *Annual Report, 1941* (Washington, DC: GPO, 1942); Densmore, *Chippewa Music*, 1:55, 2:145; Vennum, *Dance Drum*, 62.

231 Anonymous photo of the drum, MHS 76081; Ira Jacknis, "Franz Boas and Photography," *Studies in Visual Communication* 10 (Winter 1984): 39; Sol Worth, "Pictures Can't Say Ain't," *Versus* (Sept.-Dec. 1975), 86.

232 Colonel Hankins, *Dakota Land* (New York: Hankins and Sons, 1869), 383.

233 Sontag, *On Photography*, 107-8.

234 John Berger, *About Looking* (New York: Pantheon Books, 1980), 51-52; Hilger, *Chippewa Child Life*, 86; James D. Horan, *The McKenney-Hall Portrait Gallery of American Indians* (New York: Crown Publishers, 1972), 234; Kohl, *Kitchi-Gami*, 107.

235 MHS 61812. For two engravings of this work based on James Otto Lewis's original work, see *Shared Passion*, 133.

236 Berger, *About Looking*, 52, 56; Hallowell, *Culture and Experience*, 146.

237 NEMHC

238 MHS 6508-A. Clifford Geertz, *The Interpretation of Cultures* (New York: Basic Books, 1973), 6. On O-de-ne-gun, see Densmore, *Chippewa Customs*, plate 21, 98-99.

239 Don Doll and Jim Alinder, *Crying for a Vision: A Rosebud Sioux Trilogy, 1886-1976* (Dobbs Ferry, NY: Morgan and Morgan, 1976); book review, David Beaulieu, *Minnesota History* 45 (Fall 1977): 301.

240 MHS I.69.217. Killy photo album.

241 U.S. House of Representatives, *Chippewa Indians in Minnesota*, 102; *A Long Time Ago Is Just Like Today* (Duluth, MN: Duluth Indian Education Advisory Committee, 1977), 48.

Index